american artists

from the Russian

Empire

GRAFICART

american artists

the state russian
museum

foundation
for international arts
and education

# from the Russian Empire

paintings and sculptures from museums,
galleries in the U.S. and private collections

for the exhibition in

Fred Jones Jr. Museum (The  University of Oklahoma),

San Diego Museum of Art (California),

The State Tretyakov Gallery (Moscow) and

The State Russian Museum (St Petersburg)

**Director of the State Russian Museum**
Vladimir Gusyev

**President of the Foundation for
International Arts and Education**
Gregory Guroff

**Idea and Concept of the Project**
Joseph Kiblitsky,
Yevgenia Petrova

**Editor-in-chief**
Yevgenia Petrova

**Organisational Committee of the Project**
Gregory Guroff, Katharine Guroff,
Joseph Kiblitsky, Yevgenia Petrova,
Elena Romanova

**Artistic Editor**
Joseph Kiblitsky

**Catalogue Contributors**
Yevgenia Petrova, Alison Hilton,
Percy North, Harlow Robinson,
Sharon Marie Carnicke, Beth Holmgren

**Design**
Kirill Shantgay

**Coordination**
Katharine Guroff, Anna Laks,
Tatyana Melnik, Elena Romanova

**Editor**
Elena Romanova
Katharine Guroff

**Proofreader**
Elena Naydenko
Anna Krasilnikova
Irina Tokareva

**Translation from Russian**
Elena Romanova
Katharine Guroff

**Computer Layout**
Julia Kharchenko
**with assistance from**
Nataliya Kuzmina

**Photography**
Richard Goodbody
Paul Hester
Gabe Palacio
John Parnell

The State Russian Museum present: American artists from Russian Empire /
Almanac. Edn. 208. СПб: Palace Editions–Graficart, 2008

© State Russian Museum

ISBN 978-3-940761-19-4 (International)

Printed in Italy

The State Russian Museum and the Foundation for International
Arts and Education would like to thank the following organisations and
individuals for their contribution to the project:

Art Institute of Chicago
Brooklyn Museum
Fred Jones Jr. Museum, University of Oklahoma
Nasher Museum of Art at Duke University
National Portrait Gallery of Art, Smithsonian Institution
Philadelphia Museum of Art
San Diego Museum of Art
The Jewish Museum, New York
The Metropolitan Museum of Art
The National Gallery of Art
The Smithsonian American Art Museum
The Smithsonian Hirshhorn Museum and Sculpture Garden
The State Tretyakov Gallery
Whitney Museum of American Art

ABA Gallery
Abby M. Taylor Fine Art
Hollis Taggart Galleries
Michael Rosenfeld Gallery
Spanierman Gallery LLC
Tobey C. Moss Gallery

Mary Arapoff
Anthony and Judy Evnin
Florence and Donald Morris
Kate Rothko Prizel and Ilya Prizel
Alexander Smuzikov, Moscow
Boris Stavrovski
Alex and Irene Valger

**with support from**

Konstantin Grigorishin, Energy Standard Group
Anthony and Judy Evnin
Gail and Mike Yanney, the Burlington Capital Group
Slade Foundation
The U.S. Federal Council on the Arts and the Humanities,
the Indemnity Program
Trust for Mutual Understanding

**General sponsor**

# Morgan Stanley

**Sponsors**

# contents

**William J Burns**. United States Ambassador to Russia
Forward Letter to the Catalogue                                      7

**Yuri V. Ushakov**. Ambassador of the Russian Federation to the USA
Forward Letter to the Catalogue                                      9

**Gregory Guroff**
A Few Words from the Foundation
for International Arts and Education                                  11

**Yevgenia Petrova, Joseph Kiblitsky**
From Authors of the Idea of the Project                              15

**Yevgenia Petrova**
American Artists from the Russian Empire                             19

**Alison Hilton**
Bridging the Great Divide:
Russian Visions and the Rhythm of Modern America                     43

**Percy North**
The Russian-American Impact on Modern Art                            55

**Harlow Robinson**
Americans from Russia in Music                                       65

**Sharon Marie Carnicke**
Russian Actors in American Theatre                                   83

**Beth Holmgren**
Settling for the Real Hollywood:
Russians in Studio-Era American Film                                 97

Color Plates                                                        112

Biographies of Artists                                              244

Abbreviations                                                       285

Index of Artists                                                    286

*Embassy of the United States of America*
*Moscow, Russia*
*April 11, 2008*

**Forward Letter to the Catalog "American Artists from Russia"**

It is a great pleasure to welcome the exhibit, "American Artists from Russia," which will tour the United States and Russia in 2008-2009. Following last year's successful "300 Years of American Art" – the largest exhibition of American art ever shown in Russia – this collection of works by Russian artists inspired by their experience in America marks another milestone in cultural relations between our two countries.

In 2007 we celebrated the 200th anniversary of the establishment of diplomatic relations between Russia and the United States. By illustrating how 19th and 20th century Russian artists were influenced by America and how those artists in turn influenced American art, "American Artists from Russia" reminds us again of the many close connections that have marked those 200 years.

This exhibition also reminds us of the benefits of cooperation between museums and curators, between governments, between businessmen in both our countries. I would like to express my appreciation to the Foundation for International Arts and Education and the State Russian Museum for their vision in developing this exhibit and catalog, and to all those organizations and businesses whose support made it possible.

William J. Burns
United States Ambassador to Russia

David Burliuk
Hudson. 1924
ABA Gallery, New York
Detail (ill. 4)

**Forward letter to the catalogue "American Artists From Russia"**

April 25, 2008

Dear friends,

I am pleased to support the "American Artists from Russia" exhibit organized by the Foundation for International Arts and Education in collaboration with the State Russian Museum.

This project presents a unique opportunity to see yet another dimension of the intersection between our countries and people. It is also a great chance for our cultures to interact further, since the exhibit will be presented both in the United States and Russia, allowing audiences to compare, feel and experience cultures, events, and emotions that were so familiar and yet remain so unknown.

For generations, Russian artists have contributed to world culture. Due to various reasons, some of them immigrated to the United States. The exhibit demonstrates how these Russian emigrants continued their creative careers ones settled in America. It opens up another chapter in the history of Russian culture and gives us another reason to be proud of our compatriots, who had an impact on American art and therefore added to the bonds connecting our two countries.

I am thankful to the Russian and American sponsors of this important project. It would not have been possible to bring this treat to the audiences in both counties without their help and support.

Best wishes,

Yuri V. Ushakov

Sergei Sudeikin
Pre-Lenten Festival. Second half of the 1920s
ABA Gallery, New York
Detail (ill. 30)

a few words from
the foundation for
international arts
and education

"American Artists from Russian Empire" is the most complicated and most challenging exhibit that the Foundation has been involved in. The project has gone through significant evolution since its beginnings several years ago and it has been since its beginnings a cooperative venture with our extraordinary colleagues at the State Russian Museum, who first proposed the idea of this project and have worked with us now for several years. Beginning the project, we had no idea how great the volume of material was that we had to work through. In the course of the project we had to resolve a whole range of problems.

Since we were interested in the impact of the émigré experience on artists who came from Russia and their impact on the culture of their adopted country, we decided very early on that we had to limit the project chronologically. For the newer waves of artists we felt it was simply too early to evaluate the cultural impact, so we decided to limit the exhibit to artists who came to the U. S. before or immediately after World War II. Second, we decided to include artists who were nurtured in the cultures of the Russian Empire/Soviet Union irrespective of the ethnic origins. Third, when we faced the task of choosing the artwork to represent this vast range of artists and their production, we recognized that one exhibit could not possibly be fully representative. Moreover, for a traveling exhibit, we could include largely works of oil on canvas — and for a long tour could not include works on paper, pastels, watercolors, large sculpture works, etc. So we decided to try to utilize the catalogue to give a broader picture of the Russia emigration. We have thus included in the catalogue many things we could not present in the exhibit. We have also commissioned articles on similar people who worked in related fields, music, film and theatre. We originally bit off more than we could chew, but I hope that the viewers of the exhibit and readers of the catalogue will agree that the choices we have made are reasonable and understandable.

That being said, we believe that the exhibit itself is a fascinating foray into the work of émigré artists and provides us with insights into the émigré experience and more broadly into the creation of American culture distilled as it is from the multifarious strands. We are extremely grateful to the many museums, galleries and private collectors who have entrusted us with their precious works. We hope that the exhibit is of interest to American audiences who may know little of the ethnic origins of many of the artists and may appreciate the contributions emigrants have made to enriching American culture. In the past, cultural figures who left the Soviet Union were virtually erased from memory, we hope equally that this exhibit and catalogue will help Russian audiences take pride in

**Vladimir Izdebsky**
Untitled
First half of the 1960s
State Russian Museum
Detail (ill. 107)

the contribution their countrymen/women have made to American, and world, culture. Many of these artists were well established at home before they left, and the exhibit and catalogue offer an opportunity to compare their works before and after they left.

As I have already indicated, the project has been from the beginning a joint venture with our colleagues from the State Russian Museum. Yevgenia Petrova, Deputy Director of the State Russian Museum, along with Joseph Kiblitsky also of the State Russian Museum, brought the original conception to us several years ago. Yevgenia Nikolaevna with her amazing energy and determination accomplished an incredible amount of research identifying artists, their biographies and *oeuvre*, and compiling the checklist for the exhibition and the catalogue.

The FIAE staff is very lean and mean. Elena Romanova and Kathie Guroff have tracked down the works for the exhibit in the U.S. museums, galleries, and private collections. They negotiated the loans, and developed the annotations and biographies for the catalogue, jointly editing them with SRM staff. Little did we know when we began how labor intensive such a venture is and how many details went into a venture this complicated. Doug Robinson, our angel in disguise, assisted by Alec Guroff, handles the logistics for all of our exhibits with such calm and aplomb that it appears that no task is too complicated.

From the outset, we have been blessed by amazing support from the Trust for Mutual Understanding, from Tony and Judy Evnin, from Gail and Mike Yanney, and from the Slade Foundation. They provided the crucial support when the project was first being launched. The major sponsor on our side has been Konstantin Grigorishin to whom the Foundation owes an enormous debt of gratitude. And, in Russia a similar role has been played by Severstal and Lukoil. The most significant support for the exhibit was provided by Morgan Stanley.

The cost of insurance for art exhibitions has escalated to such a point that without assistance many exhibitions will simply not happen. We are very grateful to the Federal Council on the Arts and Humanities that has provided an "indemnification" for the Russian leg of the exhibit tour. This is one of the least known, but most efficient and effective program in the U.S. Government, and it is administered by the amazing Alice Whelihan. A special word of thanks goes to Sonya Bekkerman and her staff at Sotheby's who were instrumental in helping us with the indemnity application.

We hope that the readers of this catalogue and the visitors of the exhibition find it both aesthetically pleasing and intellectually enriching.

Gregory Guroff, President
Foundation for International Arts & Education

Nina Schick
Manhattan Cityscape. 1940s
Private collection of Judy and Anthony Evnin
Detail (ill. 60)

from the authors
of the idea of
the project

*American Artists from the Russian Empire* is a theme that was born within the walls of the State Russian Museum about five years ago as a continuation of the series *Art of the Russian Emigration*. Previously, in 2003, the *Russian Paris* exhibition took place in St. Petersburg, France and Germany. In the future we hope to research the fate of the Russian artistic emigration to Germany and other countries.

By focusing specialized treatment on the works by the émigré artists we, in no way, have any desire to paint the art of other countries with the color of Russia. To begin with, this theme is an important one for history of Russian culture between the 1930s and the 1960s, because it was forbidden in the Soviet Union to even mention those who left the country. That is the reason why the names of many artists and other cultural figures who previously were famous in their country, were almost erased from the history of the nation's art. What they did after their departure, what fate they encountered, what relations they had with the culture of the country that adopted them — these and many other questions frequently remained unanswered until today. The names of the artists, who left in their childhood and were not yet famous in their Motherland, are at best mentioned in reference books. Their art as a rule is not known to their fellow countrymen.

Addressing this theme, we, of course, did not limit ourselves by a goal of only identifying the circle of American artists who were connected to Russia by their roots. Most of all, this circle is so wide that it was unrealistic to include all who entered there within the framework of one exhibition. First of all, we were interested in artists who were most important to both Russian and American cultures. It was important, also, to trace the process of their adaptation to another environment and the extent of their creative ties with Russia. The exhibition and the catalogue include the work of many artists and sculptors who left the Russian Empire and the Soviet Union before the end of the 1930s and did not return to their Motherland. It was not only because from the end of the 1930s under the coming rule of Joseph Stalin immigration was almost impossible until the end of 1960s. These decades of the 20th century were the time for rapid development of various genres and productive artistic tendencies in Russia. Those leaving the Russian Empire and the Soviet Union had quite a bit to bring along with them to America.

**Ben Shahn**
Renascence. 1946
Fred Jones Jr. Museum of Art
The University of Oklahoma, Norman
Purchase, U.S. State Department collection, 1948
Detail (ill. 68)

15

In turn, America of 1940s—1960s could offer great opportunities to the newly arrived to develop their talents in various styles and directions, which was impossible in the Soviet Union.

Unfortunately, it was impossible to include all the material in its fullness in the framework of the exhibit and publication. Quite a few American artists and sculptors of Russian heritage were left outside the borders of this project. The work of theatre and cinema artists, designers, who worked on book, magazine, and newspaper illustrations, fashion designers and applied art professionals was not included in the framework of this exhibit and the catalogue. Research on their contributions to the American culture demands special attention, which we hope will be given to these spheres of art in the future.

It goes without saying that neither this publication that we offer to our readers nor the exhibit itself exhaust the theme of *American Artists from the Russian Empire*. Just the opposite, the material we have gathered so far will hopefully push researchers to take further steps. We would be glad if the first exhibit with this theme in American museums (Fred Jones Jr. Museum at the University of Oklahoma and San Diego Museum of Art) and Russian museums (the State Russian Museum, St. Petersburg and the State Tretyakov Gallery, Moscow) will serve as a push toward new exhibitions, articles, and books in America as well as in Russia.

The material presently gathered is the result of the labor of not only the authors of this idea and the exhibition curators. We had help from our colleagues in many American museums from the very beginning. With our special appreciation we would like to remember our first steps at the Art Institute of Chicago, the Modern Museum of Art, the Brooklyn Museum, the Jewish Museum in New York, the New York Library and the Archive of American Art of the Smithsonian Institution. We sincerely thank our colleagues in those organizations for their advice and help.

Such a multi-year project would not have been possible without the financial support. We had assistance from the Trust for Mutual Understanding (Richard Lanier), Severstal, and Lukoil throughout the various stages of this project. The organizers of the exhibit express a special gratitude to Morgan Stanley as the general sponsor of the exhibit and the publication. We thank the heads of those organizations as well as colleagues for their trust and generosity. No less significant was the help of individuals who believed in the importance of this project. Gail and Michael Yanney, Judy and Anthony Evnin and Konstantin Grigorishin — please accept our warmest words of gratitude.

It is impossible, unfortunately, to name everyone who assisted us with this project. But there are few people who shared the weight of all the problems we encountered during the work on the exhibit and the catalogue. Greg Guroff, President of the Foundation for International Arts and Education and his colleagues, Elena Romanova and Kathie Guroff, worked shoulder to shoulder with us during these several years. They believed in the usefulness of this project and having rolled up their sleeves, worked together with us.

Not everything went the way we wanted it to go. For example, we had to change our ideal checklist for the exhibition which included works from major American museums. Not all the museums could lend their works to the exhibition for various reasons. The search for alternative opportunities was put on the shoulders of Kathie Guroff and Elena Romanova, along with the tedious work of maintaining all correspondence, writing agreements, collecting images and texts for the catalogue, and translation and editing of the English edition of the catalogue.

It is not enough to simply thank Greg Guroff and his team from the Foundation for International Arts and Education. They are our partners in this project who shared with us all the joys and tears of the results of this joint collaboration.

Not insignificant was the work on preparation of artists' biographies and project coordination — Elena Yakovleva, Anna Laks, Tatyana Melnik, Marina Panteleymon, Irina Tokareva from the State Russian Museum who implemented the project on the Russian side.

We are thankful to our colleagues and the staff at the State Tretyakov Gallery who decided to present this exhibit to the public along with our colleagues in Oklahoma and San Diego.

<div style="text-align: right;">

Yevgenia Petrova,
Joseph Kiblitsky
State Russian Museum

</div>

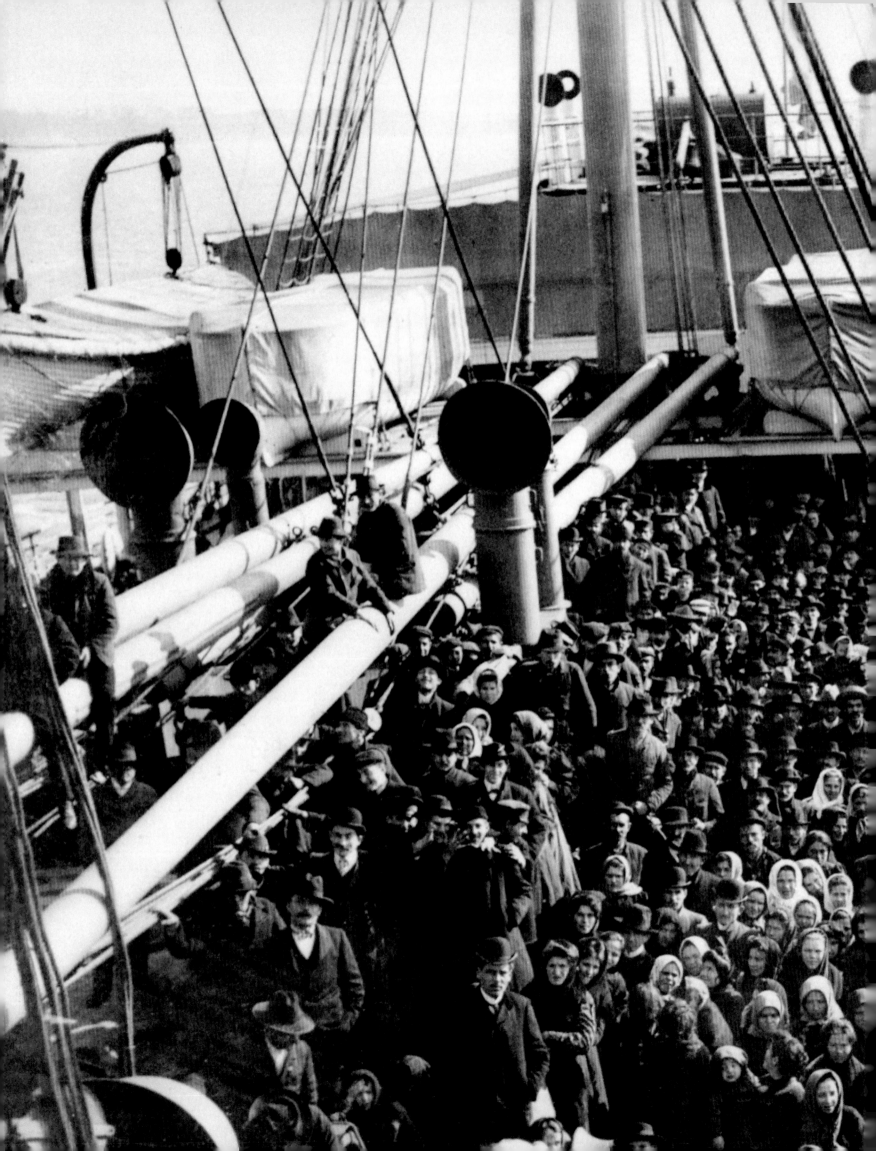

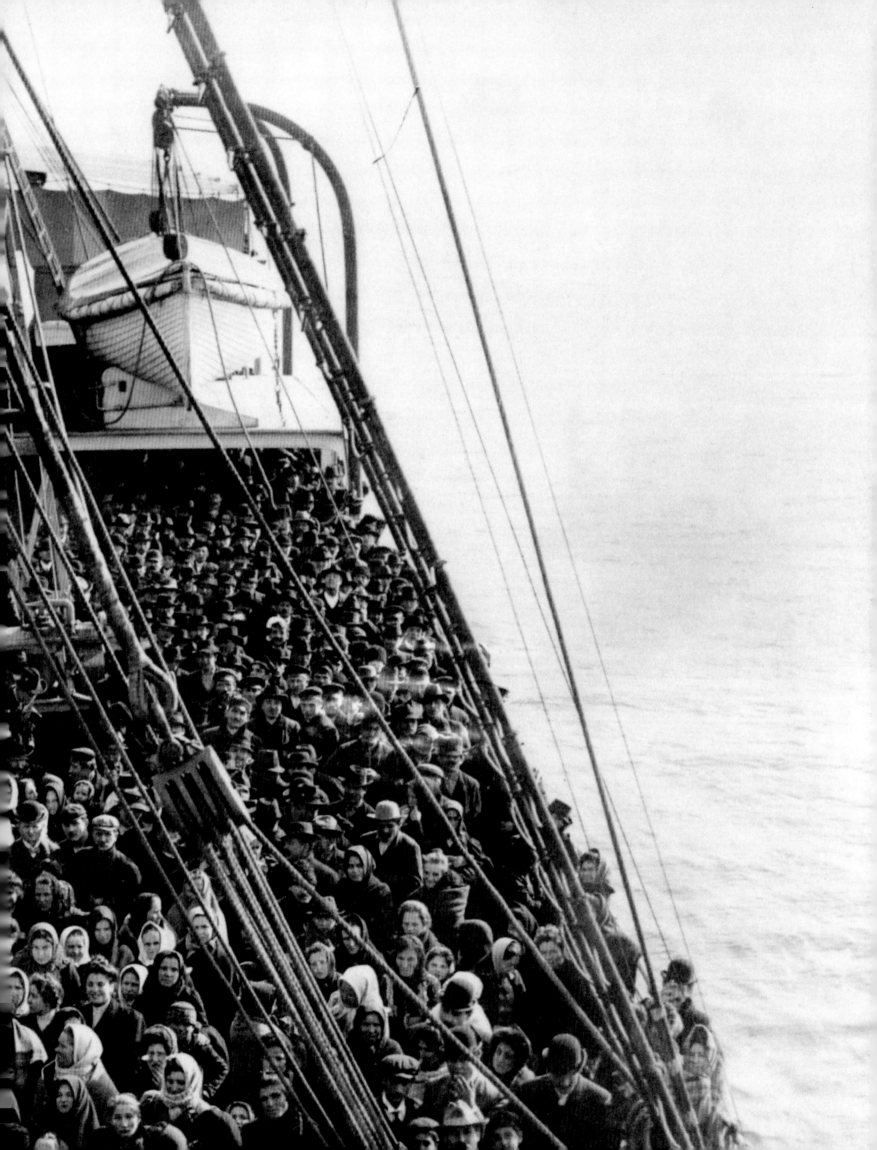

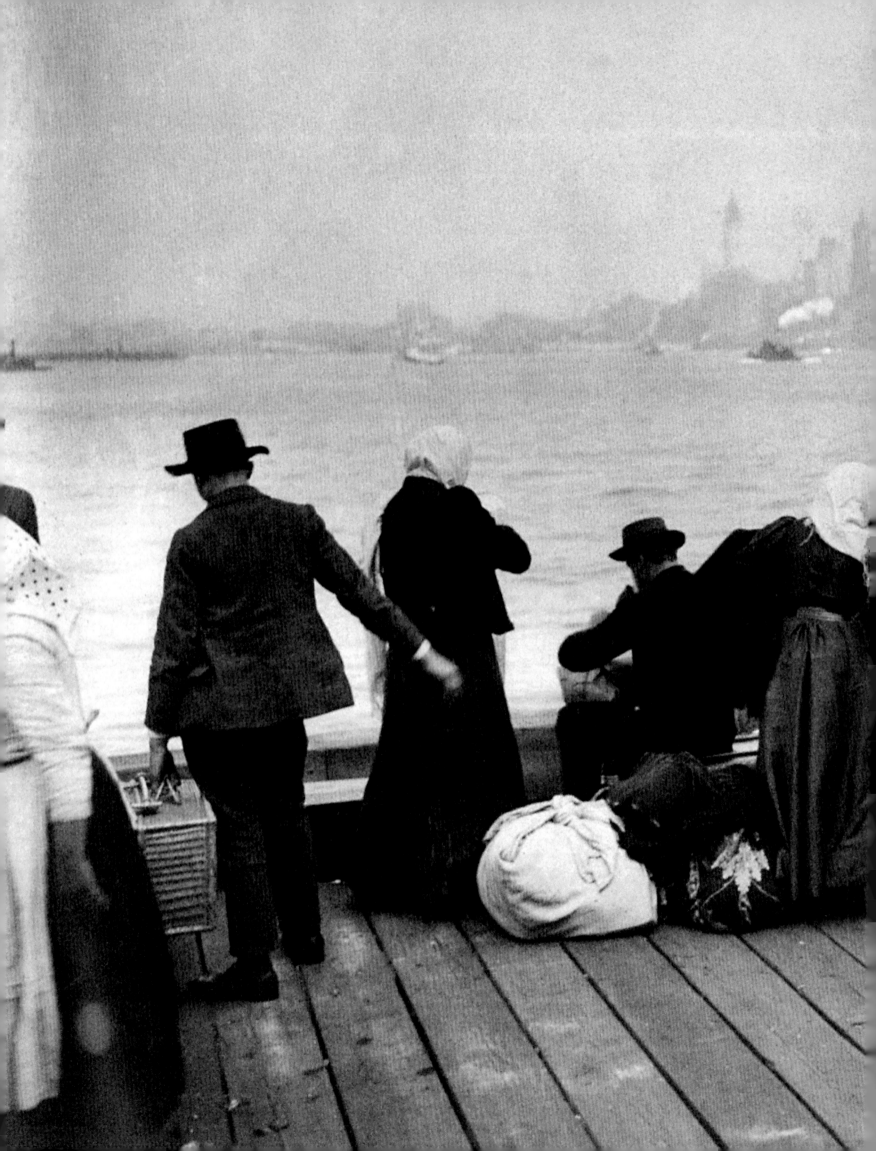

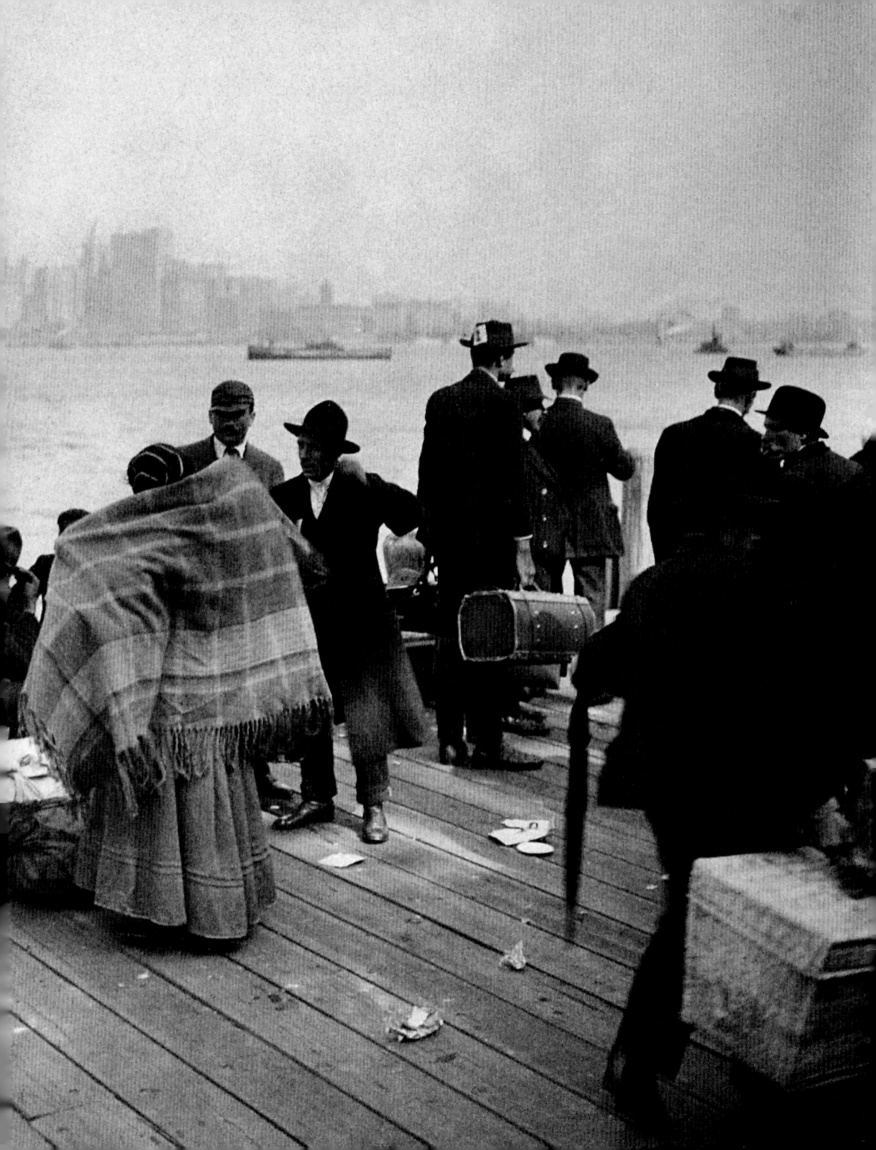

Yevgenia Petrova,
Ph.D., the State Russian Museum

# american artists from

America and Russia are both multinational countries, but their respective cultures were formed by different principles. Traditions of the native population, mostly Russian, provided the soil for Russian culture. American culture was developed according to different historical laws — numerous diverse waves of immigrants interacted and were layered one upon another. Principles of cultural integration for North American civilization are still being discussed and debated (i.e., Melting Pot, mosaic, symbiosis, or synthesis). Every ethnic and cultural group arriving on U.S. territory had to adapt to the situation, while at the same time bringing its unique contribution to the overall American landscape. Russia became one of the most notable sources of the formation of American contemporary culture. Just a few names of famous American artists of Russian origin are great testimonials to the process of integration into American culture of those born on the territory of the Russian Empire — Mark Rothko (Markus Rotkevich), Louise Nevelson (Leah Berlyavskaya), Jacques Lipchitz (Chaim Jacob), and Arshile Gorky (Vosdanig Anouk Adoian).

However, cultural ties and familiarity of America and Russia, which, at a later time, served as the basis for communication between the two, were established long before the first wave of Russian immigration. As secretary to the Russian Consul General to the United States, Pavel Svinin (1787–1839) arrived in Philadelphia in 1811. This young diplomat, with a mission to "learn about culture and traditions of the country, to develop mutually beneficial relations,"[1] had a multifaceted and wide interpretation of his tasks at hand. Svinin decided to present America to his fellow citizens not only by its literature and press. He traveled extensively throughout the country and as a result produced several watercolor albums (currently in the State Russian Museum, St. Petersburg, ill. on p. 24,

# the russian empire

and the Metropolitan Museum, New York).[2] The albums captured American traditions, nature, and architecture of new cities with a very surprising accuracy. In 1814 *The Son of the Fatherland*, a St. Petersburg magazine, published excerpts from Svinin's future books *A View of the United States of America*, and *Traveling Across North America*, which came out in different publications in 1814 and 1815.[3]

Svinin's knowledge about the U.S., reflected in texts and images created by him between 1811 and 1813, was the reason for reprinting one of his watercolor albums in 1930.[4] However, Svinin did not limit his publications to introducing the U.S. to the Russian audience in the beginning of the 19th century. In 1813 he published a book in Philadelphia about Moscow and St. Petersburg, which he illustrated himself.[5] Thus, both Russians and Americans had an opportunity at the beginning of the 19th century to become acquainted with each other's countries through the images and texts by Pavel Svinin — an artist, writer, and publicist.

[1] N. N. Bolkhovitov, *Stanovlenie russko-amerikanskikh otnoshenii. 1775–1815*. M., 1966. pp. 350–351.

[2] About this see, *Traveling Across North America. 1812–1813. Watercolors by the Russian diplomat Pavel Svinin. Sixty-eight watercolors of the Russian Museum, St. Petersburg*. New York: Harry Abrams Publisher Inc.; St. Petersburg: Izokombinat Khudozhnik RSFSR, 1992.

[3] *Syn otechestva*. 1814, Nos. 36–37; 45–48.

[4] *Picturesque United States of America 1811, 1812, 1813: being a memoir on Paul Svinin, Russian diplomatic officer, artist, and author, containing copious excerpts from his account of His Travels in America, with fifty-two reproductions of watercolors in his own sketch-book*. By Abraham Yarmolinsky, Introduction by R. T. H. Halsey. New York, William Edwin Rudge, 1930.

[5] *Sketches of Moscow and St. Petersburg*. Philadelphia, 1813.

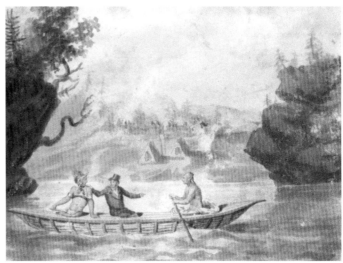

The next stage of artistic descent upon the U.S. occurred at the end of the 19th century. "If it had no other claims to remembrance, the winter season of 1888 will at least be recalled for many years to come as the epoch of Vasily Vereshchagin's advent in New York," that is how Valerian Griboedov described it in his article "A Russian Apostle of Art" in *Cosmopolitan*.[6] In 1888 Vereshchagin brought 59 crates of his paintings to New York. Judging by the amount of press received on this occasion, the public was enraptured by his works. Griboedov commented on Clarence Cook's article, agreeing with him that the exhibition was "an intellectual feast, such as none other presented to the public for the past twenty-five years."[7] In 1889 the artist traveled to Chicago to present his exhibit. In 1901 he came back to America to paint the Spanish-American War. Vereshchagin received support from General Arthur McArthur who bought several of his works about military hospitals and the dead. The paintings were exhibited to the admiring public of New York and then at the Art Institute of Chicago in 1901.[8] The same year the newspapers were full of information on these cultural events. President Theodore Roosevelt admired the artist as well and commissioned him to portray the Battle of San Juan Hill. The Astor Gallery held an auction of Vereshchagin's works on November 26, 1902 that presented ten years of the artist's work. An admirer of Roosevelt purchased *The Battle of San Juan Hill* and two other works about the Philippines and all others were sold to American collectors.[9] There are many other Vereshchagin's works in the United States, but they have not yet been found. The Brooklyn Museum of Art, however, has three large pieces in its collection: *A Resting Place of Prisoners*, that describes the killing of Turkish prisoners of war in the Russian-Turkish War, 1877–1878, *The Road of the War Prisoners*, and the *Crucifixion*,[10] dedicated not only to the Biblical theme. The paintings reflect Vereshchagin's pacifist views — he could not tolerate cruelty and murder, whether connected to war or religion.

Almost at the same time another famous artist from Russia visited America. Ivan Aivazovsky (1817–1900) exhibited 24 of his paintings in New York (1892), and 20 works

**Pavel Svinin.** New York. 1812–1813
Watercolours on paper. 4 x 5¹/₄ in. (10.2 x 13.2 cm)
Sheet from the *Travel across America*
album (mounted on passe-partout)
Received in 1953 from the Ministry
of Culture of the USSR. State Russian Museum

**Pavel Svinin.** North America Inhabitants. 1812–1813
Watercolours on paper. 4 x 5¹/₄ in. (10.3 x 13.3 cm)
Sheet from the *Travel across America*
album (mounted on passe-partout)
Received in 1953 from the Ministry
of Culture of the USSR. State Russian Museum

[6] "A Russian Apostle of Art" by Valerian Gribayedoff. *Cosmopolitan*. Vol. VI, 1889, n. 4, February, p. 311.

[7] *Ibid*.

[8] We will give examples of just a few publications: *Chicago Chronicle*, Dec. 7, 1901; *Chicago Post*, Dec. 7, 1901; *Chicago Record Herald*, Dec. 8, 1901; *Chicago Chronicle*, Dec. 9, 1901; *Chicago News*, Dec. 13, 1901; *Chicago News*, Dec. 14, 1901; *Chicago Tribune*, Dec. 19, 1901.

[9] "Russia's Forgotten Pacifist Painter." Typed manuscript by Francis B. Randall, 1981 (Brooklyn Museum archives).

[10] Brooklyn Museum documents, as well as probably Vereshchagin himself, list the work as *A Crucifixion in the Time of the Romans* (259 x 399). Presently, the painting is rolled up and is not available for any photography.

in Chicago (1893). Aivazovsky always worked fast and produced a series of paintings that he dedicated to America during the time he was in the States. In a letter dated January 9, 1893, to the Corcoran Gallery, he wrote about two particular canvases: "Gentlemen, I personally desire to present to the Corcoran Gallery in the national capital of the United States of America two of my paintings, hoping to express the heartfelt appreciation of the people of my country for the generous and timely assistance rendered by the United States government during the recent famine in Russia. Sincerely yours, I. Aivazovsky, Professor of Fine Arts, St. Petersburg, Russia."[11]

The two paintings took on a new meaning during the Cold War era. On May 6, 1961, Jacqueline Kennedy organized an exhibit at the White House called "Quiet Diplomacy." Her idea was to emphasize that Americans had warm feelings toward the Russian people and were ready to help during difficult times, regardless of the general attitude toward the Soviet government. Two of the Aivazovsky's paintings were part of that exhibit.[12] One of the paintings portrays an American ship in a Russian port. It brought food so needed by the hungry people of Russia in 1892. Russian people came out to greet the ship in boats and are seen waving their hats. The other painting has more of a plot. The food supplies arrive on a *troika*, a sled drawn by three horses, and the streets are lined with citizens of Feodosiya, Crimea. Both paintings are dedicated to the generous American gesture that gave Russia 5 million tons of grain during the great famine on the Volga River in 1891–1892.[13] "Mrs. Kennedy Uses Art in 'Quiet' Diplomacy'" was a title of the article that was published and accurately and fairly described this occasion.[14] The Corcoran Gallery of Art, which apparently no longer needed the paintings, sold both at auction even though they had not only artistic value, but also a great sentimental value for Russians and Americans (Sotheby's, New York, May 3, 1979, lot 29 and Sotheby's, New York, April 15–16, 2008).

Although Ivan Aivazovsky, Vasily Vereshchagin, and Pavel Svinin left a remarkable impression on American cultural life (along with their contemporaries Konstantin Makovsky, Ivan Pokhitonov, and others), they returned to their Motherland without becoming American citizens. Their purpose was not to stay and adapt to American society and cultural life.

Russian artists of the 20th century did have such a need. Emigration from Russia, including immigration to the U.S., started before the 1917 Revolution. The Jewish population of Ukraine, Latvia, Lithuania, Moldova, Poland, and Byelorussia — that were then part of the Russian Empire — felt this process the most since a majority of the Jewish population lived in those provinces. Lack of equal rights, poverty, pogroms and cruelty of local police that limited the Jewish population to 'ghetto' settlements caused this segment of the population to leave those homes in search of a better living environment outside of the Russian Empire.

11
TSGIA, f. 789, op. 1, 1891, d. 80, l. 124. Several paintings dedicated to Columbus' discovery of America were mentioned in the report of the Imperial Academy of Arts.

12
"The Fish Room Gets 2 Russian Paintings," by David Wise. *The Washington Post (Times Herald).* May 6, 1961.

13
*Ibid.*

14
"Mrs. Kennedy Uses Art in Quiet Diplomacy," by David Wise. *New York Herald Tribune,* p. 2, May 6, 1961.

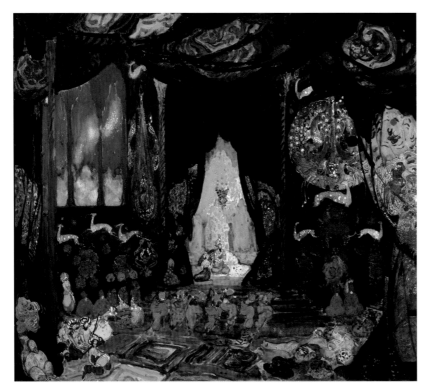

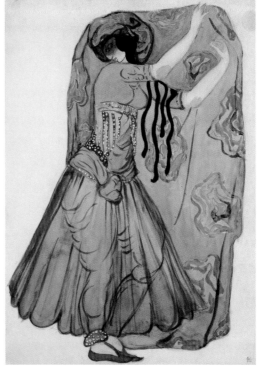

Jews were among the first immigrants to arrive from the Russian Empire. They either went straight to the U.S. or through other countries. Such famous artists as the Soyer brothers, Louis Lozowick, Ben Shahn, Mark Rothko, Peter Blume and others arrived before the 1917 revolutions in Russia. All of them had great difficulties in the beginning and did not start their artistic careers right away. According to the memoirs of Mark Rothko's sisters, he sold newspapers upon his arrival in America, just like many of his contemporaries.[15] The Soyer family came to the U.S. in 1912 and although their father was a teacher of Hebrew, during the day the brothers did manual labor jobs and painted during their free time in the evenings.[16]

This way of life was rather familiar to most of those who became artists in the U.S. In order to survive and succeed, the immigrants tended to spend time together, especially if their friendships helped with the development of their professional careers. During the first few decades of the 20th century, the immigrants opened their own schools or created various artistic societies and groups where they simultaneously studied English, learned more about their professions, and discovered how to market their works to galleries and potential buyers.

The Education Alliance became one of the most important art schools of the 1920s. Abbo Ostrovsky who came to the United States in 1908 was its gracious genius. Having graduated from the National Academy of Design, he opened an art workshop in the East End and later became one of the leaders of the Education Alliance which prepared sculptors, artists, lithographers, and designers. By 1925, 238 students attended the school —

**Boris Anisfeld.** Sultan's Palace. 1911
Set design for Mily Balakirev's ballet *Islamey*
Tempera on cardboard. 27$^{1}/_{4}$ x 29$^{3}/_{4}$ in. (69 x 76 cm)
Received from the State Museum Fund, Leningrad
State Russian Museum

**Boris Anisfeld.** Princess. 1911
Costume design for Mily Balakirev's ballet *Islamey*
Watercolours and gouache on cardboard
18$^{3}/_{4}$ x 13$^{1}/_{2}$ in. (48.1 x 34 cm)
Received from the State Museum Fund, Leningrad
State Russian Museum

[15]
From the interview with the artist's sister Sonya Allen, September 15, 1984, Archive of American Artists, reel 4937, frame 1.

[16]
Moses Soyer, 1899 –1974; "A World of Humanist," *Art News*, Oct. 1974, p. 54.

most of whom were immigrants. During the day they worked, and attended school at night. Peter Blume, Isaac and Moses Soyer, Louis Lozowick, Louise Nevelson were among its students.

*The Ten* group was created in 1935 and many of the Russian immigrant artists were among its members at various times — Ben Zion, Mark Rothko, Joseph Solman, Ilya Bolotowsky, Nahum Tchacbasov, and John Graham. They worked alongside their American counterparts — Maryann Villard, Adolf Gottlieb, Louis Schanker, Harris and Kufeld — searching for galleries and organizing exhibits,[17] which later, without a doubt, helped them to become famous and succeed in the art world. However, fame did not come quickly to them. Even before it reached the most successful ones, they had to go a long way to achieve it. Many of the artists who came after the 1917 Revolution were already famous and successful at home and they were able to do well in the U.S. almost at once, receiving public appreciation and critical acclaim. Unlike their countrymen, they were often wealthier to begin with than those who had struggled just to reach America. Perhaps, some of their success was due to the exotic nature of Russia in America and some of it was due to the artists' "refugee" status. The fact that the artists had to flee from Revolutionary Russia probably stimulated the already existing interest in their work and their lives in the 1920s. During this time, exhibits of Russian artists and/or works that came from Soviet Russia occurred one after the other.

In the early 1920s, artists who were already famous in their country arrived in America — Boris Anisfeld, Boris Grigoriev, Nicolai Fechin, Sergei Sudeikin, David Burliuk and others. They brought with them a very rich experience of Russian cultural life at the end of the 19th to the beginning of the 20th century. Each one had his own style and theme as well as an extensive background in painting. Anisfeld was famous in Russia for his fantastic use of colors and his theatre and costume design. Boris Grigoriev was known for his new and sharp approach to the theme of the Russian village, expressive ways of portraying everyday life, and painting portraits of epic standards. (*The Land of the People*, 1918, and *Portrait of Vsevolod Meyerhold*, 1916, ill. on p. 28 — both currently in the collections of the State Russian Museum, St. Petersburg). Nicolai Fechin was viewed as a Russian impressionist. Sergei Sudeikin always surprised the public and critics with his wild imagination, and ironic mystical changing nature of themes, behavior, and scenery. Upon arrival in the U.S. each of the artists was immediately included in the cultural life of the country. Anisfeld, who came to America in 1918, received an invitation to create costume and stage design for *Violetta — the Queen of Thieves* at the Metropolitan Opera and *The Love for Three Oranges* with Prokofiev's score. Although only a few understood the music of this famous composer, the stage design was extremely successful. One art critic wrote about Anisfeld's work: "A universal figure — incidentally Russian. More profound, more deeply-rooted, more sonorous than Bakst, his utterance makes tremulous all the fabric of such paganistic diversions as the Ballets Russes."[18]

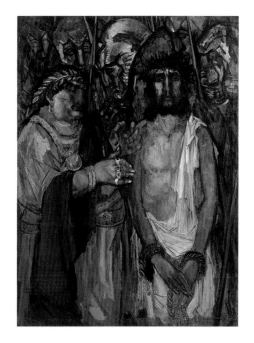

**Boris Anisfeld.** Christ and Pilate. 1940s (?)
Oil on canvas. 54 x 38$^{1}/_{5}$ in. (137 x 97 cm)
ABA Gallery, New York

**Boris Anisfeld.** Sodom and Gomorrah. 1963–1964
Oil on canvas. 65 x 38$^{1}/_{5}$ in. (165 x 97 cm)
Professor Stravrovski collection, New York

17
From Barbara Schickler's interview with Ben-Zion. August 3, 1982, Archive of American Artists, reel 4937, frame 109, p. 21.

18
Mr. James Britton in *American Art News* — Extracts from Press Comments on the Anisfeld exhibition, *The Brooklyn Museum Quarterly*. Vol. VI, January 1919, No. 1, p. 10.

After great theatrical success, Anisfeld was offered an opportunity for a solo exhibition at the Brooklyn Museum (1919), where he exhibited 120 of his works mostly from the Russian period. In his introductory article for the catalogue, Christian Brinton wrote, "It would be difficult to imagine anything farther removed from the conventional than the escape, from revolution and from famine-ridden Russia, of the decorative painter, Boris Anisfeld..."[19] The author further described the works as typically Russian in their color, complexity and richness, "Typically Russian in its emotional fervor... their purpose is "to stimulate the creative and imaginative sensibilities through its freedom of subject-matter, its richness of color, and inherent beauty of rhythmic line."[20]

Other critics noted that Anisfeld's work "...is identified with the movements that seem the rebellions of today." The author continues, "has an unusually strong sense of color, so strong as to verge on the barbaric, and this may be a part of his **Slavic inheritance**" [emphasis by the editor].[21]

Gradually, the success of Anisfeld's first years in the U.S. diminished. Theatre was no longer a priority during the years of the Great Depression in the late 1920s. Anisfeld was not in demand as a theatre designer. Teaching at the Art Institute of Chicago became his main occupation. Almost two decades passed before Anisfeld exhibited again, but during that time he created a few very interesting paintings with a Biblical theme. He also modernized his 'artistic language' during that period. He started painting abstract works, and not just figurative paintings. Russia did not know this Anisfeld. It was the same wonderful artist who described himself as "I paint what I feel, not what I see,"[22] but yet it was a different painter who moved away from the theatrical nature of painting and was concerned about human problems. However, the public did not see these works until the retrospective exhibit on Anisfeld in Chicago (1958). Another exhibit of his works took place at the Lincoln Center Library of Performing Arts (1963), when all things Russian were becoming popular again, and his most substantial exhibition took place at the National Gallery of Art, Smithsonian Institution (1971).[23] In Russia, the public saw his works created after 1968 only in 2001.[24] The artist, who was known by his adoring fans for theatre design, really only revealed his talent in his works of the 1930s—1950s. America of that period was drawn to social realism, expressionism, and abstract painting, thus lyrically dramatic works of Anisfeld were not duly appreciated. There was still literature about the artist in late 1950s — early 1970s, but mostly on the subjects of his achievements in theatre design, his years of teaching, and as a colorist.[25]

Boris Grigoriev, who arrived in the U.S. in 1923 at the time of revolutionary events in Russia of the late 1910s — early 1920s, was extremely popular among the public and critics. Ivan Narodny wrote in his article *Art Under the Soviet Rule*: "The hor-

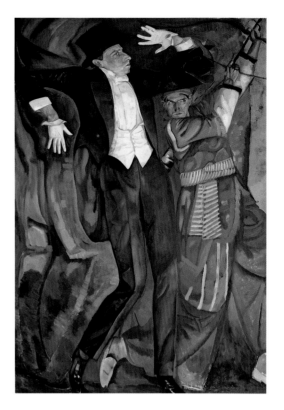

**Boris Grigoriev.** Portrait of Vsevolod Meyerhold. 1916
Oil on canvas. 97¼ x 66⅕ in. (247 x 168 cm)
Received in 1920 from the collection of A. A. Korovin, Petrograd. State Russian Museum

[19]
Christian Brinton. "The Boris Anisfeld Exhibition," *The Brooklyn Museum Quarterly*. Vol. VI, January 1919, No. 1, p. 7.

[20]
*Ibid.*, p. 9.

[21]
Mr. James Britton in *American Art News* — Extracts from Press Comments on the Anisfeld exhibition, *The Brooklyn Museum Quarterly*. Vol. VI, January 1919, NO. 1, p. 13–14.

[22]
*Boris Anisfeld. Retrospective Exhibition*, The Art Institute of Chicago. May 8 — June 8, 1958 (epigraph to Dudley Crafts Watson's introductory article).

[23]
A Conversation with the Artist's Daughter and Nicholas Fox Weber, Paintings by Boris Anisfeld and selection of his designs for ballet and opera. November 28, 1979 through January 12, 1980. A.M. Adler Fine Arts Inc. (n.p).

[24]
Boris Anisfeld. ABA Gallery, 2001.

[25]
Edith Weigle, for example, called him a romantic realist (his style is his own — romantic, realistic), *The Wonderful World of Art*, 1973, December.

rors and miseries of the revolution have evoked another type of modern Russian art, which expresses itself more in a new primitive portrait and figure paintings than in any geometrical symbolism of the futurist order. Amazing portraits and figures in watercolors and drawings by Boris Grigoriev possess a kind of primitive coarseness and can be considered the clearest examples of that time. His heads of hungry desperados, mad *moujiks* and revolutionary characters, drawn in the manner of the primitive peasant painters, are vivid illustrations of his country's agonies and sorrows and tell without words of the effects of a great upheaval and recall in the minds of the onlookers the abnormal characters of Dostoyevsky's and Gorky's stories. Grigoriev's art is naive, primitive and brutal, yet from it emanates a spirit that speaks the truth of the time. He can be called the illustrator of the famished race of nihilists and the pictorial story-teller of the Russian terror."[26] That is exactly how Grigoriev was perceived and remembered in America.

However, despite his success and being in demand in the U.S., despite his extensive travels to France, Italy, Chile, Grigoriev hoped to return to the Soviet Union. In his letter to Anatoly Lunacharsky he wrote, "I have traveled all over the world, but I have not found happiness. I love only my Motherland and I feel that I could be more useful to it now."[27] Grigoriev appealed to his famous and influential friends in the Soviet Union — to poets Vladimir Mayakovsky and Vasily Kamensky — but to no avail. The authorities refused to let him come back. His works kept in the collections of the Soviet museums were not exhibited for a long time. Deeply offended, Grigoriev wrote: "For once and for all. I will give up my 'Raseia [Russian] pictures' those which used to interest my soul. Now I will enter the real world of painting…"[28]

**Boris Grigoriev.** Portrait of a Banker from Wall Street. 1935
Mixed media on cardboard. $15^1/_2$ x $12^1/_2$ in. (39 x 32 cm)
Private collection

**Boris Grigoriev.** Chilean Landscape (Cup of Coffe). 1928
Gouache on paper. $13^1/_2$ x $19^1/_2$ in. (34 x 50 cm)
ABA Gallery, New York

Grigoriev, along with his wife and son, traveled to South America. The Chilean government commissioned a mural for the National Library (5.5 x 11 m) — *Faces of Chile*, which was never finished. The still lifes and landscapes he brought back from Chile represented a very different Grigoriev.

The end of 1920s was not successful for him in America. The economic decline greatly influenced the market. The artists lost their patrons and no one else was buying their works. The same happened to Grigoriev. Even his fantastic and psychologically powerful work, *The Portrait of Rachmaninoff,* was not sold. Fame and success smiled at Grigoriev again only in the early 1930s. Once again, his Russian-themed works were most popular — mainly illustrations to Fedor Dostoyevsky's novel, *Brothers Karamazov.* In April 1933 about 60 drawings along with still lifes, landscape, and street scenes were presented to the American public and critics.[29] The critics for *Brothers Karamazov*[30] were full of admiration and the new works were reviewed with curiosity. His new style expressed in portraits, still lifes and landscapes were discussed in reviews — Grigoriev happens to be "Not So Russian," declared one of the headlines. It also noted that, "In the present exhibition there was a 'good-bye to all that' feeling

26
Ivan Narodny. "Art under the Soviet Rule," *International Studio*, March 1923, p. 468–469.

27
Quotation from: *Boris Dmitrevich Grigoriev. A Biography.* Serge-Aljosja Stommels. Nijmegen, 1933, p. 74.

28
*Ibid.,* p.76.

29
*The Art Digest,* November 15, 1933, p. 21.

30
"Around the Galleries" by Jane Schwartz, *The Art News,* Saturday, December 8, 1934.

and an adaptation to new circumstances that is 'somehow effecting.'" However, he asserted, "when it comes to the landscapes and still lifes something of the former refulgence of Russian spirit animates the artist and **the colors become Slavic**."[31]

In 1935, the Academy of Allied Arts in New York presented Grigoriev's exhibit that spanned 15 years of work and included 56 paintings. The works from the series *Memories of Russia (*ill. 8*)*, and the mural based on his impression of the U.S. performance of the Moscow Art Theatre production of Nikolai Gogol's *The Inspector General* (1934) were part of this exhibition. In 1934 Grigoriev presented his own exhibition to the American public, which included 44 works of those painted in Southern France and Chile. The critics believed that "having burned his old bridges, over which he traveled to prominence in conservative circles, Grigoriev now turns to a new technique and a new interest in painting."[32] "It might be said that in his new freedom the artist has gone French in execution while retaining the spirit and originality of his Russian heritage."[33]

Boris Grigoriev was one of the most colorful and dramatic figures of the Russian immigration. Americans, without a doubt, recognized his enormous talent, skills and the expressiveness of his art. But to them, as to himself, he remained a Russian artist, even though he tried to leave behind his Russian themes and style formed by a long Russian experience. His Chilean landscapes, street scenes, a few depictions of skyscrapers which were done in gouache, are light and transparent. They represented a different Grigoriev who was capable of change. "I am in love with the future, interested in the present — and I hate the past," the artist wrote about himself in 1938.[34] Grigoriev was ready to cross the Russian boundaries of his work, but death cut his path short. These new themes and characteristics of Grigoriev's work of the second half of the 1930s once again did not interest America of that period and for that reason the public and critics who adored and appreciated him, did not consider him to be their own American artist.

The same can be said about the majority of artists who came from Russia, who were already established prior to their immigration.

Sergei Sudeikin who left Russia in 1918, reappeared in the U.S. in 1923 after having spent time in France. He joined the ranks of successful Russian immigrants almost immediately. He worked as a set designer for the Metropolitan Opera (1925), and other theatres in New York and Los Angeles, including Hollywood, and participated in early exhibitions at the Brooklyn Museum, New York (1924), the Art Institute of Chicago (1929), and the Carnegie Institute (1929), as well as other smaller exhibitions at private galleries in New York and Los Angeles (1934–1939). Sudeikin was successful and in demand.[35] However, again, Americans appreciated the Russian-ness in his works. In his introduction to Sudeikin's exhibit of 1924, Christian Brinton wrote, "He is indeed richly, fundamentally Russian."[36] "Gogol, who likewise won his way through tears to laughter, Ostrovsky, who

**Sergei Sudeikin.** Florida. 1930s
Oil and mixed media on canvas. 24 x 20 in. (61 x 51 cm)
Collection of Alexander Smuzikov, Moscow

[31] *The Art Digest*, May 1, 1933, p. 13.

[32] *The Art Digest*, January 15, 1938, p. 28.

[33] *Ibid*.

[34] Quotation from: *Société Anonyme. Modernism for America*. Edited by Jennifer R. Gross. Yale University Art Gallery, 2006.

[35] See: Elena Gasparova. *Archive of "Fallen Angels," Pinakoteka*. No. 22–23. Moscow, 2006. p. 26-28.

[36] *Segei Jurievich Sudeyikin*. By Christian Brinton. Painting by Sergei Sudeikin presented at the New Gallery, March 15 to April 15, 1924, 5/10.

**Sergei Sudeikin.** Harvest. 1910s
Oil on canvas. 55$^{1}/_{5}$ x 80$^{1}/_{3}$ in. (140 x 204 cm)
ABA Gallery, New York

satirized the society of the eighteen-sixties, and Shut, fantastic fun-maker of the simple *muzhik*, are his kinsfolk."[37] The critic continues, "And yet, aesthetically speaking, Sudeikin, despite a fecund native patrimony, is less a Slavic and more a Western artist."[38]

Most likely Christian Brinton saw the Western features in his anti-social, anti-realistic and decorative characteristics, which are typical of Sudeikin's theatrical and other paintings. Brinton was right. As surprising as it is, Sudeikin's Russian clowns, summer and winter festive scenarios were not melancholic, which was rather typical of the works of his contemporaries. Sudeikin's interpretation of Russia was more ironic and metaphoric; it was sharper and clearer than that of Kustodiev, Maliavin and others who relied on Russian themes in their art. This particular talent of Sudeikin and his way of thinking unfortunately hid his potential abilities, which were not seen by his contemporaries. Sudeikin's American works are very different from his early theatrical drawings. In 1929 he presented *La Sacre du Printemps* (*The Rite of Spring*) painted for the Steinway Collection and published in *Vogue* (June 15, 1929). Just as in one of the drawings from a series of graphic works dedicated to World War I (1914) by Natalia Goncharova, Sudeikin created his own apotheosis to the victims of war. The heads of people and horses all throughout the canvas are illuminated with rays — this is a metaphoric painting that does not portray happiness, irony or festive atmosphere.

Sudeikin became almost unrecognizable to his audiences in the 1930s.[39] *American Panorama* was published in *The Art News* (April 7, 1934), depicting a large American family seated in front of the widely open barn gates with an American landscape in the background. These works represent Sudeikin's attempts to become part of American cultural

[37] *Ibid.*

[38] *Ibid.*

[39] See: Elena Gasparova. Mentioned article. p. 30.

**David Burliuk.** Bridge
(Landscape from Four Points of View). 1911
Oil on canvas. 38¹/₅ x 51¹/₂ in. (97 x 131 cm)
Received in 1920 via IZO Narkompros, Moscow
State Russian Museum

**David Burliuk.** Horse-Lightning. 1907(?)
Oil on canvas. 24¹/₂ x 26³/₄ in. (62 x 68 cm)
Received in 1933 from M. V. Matiushin, Leningrad
State Russian Museum

life, leaving scenes connected to Russia behind. However, based on a few remarks after his death in 1945, the 'American' page of Sudeikin's works remained unnoticed. Yet everyone wrote about him as an artist of Russian themes, "In all of his works, Sudeikin is Russian. He is absolutely at home in the cheerful atmosphere of *Petrouchka*"[40].

David Burliuk (1882–1967) is one of the most colorful figures of the Russian avant-garde. A scandal seeker, rejecting the basis of classical values, he was full of new ideas and surrounded himself with young artists and poets. He was considered to be one of the masterminds of Futurism in Russia. He wrote poems, prose, and critical articles and was very prolific in his painting and graphic arts. In Russia, Burliuk created several important futuristic works — *The Bridge from the Four Points of View*, *Malorossy*, and *Horse-Lightning* (All of these are currently in the State Russian Museum).

In 1920, Burliuk left Russia with his family and traveled to the Far East. He arrived in America from Japan. Burliuk was lucky. This colorful artist and convincing conversationalist met Katherine Dreier and Christian Brinton immediately. At the time, Dreier was very interested in all cultural movements in Russia and later wrote a book about Burliuk.[41] Brinton was one of the most famous critics writing about Russian immigrants. The friendship with these two and other artists from different countries helped Burliuk to become a part of American cultural life. Being very perceptive and able to turn his ideas into art rather quickly, Burliuk almost immediately started to paint upon his arrival in the U.S. (*Workers, ill. 5; Mechanical Person*, and others). In these works Burliuk remained a futurist, although not exactly in form, but in content as he dealt with real problems demanding attention in the contemporary world.

The artist worked a lot and in the beginning his works were in demand for exhibitions and purchase. But the 1930s proved to be difficult for him as well. He struggled with

[40]
*The Art News*, May 12, 1945.

[41]
Dreier. Burliuk (New York: *Société Anonyme* and *Color and Rhyme*, 1944).

American-themed paintings. As his wife, Maria, wrote: "Burliuk portrays the southern part of Broadway. These paintings are documents of New York, but they did not come easily for him — after green Russian landscapes, cottages, and marshes. It is impossible to count their windows and number of floors — they disappear in the dusk and shadows of neighboring skyscrapers and evening. Below, there is a life of small vendors: pretzels — two for five cents; hotdogs with bread and a pinch of cabbage for five cents."[42]

In her diary, Maria Burliuk singles out several New York views painted by her husband, including *The Building on the Corner of 1st Avenue and 7th Street* (117 x 76 cm). "These compositions are complex in their ugly and monotonous details, without each it is impossible to find the end," she adds. [Ed. — Maria means "completeness"][43]

Burliuk tried to be contemporary. But the more he tried, the more he deviated from mainstream American art and the closer he got to its commercial side. Works of a "souvenir" nature on Russian and American themes began to dominate his art along with the earlier repeated futuristic themes. These "souvenir" works, however, allowed Burliuk to be more American. Taking American primitivism of the 18th–19th centuries as his guide, Burliuk repeated, to some degree, the path of the early Russian avant-garde, just in the same way Natalia Goncharova and Mikhail Larionov used various items, created by the hands of folk masters, as the basis for their art. However, icons, various folk paintings, decorated distaffs, and toys were familiar items for Goncharova and Larionov from early childhood. They created a new style of neo-primitive art, freely interpreting their sense, form and colors. Burliuk had to adapt his visual world to what was familiar and recognizable to American audiences. In his art with American themes, he combined reality with his imagination, which at times included elements from his Russian recollections. In his art of this period, curiously Burliuk, such a main figure in both Russian and American art, stopped being a Russian artist, but yet could not be characterized as a modern American artist. Burliuk's work of that period was intentionally created to be naïve so it would be perceived as amateur. This particular approach to his art was suitable for the souvenir industry and limited Burliuk's artistic potential. Perhaps Burliuk recognized that and tried to find other ways to express his wild nature. Being active in life and sensitive to his own role in society, he continued to be one of the centers of the Russian immigration. Together with his wife, he published *Color and Rhyme*, a magazine in which he attempted to introduce Russians and Americans to each other's cultures.

Just like David Burliuk, Boris Grigoriev, and Boris Anisfeld, other artists who were already famous, established and successful in Russia arrived in America at various times — Nicolai Fechin, Nicholas Roerich, Philipp Maliavin, Gleb Derujinsky, Nicholas Vasilieff, as well as other sculptors and artists whose stylistics were almost untouched by this

**David Burliuk.** Landscape. 1930–1940s
Oil on canvas. 20 x 18 in. (50.8 x 45.7 cm)
Private collection

**David Burliuk.** Tea-Drinking
(Self-Portrait with Raphael Soyer). 1947
Oil on canvas. $13^{1}/_{3}$ x $15^{3}/_{4}$ in. (34 x 40 cm)
Private collection, Germany

42
*Color and Rhyme.* 1967–1970. No. 66, 1937, p. 39.
43
*Ibid.,* p. 40.

journey. America also did not greatly impact the art of those artists who spent quite a bit of their time in Europe (Naum Gabo, Eugene Berman, Leonid Berman, and others). Even Alexander Archipenko was not associated with American art for a long time. In April 1920, Archipenko's friend Duchamp wrote to him, "New York needs to see what you have done these last years."[44]

In the collection of articles about Archipenko assembled by Katherine Dreier on the occasion of the *Société Anonyme* exhibit (1921), one of the critics discussed the concept of female figures in Archipenko's works, noting that "…they had all the incomparable beauty of modern plumbing…"[45] Christian Brinton, who was a member of Société Anonyme, tried to soften the dislike toward the material nature of art by the American public and critics, even though Katherine Dreier also shared some of the same feelings towards Archipenko's art. After meeting Archipenko, Brinton, who helped Dreier organize these exhibits, wrote of his own intentions to "Get him absolutely with us."[46]

Yet for the catalogue cover of Archipenko's second exhibit in New York (January — February 1924), Brinton chose purple colors that represented "…luxuriant Slavo-orientalism of his beloved Ukraine." According to Brinton, through his Russian heritage Archipenko came to "…a mystic stylistic vision," resulting in "a perfect embodiment of plastic absolutism."[47]

Archipenko first presented his engineering creation *Archipentura* — a tool for reflection of changing paintings in New York (1931), which he patented in 1927. Based on the judgment of the press, the public did not appreciate the innovative art of Archipenko.[48] This contraption, operated by a motor, was a screen of horizontal stripes that looked like Venetian blinds. Once unfolded, a changing image was projected onto the screen. The viewers would see a model undressing herself until she became nude. They appreciated seeing the naked mechanical woman more than they appreciated this artistic and technical miracle, or rather the innovative art of Archipenko. However, the attitude of the American audience did not concern Archipenko. He continued to experiment in sculpture and painting, creating many of the wonderful works throughout his life in the U.S. that are kept in the collections of major museums worldwide.

Alexander Archipenko, like Jacques Lipchitz or Ossip Zadkine, sharpened his talents in Paris, in an atmosphere of euphoric innovation, and came to America as an established artist. America did not always accept the innovative nature of their art, but it gave them great opportunities to work productively and experiment with monumental forms. Archipenko, Lipchitz, and Zadkine's sculptural masterpieces are located on American streets and squares. They fit in very nicely with the surrounding architecture introducing some European flavor.

[44]
*Alexander Archipenko: A Centennial Tribute* (Washington, DC: National Gallery of Art, 1986, p. 48).

[45]
Quotation from: *A Big Cosmic Force. Katherine Dreier and the Russian/Soviet Avant-Garde.* Dickran Tashjan, *Société Anonyme. Modernism for America.* Edited by Jennifer R. Gross. Yale University Art Gallery, 2006 (n.p.), comment. 17.

[46]
Christian Brinton, letter to Dreier, October 26, 1923. Box 5, folder 1436 Katherine S. Dreier Papers.

[47]
Brinton, Introduction to *The Archipenko Exhibition* (New York; Kingore Gallery, 1924), comment. 21.

[48]
*Société Anonyme. Modernism for America.* Edited by Jennifer R. Gross. Yale University Art Gallery, 2006.

Pavel Tchelitchew and Boris Margo came to the U.S. as adults as well. They too had skills, if not fame gained in Russia and Europe and are still not completely understood. There is much literature available on Tchelitchew.[49] His works can be found in the major museums and art galleries in the U.S. His works also surfaced in Russian private collections very recently.[50] Tchelitchew's works are more often included now in a variety of exhibits. However, his complex content and presentation, like an individual language, are still not fully understood. The meaning of Tchelitchew's works is traced in the end in the series of paintings dedicated to Heaven, Purgatory, and Hell. He could not accept the contemporary reality with its flaws and moral ugliness and expressed this attitude in his *Phenomena*. (1936–1938, in the State Tretyakov Gallery, ill.74, and its sketch, 1938, in the Hirshhorn Museum and Sculpture Garden, Smithsonian Institution, ill. on p. 56). The author planned to portray Hell in these paintings. There are about 100 figures of real and historical personalities included in these works. *Phenomena* is Tchelitchew's portrayal of the contemporary world. The artist also places his self-portrait in the lower left corner of the canvas. He is looking at the world in front of him and he is frightened and sad. In the background there are American skyscrapers and landscapes that look Spanish or Italian. The distorted figures, faces, arms and legs of people on this painting make it visually strange and scary. The idea of the artist is well expressed, and he notes, "In spite of *Phenomena* being a thunderbolt in a frame, it is the mildest lamb, compared to the epoch which we have to witness… We are living in the midst of most appalling and impossible not to be seen horrors and madness — and everyone covers them with pretty rugs and wallpaper and chintz!"[51] Unlike Picasso who portrayed Death coming upon innocent people in his *Guernica*, Tchelitchew portrays another tragedy of life that eats and destroys people from the inside.

**Gleb Derujinsky.** Madonna with a Child. 1946 *
Carved pear-wood icon plaque
$10^1/_2$ x 10 in. (26.7 x 25.4 cm)
Boris Stavrovski collection, New York

Heaven is depicted in Tchelitchew's *Hide and Seek* (1940–1942, now at the Museum of Modern Art). However, the children are no less scary and ugly in this painting than are the adults in *Phenomena*. A tree — the symbol of life — is entangling its angry branches around the children, as if squeezing the juices out of them for itself. Thus, Tchelitchew was not able to portray Heaven. Yet, on the other hand, the result was different — Hell for children symbolizes the future of mankind, just as for adults. Perhaps in this painting, Tchelitchew started another theme, which he developed later in another series of his works dedicated to *The Interior Landscape*. The children in *Hide and Seek* are not images from life or his imagination. Their heads are depicted as images of the brain. One of the figures does not have any skin and is illuminated from the inside.

Tchelitchew's art turns to anatomical paintings in the 1940s. "The brilliant twigs and branches of his body, the blaze of his bones, the lightning of his nerves, and the athletic tremors of his muscles," become his main interests.[52] The scarier the outside world is, the more Tchelitchew turns inward. He transfers all his emotions into

49
We will name just a few publications that describe the life and artistic career of Pavel Tchelitchew broader: *The Divine Comedy of Pavel Tchelitchew. A Biography of Parker Tyler*. New York, Flesh Publishing Corporation, 1967; Tchelitchew. 1893–1957. Lincoln Kirstein. Twelve Trees Press.

50
See: Elena Gasparova. Mentioned article. p. 30.

51
Tchelitchew. 1893–1957. Lincoln Kirstein. Twelve Trees Press.

52
*The Divine Comedy of Pavel Tchelitchew. A Biography of Parker Tyler*. New York, 1967, p. 438.

the image of the body and its analytical structure. The artist is not interested in the outside, he is interested in what is hidden inside in what he refers to as a "third body." We know less of the map of our human body than of towns, countries or the shifting imaginary boundaries of a political world. We may be roughly familiar with our skin and the masses beneath it; with our height, weight and shape; but our mirror, through habit, at once flatters and dulls any real curiosity. The most superficial vanity or fright can diminish our need for a more accurate or penetrating self-knowledge.[53]

Tchelitchew calls this series *The Interior Landscape*. The paintings actually present colorful landscapes that are painted within the frame of a human body. Although the artist places great emphasis on the schematic compositions that make up a human body, they do not look like *ecorche* or analytical sketches. These images carry something unearthly and unlikely of human flesh, as if the life of a body is captured outside of it — it is purer, more aesthetic and more fulfilling outside of the flesh. Tchelitchew said to the poet and critic Eduard Roditi: "In some of my pictures, the five senses are symbolically identified with the five basic elements. The nerves of the body, painted in a vivid yellow that exhales a halo of magenta red, represents fire, or the ambiguity of all that burns, whether hot or cold. The veins and arteries are blue, and represent the air and sky, through which flows the lifeblood of light; for the lymph, I chose a green that also suggests water; for the bones, an ochre yellow that suggests rocks and earth; for the soft tissues of the body, for the flesh that is like the empty spaces beneath the stars, I chose white to represent ether."[54]

*Heads* (ill. 76, 77) appeared almost at the same time in Tchelitchew's art. As images of interaction between humans and space they are more laconic than *Interior Landscapes* (ill. 75) and portray an imaginary line between humans and space. These

**Pavel Tchelitchew.** Study for *Hide and Seek*. 1938
Watercolor and ink on paper. $13^{3}/_{4}$ x $16^{1}/_{2}$ in. (35 x 42 cm)
Suleyman collection

[53]
Tchelitchew. 1893–1957. Lincoln Kirstein. Twevle Trees Press, 1994, p. 92.

[54]
*Ibid.*, p. 96.

images are rarely portraits. Nonetheless, portraits for Tchelitchew were just reasons for his dialogues with a canvas. Moreover, in his series *Heads*, typology and structure were most important. Like geometrical schemes and spider-webs, these images provide insight into the next stage in Tchelitchew's work where he departs from everyday life — he enters imaginary space travels in his works *Sun* (1945, Michael Rosenfeld Gallery) and in the whole series *Untitled* (1953, Museum of Modern Art, New York). Unexpected and daring — that is what Tchelitchew's art was for the American public of 1930–1950s. Based on his friends' memories, he was neither well received nor understood by the American public. The critics recognized his talent, masterful skills, uniqueness and the scandalous nature of his works, especially those with a sexual orientation. But there is no distinctive "niche" for Tchelitchew's style. He was sometimes compared to Dali and other surrealists. But something did not make sense in this characterization. Actually, Tchelitchew's works of imagination and his scandalous behavior were not characteristic of surrealists. He is more complex and yet simpler in this sense. His themes are always about people, their lives, suffering, and pain, as ugly as they get. The sources of his works were his own life and double-sided personality, with his own faults, and those of the people surrounding him. This "anti-social" façade of his works did not suit the intellectual climate of Manhattan in the 1930s and was more reminiscent of a Stalinist and Trotskist approach to art.[55]

Tchelitchew, as his friends remember, did not lack for an ego, although, he was able to tolerate skeptical public attitudes with dignity. "But my work is … not more a wriggly coastline animal … I am gone a bit too far to think of any importance of X-Y-Z opinion for my work…" [56]

**Pavel Tchelitchew.** Head from Side. 1951
Pastels on paper. $19^{2}/_{3}$ x $13^{3}/_{4}$ in. (50 x 35 cm)
Suleyman collection

**Pavel Tchelitchew.** Apoteosi. 1954
Oil on canvas. $26^{3}/_{4}$ x $20^{1}/_{2}$ in. (68 x 52 cm)
Suleyman collection

[55] As Lincoln Kirstein writes in his monograph about Tchelitchew, even people close to him had rather orthodox thoughts. Charles Ford and Parker Tyler wrote poetry and prose with 'social content.' Ford protested against racial discrimination along with members of the Communist Party. That is social ideas were very popular in society. Tchelitchew's paintings, of course, were in discord with prevailing attitudes (Lincoln Kirstein, p. 69).

[56] *Ibid.*, p. 72.

Although Tchelitchew worked hard and long in the U.S. leaving much of his legacy in this country, his artistic roots came from Europe. In Russia he noted Mikhail Vrubel as his inspiration, in Italy he followed Leonardo da Vinci and in Spain he admired Juan Miro among others. His favorite literary pieces were Dante's *Divine Comedy* and the Bible.

It is unknown whether Tchelitchew knew of Pavel Filonov's work, who was very well known in the Soviet Union of the 1920s, but at any rate, Tchelitchew's series *The Interior Landscape* and *Head* were rather similar to Filonov's work in that they portrayed processes inside humans which were invisible to the eye. Whether Tchelitchew and Filonov knew each other remains a mystery. But another Russian immigrant who arrived in the U.S., Boris Margo (Margolis) declared that he was Filonov's student.[57] He arrived in America in 1930, bringing with him the experience of an abstract expressionist — a genre he used throughout his career in the U.S.

John Graham was among those who came to America as an adult. Like Pavel Tchelitchew, Graham was eccentric in life and extravagant in his art and actions. His contemporaries were often left to wonder what was true and what was the artist's imagination — in his stories, paintings, and graphic works.[58] Graham was a legendary figure in American art during the 1930–1950s. He freely transformed manners and techniques of his predecessors into his own style, creating the unique and recognizable world of John Graham. It was a world without reality. Even the artists' portraits of real people had a trace of Graham's fantasies and imagination. He either painted the scenes from real life or from photographs, imagining that same scene in front of him and then recreating it again in his own memory. Everything that aroused his interest inspired the artist to paint new works. Graham's paintings were abstract, surrealist, and symbolic. Improvisation, which was a special form of aesthetics in his view, dominated many of his works. Graham the artist and Graham the person often crossed paths with each other in his art. The women in mysterious outfits, painted from old photographs and current fashion magazines, horses galloping from everywhere and nowhere, reminiscent of Leonardo da Vinci sketches, images of figures and heads — all of them were either his visions and perception of a previous life or imagery used specifically to preserve his legendary exotic background of a fictitious royal heritage.

**John Graham.** Exotic of a Woman. 1940
29 x 22³/₄ in. (73.7 x 58.1 cm)
The Smithsonian American Art
Museum, Washington
Gift of Mortimer Brandt

**Graham's mother, Eugenia Dombrovski**
Photograph
John D. Graham Papers, Archives of American Art
Smithsonian Institution, Washington

Clearly, Graham's life was not easy, but it was not unusual for Revolutionary Russia. As stated in the archives of the Federal Security Service of the Russian Federation, John Graham, born as Ivan Dombrovsky, lived and served in the Cherkess Cavalry Regiment (October 1, 1915 — December 1917) and later transferred to the Preobrazhensky Regiment. He was demobilized. In May 1918, he received the rank of Commissar of the 4th Army Regiment and was arrested in the same year for being a member of the counter-revolutionary organization known as "The Union for Defense and Freedom of the Motherland." He was imprisoned in Taganskaya and Butyrs-

57
Boris Margo. *Surrealism to Abstraction. 1932–1952.* September 3 — November 13, 1993. Michael Rosenfeld Gallery, New York, p. 5.

58
*John Graham* by Harry Rand. *John Graham Sum Qui Sum.* Allan Stone Gallery, October 22 — December 22, 2005, p.10.

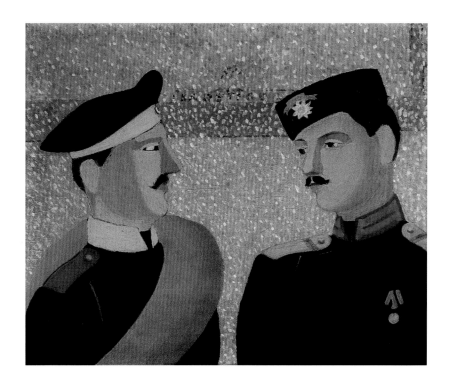

John Graham. Two Soldiers. Circa 1942
Oil on canvas. 20 x 24 in. (50.8 x 61 cm)
Collection of Florence and
Donald Morris, New York

kaya prisons. The Polish Embassy appealed for his release since he was born in War-saw. Felix Dzerzhinsky personally freed him, having Graham sign a promissory note that he would not protest against the Soviet Rule.[59] Having become an artist, Graham kept his promise. He painted a series of Soviet soldiers during the years of World War II. In April 1942, Graham took part in an exhibition, *Paintings by Russian-Americans* at the Phillips Memorial Art Gallery. To the American audience, Graham's paintings of Russian soldiers seemed to be only an exotic imagination of the artist. But for Ivan Dombrovsky those images were a way to express his sympathy towards the Russian people fighting at that time against the Nazi, if only as memories of his own service in the Army.

In the 1930–1940s Graham was still Russian to his Russian émigré friends, but at that time he was already an American artist according to his themes, evocative patterns, and artistic expression of ideas. One critic wrote, "His origins were exotic, but by engaging himself fully in the development of the local product, Graham became more an American artist than others dragooned into the history of 'American art'…"[60]

Moreover, Harry Rand, in his article about Graham wrote, "John Graham was one of the very few who deflected the course of modern American art out of the rut of provincialism."[61] Without Graham, Pollock would not have appeared when he did; Graham was also a very important figure for Arshile Gorky, David Smith and Willem de Kooning.[62] In addition, there is one more name of an American artist (with a Czech background) whose work is often reminiscent of Graham's — Andy Warhol's use of photographs and other original materials, as well as his use of colors is yet another example of Graham's influence in art.

59
Note from the Central Archive of the Federal Security Service of the Russian Federation. Moscow, December 6, 2002. 10/a-4321. Given this opportunity, I thank L. A. Malashevskaya for help with archival materials.

60
*John Graham* by Harry Rand. *John Graham Sum Qui Sum.* Allan Stone Gallery, October 22 — December 22, 2005, p. 16.

61
*Ibid.*, p. 29.

62
*Ibid.*, p. 21.

Arshile Gorky and Graham were very close friends at the end of the 1920s. It cannot be excluded that the family name "Gorky" appeared with Arshile through Graham's participation. "Gorky", which in Russian means "bitter", describes a difficult (bitter) life. When he entered art school, Vosdanig Anouk Adoian presented himself as a nephew of the famous Russian-Soviet author Maxim Gorky. In those years, America poorly understood that Russia and Armenia, which had been Vosdanig Anouk Adoian's birthplace, and where the famous artist had lived, were not one and the same place. The average American did not know that Maxim Gorky was a pseudonym. The writer's real name was Alexey Peshkov, and his nephew should have had this same last name.

Gorky was beholden to his older friend not only for the mystification. His painting *The Artist with His Mother* (circa 1926–1936, Whitney Museum of American Art, New York), painted from a photograph, is very close to Graham's works and his understanding of the relationship between nature and art in its imagery, color selection, and graphic decisions. Later, just as Graham had, Gorky devoted his time to abstract expressionism, which brought him fame.

**Moses Soyer.** Portrait of David Burliuk. 1930–1940s
Oil on canvas. Private collection

Expressionism in two forms — figurative and abstract — became especially popular in America in the 1930–1940s. John Graham, Arshile Gorky, Mark Rothko, Max Weber, Joseph Solman, and Ben Zion are among those who worked in this genre. Social themes often appeared in the expressionist framework. Max Weber and Ben Shahn took special roles in the expressionist art of the 1930–1940s. Ben Shahn's famous *Passion of Sacco and Vanzetti* (1931–1932, Whitney Museum of American Art, New York, ill. on p. 41), and his New Jersey murals (1937–1938) depicting the images of blue-collar workers and intelligentsia are American classics of social realism.

Ben Shahn's work is a reflection of American history that has roots in his Russian-Jewish heritage. The artist's active relationship with life, his metaphoric images (*New York*, 1947, The Jewish Museum, New York, ill. 69), and his direct portrayal of Biblical themes all come from his childhood memories of his Jewish upbringing. Max Weber had a similar base.

The Soyer brothers — Moses and Raphael — had very different voices in the choir of Russian immigrant artists. Their social realism was quiet and peaceful. The paintings of Rafael and Moses Soyer are not lectures, they are not satires. They are not posters. They are sketches and observations, reflecting on the mosaic of the world that surrounds them. The daily lives of ordinary people at home and on the streets, without embellishment, but yet not without emotional emphasis, become a main theme of the Soyer brothers. The atmosphere of the streets, apartments, inexpensive cafes, clothing, faces, the manners and behavior of the 1930–1940s generation are portrayed truthfully and with warmth. In this sense the Soyers' social realism is not only important as an artistic contribution, but also as documentation of the American life of the 1930–1940s.

Peter Blume and Louis Lozowick captured a very different aspect of community life. The main emphasis of their work was on form. In Peter Blume's industrial, everyday paintings, observation of reality combines with light shades of symbolism and even surrealism, which are traced in some of the images.

Louis Lozowick was a poet of the city, with its skyscrapers escaping upward, closing tightly on the streets, bridges, smokestacks, trains, all sorts of mechanisms, bringing to life this heavy mass. Janet Flint, in her article on the 1983 exhibit wrote "He was a man of diverse interests and talents — historian and critic as well as pioneering artist — whose significant contributions to the art and thought of his age are only now coming to be fully recognized."[63]

Lozowick was one of the central figures in the constructivist movement of American art of the 1920s. He became acquainted with this genre in Berlin (1921–1922) where he befriended El Lissitsky. His short trip to Russia and interaction with Malevich, Tatlin, Altman, Sterenberg and Puni[64] assured Lozowick of the correctness and modernity of his choice for his creative career. Having accepted these new aesthetics, Lozowick arrived in the U.S., which was itself the century's personification of machines and mechanization. He took part in the most important American exhibitions of that period, such as *The Machine Age in America* (New York, 1922). In 1927, Lozowick expressed his own credo, to which he remained faithful in his paintings and graphic works throughout his life: "The dominant trend in America of today, beneath all the apparent chaos and confusion, is towards order and organization which find their outward sign and symbol in the rigid geometry of the American city: in the verticals of its smokestacks, in the parallels of its factories, the arc of its bridges, the cylinders of its gas tanks."[65]

In the 1930s, during the Great Depression, Lozowick worked on mural paintings, like many of his American contemporaries. There is "…a fine pair of murals by Louis Lozowick…"[66] at the James A. Farley General Post Office. The murals suffered quite a bit during World War II and afterward and, unfortunately, are barely visible now. Between 1940 and his death in 1973 Lozowick took part infrequently in personal and group exhibitions, delivered lectures and wrote his memoirs. He was not forgotten in America. His paintings and graphic works can be found in major museums and art galleries. Even today Lozowick is considered to be one of the most important figures in American art of 1920–1930s.

As a replacement for constructive aesthetics, a perfect expression of enthusiasm for urbanization in the 1920–1930s, American art moved toward non-objective representation of ideas, following in Europe's footsteps. Already in 1923, Wassily Kandinsky's exhibit was presented in New York for the first time. It produced a great impression on many, and especially on the artists. However, abstract art, as a type of artistic

**Ben Shahn.** From the *Passion of Sacco and Vanzetti* series. 1931–1932
Tempera on canvas. $84^{1}/_{2}$ x 48 in. (214.6 x 121.9 cm)
Whitney Museum of American Art, New York

63
Janet A. Flint. Louis Lozowick. *In the Prints of Louis Lozowick.* National Museum of American Arts. November 5, 1982 — April 10, 1983 (Introduction).

64
*Ibid.*, p. 26.

65
Loius Lozowick. "The Americanization of Art." *Machine Age Exposition*, catalogue of an exhibition held in Steinway Hall (New York City), 1927, p. 18–19.

66
*Guide to the City's Depression Murals* by Grace Glueck, Published: January 7, 1994.

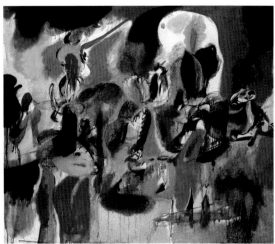

thinking, would become part of American art only later in the mid-1930s. Ilya Bolo-towsky, who came to the U.S. in 1923, became one of the most important adherents of American abstract art. He left Russia with his parents when he was sixteen and was not familiar with Malevich's Suprematism or Kandinsky's abstract art. He became acquaint-ed with Russian Cubism, Suprematism, and Constructivism at the New York exhibit of 1932. There he also became acquainted with Piet Mondrian's paintings for the first time. Bolotowsky's first abstract compositions appeared during the Works Progress Admin-istration (WPA) times, when the government supported the artists though this Fed-eral program during the Great Depression. About the same time Bolotowsky took a leading role in forming the Association of American Abstract Artists (AAA). "Balancing color and line in forms that are deceptively simple, beautifully colorful, and handsomely functional, he has created an art that perpetuates the refinement and transcendent vitality of the highest formal ideal."[67]

Bolotowsky's abstract art did not remain unchanged throughout his life. Having begun his career under the influence of Mondrian and Miro's and creating a neoplastic style, the artist changed the shapes of his abstract compositions (triangular, rhomboid, and rectangular) using colors as dominant forces. In the early 1960s, Bolotowsky de-veloped the idea of vertical volume — a shape that had interested him previously. Besides colorful canvases that started to be dominated by red, Bolotowsky worked on painting sculptures which he called columns. Robert M. Alice, in his essay for Bolo-towsky's 1970 exhibit, rightly noted that "...the artist's more recent paintings with the jewel-like quality of color bring to mind the icons of Bolotowsky's native Rus-sia."[68] In response to a correspondent's question, "Do you feel that, in spite of the fact that you have lived and worked in the United States for most of your life, your own Russian background is discernable in your painting?" the artist answered, "Cer-tainly, as one gets older, one's origins are reasserted."[69] No less significant for the appearance of this kind of work of Bolotowsky was his acquaintance with Malevich's

**Ilya Bolotowsky.** Premièr étude de peinture murale pour Williamsburg [First Study for Williamsburg Muraal]. 1936
Oil on canvas. 19$^{1}/_{2}$ x 34$^{1}/_{2}$ in. (49.5 x 87.6 cm)
Jean T. Washburn Gallery, New York

**Arshile Gorky.** Water of the Flowery Mill. 1944
Oil on canvas. 16$^{3}/_{10}$ x 19$^{1}/_{5}$ in. (41.5 x 48.75 cm)
The Metropolitan Museum of Art, New York

[67] Adelyn D. Breeskin. *Ilya Bolotowsky*, Catalogue. 1974, p. 11.

[68] *Ibid.*, p. 9.

[69] *Ibid.*, p. 19.

works of art, which took place in America at the Museum of Modern Art. In the same interview, next to Mondrian's, was Malevich's name whose work Bolotowsky probably preferred more.

Alexander Liberman arrived in the U.S. in 1914 adding to the number of American abstract painters. His works, just like those of Bolotowsky, show a certain familiarity with Russian non-objective art, especially with Malevich's work.

It is unknown whether Louise Nevelson knew about Malevich, about his *Black Square*, *White on White*, or his white sculptural forms that he called *architectons*. Perhaps she saw Malevich's works or their reproductions. Whatever the case is, it is hard not to see some association with Malevich called forth by Nevelson's preferences for black and white and vertical parallelepipeds included in many of the artist's compositions (*Dawn's Wedding Feast*, 1956–1958, private collection; *Bicentennial Dawn*, 1976; James A. Byrne Federal Courthouse, Philadelphia).

Perhaps the next point may be controversial and unexpected, but Mark Rothko's abstract works of the 1940s and later have a familiar proximity to the works of Russian non-objective artists, especially Olga Rozanova's *Red and Yellow* (1916, the State Russian Museum) and backgrounds in some works of Malevich in the late 1920s — early 1930s. It is, of course, possible to draw such parallels to European or American painters, who had no connection to Russian culture. However, immigrants from the former Russian Empire probably had a better chance to understand Russian avant-garde, accept it, and include it in their artistic arsenals.

Jules Olitsky, who barely spoke Russian since he emigrated to America as a child, confessed to the author of this article his impressions of Russia, several years before his death. His mother had told him stories of his Motherland. He later started to read Russian authors and acquainted himself with Dostoyevsky, Tolstoy, Chekhov, etc. When it was possible to see in America the works of Russian artists, including Malevich and Kandinsky, they were for Olitsky in his words, not foreign. He accepted their art as part of his culture.

The delicate and complex question of mutual influence cannot, of course, be resolved one-dimensionally. As one would say, the ideas are out there, including the artistic ones. However, it is impossible not to note and emphasize that there were Russian "sources" in the works of American masters, who were more or less acquainted with Russian culture. As a rule, literature about these artists practically omits evidence or contacts and relations with their former Motherland, and attitude towards contemporary events, taking place there. However, this is a very important point in their lives and their artistic careers. It is impossible not to consider the fact that

**Mark Rothko.** The Sacrifice of Iphigeneia. 1942
Oil and pencil on canvas. 50 x 36³/₄ in. (127 x 93.7 cm)
Collection of Christopher Rothko

**Olga Rozanova.** Non-Objective Composition
(Suprematism). Circa 1916
Oil on canvas. 24¹/₂ x 16 in. (62.5 x 40.5 cm)
Received in 1926 from the Museum of Artistic Culture, Leningrad. State Russian Museum

many immigrants who came to America from various corners of Russia, spoke Russian at home and among themselves. Even though they would forget Russian at times, they still could understand Russian conversation and read in Russian. In the beginning, their fellow former countrymen surrounded them. Close friendships were forged between Gorky and Graham, who are remembered, as along with Nicholas Vasilieff and Nicolai Cikovsky, in Maria Burliuk's diary. The relationship between the Burliuk family and Graham were so friendly that Graham confessed the true history of his Russian era to them.[70] The artist also told them about his difficult relationship with his spouse Eleanor [71] and about his religious quest.[72]

Gorky also visited the Burliuk family during his hardest times. "I would like to lie in the grass, close my eyes and feel how clouds move in the sky… sometimes I want to cut my paintings… they are useless. The art cannot survive in America," complained Gorky to Maria Burliuk in 1933.[73] He confessed to Burliuk's son in 1934 that he wanted to live among his own people "I am tired of America, no one needs paintings, the technology has moved on… Looking from the airplane you cannot see any shapes, everything is smooth and flat… It is not important how one would paint a brow… a little higher or closer to the ear."[74]

Meeting frequently, the artists talked about art, shared news, including news of the Soviet Union at that time. Rafael Soyer's wife visited the Soviet Union in 1934 and she and Burliuk discussed this event at a café.[75] Friends attended each other's exhibitions without fail and helped each other as much as they could during these difficult years for America. They did not limit themselves to their Russian circle, yet close friendships, as a rule, were formed only with their countrymen. There is even a painting by Rafael Soyer entitled *My Friends* (1948, a gathering at the Butler Institute of American Art, Youngstown, ill. on p. 45) that portrays besides the brothers, Chaim Gross and David Burliuk. In David Burliuk's portrait of Russian artists of 1924, Christian Brinton is surrounded by Burliuk himself, Rafael Soyer, Nicolai Cikovsky, and Arshile Gorky. These close friendships among Russian immigrants continued to develop until the 1950s. Later their circle gradually started to disintegrate. Some developed strong international connections while others gained great fame and changed their environments. Whatever the case was, close relationships among the immigrants from Russia during the early periods helped them to find themselves. However, their relationships with American artists, collectors and galleries were of great help as well.

Despite the attitude towards political events of the Soviet Union, most of the immigrants from Russia were genuinely concerned about the events that were taking place. For example, in 1920, Max Weber wrote in one of his private letters to a friend: "You suggest my coming to France, because I could live cheaper; in fact I would live without expense. …that is because I would not go to France. I would if I could, go to

**Graham John and Gorky Arshile**. Circa 1934
Photograph
Archive of Smithsonian Institute, Washington

70
*Color and Rhyme*. 1965–1966, 1933, p. 68.

71
*Ibid.*, 1934, p. 63.

72
*Ibid.*, p. 72.

73
*Ibid.*, p. 60.

74
*Ibid.*, p. 51.

75
*Ibid.*, p. 81.

Russia to help my people, to help the creators of the new order…"[76] Socialist in his views, Weber, like many others at that time, believed in the future of Russia. Sympathetic to people's tragedies during World War I and the Revolution, he was convinced that "nobody at no time will conquer Russia … the greatest people on earth … Russia is like the pregnant mother on her bed giving birth … but the child would be beautiful and glorious. And a new era of mankind will come."[77]

Although Pavel Tchelitchew had no illusions about the events taking place in the Soviet Union, he willed the most important painting of his career *Phenomena* to the State Tretyakov Gallery in Moscow and his sister donated various drawings to the State Russian Museum in Leningrad (now, St. Petersburg). Louis Lozowick, who visited Soviet Russia at the beginning of the 1920s, was one of the first to begin actively to introduce Russian avant-garde to the American public. He published poems by Kazimir Malevich in 1922. He introduced the Soviet public to American art during his trip to the Soviet Union in 1927. Later, Alfred Barr, in establishing the Museum of Modern Art's collection, frequently consulted with Louis Lozowick about individual artists.

During World War II, Max Weber was a member of the aid committee to the Soviet Union. Many Russian immigrant artists participated in a New York exhibit that took place at that time. Many of them had lived in America for a long time by then, were famous, and some were even significant. They perceived themselves as Americans. But some invisible threads from the past reappeared in their art from time to time. Ben Zion, also an immigrant from Russia, defined American art with great precision, in his article on the subject of international and national art, *What is American Art?* (1982).

What is art of any specific country? It is the sum of the creative expressions of its individual artists. In other words, everything that was created in a given country, and has creative value…[78] "As a Jew, being adopted by America, and adopting it, my contribution to its art expression can be only within the realm of my experience. This is the only source a creative artist can rely on. The realm of a man's experience starts in his very early childhood. Thus, like the ropemaker, walking backward while spinning his rope, an artist walks backward to the very early beginnings of his being, spinning the yarn of his creations …I see a beautiful landscape or moving scene. The mere act of its being created in America, makes it a part of American expression…"[79]

In our view, Ben-Zion said everything that defines the meaning of the theme "American Artists from Russian Empire." It does not matter whether the artists melted into the American environment or contributed a part of their Russian experience — they made an enormous contribution toward the colorful mosaic of international culture, from which American art was formed.

**Raphael Soyer.** My Friends. 1948
Oil on canvas. $27^{1}/_{2}$ x $23^{1}/_{2}$ in. (70 x 60 cm)
Collection of the Butler Institute of
American Art, Youngstown

[76]
Archive of American Artists, Max Weber, frame 186.

[77]
*Ibid.*

[78]
"What is American Art?," Archive of American Artists, reel No. 69/122, frame 030, sheet 1.

[79]
*Ibid.*, sheet 3.

Alison Hilton,
Ph.D., Georgetown University

# bridging the great divide: russian visions

## Arrivals

*Rush Hour — New York* (1915, National Gallery of Art), Max Weber's dynamic rendering of a characteristic moment in his adopted home city, embodies the energy and pace of modernist innovation in the studios and galleries of lower Manhattan.[1] The artist had studied and exhibited in Paris before returning to join a group of young painters who helped to introduce cubism and futurism to American audiences. At the same time, Weber's Russian contemporaries Mikhail Larionov, Natalia Goncharova, David Burliuk, the slightly younger Kazimir Malevich, and their colleagues in avant-garde artists' groups in Moscow and St. Petersburg were exhibiting their own, assertively Russian visions of rhythm and motion, inspired by observation of the life around them and by their study of modern French and Italian art. A child of ten when his family emigrated from Russia in 1891, Weber considered himself an American artist and he played no part in Russia's seminal avant-garde art movements. The striking visual similarities between works such as *Interior of the Fourth Dimension* (1913, National Gallery of Art, ill. 1) and examples of Rayist works by Larionov and Cubo-Futurist paintings by Malevich are a matter of affinity rather than contact or influence.

The artistic affinities between Russia and America are significant. This exhibition of *American Artists from Russian Empire* examines a vast range of experiences, attitudes, and creative choices in the work of some fifty artists who came to America from Russia, Ukraine, Latvia, Lithuania, Russian Poland, Armenia, Azerbaijan and other parts of the former Russian Empire. Several arrived as established artists; others were children when their families fled pogroms or civil war. Many found supportive and

# and the rhythm of modern america

stimulating communities, including immigrants from all parts of Europe, in New York, Chicago, Boston, and Los Angeles. Some studied and later taught at the Art Students' League, the National Academy of Design, the Cooper Union, or the New School for Social Research, and took part in the formation of important professional groups such as the American Artists' Congress. But others had less success in assimilating or in forging careers. The loss of a familiar environment and audience was especially acute for mature artists. One artist later summed up his arrival in New York: "To me America would be the beginning of a new life; to others, a final resting place… This was the great divide in our lives; our lives split in two."[2]

The concepts of artistic exile, displacement, and Diaspora are important today, crucial to our understanding not only of contemporary art but also of cultural interactions. There are common strains in the experiences of the American artists from Russia and thousands of other artists who left their native countries under difficult circumstances.

[1] Frances K. Pohl, *Framing America: A Social History of American Art*. New York, Thames and Hudson, 2002, 301 introduces the chapter on American modernism with this work.

[2] Louis Lozowick, *Survivor from a Dead Age: The Memoirs of Louis Lozowick*, ed. by Virginia H. Marquardt. Washington and London, Smithsonian Institution Press, 1997, 139.

The exhibition seeks to highlight distinctive aspects of the move from Russia to America, and to discover what made the move to America so significant for Russian artists. Though geographically distant from European centers of commerce and culture, Russia and America were not culturally isolated; both nations shared Europe's heritage, while asserting their distinct identities. In the late eighteenth and nineteenth centuries, Russian and American artists measured their achievements against European standards, and some did not just emulate but rivaled these models. America's exoticism fascinated many Russians, as did its reputation as a land of freedom and opportunity: motivations for both visitors and immigrants. Among the Russian artists who traveled to observe, record, and take back impressions and images of America's landscapes and society were the diplomat Pavel Svinin, who published an illustrated book about America in 1813; later in the century Ivan Aivazovsky, the famous marine painter and Vasily Vereshchagin, known for his scenes of Russian military engagements in the Balkans and Central Asia, toured America. Besides finding new material for paintings, they held exhibitions and sales of their work. Russian artists also sent works to the world's fairs in Chicago in 1893 and St. Louis in 1904, and a few, such as Nicholas Roerich and Boris Grigoriev, lived and worked for extended periods in America.

**Brooklyn Bridge. New York.** Early 20th century
Photo Courtesy of the Library of Congress

By far the largest group of American artists from Russia were immigrants. Some had established careers in Russia before emigrating — in many cases to Berlin or Paris first, and only later to New York — while many others were young children when their families fled pogroms, revolution, or civil war. Although individual circumstances varied, it is evident that the artists who were involved in art movements in Russia or Europe (and may have hoped to remain there) had expectations and experience different from those of the younger group, who grew up in the new country and first became aware of their artistic vocations in America. One question to consider is whether aspects of the immigrant experience and artistic life in America fostered assimilation and encouraged active involvement in the new environment. Did the Russian artists who came to America have different opportunities from those available to artists like Marc Chagall, Alexandra Exter, Konstantin Korovin, Wassily Kandinsky and others who remained in Europe?

We will also examine the processes of cultural exchange and integration through the eyes of Russian artists who participated in some of the formative moments of American art. Chapters in this catalogue delineate the broader contexts of the roles of Russians in American visual arts, music, theatre, and cinema; the biographical section not only provides details on artists' careers but also reveals examples of shared experiences and contact among those working in visual and performing arts. Immigrant artists from other countries play an essential role, and many artists in this exhibition were more closely connected with their peers in America than with Russian culture. Our focus here is on selected themes, both visual and social, that aroused especially strong

bridging the great divide:
russian visions and the rhythm
of modern america

responses among Russian-American artists. Expectations and realities of immigrant life in Europe and in America involved problems of identity and assimilation. New kinds of artistic communities emerged first on the Lower East Side of Manhattan and then more widely during the Great Depression, when government-sponsored WPA projects assisted many artists. Visions of the modern American city, skyscrapers, and machines contributed to the discovery of new ways of creating art. Some of these themes and experiences have surprising parallels in Soviet Russian art and there were occasions — such as a major exhibition of Soviet art in New York at Grand Central Galleries in 1929 and a few direct contacts between Russian-American and Soviet artists — when these similarities might have suggested potential for further artistic interactions.

## Expectations and Realities

America was not the first or even the preferred destination for Russian émigrés in the late 19th and early 20th centuries. Berlin, Paris, Prague, Constantinople, and other cities offered cosmopolitan intellectual life, and those who left Russia could join established Russian enclaves. After the revolution and civil war, two or three million Russians fled abroad. Berlin had the greatest concentration in the 1920s, followed by Paris, and later New York. The range and variety of émigre culture matched those of the prerevolutionary and early Soviet eras, and represented virtually all trends in literature and art, music, theatre, and the burgeoning movie industry. Galleries, special exhibitions, and publications such as *Zhar Ptitsa (Firebird)* featured traditions of the *World of Art* group as well as the more avant-garde associates of Diaghilev's *Ballets Russes,* such as Goncharova and Larionov. The first important Soviet art exhibition abroad, the *Erste Russische Kunstausstellung* in Berlin in 1922 was a magnet for émigrés. Constructivist El Lissitzky and other exhibitors stayed on for some time afterwards, and Lissitzky's work and his journal *Veshch (Object)* stimulated interactions with German, Dutch, French, and English modernist counterparts.[3] While the émigrés' cultural contributions garnered most attention, it is important to remember the hardships experienced by all refugees.

American writers, artists, and social workers recognized the need to document the immigrant experience. Spurred by social concerns, such projects also stimulated new ideas in American art at the beginning of the century.[4] Photographs are among the indelible images of the hardships immigrants faced. Jacob Riis, an immigrant from Denmark, photographed New York slums and sweatshops: *Bandit's Roost* (1888), which shows an alley controlled by gangs, and his book, *How the Other Half Lives* (1892); Lewis Hine's photographs of Ellis Island and New York's child workers a decade later, were instrumental for new social welfare programs. Alfred Stieglitz's *The Steerage* (1907) expresses the vulnerability of displacement so starkly that it has become virtually an icon of immigration. By this time, the number of Russian Jews arriving in New York had reached a high of over 125,000.[5] Artists portrayed Lower East

3
See John E. Bowlt, "'Where is My Home?" Russian Artists in Emigration," in Natalia Teteriatnikov, Alison Hilton, Nancy Van Norman Baer, and John E. Bowlt, *The George Riabov Collection of Russian Art,* New Brunswick, NJ, Jane Voorhees Zimmerli Art Museum, Rutgers University, 1994, 135-59. Robert C. Williams, "Russia Abroad," in *Russia Imagined: Art, Culture, and National Identity, 1840–1995.* New York, Peter Lang, 1997, 143-52.

4
Cynthia Jaffee McCabe, ed. *The Golden Door. Artist Immigrants of America, 1876–1976.*
Hirshhorn Museum and Sculpture Garden. Washington DC, Smithsonian Institution Press, 1976. McCabe's introduction, "A Century of Artist-Immigrants," gives detailed background on the social and legal issues as well as artists' experiences.

5
McCabe, "A Century of Artist-Immigrants," 25, citing Moses Rischin, *The Promised City: New York's Jews 1870–1914.* New York: Corinth, 1964, 270.

Side Manhattan in ways that bring out the vitality and color, not just the anxiety and confusion, of immigrant life. George Bellows' *Cliff Dwellers* (1913, Los Angeles County Museum of Art) and George Luks' and Bernice Abbott's Hester Street scenes celebrate the congregation of many nationalities, customs and languages. They balance the obvious hardships with a sense of optimism about life in America.

For émigrés with credentials and ambitions in art, American cities promised opportunity. Russian art had already received some publicity thanks to the World's Fairs, the Columbian Exposition in Chicago in 1893 and the Louisiana Purchase Exposition in St. Louis in 1904. The Chicago exhibition included works by well-known realist painters of the 1880s, but featured mostly decorative art. The collection sent to St. Louis, numbering some 600 works, was the largest exhibition of Russian paintings ever sent abroad, and included works by Il'ia Repin, Vasily Vereshchagin, and by artists who later worked in America, Nicholas Roerich and Ivan Deneev (Djeneeff).[6] Émigré Russian culture had a spectacular debut in New York with productions of the *Ballets Russes* beginning in 1916.

The Soviet Government organized a *Russian Art Exhibition* at the Grand Central Palace in New York in 1924 with both promotional and commercial aims. Five years later, a more current display, entitled *Exhibition of Contemporary Art of Soviet Russia* and sponsored by the Amtorg Trading Corporation, filled the Grand Central Palace with 343 paintings and graphic works, and 37 sculptures. In his forward to the catalogue, American critic Christian Brinton points out qualities that visitors might look for in the new Soviet art. "Following the pulsing social rhythm of the day, soviet art is at present rejoicing in its new-found freedom. …You will find … little to remind you of prerevolutionary Russian art. …Fresh, virile forces … replace those that were engulfed in the greatest cataclysm of the modern world."[7]

## The Modern City and New Art

In the 1920s, New York continued to embody urban optimism and a new pace of life for artists from all over America as well as from other countries. The art stimulated by crowds, tall buildings, bridges, parks, and public spectacles ranged from detailed representations to almost abstract formal equivalents of color and motion. Like the artists who responded most energetically to this vitality early in the century — the Russian immigrants Max Weber and Abraham Walkowitz, and the Italian Joseph Stella, the slightly younger Louis Lozowick translated the buildings of New York and other cities into powerful, upward-thrusting rectangles and trapezoids. *Pittsburg* (1922–1923, Whitney Museum, ill. 3), one of his series on American cities, is among the best examples of this concentrated blend of observation (seen in the tan, gray, and brick-red facades) and intuitive expression of the

**Abraham Walkowitz.** Five Women. 1904
Pencil and gouache on paper
$14^{1}/_{4}$ x $11^{1}/_{2}$ in. (36.2 x 29.2 cm)
Spanierman Gallery, New York

[6]
Robert C. Williams, "America's Lost Russian Paintings and the 1904 St. Louis Exposition" in *Russia Imagined*, 187–213.

[7]
Christian Brinton, forward, *Exhibition of Contemporary Art of Soviet Russia*, New York, Grand Central Palace, February, 1929, unpaged.

bridging the great divide:
russian visions and the rhythm
of modern america

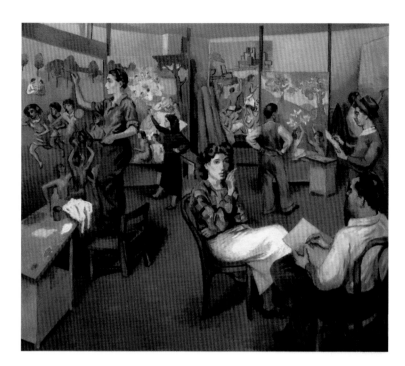

**Moses Soyer.** Artists on WPA. 1935
Oil on canvas. $36^{1/4}$ x $42^{1/4}$ in. (91.7 x 107 cm)
The Smithsonian American Art
Museum, Washington
Gift of Mr. and Mrs. Moses Soyer

visual and physical sensation of looking upward toward the rooftops. Americans Charles Demuth, Charles Sheeler, Elsie Driggs, and Georgia O'Keeffe responded to cities in similar ways. Almost twenty years later, a younger Russian artist Nina Schick painted *Manhattan Cityscape* (1940s, Evnin Collection, ill. 60) as a planar grid of rooftops and jutting skyscrapers. The aqua, rose and tan patches of the facades stand out sharply against the pale sky; the effect is bright and almost decorative, in contrast to the dynamism Lozowick's work projects. Lozowick, who traveled to Paris, Berlin, and Moscow in the 1920s and met several Soviet artists, became an important link between art movements in America and Russia; his contacts and his machine aesthetic are discussed later in this essay.

## The Great Depression

In contrast to the modernist optimism about cities, machines, and the future, much of the American art of the 1930s reflected the realities of the present. Immigrant artists who lived through the Great Depression, like their native-born peers, knew at first hand about hardship and the struggle for survival. Many of them, or their parents, had come to America to escape worse conditions, many were Socialist by conviction, and many used their art to expose social issues. Whether their background made the works of Moses and Raphael Soyer, Peter Blum, Ben Shahn, or other immigrants from Russia, Ukraine, or Lithuania any more acute than that of Walker Evans, Dorothea Lange, Isabel Bishop, or Jacob Lawrence is a moot point; what is important is that these artists, some of them close friends, shared struggles and uncertainties. Those who participated in the WPA Federal Arts Project also became part of a new kind of community, an artists' group defined not by styles or manifestos but by experience.

Art sponsored by the WPA included mural paintings, graphic art, photography, and sculpture; the genres and styles represented by the WPA artists from Russia — among them Peter Blume, Ilya Bolotowsky, Gleb Derujinsky, Arshile Gorky, Louis Lozowick, Mark Rothko, Ben Shahn, Simka Simkovich, Joseph Solomon, Moses and Raphael Soyer, and Nahum Tchacbasov — range from social realism to abstraction. Several works in the exhibition relate to characteristic themes in American art of the Depression era. The murals commissioned by the government for post offices, court houses, and other government buildings are probably the best known forms of WPA art. Smaller works in the exhibition, such as Simka Simkovich's *Merry-Go-Round* (1930, Whitney Museum, ill. 58) may suggest the style of the large murals Simkovich produced for the Mississippi Court House. Ben Shahn was engaged in all kinds of federal projects, the Farm Security Administration's photographic documentation of the rural South along with Walker Evans and Dorotha Lange, the mural project, assisting Diego Rivera at Rockefeller Center, and posters for the U.S. Department of War Information. His paintings retain the flat, poster-like style of his murals and posters, conveying a sense of isolation through strong contours and contrasts of scale against almost empty spaces in works such as *Renascence* (1946, Fred Jones Jr. Museum of Art, ill. 68) and *New York* (1947, The Jewish Museum, New York, ill. 69).

Another strain in the art of the 1930s is seen in the more intimate vignettes of ordinary people alone or with others, sometimes sharing a meal. Portraits by Moses and Raphael Soyer, and especially Raphael Soyer's *Roommates* (circa 1934, Michael Rosenfeld Gallery, ill. 54), like many other works by the Soyer brothers and by Isabel Bishop, both invite and distance the viewer. A few works seem to reflect Russian-Jewish immigrant life in particular: Weber's *The Talmudists* (1934, The Jewish Museum, New York, ill. 42) and *Sabbath* (1941, The Jewish Museum, New York, ill. 44), and Peter Blume's *Pig's Feet and Vinegar* (1927, The Jewish Museum, New York, ill. 40). Provocative variations on Depression-era themes are offered by David Burliuk, a notorious member of the Russian neoprimitivist and futurist avant-garde, who emigrated to the U.S. at age forty in 1922. The large painting, *Shame to All but to the Dead (or Unemployedville)* (1933, Nasher Museum of Art at Duke University, ill. 7) looks like a sketch for a mural with its horizontal format and its didactic clarity — at the left a prosperous avenue of high-rise apartments; at the right a sprawling slum, against a glaring blue sky — but the message is scarcely upbeat.

It is one of art history's paradoxes that during the same years that the U.S. government sponsored art projects as part of a massive social relief effort, the Soviet government commissioned art to promote and celebrate achievements of socialist industry and agriculture, and expended vast state resources on displays such as the *Industry of Socialism* exhibition held in Moscow in 1939.[8] To equate the WPA with the agencies of Soviet Socialist Realism would be a misleading over-simplification. Yet it is intriguing to

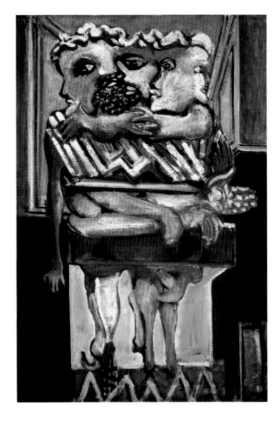

**Mark Rothko.** Untitled. 1941–1942
Oil on canvas. $35^3/_4$ x $23^3/_4$ in. (91 x 60.6 cm)
National Gallery of Art, Washington
Gift of the Mark Rothko Foundation, Inc.

[8]
Susan E. Reid, "Socialist Realism in the Stalinist Terror: The Industry of Socialism Art Exhibition, 1935-41," *Russian Review*, vol. 60, No. 2 (Apr., 2001) 153–184.

bridging the great divide:
russian visions and the rhythm
of modern america

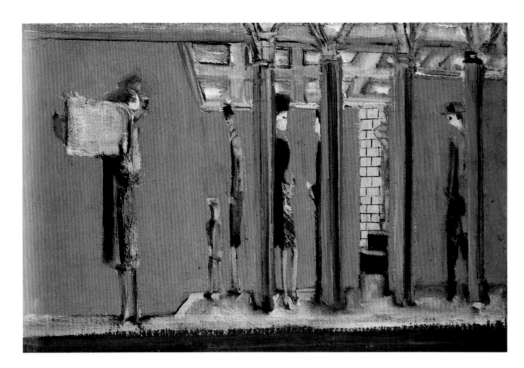

Mark Rothko. Untitled [Subway]. Circa 1937
Oil on canvas. $20^{1}/_{4}$ x 30 in. (51.1 x 76.2 cm)
National Gallery of Art, Washington
Gift of the Mark Rothko Foundation, Inc.

speculate about what the careers of some of our Russian-American artists might have been like had they not emigrated.

## Artistic Interactions and New Ways of Creating Art

America's signature contribution to modern art, Abstract Expressionism, had sources both in the formal experiments of the early 20th century — in Russia, Germany, the Netherlands, and France — that led to geometric abstraction and in the subjective, surrealist strain that influenced gestural abstraction. We have already seen that Russian immigrant artists contributed to the major strands of American art in the first half of the century: both realism and social concern and the European-based modernism that introduced abstraction to America. Continued searches for new forms and methods had an important feature demonstrated in the exhibition: the interaction of media and methods of painting, sculpture, and graphic arts. Max Weber, much like Matisse and Picasso, sometimes used sculpture as a way of visualizing forms for his paintings; his *Interior of the Fourth Dimension* could have been executed as a low-relief sculpture. The works of Lozowick, Alexander Archipenko, Vladimir Izdebsky, and Alexander Liberman are relevant in this context, and in many ways parallels the research into two — and three-dimensional forms by Russian Constructivists Alexander Rodchenko and Naum Gabo. Gabo, a truly international figure, taught at the Bauhaus, worked in Paris and London, and emigrated to the U.S. in his fifties and created a substantial body of work; although only a few of his large projects were realized, he had extensive influence on younger American sculptors.

Besides interactions across media, a key factor in the emergence of New York as a new art center was the cross-fertilization of discoveries and movements on an international level. The political disruptions of the 20th century — persecution, revolution, and war, culminating in World War II — brought hundreds of artists to America. The traditional melting-pot metaphor does not serve for the art world, because the variety of elements combined to yield a tremendous range of results. Before turning to this last component of the exhibition, the emergence of the New York School and American Abstract Expressionism out of a mingling of American and European sources, it is worth looking at the experience of one artist who deliberately sought contact with contemporary art in Europe and Russia, Louis Lozowick.

Lozowick was a prolific writer of articles, notes, and memoirs. Published as *Survivor from a Dead Age*, his memoirs detail his Jewish-Ukrainian childhood and art studies in Kyiv, the trans-Atlantic voyage at age fourteen, early studies and friendships with artists in New York, and his European travels between 1920 and 1923, during which he made contact with Russian émigrés as well as French and German artists. In Berlin he got to know El Lissitzky and a contingent of other artists — Nathan Altman, David Sterenberg, and Naum Gabo, among others — represented in the great exhibition of contemporary Soviet art, the *Erste Russische Kunstausstellung* at the Galerie Van Diemen in October 1922. They invited Lozowick to visit the Soviet Union to meet other artists and witness the "revolutionary changes that had been accomplished in the art institutions."[9] Rodchenko, one of the first artists he met, gave Lozowick catalogues of recent Constructivist exhibitions and introduced him to other members of the group, including Vladimir Tatlin. Lozowick told everyone that he was eager to learn as much as he could about Soviet art and as a result he was inundated with pamphlets and manifestos. One day he was taken to meet students at the Higher State Art-Technical Workshops (VKhUTEMAS) [Vysshie gosudarstvennye khudozhestvenno-tekhnicheskie masterskie], and had an unusual opportunity to present American culture to Russians. He recalls: "Then came the inevitable interrogation about America. Was I ever in Detroit, and did I go through the Ford factory? …Did I ever visit the steel mills of Pittsburgh?"[10]

The informality of Lozowick's narrative doesn't obscure the fact that he observed and responded thoughtfully, established mutual regard and trust with such leading figures in Soviet art as Rodchenko and Sterenberg, and understood the importance of Constructivist researches in painting, sculpture, typography, and stage design. Moreover, when he returned to New York in 1924, he continued his involvement with current Soviet art. Katherine Dreier invited Lozowick to submit two works to the *Société Anonyme's* exhibition of Russian Suprematism and Constructivism and to give a talk about modern Russian art.[11] Lozowick visited Russia again in 1927, for the opening of an exhibition of his work at the Museum of Western Art in Moscow, and in 1931; on

**Louis Lozowick.** Minneapolis. 1925
Lithograph. $11^{3}/_{5}$ x 9 in. (29.7 x 22.7 cm)
Art Institute, Minneapolis, John R. Van Derlip Fund

9
Lozowick, *Memoirs*, 221.

10
Lozowick, *Memoirs*, 228-29, 236.

11
Lozowick, *Memoirs*, 253, Marquardt notes that this lecture became the basis for her book *Modern Russian Art* published by the *Société Anonyme* in 1925.

bridging the great divide:
russian visions and the rhythm
of modern america

these trips he witnessed the decline of Constructivism and the growing influence of the realist Association of Artists of Revolutionary Russia, the AKhRR.

Lozowick's publications show the results of his study of Soviet art and his conviction that sensations, aesthetic ideals, and beliefs expressed through art can be valid across national boundaries. In his essay *The Americanization of Art* for the 1927 *Machine-Age Exposition* in New York, he expresses ideas strikingly similar to those in Naum Gabo's and Alexei Gan's writings on Constructivism, which he quotes in his memoirs.[12] "The history of America is a history of gigantic engineering feats and colossal mechanical constructions. … The dominant trend in America today is toward an industrialization and standardization which require precise adjustment of structure to function." He explains that we seek an order and organization beneath the apparent chaos of our cities, an "underlying mathematical pattern" that the artist will articulate and define. He relates his own drawings and prints of machine forms to this task. "A composition is most effective when its elements have a double function: associative, establishing contact with concrete objects of the real world and aesthetic, serving to create plastic values. … In this manner the flowing rhythm of modern America may be gripped."[13]

Just as Lozowick considered his compositions part of a larger, international development in art, other artists with similar interests in mechanical and geometrical form made the legacy of early 20th century geometrical abstraction a part of postwar American art. Ilya Bolotowsky was among the most influential. He arrived in New York in 1923, was a founding member of the American Abstract Artists group, and was one of relatively few WPA artists, including Arshile Gorky and Stuart Davis, to produce abstract murals for public buildings. He had a long career of teaching and exhibiting, and he is represented in the exhibition by two characteristic works completed near the end of his life, *Red, Blue, White Ellipse* (1973, Brooklyn Museum, ill. 113) and *First Rhomboid Column* (1976, Michael Rosenfeld Gallery, ill. 115). Bolotowsky's painted wood column combines two- and three-dimensional forms, an important characteristic for geometrical abstraction also seen in the sculpture of Archipenko, Izdebsky, Liberman, and Louise Nevelson.

The other strand of Abstract Expressionism, a combination of cubist perceptions and surrealist searches for subconscious forms and archetypes, was equally nourished by interactions among artists working in Europe and later in America. The most important links between Russia and America were through Pavel Tchelichew, Arshile Gorky, and Mark Rothko.

Tchelichew had studied with avant-garde painter and stage designer Alexandra Exter in Kyiv before leaving Russia for Berlin and Paris, where he became well known both as a painter and as a designer for Diaghilev's ballet. Working in the U.S. from the mid-1930s through 1940s, he developed a style that had little in common with most

**Arshile Gorky.** The Betrothal II. 1947
Oil on canvas. $50^{2}/5$ x 38 in. (128 x 96.5 cm)
Whitney Museum of American Art, New York
Museum purchase

12
Lozowick, *Memoirs*, 240; Aleksei Gan, *Konstruktivizm (Constructivism)*, 1922, extracts translated in John E. Bowlt, *Russian Art of the Avant-Garde: Theory and Criticism 1902–1934*, New York: Viking, 1976, 214–225.

13
Louis Lozowick, "The Machine-Age Exposition," (New York: Little Review, 1927), 18–19, reprinted in Lozowick, *Memoirs*, 282.

Depressionera art, but instead suggested a hallucinatory vision of the human body or mind, as in *Anatomical Painting* (1946, Whitney Museum, ill. 79), or the interpenetration of self and outside world, as *Hide and Seek* (1940–1942, Museum of Modern Art).

Gorky, born Vosdanig Anouk Adoian in Armenia, made the difficult journey to America at age sixteen; he worked in Boston and New York, where he became friends with Dutch immigrant Willem De Kooning and began experimenting with automatism. Meanwhile, he participated in WPA projects, including an important commission for murals at the Newark airport. Two works in the exhibition, both titled *Abstract Composition* (1930, ABA Gallery, New York, ill. 80, 81), are similar in style to these murals, with a combination of cubist-derived angular and curved shapes on flat backgrounds. A few years later, in the early 1940s, Gorky redirected his approach, incorporating biomorphism and automatism in works such as *Garden in Sochi* (1941, Museum of Modern Art) that referred directly to his Armenian childhood. These works, linking the past of his memories with the urgent investigations of form, the subconscious, and accident, had an enormous impact on American art.

Rothko was ten when his family arrived in New York and traveled on to Portland, or soon after, so he missed the immigrant life of the Lower East Side, and only discovered his artistic interests at Yale University. He went on to study under Max Weber at the Art Students League in 1925, and in the 1930s he worked in the easel painting section of the WPA. The earliest paintings are representational, with awkward figures in dark surroundings. In *Figure Composition* (1936–1937, National Gallery of Art, ill. 95) the mask-like faces convey a sense of disconnection in spite of the warm colors. During the 1940s, Rothko began to develop the concepts of creation and the suggestive, layered, and fluid forms that led to his mature work. *Olympian Play* (1943–1944, National Gallery of Art, ill. 96) is characteristic of this stage. Rothko referred to himself and his friends Adolph Gottlieb and Barnet Newman as "Myth Makers." The artists considered mythic archetypes to be a source of human culture and creativity, and in 1943 they explained their ideas in a famous *Letter* in the *New York Times*.[14] Asserting that the only valid subject matter "is tragic and timeless," they professed "spiritual kinship with primitive and archaic art." The letter emphasizes the need for timelessness and universality in art: "significant rendition of a symbol, no matter how archaic, has as full validity today as the archaic symbol had then." Rather than illustrating myth, the artists sought to understand the roots, the "elemental truth" of mythic concepts and to interpret the concepts through their own experience. Just as myth had the capability to preserve a spiritual contact with something universal, Rothko believed that art must expand its capacity from the task of representation to a power to transform experience and human consciousness.

This conception of universal validity, and the art that inaugurated the identifiably American movement Abstract Expressionism, brings us back to the consideration of the

**Pavel Tchelitchew.** Final sketch for *Phenomena*. 1938
Oil on canvas. 35 x 45³/₄ in. (89 x 116.2 cm)
Hirshhorn Museum and Sculpture Garden, Smithsonian Institution, Washington
Bequest of Joseph H. Hirshhorn , 1981

14
*New York Times* (June 13, 1943), reprinted in Herschel B. Chipp, *Theories of Modern Art*. Berkeley, Los Angeles and London, University of California Press, 1968, 544–545

bridging the great divide:
russian visions and the rhythm
of modern america

many kinds of artistic interactions that went into the formation of modern American art, interactions in which Russian-American artists were actively engaged. The importance of Russian artists' roles in American culture is unquestionable; their work is so much a part of American art that many textbooks do not mention the artists' national origins. Less well known are the efforts of some of these artists to inform Americans about Russian culture. Lozowick participated in Dreier's exhibition of Russian Suprematism and Constructivism and published related articles; Bolotowsky created a Russian-English art dictionary; Burliuk made his studio a meeting place for many Russian and other immigrant artists, and hosted Soviet celebrities such as the poet Vladimir Mayakovsky; and Raphael Soyer was among those who joined the John Reed Club in the 1930s. Many artists continually recalled Russian, Ukrainian or Armenian settings and themes in their work, and others defined themselves as completely American; some struggled with the dilemma shared by many émigrés and exiles, whether to maintain their native heritage or project an American identity. Inevitably, there were also immigrants who never assimilated, and remained between two worlds.

The traditional American notion of a multi-national melting pot, and the goal of transforming new immigrants into full citizens, though tarnished by restrictive legislation over the years, had an unforeseen effect in changing the essential nature of emigration and immigration. The characteristic tightness of Russian émigré communities in early 20th-century Europe and America, the crowded conditions, reliance on neighbors, and shared language, seems to have been lost for the most part. This could be a serious loss, especially for artists from the Soviet Union, as the experience of a relatively recent émigré suggests. The status of interior emigration for unofficial artists during the Brezhnev years — the lack of normal opportunities for exhibition and support that horrifies Americans — was actually comparable to geographical emigration in some ways. The close community of trusted friends was all important. One artist who left the country in the 1970s said that despite apparently unlimited artistic freedom abroad, there remained a sense of loss.[15] All immigrants face the loss of a familiar and valued culture, in the most basic sense. For the artists from Russia represented in this exhibition, coming to America also offered a chance to participate in the formation of a new culture.

[15]
Author's notes of a comment by Oleg Prokofiev during a meeting of artists, critics, and scholars in preparation of the exhibition and catalogue *New Art from the Soviet Union: The Known and the Unknown*, edited by Norton Dodge and Alison Hilton, Washington DC, Acropolis, 1977.

Percy North,
Ph.D., Montgomery College

# the russian-american

Modern art, as a break from the hidebound academic traditions of the 19th century, erupted belatedly on the American scene in February 1913 at the International Exhibition of Modern Art at the 69th Regiment Armory in New York City and then traveled to Chicago and Boston. Despite the dramatic and far reaching influence of the Armory Show and its introduction of modern art to a large audience, modern art had been familiar to art cognoscenti in America for several years prior to the exhibition primarily through the auspices of Alfred Stieglitz. An internationally renown photographer Stieglitz had a gallery on Fifth Avenue from 1905, known by its address at 291 and an influential journal *Camera Work* that addressed photography as one medium of modern artistic expression. He championed art that expressed the ethos of the new industrial age with its increasingly tall buildings, reliance on the machine, and ever increasing speed of transportation and communication. He also appreciated art that reflected an inner emotional charge rather than a simple description of appearances.

Max Weber, an emigrant from Russia, was an influential member of Stieglitz's circle of intimates and a pioneer modernist. Weber's friend Abraham Walkowitz, another Russian immigrant was also associated with the Stieglitz Circle, although less important to the development of American modernism than his friend. Weber and Walkowitz were among the thousands of Russian immigrants who swelled American cities from the 1880s until immigration was severely restricted in the 1920s. During the first decade of the 20th century Russians and Italians constituted the largest group of American immigrants. Like many if not most of the Russian arrivals, Weber and Walkowitz were Jewish and their families brought them to the United States to escape from persecution in Russia.

# impact on modern art

Walkowitz had a solo show at 291 in 1912 and the following year he organized a ground-breaking exhibition of children's drawings there. Weber, however, was the first American artist to develop a personal response to Cubism and remained a dynamic creative force in American modernism throughout his long, multi-faceted, and successful career.[1] It was primarily through Weber's encouragement that Stieglitz gave Cézanne and Picasso their first shows in the United States in 1911. Weber's collection of works by the idiosyncratic artist Henri Rousseau formed the first exhibition of Rousseau's work at Stieglitz's gallery in a memorial tribute in 1910 after the artist's death the previous year, thus bringing recognition to an artist who had labored in obscurity in Paris. After their arrival in the U.S., Weber's Orthodox Jewish parents settled in the Williamsburg section of Brooklyn, a borough of New York City that is still a predominantly Jewish enclave. Despite the Orthodox Jewish proscription against graven images, Weber convinced his parents to let him attend Brooklyn's Pratt Institute, then as now a celebrated art school, by explaining that he would take the teacher training course to

[1] Max Weber had a far-reaching influence on numerous areas of American modernism from his return to New York in 1909 to the very end of his career. In 1910 he published *The Fourth Dimension from a Plastic Point of View* in *Camera Work*, the first treatise to address the aesthetics of the new mathematics and its implications for pictorial space. In 1913 he was the first American modern have a solo museum exhibition at the Newark Museum in New Jersey. In 1914 he was one of the founders of the Clarence H. White School of Photography and through his teaching of art history and aesthetics influenced the first generation of modern photographers. That year he published *Cubist Poems,* (London: Elkin Mathews) followed by *Essays on Art* in 1916 (New York: William Rudge), the first American text to explore the importance of the spiritual in modern art. The following year he was one of the founding directors of the Society of Independent Artists. In 1915 Weber created some of the first abstract sculptures by an American. Weber became the first modern artist to teach at the Art Students League in 1918, and he was the first American modern to have a solo show at the Museum of Modern Art in 1930. His national profile increased in 1936 when he became the national chairman of the American Artists Congress. Weber was also the most important American artist to translate religious themes into a modern idiom through his paintings of Rabbis and the ecstatic Jewish Hasidim. He won frequent national prizes during the 1930s and 1940s for his Cézanne inspired work and his expressionist paintings of the 1940s and 1950s served as a jumping off point for the swirling forms of the action painting of the Abstract Expressionists.

provide a career that would not require him to work on the Saturday Sabbath. The defining moment in Weber's career came in 1905 after he had been teaching art for four years, when he embarked for an extended stay in Paris. There Weber studied with Henri Matisse in 1908 and also met Pablo Picasso the same year that Sergei Shchukin and Ivan Morozov, the great Russian collectors of French modernism, were introduced to these heroic innovators of 20th-century art. When Weber returned to New York in January of 1909, missing the debut of Diaghilev's Ballets Russes in Paris that year, he brought with him original works by Matisse, Rousseau, Toulouse-Lautrec, Dunoyer de Segonzac, and the first Picasso painting to come to the United States. Weber also brought Japanese prints, African statuettes, and photographs of the works of Paul Gauguin and Paul Cézanne, along with innovative ideas for the production of a new livelier mode of art to reflect the special character of the 20th century, which he introduced to the coterie of artists and writers who congregated at 291.

Weber had been friendly with Walkowitz in Paris where they had both studied at the Academie Julian. In Paris Walkowitz saw Isadora Duncan dance and she became the obsessive subject of the artist throughout his life. He produced thousands of drawings of her in fluid movement reminiscent of Rodin's dancing figures. Walkowitz aided Weber in staging his first solo show at a small framing shop on Madison Avenue in 1909, the year after he had his own solo show there, the first by an American modern. It was Weber, however, who encouraged Walkowitz's production of his most important works, a series of cubist scenes of Manhattan, the new modern city. Unfortunately, although Walkowitz lived to the venerable age of eighty-seven, he had gone blind thirty years earlier and his career was truncated.

"In 1906, 14 year old Louis Lozowick packed a change of clothes, $25 to present to Ellis Island immigration officials, a sack of lemons and toasted dark bread dipped in beer to combat seasickness, and entered the illegal Russian underground that guided émigrés to America."[2] Lozowick had initially been inspired by the work of the Russian Wanderers, who depicted genre scenes of ordinary Russians in a clear realist style, from his training at the Kyiv Art School. His work in America, however, was radically changed to an expression of the new machine age through scenes of factories and America's tall cities in a style influenced by Cubism. Today best known for his lithographic prints, Lozowick is heralded as one of a group of modern American artists who invested urban subjects with radical constructive techniques indicative of the energy and dynamism of the industrial age. Morris Kantor, who was brought to New York in 1906 by his parents from Minsk, also developed a response to Cubism. Kantor, however, produced only a small body of cubist inspired works before he turned to lyrical realism and then a surrealist style during the 1930s. Ben Shahn, who became the leading exponent of socially conscious art during the 1930s also arrived in New York in 1906 from Lithuania. Radically political throughout his life, Shahn is best known for his series of gouache paintings based on the execution

[2]
Cynthia Jaffe McCabe, *The Golden Door: Artist Immigrants of America 1876–1976*, Washington: Smithsonian Institution Press, 1976, p. 140.

of the anarchists Sacco and Vanzetti in 1931 (ill. on p. 41), a diatribe against what he considered to be political injustice created in a poster style that addressed the issue of new print and image media typical of the 20th century.

In 1910 Stieglitz staged an exhibition *Younger American Painters* of work by the young American moderns who had been working in Paris. This landmark exhibition introduced Americans to some of the new forms of art that had been gestating in Paris. Weber was the most advanced artist in the show. He was the first American to produce cubist inspired work and the first to have his new cubist paintings published in the American press in a review of the *Younger American Painters* show. Vituperative criticism of Weber's radical work in the press, however, left an indelible mark on the artist throughout his career. The same year innovative young Russian artists including the leaders Mikhail Larionov and Natalia Goncharova also introduced Modernism in the form of a Russian assimilation of French Cubism and German Expressionism to their countrymen in the *Jack of Diamonds* exhibition, but their works remained largely unfamiliar to an American audience.

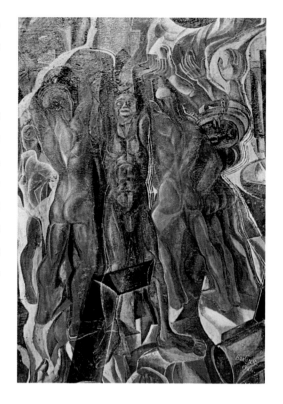

**David Burliuk.** Mechanical Man's Appearance.
Atomic Bomb (Detail). 1925
Oil on canvas. $15^4/_5$ x $24^2/_5$ in. (40 x 62 cm)
Private collection, U. S.

Although Camilla Gray, the pioneering historian of Russian Modernism, referred to Cubo-Futurism in her groundbreaking text *The Russian Experiment in Art* as, "a movement peculiar to Russia and immediately preceded the schools of abstract painting which arose in Russia during the years 1911–1912, in which the Russians emerged as pioneers in the modern movement,"[3] Weber's most innovative work created between 1913 and 1919 would best be described as cubo-futurist for its integration of the Parisian and Italian styles with American urban subjects. Weber, however, was as unfamiliar with Russian experiments as were other American artists and the similarity of their work reflects mutual sources rather than direct contact. David Burliuk, who participated in the *Jack of Diamonds* exhibition and was a proponent of Cubo-Futurism, immigrated to the United States and settled in New York City in 1922. Although he was active as an artist in New York, he arrived after the first burst of modernism and has generally been overlooked in histories of American art. Today he is considerably better known for his work in Russia than for his later more extensive career in the United States.

Among the innovative young modernists in New York during the early years of the century, William Zorach, Weber's closest artist associate, arrived in the United States. Although his father adopted the surname Finkelstein, Zorach's first name became his surname and he was referred to as Billy from his childhood school years in Cleveland, Ohio. Like so many Russian immigrants to America who were fleeing persecution, a change of name and the forging of a new identity in the new world provided a measure of freedom and escape from the past. Weber's father had exchanged the complicated Russian name Krivyatizky (spelled variously due to the vagaries of transliteration) to the simpler Weber, a German word for weaver that reflected his trade as

3
Camilla Gray, *The Russian Experiment in Art 1863–1922*, London: Thames & Hudson, 1962, p. 94. Gray translates *Jack of Diamonds* as the *Knave of Diamonds*, both of which indicate the playing card.

a tailor and the primary industry of his native Bialystok. Curiously Morris Weber's brother adopted the more lyrical Blumenthal.[4] Most of the Russians who came to the United States like Marcus Rothkowitz who became Mark Rothko, simplified their extenuated Russian names and made them more Yankee.

Ivan Gratianovitch Dombrovski adopted the English sounding name John Graham. Although he created some Russian modernist inspired works like those by the Suprematists that were distinctly minimalist, none of these early works survive and they had a negligible influence in America. His later eclectic and idiosyncratic if interesting work is also little known today due primarily to its heterogeneous nature. Graham's influence came more through his writing than from his painting due to the varied twists and turns of his style and his avoidance of being typecast by a signature style of painting.[5]

A notable and curious exception to this abandonment of Russian identity was the young Armenian Vosdanig or Vostanig (later Manouk — or Manuk after his grandfather) Adoian.[6] Arshile Gorky even claimed that he had been born in Russia and had studied in Paris at the Academie Julian (appropriating these elements from the life of his friend Weber) when he applied to teach at the Grand Central School of Art, where he had studied with Nikolai Fechin, and where he became the teacher of Rothko.[7] His friendship with Graham, through Burliuk probably around 1929, solidified his Russophile inclinations. As Cynthia McCabe notes in her seminal catalogue for the exhibition *The Golden Door*, "Perhaps no other major American painter's career was more strongly rooted in his foreign background than was Arshile Gorky's."[8]

"Both artists (Graham and Gorky) had immigrated to America in 1920, lied about their background, created colorful personas, and referred to themselves as Russians. Graham an even more imaginative fabricator than Gorky, rarely told any story straight"[9] and was constantly reinventing himself. Although Graham was almost a generation older than Gorky, the younger friend was the more influential of the two. Gorky's art has been acknowledged as the pre-figuration of Abstract Expressionism, America's first major internationally recognized school of modern art. His free flowing line and abstract compositions of the 1930s and 1940s were some of the most interesting and challenging work being produced in America at the time and are early examples of the action painting that would dominate critical attention throughout the 1950s in the decade after Gorky's suicide in 1948.

As a response to the political radicalism of newly arrived Southern and Eastern European immigrants in the organization called the International Workers of the World, in 1917 a bill requiring all immigrants to be literate was passed to restrict immigration. Since the literary requirement failed to limit immigration, more stringent restrictions were subsequently enacted in 1920 and 1924.[10]

4
Information provided by the genealogical research of Weber relative Solna K. Wasser.

5
Bruce Weber, *Toward A New American Cubism*, New York: Berry-Hill Gallery, 2006, p. 23. Weber discusses the impact of Graham's *System and Dialectics of Art*, pp. 54-55.

6
Weber, p. 28

7
Ibid. p. 29.

8
McCabe, p.194.

9
Weber, p. 31.

10
Percy North, *Into the Melting Pot: The Immigration of American Modernism*, Williamsburg, VA: Joseph and Margaret Muscarelle Museum of Art, 1984, p. 11.

Despite these new restrictive American immigration policies, Russian artists including Alexander Archipenko, Ilya Bolotowsky, Nicolai Fechin, and David Burliuk found their way to America for a more congenial place to work than Russia with its privations after the revolution. They brought with them modern ideas about art that were unfamiliar to American painters who were still under the spell of the school of Paris, if influenced by anything outside of the United States due to a growing American distrust of anything foreign. The most popular and applauded American art of the 1920s and 1930s was primarily nativist in sentiment, regional in subject, and realist in imagery since reverence for realist and narrative art took hold internationally after World War I. Weber's work became increasingly naturalistic and relied on traditional still life, landscape, and nude figure studies. Zorach abandoned his cubist influenced painting for monumental realist sculpture and Walkowitz also slipped away from his dynamic cubist scenes as did Kantor.

In an attempt to counter the retrograde passion for regional genre scenes and to reinvigorate avant-garde art in America, the Société Anonyme, an art organization to promote modern art founded by Marcel Duchamp and Katherine Dreier in 1920, sponsored a massive art exhibition at the Brooklyn Museum in 1926. Intended to rival the international scope of the Armory Show, albeit on a smaller scale, the Brooklyn exhibition included 307 works by 104 artists from 23 countries. Seven artists were listed in the catalogue as representatives of Russia, including the internationally acclaimed Wassily Kandinsky and the considerably lesser-known Constantin Alajalov. Burliuk, and Archipenko were already living in America and like them Gabo would also become an American citizen. The exhibition introduced Americans to Suprematist and Constructivist work by Kazimir Malevich, El Lissitzky, Gabo, and his brother Anton (later Antoine) Pevsner but the implications of their art would not be manifest in American art for another generation.[11]

During that same year twenty-six year old, Edith Gregor Halpert, who would refer to herself as the little girl from Odessa, inaugurated one of the first art galleries in Greenwich Village and began transforming the New York gallery scene. Born Ginda Fivoosiovitch somewhere around 1900, Halpert had immigrated to New York in 1906 with her mother and sister along with hundreds of thousands of Russian Jews escaping from the persecutions in Odessa that erupted in widespread violence after the abortive revolution in 1905. Halpert's mother, who brought her two daughters to America in an attempt to find a more secure life, shortened the family name to Fivisovitch to make it more accessible for Americans. Her daughter, however, jettisoned her Russian Jewish names to reinvent herself as Edith Fein. She later adopted her patronymic Gregor,[12] along with the surname she acquired when she married Samuel Halpert, a painter born in Bialystok like his friend Weber. As the director of the Downtown Gallery, she revolutionized the marketing of American art and steadfastly promoted American modernism during the depression years of the 1930s and the war years of the 1940s. After Stieglitz's death in 1946 she handled many of the artists who had been cham-

**Alexander Archipenko.** Turning Torso. 1921
Bronze. 28 x 13$^1$/$_2$ x 5$^1$/$_2$ in. (71.1 x 34.3 x 14 cm)
San Diego Museum of Art
Gift of Earle W. Grant

[11]
Naum Neemia Pevsner, changed his name in 1915 so that he would not be confused with his brother Anton who was also a sculptor. The information from the Société Anonyme catalogue courtesy of Joy Weber.

[12]
Lindsay Pollock, *The Girl With the Gallery: Edith Gregor Halpert and the Making of the Modern Art Market*, New York: Public Affairs, 2006, p. 13.

**Joseph Solman.** Still Life with Book,
Tobacco Can and Colored Napkin. 1941*
Oil on canvas. 12 x 20 in. (30.5 x 50.8 cm)
The Jewish Museum, New York
Gift of Helen and Frederick S. Romanofsky

pioned by Stieglitz. In addition, as an advisor to Abby Aldrich Rockefeller, Halpert was
an influential force behind the founding of the Museum of Modern Art in 1929.

As international tensions escalated in Europe during the 1930s, New York became a
safe haven for artists seeking asylum from the conflict. Foreign-born artists were more
likely to have been influenced by Surrealism, a movement gestated in France during
the 1920s that emphasized dream states, displacement of time, and a reverence for
myth, but it had relatively little impact in the Unites States since popular American art
remained predominantly realist and regional. Despite American reticence to embrace
Surrealism, however, it would have major ramifications for the development of Abstract
Expressionism. The 1936 exhibition *Fantastic Art, Dada, Surrealism* at the Museum of
Modern Art introduced Americans to the movement, which became the most pervasive
international avant-garde art of the 1930s. Russian immigrants Eugene Berman,
Leonid Berman, Peter Blume, Pavel Tchelitchew, and Nahum Tchacbasov formed the
largest cadre of Surrealists working in the United States.

The Museum of Modern Art also presented *Cubism and Abstract Art* that year in-
cluding the work of Archipenko and Gabo. The exhibition received international at-
tention when customs officials in New York refused to allow the abstract sculptures
from abroad designated for the show to enter the United States as works of art. The
exhibition was a catalyst for the founding of the American Abstract Artists Group
that included Bolotowsky, an artist from St. Petersburg, among its founding mem-
bers. Bolotowsky was primarily influenced by the purist work of Piet Mondrian and
he embraced an ordered system of geometric abstraction typical of the work by most
of the artists associated with the exhibiting society. The group was especially energized
by when Mondrian arrived in New York during World War II.

In 1934 a group of predominately Russian Jewish artists whose work ranged from geometric abstraction to expressionism in opposition to the prevalent trend of narrative realism in America exhibited together at the Gallery Secession. The following year Ben-Zion, Ilya Bolotowsky, Adolph Gottlieb, Mark Rothko, Louis Schanker, Joseph Solman and Nahum Tchacbasov formed an exhibiting society for mutual support called *The Ten: An Independent Group* and they organized their first exhibition at the Montross Gallery. They achieved international recognition in 1936 with a group show at the Galerie Bonaparte in Paris where they challenged American provincialism. Their public profile increased in 1938 when they presented an exhibition at the Mercury Galleries in opposition to the conservative policies of the Whitney Museum of American Art.

Rothko became the polemicist for the Whitney Dissenters and their message was widely circulated throughout the country. Rothko and his friend Gottlieb became recognized as the leading theorists for a new art when their letter to the Art Editor of the *New York Times* was published in the newspaper on June 7, 1943. Key points in their program were laid out in a list including: "We favor the simple expression of the complex thought. We are for the large shape because it has the impact of the unequivocal. We wish to reassert the picture plane. We are for flat forms because they destroy illusion and reveal truth. We assert that the subject is crucial and only that subject matter is valid which is tragic and timeless."[13]

Rothko was by far the most important and influential artist of *The Ten* and he is still revered as one of the major masters of American mid-century art. Unlike the vast majority of Russian immigrants, Rothko's family had settled in Portland, Oregon on the upper west coast far from the cultural capital of New York. Also unlike them, Rothko did not disavow his heritage and Rothko uncharacteristically spent two years at Yale University, a bastion of old line Protestantism, before settling in New York where he enrolled at the Art Students League. In 1925 he entered the still life class of Weber, whose emphasis on the spiritual nature of art became a catalyst for Rothko. Weber was a charismatic teacher and students flocked to his classes to hear his theories of art, published from transcriptions of his lectures at the White School in 1916 as *Essays on Art*. Rothko had his first professional exposure in a group show at the Opportunity Gallery in 1928. The following year Rothko secured a post as a teacher to children at the Center Academy of the Brooklyn Jewish Center where he taught until 1952. The security of the teaching position allowed him the freedom to experiment with art that was radical and unpopular, but would change the landscape of visual imagery.

By the end of the 1940s Rothko had developed his "signature format: tiered clouds of color magnetized before the symmetrical pull of horizontal and vertical axes," as a "metaphor of the supernatural world beyond."[14] His works are still and quiet to count-

[13]
The letter was reprinted in *Mark Rothko*, London: The Tate Gallery, 1983, pp. 77–78

[14]
Robert Rosenblum, ibid. p. 22 & 24.

er the bustle, noise and confusion of the modern world. They address absence rather than presence, contemplation, and calmness whereas for the most part the art of his contemporaries is full of action and bravado. Rothko's paintings create an aura of detachment and disengagement from the consumer society that burgeoned in America during the 1950s and 1960s. They were perfectly suited to define the meditative interior of the non-denominational chapel in Houston commissioned by Dominique and John de Menil that serves as Rothko's memorial. Although the chapel was commissioned in 1964 and the paintings were essentially completed by 1967, the chapel was not dedicated until 1971, a year after Rothko's suicide.

Archipenko, Gabo, Louise Nevelson, and Alexander Liberman were influential in the development of a modern sculptural aesthetics, which was slower to gestate in the United States than innovative painting. While Archipenko and Gabo had made names for themselves as sculptors of note before their arrival in America, both Liberman and Nevelson were relative late bloomers as successful artists.

Although Archipenko's art had been known in the United States since the Armory Show in 1913, he did not arrive until 1923. He opened a successful art school in New York City, taught in art departments of a number of American universities, and held many one-person shows from coast to coast, all of which contributed greatly to Modernism.[15] One of the most innovative 20th-century sculptors, Gabo did not settle in the United States until 1946, past the middle of his distinguished career. Gabo was one of the originators of Constructivism and his wall mounted *Head No. 2*, constructed of cardboard of 1911, broke new ground. Gabo explored the idea of space rather than mass in sculpture and in the United States he worked with a variety of unusual materials including plexiglas and plastic string. He produced sculptures that hung and even those that moved as he experimented with new ways of thinking about the nature of sculpture and how to work with transparency. Some of his works seem to float in space as if by magic and they have a mathematical purity and elegance.

Born in Kyiv, Liberman was educated in Paris and began a career in publishing there. In 1941 he immigrated to the United States to work for the internationally prestigious publishing firm Conde Nast where he became the editorial director of the communications giant from 1962 to 1994. Late in his career, Liberman began to paint, but he soon realized that sculpture was his metier and he achieved recognition for his monumental constructions in industrial material. "Louise Nevelson's life was the quintessential American success story — an immigrant invents a new identity for herself and achieves fame in the New World."[16] Nevelson's career, however, had a long gestation for her to achieve acclaim. Nevelson, moreover, had to leave Maine for New York to find a congenial community for her art. Both Nevelson and Liberman took their artistic cues from the constructive techniques of Gabo and other constructivists, although

**Louise Nevelson.** Dream House XXXII. 1972
Painted wood with metal hinges
75 x 24$^3/_5$ x 16$^4/_5$ in. (190.8 x 62.6 x 42.9 cm)
Hirshhorn Museum and Sculpture Garden,
Smithsonian Institution, Washington
Bequest of Joseph H. Hirshhorn, 1981

[15]
Wayne Craven, *American Art: History and Culture*, Madison, WI: Brown & Benchmark, 1994, p. 488.

[16]
Laurie Lisle, *Louise Nevelson: A Passionate Life*, New York: Summit Books, 1990, p. 9.

Liberman worked with industrial materials and Nevelson constructed her environmental sculptures from the wooden detritus of urban America. Their large-scale abstract constructions enliven many urban spaces.

By the time that Nevelson and Liberman attained national recognition, New York had become the world's new art center and had edged out Paris as the most important city for art in the world. Aspiring artists from all over the globe expanded the formerly intimate art community into the major international marketplace that it remains today. Although it is curious that so many Russian Jewish immigrants from a religious background that discourages figurative imagery would become artists, it is less remarkable that the Russian born artists in the United States would congregate in New York and become friendly rivals in the small and select Manhattan art world. That these artists selected new identities and a new way of thinking after they made their sea voyage seems to have opened them to the possibilities of a new way of making art to revolutionize the visual landscape. Their influence on the nature and direction of American art is undeniable and many of them remain heroic figures in the history of art.

Harlow Robinson,
Ph.D., Northeastern University

americans from

America's long-running love affair with Russian music and musicians — and vice versa — began in earnest when Pyotr Ilych Tchaikovsky came to visit the United States in 1891. Arriving in New York in April, 1891, less than six months after the successful premiere of his new opera *The Queen of Spades*, he was surprised to learn that his impressive reputation had preceded him to the wilds of North America. "It seems that I am ten times better known in America than I am in Europe… There are some pieces of mine which they still don't know in Moscow; here they play them several times in a season and write whole articles and commentaries about them. They have played the Fifth Symphony two years running. Isn't this funny?!!!"[1] It also helped that Tchaikovsky's First Piano Concerto, destined to become one of his most popular works, had received its world premiere in Boston sixteen years earlier, on October 25, 1875, with the German pianist and conductor Hans von Bulow (1830–1994) as soloist. True, it is generally believed that Tchaikovsky allowed the Concerto's premiere to occur in such a remote and (at the time) provincial locale because the work had been viciously criticized by his mentor Nikolai Rubinstein back in Russia, and he wanted to try out the piece far away from Moscow's wagging tongues. By the time he arrived in America in 1891, Tchaikovsky (1840–1893) was at the height of his fame, having completed five of his six symphonies, seven of his eight operas, the ballets *Swan Lake* and *Sleeping Beauty*, two of his three piano concerti and the *1812 Overture*. Oddly, the spectacular *1812 Overture*, written for the 70th anniversary in 1882 of the Russian victory over Napoleon in 1812, would (complete with fireworks and firing cannons) come to play a prominent role in the celebration of American independence on July 4, especially in Boston, where it is still performed each year on the Charles River esplanade and televised to a national audience — its

# russia in music

nationalistic and pro-monarchy sentiments notwithstanding. Similarly, Tchaikovsky's last ballet, *The Nutcracker*, has become a standard fixture in the American observance of Christmas, performed by ballet companies all over the country, its music piped unceasingly into malls and office elevators.

All this was still in the future, however, when Tchaikovsky arrived in New York in 1891. His most important appearance was on April 23, at the ceremonies inaugurating Carnegie Hall, when he conducted his *Coronation March* to laudatory reviews. "I must admit that the scale and impressiveness of all the Americans undertake is tremendously attractive," he wrote home. "I also like the comfort about which they take so much trouble. My room, just like every other room in all the hotels, has gas and electric light and private bathroom and lavatory; there are heaps of extremely comfortable furniture; there is an apparatus for speaking to the reception desk and all sorts of things to make one comfortable which do not exist in Europe. In short, there is a great

1
Tchaikovsky, P. I. *Pis'ma k blizkim: Izbrannoe*. V. A. Zhdanov, ed. Moscow, Gosudarstvennoe muzykal'noe izdatel'stvo, 1955, 489. Letter to V. L. Davydov, April 18, 1891. Translated by Harlow Robinson.

deal about the country which I like very much and find remarkably interesting."[2] This was a sentiment that would be shared by many of Tchaikovsky's fellow Russian musicians in the years to come.

In part because of this celebrated visit to the United States (he took in Niagara Falls, and also appeared in Washington, Philadelphia and Baltimore) at a moment when American elite culture was just beginning to find its voice and expression, Tchaikovsky has always been very popular with American audiences; he has almost become an honorary American composer. The fact that so many Russian musicians and dancers who had grown up performing his works later emigrated to the United States beginning around World War I also helped his reputation. Dancers like Anna Pavlova and choreographers like Michel Fokine, Léonide Massine, and George Balanchine were influential in bringing Tchaikovsky's music to the attention of the American public. So were Russian conductors who later came to live and work in America, such as Serge Koussevitsky (1874–1951), who would become the music director of the Boston Symphony Orchestra in 1924.

Nor did it take long for Hollywood directors and producers to discover the powerful emotional sensitivity of Tchaikovsky's music. In the silent era, Tchaikovsky's scores were used directly as a source for movie hall pianists, who played excerpts to convey particular recognizable emotions as accompaniment or counterpoint to the action on the screen. And what is considered the first "talkie," *The Jazz Singer* (1927), also uses themes from Tchaikovsky (the love theme from his fantasy-overture *Romeo and Juliet* and the *Serenade Melancholique*), juxtaposing them with Jewish liturgical music and Broadway tunes to symbolize the identity confusion of the main character, a son of immigrants played by Al Jolson. Later, Tchaikovsky's music was heavily imitated by many of the masters of Hollywood film music, from Max Steiner to Dmitri Tiomkin (himself a Russian émigré) to John Williams.

During the years following Tchaikovsky's highly publicized visit to the United States (he died only two years later), other Russian composers continued to arrive on tour, and sometimes to stay permanently. The first of Sergei Rachmaninoff's many visits to America (he would finally settle in Los Angeles during World War II) took place in 1909. As a special present to the American public, Rachmaninoff performed the world premiere of his formidable new Piano Concerto No.3 in New York with the New York Philharmonic conducted by Walter Damrosch on November 28. Rachmaninoff repeated the performance at Carnegie Hall on January 16, 1910, with Gustav Mahler conducting. Rachmaninoff's feelings about America were always somewhat ambivalent. He very much enjoyed the large fees he could command there, and liked to call the USA the "dollar princess," but at the same time found the American obsession with "business" unappealing. After returning to Moscow in early 1910, he wrote to a friend

[2] Ibid, 489.

that "all I can say about America for the moment is that I aged there, for I got awfully tired."[3] And yet in late 1918, a year after leaving Russia permanently in the aftermath of the 1917 Bolshevik Revolution, Rachmaninoff would return to America, and use it as his base of operations throughout the 1920s.

In 1906, another prominent Russian pianist-composer, and a friend of Rachmaninoff, Alexander Scriabin (1872–1915), also came on tour to the United States. In New York, he performed under the Russian conductor Vasily Safonov (1852–1918), who was the chief conductor of the New York Philharmonic from 1906 to 1909. At the dawn of the twentieth century, Russian music and musicians had gained respect and authority in the American musical world, which was rapidly expanding as the country's wealth grew. Newly enriched industrialists contributed large sums of money to establish and maintain symphony orchestras, opera houses and conservatories, which were staffed by leading musicians from Europe and Russia.

Another Russian musician who made a big impression on American audiences before World War I was the renowned operatic bass Fyodor Chaliapin (1873–1938). On November 20, 1907, Chaliapin made his American and Metropolitan Opera debut in the title role of Boito's *Mefistofele*. Many considered this strapping Russian *muzhik* from Kazan the greatest bass in the world. And yet it took a while for American critics to warm up to his earthy style. Chaliapin's bare-chested sensuality and his aggressive physicality offended their Puritan sensibilities; his raw, powerful vocalism insulted their delicate ears. After this first "short and far from happy stay," the mercurial and often overbearing Chaliapin pronounced America sadly lacking in cultural awareness. "I pity Americans," he said, "because they have no light, no song in their lives. They are children in everything pertaining to art."[4]

But there was a recent immigrant from Russia to the United States in the audience at the Met who believed that the American public could come to admire Chaliapin's art as much as he did. His name was Solomon Hurok. Like thousands of other Jewish immigrants from the Russian Empire, Hurok (1888–1974) had arrived in New York in 1906 on a ship from Hamburg, seeking greater economic and personal opportunities and freedom from the anti-Semitism that was rampant in the final decades of the Tsarist regime. Within a few years he had become an American citizen and a political activist and impresario, presenting musical and dance "attractions" to a hungry and growing public. Before long, Hurok even managed to sign up the intimidating Chaliapin as one of his clients, and finally engineered his highly-publicized return to New York in 1921. The highlight of that tour was Chaliapin's appearance in the title role of *Boris Godunov* at the Metropolitan Opera. Even the fact that Chaliapin sang in Russian and the rest of the cast in Italian, as had been the practice at the Met for the last nine seasons, failed to ruin the strong dramatic impact of his performance on

**Pyotr Tchaikovsky.** Circa 1890
Photograph by A. Pazetti, St. Petersburg
Reproduced from *Tchaikovsky. 1840–1893*
Moscow, 1990

3
Rakhmaninov, S. V. *Literaturnoe nasledie v trex tomakh, t. 2*.
Z. A. Apetian, ed. Moscow, Sovetskii kompozitor, 1980, 9. Letter
to M. L. Presman, Feb. 24, 1910. Translation by Harlow Robinson.

4
Davis, Ronald. *A History of Music in American Life, Vol. II: The Gilded
Years, 1865–1920*. Huntington, NY, Robert Krieger, 1980. P. 6.

December 14, 1921, one of the greatest and most rambunctious nights in the Met history. Chaliapin's triumph at the Met came at a time when that very conservative institution was beginning to reflect new social realities. The old aristocratic families that had long supported and monopolized the opera were being challenged by a rising tide of democratization reflected in the diversity of the crowd — which included many recent immigrants — jamming in to hear *Boris*.

After fulfilling his very successful American engagements under Hurok's auspices in 1921–1922, Chaliapin returned briefly to Russia. He stayed in Petrograd (as St. Petersburg was renamed 1914–1924) only long enough to sing his last performance (a benefit) in a Russian theatre, in the lead role of *Boris Godunov*. Shortly afterward, he left Russia with his second wife, their daughters, and his stepdaughter, never to return. Until his death in 1938, Chaliapin appeared frequently in the United States, although he was based in Europe.

Like so many other musicians and composers, Chaliapin had left Russia because he found conditions there following the 1917 Bolshevik Revolution extremely challenging. "Little by little life became more and more difficult," he wrote later. "It was as hard for me to get milk and bread — the bare necessities — as for the humblest workingman to provide food for his family. I was glad to sing for the reward of a bag of flour, a ham, some sugar. Sometimes, even, I received a little money, which had already become of very little value." Despite his intense patriotism and passion for Russian music and culture, Chaliapin eventually felt he had to leave his homeland. "The day came when it seemed to me an absolute necessity to get out of Russia and see if I had been forgotten."[5]

Not only Chaliapin, but his sons Boris and Fyodor, Jr. also left Russia and made significant contributions to American culture. A distinguished painter and illustrator, Boris painted portraits of Rachmaninoff, Toscanini, Koussevitsky, Heifetz, and many of his own father, as well as nearly 200 covers for *Time*, several of which are included in this exhibition. Fyodor Chaliapin, Jr. (1905–1992), the youngest of his father's six children, pursued a long career as a stage and film actor, and appeared in such classic movies as *For Whom the Bell Tolls* (1943) and *The Bridge of San Luis Rey* (1944).

During World War I and in the years following the 1917 Bolshevik Revolution, thousands of musicians followed Chaliapin's example, leaving Russia in search of a more stable creative environment. Some went to Berlin, some to Paris, some to Argentina — and a good number to the United States. Pianists, violinists, cellists, composers, conductors, and singers arrived in large numbers, and immediately began to enrich American musical life. Because their "language" was the universal one of music, it was in many ways easier for musicians to make the difficult transition to a new life.

[5] Chaliapin, Fyodor. *Pages from My Life: An Autobiography*. Revised, enlarged and edited by Katharine Wright, translated by H. M. Buck. New York, Harper, 1927, 308.

Among the early arrivals was Sergei Prokofiev (1891–1953), who at the time of Bolshevik Revolution was just entering a crucial stage in his young career as a composer and pianist. Prokofiev's decision to leave the USSR in 1918 was motivated less by ideological than by practical concerns. In his diary, he claims it was a female acquaintance who gave him the idea of going to America: "Go to America! Of course! Here life is sour, there it is pulsating, here is slaughter and nonsense, there is a life of culture, here there are pathetic concerts in Kislovodsk, there are New York and Chicago. I no longer have any doubts. I will go in the spring. I just hope that America does not feel hostility towards individual Russians!"[6] As entries in his diary from this period make clear, Prokofiev was not at all sure where he should go at this extremely confusing moment.

In response to his friend's insistence that it was very important for him to be successful in America, "I answered that this success interests me only superficially, from the financial point of view. I do not consider the inner meaning of my success in America to be very valuable, since the Americans are insufficiently refined musicians for me to listen carefully to their opinions." On March 11, 1918, he wrote: "America has again started to attract me. But what lay ahead — considering the political events, the situation of the Germans at the moment, and the capital cities that I had not seen in such a long time — was so full of uncertainties, that it was impossible to count on anything or to regret anything: *rien n'est certain.*"[7]

In Russia, Prokofiev, who reached the age of 27 in April 1918, faced nearly insurmountable difficulties in arranging concerts (those planned for 1917–1918 had been cancelled) at a crucial moment in his career, just when he was beginning to attract the attention of important critics, publishers and impresarios. Unlike Rachmaninoff, who had already written most of his mature music by 1918, or Stravinsky, already famous abroad for the ballets he had written for Sergei Diaghilev's Paris-based Ballets Russes (*Firebird, Petrouchka, the Rite of Spring*) before World War I, Prokofiev was not yet fully established as a major composer. Before he left Russia, only four of his major orchestral works had been performed in Russia: the first two piano concerti, the *Scythian Suite* and the Symphony No. 1 (*Classical*). (And the premiere of the *Classical Symphony* in Petrograd in April 1918 went almost unnoticed amidst the revolutionary chaos.) He was better known as a pianist, having played the premiere of the two concerti and of four of his own piano sonatas.

Why did Prokofiev decide to go to America rather than to Europe? The main reason was his meeting in summer 1917 with Cyrus McCormick, Jr. the son of the inventor of the first commercially successful mechanical reaper. A passionate music-lover, McCormick promised Prokofiev he would help him if he came to the United States — especially in Chicago, where he lived. Also, the war was still raging in Europe in spring

**Boris Chaliapin.** Portrait of Fyodor Chaliapin. 1934
Oil on canvas. $35^{4}/_{5}$ x 28 in. (91 x 71 cm)
Private collection, New York

[6]
Prokof'ev, S. S. *Dnevnik 1907–1918.* Paris, 2002, 678. Translated by Harlow Robinson.

[7]
Ibid, 689.

of 1918, although the new Soviet government had withdrawn its troops from the front and signed a ruinous treaty with Germany and Austria-Hungary. In any case, Prokofiev told friends and the Soviet Commissar for Education, Anatoly Lunacharsky, who helped him secure the necessary travel documents, that he intended to stay abroad for perhaps six months or so, not permanently.

When Prokofiev approached Lunacharsky in April, 1918, on the same day as the premiere of his *Classical* Symphony in Petrograd, to request his help in leaving Russia, Lunacharsky at first attempted to persuade the composer to stay.

"You should stay here, why do you want to go to America?" I have been working for a year without a break, and now I want to gulp down some fresh air. "We have so much fresh air here in Russia." Yes, in the moral sense that is true, but right now I am eager for some physical fresh air. Just think what it will be like to cross the great ocean along a diagonal line! "All right, sign this paper, and we will give you the necessary documents."[8]

On May 2 Prokofiev left for Moscow to catch the trans-Siberian express, and then a boat from Japan to California. He would see St. Petersburg again only nine years later, in 1927.

When Prokofiev finally arrived in New York in autumn 1918, after being briefly detained by U. S. immigration officials in San Francisco as a possible Bolshevik, he immediately set about trying to make himself and his music known to the American public. He was disappointed to find, however, that even in New York the musical public was conservative and for the most part unreceptive to "modernist" music — especially from a young "Bolshevik" (as he was called in several newspaper reviews) composer. Prokofiev's American career was slow to develop, and he was constantly in need of money. Relatively few commissions came from American sources. Because of his connection with McCormick, Prokofiev had better luck in Chicago than in New York. Two major works — the Piano Concerto No. 3 and the opera *Love for Three Oranges* — were first performed in Chicago in the same year, 1921. *Love for Three Oranges*, Prokofiev's first full-length opera to reach the stage, was a commission from the Chicago Opera.

But Prokofiev's most important patron in America was another Russian émigré — conductor Serge Koussevitsky. Koussevitsky had promoted Prokofiev's music back in Russia before the Revolution, and in Paris in the early 1920s. In 1924, Koussevitsky was appointed as the new conductor of the wealthy and prestigious Boston Symphony Orchestra. In this capacity, Koussevitsky commissioned many works by contemporary Russian émigré composers, including Prokofiev, Stravinsky and Vladimir

[8] Ibid, 696.

Dukelsky (known in America as Vernon Duke). Prokofiev's Fourth Symphony was written for a BSO commission, and the BSO under Koussevitsky regularly frequently performed other works by Prokofiev, who was a frequent guest artist (as conductor and five times as piano soloist) in Boston during the 1920s and 1930s, even after he had moved to Europe. Prokofiev also received a commission from the Library of Congress for his String Quartet No.1 (1930).

But Prokofiev was not successful in persuading the Metropolitan Opera in New York to stage his operas, a source of considerable frustration, since he had dedicated a great deal of his time in the 1920s to the composition of the large opera *The Fiery Angel*. To Koussevitsky and others, Prokofiev complained chronically that his music was insufficiently understood and appreciated by American audiences and critics, and that he was perceived more as a pianist than a composer.

In order to survive financially, and to support a wife and two young sons, Prokofiev made long and exhausting tours as a pianist across the United States through the 1920s and 1930s. In December 1925, he played fourteen concerts in two months in ten cities from Boston to San Francisco. From January to March of 1930, he gave 20 concerts in nine cities. He repeated the same routine in 1933, making 12 appearances in the course of six weeks, including one with Bruno Walter and the New York Philharmonic.

By then, he was beginning to feel that his music was finally reaching the American audience, as he wrote to his old friend the critic Boris Asafiev (still living in Leningrad). "It seems that the Americans are starting to take me seriously, the way they should. Because you know they used to behave like savages who would giggle if you played Beethoven's Ninth Symphony for them on a gramophone. That's what the kind Yankees were like: if they didn't understand something, that meant that the author was doing it as a joke, or out of spite. But now they are gradually beginning to penetrate to the seriousness of my intentions."

When in the United States, Prokofiev frequently socialized with other Russian émigré musicians, actors and artists. He was particularly fond of Los Angeles, just emerging as the center of the fast-growing American film industry. In early 1921, he met the famous Russian actress Alla Nazimova, who had moved to Hollywood and was starring in silent films. He even celebrated Russian New Year at Nazimova's house after his recital: "…After the concert the green room was literally bursting with an excited mob [which included Nazimova]. It had already been arranged that after the concert Nazimova invited us over to celebrate the Russian New Year, and she did this so successfully that I didn't even manage to cool off the way I usually do, or to shake all the hands. Nazimova has a charming little house, along with a small and pleasant group of film people and artists and the four of us. The evening — or rather, the night —

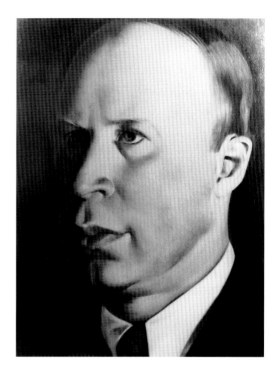

**Vasily Shukhayev.** Portrait of the Composer Sergei Prokofiev. 1932
Oil on canvas. 30³/₄ x 23³/₄ in. (78 x 60 cm). Reproduced from: Myamlin I. *Vasily Ivanovich Shukhayev*

passed very agreeably, everyone got a bit drunk, and I danced with Baranovskaya [wife of the pianist Alexander Borovsky]. At twelve midnight the lights were extinguished, we shouted "hurrah," someone sang *God Save the Tsar*, and then the *Marsellaise*. We finally agreed upon the *Glory* chorus from *A Life for the Tsar*, which I predicted would become the new Russian national anthem… At five a.m. we went out into the garden, where it was warm and smelled so fresh — and enjoyed California. Then we went home."[9]

Unlike many Russian emigres in the United States who because of their strong anti-Communist political sentiments had no interest in returning to the Soviet Union, Prokofiev never abandoned the idea that he would return to Russia. He conducted an extensive correspondence with friends and associates in the USSR and tried to stay informed on what was happening musically in his Motherland. After living in the United States from 1918 to 1922, Prokofiev moved to Europe, eventually settling in Paris. In 1927, he made his first trip back to the USSR, where he was received with enormous enthusiasm. This trip led him to consider returning permanently to Russia, where he believed his music would be better understood. Over the coming years, although he made numerous extensive tours of the United States (the last in 1938), Prokofiev spent an increasing amount of time in the USSR. He moved to Moscow with his family in 1936. On his last visit to the United States in 1938, twenty years after his arrival in San Francisco in 1918, Prokofiev traveled all the way to California. At this time, Prokofiev was one of the very few Soviet cultural figures allowed to travel abroad under Stalin's increasingly paranoid and repressive regime.

In Los Angeles, Prokofiev met Walt Disney and other Hollywood celebrities. Film director Rouben Mamoulian (himself an Armenian/Russian émigré who had left Russia for London around the time of the Bolshevik Revolution) even held a banquet in Prokofiev's honor. One of those in attendance was Arnold Schoenberg, who had been living in the United States since 1933, having fled the Nazis. Although Prokofiev was curious to meet Schoenberg — whose music he had been the first to play in Russia in 1911 — in the flesh, he remained unmoved by Schoenberg's twelve-tone system. The more glamorous film people, who were working in such a modern and exciting medium to which Prokofiev was also now making a contribution, made a much greater impression on him. Hollywood was so fascinating, and Prokofiev so flattered by the attention he was receiving, that he and Lina stayed considerably longer than he had first planned. That the seemingly infinite resources and technical sophistication of the American film industry at its zenith dazzled Prokofiev is clear from a letter he wrote to his sons Oleg and Sviatoslav, who were in school back home in Moscow.

"I've been in California for ten days now. It is very warm here — I've forgotten what an overcoat is, and the trees are covered with oranges and pineapples. Most Ameri-

[9]
Prokof'ev, S. S. *Dnevnik 1919–1933*, 144.

can films are made in Hollywood, and they build whole houses, castles and even cities of cardboard for them. Today, I went to a filming session. A big tall warehouse had been turned into the square of an old town and people galloped through it on horses. I have also been to the house of Mickey Mouse's papa — that is, the man who first thought up the idea of sketching him."[10]

Just a few years after Prokofiev made his last trip to Los Angeles, both Stravinsky (in 1940) and Rachmaninoff (in 1942) moved there from Europe to escape the war in Europe, joining many other Russian and European refugee musicians. Stravinsky would remain in Los Angeles until 1969. Stravinsky (and his wife Vera) always had ambivalent feelings about the Southern California lifestyle and the celebrity worship that reigned there, but it was Los Angeles that gave Stravinsky (and many others, including Arnold Schoenberg) personal and creative refuge from the Nazi devastation of Europe, just as Switzerland, and later Paris, had given Stravinsky refuge from World War I and the 1917 Bolshevik Revolution in Russia. As Stravinsky's biographer Stephen Walsh has observed, one of Stravinsky's prime motivations was his terror of "being stranded on the wrong edge of civilization in the event of war or revolution." Danger was not his thing.

Stravinsky led a studiously apolitical life after he came to the United States in 1939. His days were spent in his studio in his cozy little house on North Wetherly Drive, in the eternal southern California summer, and his evenings with well-heeled friends over cocktails (of which he was inordinately fond) and dinner. Esa-Pekka Salonen, conductor of the Los Angeles Philharmonic and a great champion of Stravinsky's music, likes to point out that Stravinsky lived as long in Los Angeles as he did in Russia. "If there ever was a home for Stravinsky, it was the house in West Hollywood," he has said. "And Stravinsky is maybe the most important figure in the world of the classical arts ever to have lived in Los Angeles, even though there's still very little appreciation of this fact, even in Los Angeles."[11] During his recently concluded tenure as conductor of the LA Philharmonic, Salonen tried hard to raise the consciousness of his fellow Los Angelenos, judging by the high frequency with which he programmed Stravinsky's works; his ballet *The Rite of Spring* has even become a kind of signature piece for the LA Philharmonic in its spectacular new home, Walt Disney Hall.

During the 1940s, Stravinsky was asked to write scores for several films, but he and the directors repeatedly encountered "artistic differences." In 1942, Stravinsky was commissioned to produce a score for a film about the Nazi invasion of Norway, *The Commandos Strike at Dawn*, but he balked at changes requested by Columbia and was eventually replaced by Louis Gruenberg, whose score was nominated for an Academy Award. Stravinsky did recycle the music he had written into *Four Norwegian Moods*, a

10
*Sergei Prokof'ev 1953–1963: Stat'i i materialy.* I. V. Nest'ev, G. Ia. Edel'man, eds. Moscow, Sovetskii kompozitor, 1962, 222–23. Translated by Harlow Robinson.

11
Interview with Esa-Pekka Salonen, Los Angeles Philharmonic press office, December 7, 2000

77

marvelously evocative piece for orchestra. In many ways, this warm, nostalgic and highly accessible piece makes a bridge to the earlier "Russian" phase of Stravinsky's career, with its witty treatment of folk material and bewildering "off-center" rhythms.

In 1943, Stravinsky was hired for another film score, for *Song of Bernadette*, a religious tear-jerker set at the shrine of Lourdes, but again his music was not used; veteran film composer Alfred Newman replaced Stravinsky and won his third Academy Award. Stravinsky recycled his "Bernadette" music into the second movement of *Symphony in Three Movements*, where the heavenly harp from the "Apparition of the Virgin" scene figures prominently. After the 1940s, Stravinsky steered clear of the film industry. He always demanded complete creative control, an impossibility in the producer-controlled, harshly commercial, formulaic and money-driven world of Hollywood. It was only a pressing need for cash that led Stravinsky in 1939 to sell to Walt Disney the rights to use — without any restrictions — the score of *The Rite of Spring* (composed 26 years earlier) in what eventually became *Fantasia*, a film he disliked, but that has since become an American movie classic.

The last "American" period of Stravinsky's life was not nearly as dramatic as his explosive arrival on the world stage just before World War I in Paris, and did not produce anything that could match the popularity or influence of the early scores for the Ballets Russes. But it still gave us many important works, particularly those produced in the uniquely American collaboration with another émigré from St. Petersburg, choreographer George Balanchine (*Jeu de cartes, Orpheus, Agon*). Balanchine and Stravinsky developed an exceptionally close and productive collaboration, especially for the New York City Ballet which Balanchine created and led for many years.

That Stravinsky was grateful to his adopted country is obvious from his arrangement of *The Star-Spangled Banner*, written in 1941 as a sort of thank-you note to the United States for granting him citizenship after he had left Europe looking for safer haven. The arrangement of the American anthem was undertaken not long after Stravinsky and his wife Vera had applied for American citizenship; they received citizenship in 1945, after a five-year waiting period. He saw it as a "work of national importance," and a personal tribute to the country he had come to consider his home. The first page of the published score reproduces Stravinsky's uncharacteristically emotional longhand message: "Searching about for a vehicle through which I might best express my gratitude at the prospect of becoming an American citizen, I chose to harmonize and orchestrate as a national chorale the beautiful sacred anthem *The Star Spangled Banner*. It is a desire to do my bit in these grievous times toward fostering and preserving the spirit of patriotism in this country that inspires me to tender this my humble work to the American People."[12]

Also in the early 1940s, another Russian musical giant moved to Los Angeles: Sergei Rachmaninoff (1873–1943). Rachmaninoff, who had been living in emigration from

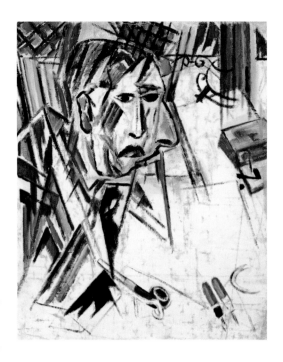

**Mikhail Larionov.** Portrait of Igor Stravinsky. 1913
Oil on canvas. $24^{1}/_{2}$ x $20^{1}/_{2}$ in. (62 x 52 cm)
Collection of Vladimir Tsarenkov, Moscow

12
Walsh, Stephen. *Stravinsky: The Second Exile, France and America, 1934–1971*. New York, Knopf, 2006, 132.

his beloved Russia since 1918, was by then wealthy and very famous as a result of his extensive tours as pianist throughout the United States over the preceding decades, and his association with the Philadelphia Orchestra, for which he wrote several new works. In 1939 he left Europe and took up residence in Long Island. When he decided to settle in Los Angeles in early 1942, he was seriously ill, suffering from sclerosis, lumbago, neuralgia, high blood pressure and headaches. At first he leased a house in the hills on Tower Road, complete with swimming pool, garden, sweeping views, and a music room that could accommodate two pianos. There he loved to play two-piano works and adaptations with his friend virtuoso Vladimir Horowitz, another Russian who had sought refuge in Los Angeles. On occasion, the two pianists hosted domestic recitals. Rachmaninoff's friend Sergei Bertensson attended a particularly memorable one on June 15, 1942, with a program of works by Mozart and Rachmaninoff (the Second suite for Two Pianos). "After the last note no one spoke — time seemed to have stopped. I, for one, forgot that I was living in Hollywood, where the word 'art' has a habit of slipping from one's memory."[13]

Rachmaninoff and his guests also did lots of talking, especially about the worsening situation in Europe and its impact on their family and friends. "Over dinner with the Horowitzes and other expatriate friends, the composer would talk about his feelings of guilt that he should be living in such luxury."[14] A few months later, Rachmaninoff bought a small house on Elm Drive, where he continued to host musical evenings. Around the same time, Rachmaninoff, an experienced and admired conductor, was offered the position of conductor of the Los Angeles Philharmonic, but his precarious health made it impossible for him to accept. Indeed, Rachmaninoff only lived in his new house for a few months. He died of cancer in Los Angeles on March 28, 1943, and his funeral was held in the tiny Russian Orthodox Church on Micheltorena Street in the Silver Lake neighborhood.

Rachmaninoff was the first composer Walt Disney thought of when he was planning the animated musical feature that became *Fantasia*; he wanted to include Rachmaninoff playing his Second Piano Concerto. "I don't know anything about music," Disney is alleged to have told Leopold Stokowski, longtime conductor of the Philadelphia Orchestra, "but I have heard of Rachmaninoff for a long time."[15] Rachmaninoff never worked on any film projects, his late romantic musical style exerted an enormous influence on the mainstream of Hollywood film music. Miklos Rosza even incorporated Rachmaninoff's *Rhapsody on a Theme of Paganini* into his original score for *The Story of Three Loves* (1953), co-directed by Gottfried Reinhardt and Vincente Minelli.

By the time Stravinsky and Rachmaninoff arrived in Hollywood, another Russian had already established himself there as one of the leading creators of film scores:

[13] Dick Adler, *Rachmaninov in Beverly Hills*, Upbeat (Los Angeles Philharmonic Magazine), October 10, 1989, 3.

[14] Ibid, 2.

[15] Friedrich, Otto. *City of Nets: A Portrait of Hollywood in the 1940s.* New York, Perennial, 1987, 35.

Dmitri Tiomkin (1894–1979). Born in Ukraine and educated as a pianist and conductor at St. Petersburg Conservatory, where he crossed paths with Sergei Prokofiev, Tiomkin had no illusions about his talent or about the nature of the work he did: "I am no Prokofiev, I am no Tchaikovsky. But what I write is good for what I write for. So please, boys, help me."[16] When Tiomkin gave his acceptance speech upon receiving an Oscar for his score for *The High and the Mighty* in 1955, he mischievously thanked Brahms, Johann Strauss, Richard Strauss, Wagner, Beethoven and Rimsky-Korsakoff. But Tiomkin was brilliant at what he did, one of the most consistently successful film composers of all time.

In St. Petersburg, Tiomkin received an excellent academic training from such pedagogues as Felix Blumenfeld (Vladimir Horowitz's teacher) and Alexander Glazunov (mentor to Prokofiev and Shostakovich) and played piano accompaniment for silent film screenings. After leaving Russia, Tiomkin made his way through Berlin and Paris before coming to New York in 1925. Like many others, he left New York after a few years to find greater employment opportunities in the film industry in Los Angeles. Tiomkin scored the film *Alice in Wonderland* (with W.C. Fields as Humpty Dumpty and Cary Grant as the Mock Turtle) for Paramount in 1933, and made his breakthrough in 1937 with the music for Frank Capra's *Lost Horizon*, for which he received the first of his 23 Academy Award nominations. In 1939 he scored *Mr. Smith Goes to Washington*, and in 1944, *The Bridge of San Luis Rey* (featuring fellow Russians Akim Tamiroff as the theatrical impresario Uncle Pio and Alla Nazimova as the Marquesa). Tiomkin won his first Academy Award for the score for the classic 1952 film *High Noon*, a tale of cowardice and conformity in a small Western town, starring Gary Cooper as a quietly courageous sheriff who has to face alone the return of a band of hoodlums imprisoned years ago largely due to his efforts and now newly released from prison and bent on revenge. Like the film, Tiomkin's score is unconventional and unheroic, built entirely around a single western-style ballad, *Do Not Forsake Me, O My Darling*, sung by the country western star Tex Ritter.

Tiomkin breaks most of the rules of Hollywood film-scoring in his ground-breaking music for *High Noon*. Most importantly, perhaps, he eliminates the violins from the ensemble. The resulting combination of lower strings, brass, wind and piano, with the harmonica heard while Tex Ritter is singing, creates a rustic, deglamorized sound that suits the anti-heroic sentiments of the film. Also, the score opens and closes very softly, with guitar, accordion and drums — in most classic Hollywood films, the overture tends to be big and string-heavy, with a climax just as the director's name appears on the screen.

The unusual concept of building the score around a single folk tune recalls the way Russian classical composers employ folk tunes; a good example is Mikhail Glinka's

**Konstantin Somov.** Portrait of the Composer
Sergei Rachmaninoff. 1925
Oil on cardboard. 25 x 20$^{1/3}$ in. (63.7 x 51.6 cm)
Received in 1964 from M. M. and S. A. Braikevich, London
State Russian Museum

16
Karlin, Fred. *Listening to the Movies: The Film Lover's Guide to Film Music.* New York, Schirmer, 1994, 53.

*Kamarinskaya*, where a folk tune is subjected to increasingly fanciful and ornate varia-tions. Indeed, it was long rumored that the tune of *Do Not Forsake Me, O My Darling* was Russian or Ukrainian, but this has never been proven.

In his excellent book *The Composer in Hollywood,* Christopher Palmer speculates on the reasons why a Russian-born conservatory-educated figure like Tiomkin could have been so successful in the American movie business. "He came from a Big Country, too, and in America's vastness, particularly its vast all-embracingness of sky and plain, he must have seen a reflection of the steppes of his native Ukraine. So the cowboy be-comes a mirror-image of the Cossack: both are primitives and innocents, etched on and dwarfed by a landscape of soul-stirring immensity and rugged masculine beauty. And as an exile himself, Tiomkin would have identified with the cowboys, pioneers and early settlers who people the world of the West. …those like Tiomkin who blazed a trail in Hollywood were actually winning the West all over again."[17] Palmer also tries to explain why Russian music (in the widest sense) was so often used for film scores: "It is as natural for a Russian to think episodically as for a Frenchman to think log-ically. Now episodic thinking is an essential qualification for any film composer."[18]

Tiomkin once observed, "A steppe is a steppe… The problems of the cowboy and the Cossack are very similar. They share a love of nature and a love of animals. Their courage and their philosophical attitudes are similar, and the steppes of Russia are much like the prairies of America."[19]

Especially since he was not trained as a composer, Tiomkin never possessed the technical expertise of Prokofiev or Stravinsky. His genius lay in coming up with themes and finding vivid ways of creating sonic color appropriate to the story and visual image, not in his ability to combine the themes into a complex symphonic structure that could stand on its own.

Tiomkin did not work on feature films set in Russia, with a single exception, the unfortu-nate bio-pic *Tchaikovsky* which he also co-produced in 1971, a Soviet-American project for which he acted more as compiler/arranger/musical director than as composer. For the most part, the scoring of Hollywood features dealing with Russia or the USSR was left to non-Russians, often to composers of German or Austrian background. There were a number of Russian musicians in the studio orchestras, however, and in production positions. Max Rabinowitz, for example, the former pianist for operatic bass Fyodor Chaliapin, settled in LA and made his living by dubbing piano parts for movie scores, and by having his hands photographed in close-up shots for piano-playing scenes.

Probably the most visible and influential of these production people was Constan-tine Bakaleinikoff, who spent his entire adult career as a conductor working in the

[17]
Palmer, Christopher. *The Composer in Hollywood.* London, Mari-on Boyars, 1993, 121.

[18]
Ibid, 127.

[19]
Thomas, Tony. *Music for the Movies* (2nd ed). Los Angeles, Sil-man-James, 1997, 85.

movie business in Los Angeles. Born in Moscow in 1896, he graduated from the Moscow Conservatory in 1916 as a cellist and composer. Like so many other musicians and artists, Bakaleinikoff left the USSR and ended up in California in 1920, where he played the cello briefly in the Los Angeles Philharmonic before being hired by the producer Sid Grauman as musical director for his movie theatres, conducting the orchestra for silent films shown at such palaces as the Egyptian and the legendary Grauman's Chinese Theatre. So familiar was he with movie audiences that they started calling him by the nickname "Backy."

With the advent of sound, he moved to Paramount, where he stayed until 1935, then went to MGM for six years, and finally worked at RKO in the powerful and demanding position of musical director from 1941 to 1957. Bakaleinikoff also composed scores for a number of films. Several of Bakaleinikoff's numerous brothers were also musicians; Misha started out playing double bass in studio orchestras (including the one that recorded Tiomkin's score for *Lost Horizon)* and then served for many years as the musical director at Columbia Studios. Vladimir was a conductor who appeared with the symphony orchestras of Cincinnati and Pittsburgh. Constantine's house in Bouquet Canyon was apparently a gathering place for Russian émigrés, at least according to a complaint made by his wife, the actress Fritzi Ridgway, to the *Los Angeles Examiner* that "whenever he brought friends home… they would exclude her from their conversation by talking entirely in Russian."[20]

Another member of the "Russian mafia" in American music was Vernon Duke. Among many other accomplishments, Duke wrote the score for a popular wartime film version of a Broadway show, *Cabin in the Sky*. That a Russian composer should write the music for one of the first all-black musicals is a peculiar and telling fact, no less intriguing than Tiomkin's central role in creating the sound track for the classic American film western. Known to millions as the American composer of such popular song hits as Autumn in New York, April in Paris, and Taking a Chance on Love (from *Cabin in the Sky*), Duke also had another identity. As Vladimir Dukelsky (his real name), he composed respectable "classical" ballets, symphonies, concerti, sonatas, oratorios, and chamber music. Born in Russia and educated at the Kyiv Conservatory, Dukelsky came to the United States in 1921. For the rest of his life, Dukelsky/Duke led a double creative life, writing "serious" music for such imposing impresarios as Serge Koussevitsky and Sergei Diaghilev with one hand, and collaborating with Ira Gershwin, Bob Hope and the Ziegfeld Follies with the other.

Composers from Russia were not alone in enriching American musical life of the twentieth century. They were joined by a large number of instrumental musicians who came to the United States and settled here, including some of the greatest names in the business. Many of them were Jews who came from Ukraine, part of the Tsarist

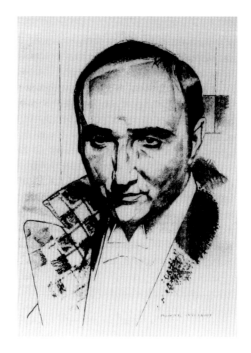

Yury Annenkov. Portrait of Dmitry Tiomkin
Reproduced from: Annenkov Yury.
*Odevaiya kinozvezdu*. Moscow, 2004

[20]
*Two Beatings Charged by Actress*, Los Angeles Examiner, June 1, 1938.

Empire and then part of the USSR until its collapse in 1991. So many were Ukrainians, in fact, that during the heyday of "cultural exchange" between the USSR and the USA in the 1960s and 1970s, a joke used to circulate that the definition of "cultural exchange" was that "they send us their Jewish violinists from Odessa, and we sedt them our Jewish violinists from Odessa." One of those who most liked to tell this joke, in fact, was the super-star violinist Isaac Stern (1920–2001), born in the Ukrainian town of Kremenets.

Stern's parents arrived in San Francisco when he was only ten months old. Although his parents loved music (his mother had studied voice with Glazunov at the St. Petersburg Conservatory) and believed in their son's talent, they did not have the means to pay for his education. Fortunately, Stern so impressed a wealthy San Francisco woman that she paid for his tuition at the San Francisco Conservatory. He studied there with Naoum Blinder, another Russian-Jewish violinist with ties to the rich Moscow-Odessa tradition. Stern's career took off when he became one of Sol Hurok's artists, under the legendary auspices of "S. Hurok Presents." They worked together closely for 35 years, until Hurok's death. Physically diminutive but emotionally expansive, Stern once said that "Playing the violin must be like making love — all or nothing." He was also endlessly enthusiastic about New York, where he lived for decades, and a tireless booster of the American principle of diversity and the melting-pot.

Two years before Stern came to San Francisco in 1920, another Russian violinist, Leopold Auer (actually, Auer was born in Hungary but lived in Russia from 1868 to 1917) arrived in New York, fleeing the chaos following the Russian Revolution. Although he only lived for another 12 years, Auer (1845–1930) taught at Curtis Institute in Philadelphia and exerted an enormous influence on the development of the contemporary school of American violin playing. Nor would a discussion of American violinists from Russia be complete without a mention of two other names: Nathan Milstein (1903–1992), born in Odessa, who came to the United States in the late 1920s, adopted New York as his hometown and became an American citizen in 1942; and Jascha Heifetz (1901–1987), born in Lithuania (when it was part of the Russian Empire), who first played in the United States at Carnegie Hall in 1917, became an American citizen in 1925 and lived for many years in Los Angeles.

One of Heifetz's friends in Los Angeles was the extraordinary cellist Gregor Piatigorsky (1903–1976), who was born in the Ukrainian city of Dnepropetrovsk and came to the United States in 1929, after several years of playing first cello in the Berlin Philharmonic. A fixture of the American musical scene as soloist and ensemble player (Heifetz and Milstein were favored partners), Piatigorsky also trained many of the great American cellists during his many years of teaching at Curtis Institute, the University of Southern California and Tanglewood Music Festival. In the

early 1960s, Piatigorsky made a triumphant return to Moscow (where he studied during World War I) as a member of the jury for the Tchaikovsky Competition.

American pianists from Russia have not been exactly scarce, either. Among the most important is Vladimir Horowitz (1903–1989), born in the Ukrainian town of Berdichev, and considered by many connoisseurs to be the most accomplished interpreter of the music of Chopin, Liszt and Prokofiev who ever lived. Horowitz became an American citizen in 1944, and helped to raise millions of dollars for the War Bond effort during World War II with his benefit performances. Also a pianist but better known as a conductor, Alexander Siloti (1863–1945) worked in the United States beginning in 1922, and eventually became a fixture at the prestigious Juilliard School in New York, where his students included the American composer Marc Blitzstein.

After the 1920s, it became much more difficult for Russian musicians and composers to emigrate freely to the United States. Stalin's strict control of all movement of Soviet citizens outside the country slowed the flow of artists coming to America dramatically. During the lengthy and stagnant Brezhnev era, musicians were often prevented from touring outside the USSR even when they were invited to do so. Beginning in the early 1960s, a few Soviet performing artists took the difficult and dangerous step of defecting from the USSR while on tour in the West. Many of them settled in the United States, where they were received not only as important musicians, but also symbols of American freedom during the Cold War. Pianist Vladimir Ashkenazy, who had already appeared "legally" in the USA under the auspices of S. Hurok Presents, decided in 1963 to remain in England with his English wife. Although Ashkenazy eventually settled in Iceland, he became an important presence in Amer-

**Mikhail Vrubel.** Nadezhda Zabela-Vrubel and Alexander Siloti at the Grand Piano. 1905
Graphite pencil, charcoal and chalk on cardboard
9¹/₄ x 15¹/₂ in. (23.5 x 39.5 cm)
Received in 1925. Gift of the Society of Encouragement of Arts
State Russian Museum

**Natalia Kruglikova.** Portrait of Horowitz. Silhouette. 1923
Black paper mounted on white paper
8¹/₂ x 8¹/₂ in. (21.4 x 21.7 cm)
Received in 1960 from N. S. Soshalskaya
State Russian Museum

ican musical life after leaving the USSR. Even more dramatic was the story of pianist Vladimir Felstman. After he announced his intention to leave the USSR in 1979, he was banned from public performance for eight years and held virtually as a hostage. Only in 1987, as glasnost began to change Soviet cultural policy, was he finally allowed to travel to the United States, where his first highly-publicized concert took place at the White House. Like so many other Russian-American musicians, Feltsman has combined an active performing career with teaching.

In some ways, Feltsman's trajectory from the USSR to the USA followed the pattern set a few years earlier by one of the greatest musicians of the twentieth century, Mstislav Rostropovich (1927–2007). Because of his defense of the dissident writer Alexander Solzhenitysn, who was expelled from the USSR in early 1974, the cellist and conductor Rostropovich found himself blackballed by envious colleagues. In frustration, he asked to be allowed to leave the USSR for two years and the request was granted in spring 1974. In fact, he remained outside Russia until after the collapse of the USSR in 1991. Soon after leaving the USSR, he was invited to play and teach in the United States. In 1977, Rostropovich was appointed as the conductor of the National Symphony Orchestra in Washington, DC, where for seventeen seasons he presided as a powerful symbol of the freedom, strength and diversity of American musical culture.

**Vladimir Feltsman**
Photograph. Reproduced
from: *Roman s samovarom*

Sharon Marie Carnicke,
Ph.D., University of
Southern California

russian actors in

The soil from which American acting grows has been tilled by actors from the Moscow Art Theatre who came to the United States and taught their art. But their acting often proved more difficult to transplant than their teaching. This essay traces the stories of four Russian actors in America in order to shed light on how the art of acting crosses cultural boundaries.

### One American Actor Who Returned to Soviet Russia

The most important voice in actor training during the twentieth century, **Konstantin Stanislavsky** (1863–1938), became an American artist without ever having emigrated. He was born in pre-revolutionary Russia into one of Moscow's wealthiest manufacturing families. He co-founded the Moscow Art Theatre with playwright Vladimir Nemirovich-Danchenko and together they made twentieth century theatre history with revolutionary stagings of Anton Chekhov's major plays. Stanislavsky then saw the Bolshevik Revolution unfold before him, a political force which turned him from a wealthy Russian man into a poor Soviet one. He stepped into American theatrical history shortly thereafter, when he and half the Moscow Art Theatre company toured the United States for twelve months in 1923 and 1924. They gave 380 performances in Manhattan, Brooklyn, Newark, New Haven, Hartford, Chicago, Boston, Cleveland, Detroit, Pittsburgh, and Washington, DC. But, unlike the American artists from Russia in this exhibit, when the tours ended Stanislavsky returned to Soviet Russia, where he died, isolated in his house, surrounded by the waves of terror that Stalin launched on his country.

# american theatre

In the US, Stanislavsky had found enthusiastic audiences and students. Despite the fact that the Moscow actors performed in Russian for English-speaking audiences, they successfully conveyed a full spectrum of human experience through their acting.

They moved spectators to tears of empathy. New York critic Russell McLauchlan called the actors' use of Russian a mere "detail of behavior;" and, he observed, "an inability to understand [proved to be...] no particular bar to comprehension." One actor described catching sight of a young woman, who held a translation of Chekhov's The Three Sisters in one hand and "in the other a handkerchief. She cried, then quickly, quickly wiped away her tears, so that she would not miss a word in the book, then again more tears."[1] Reviewer Kenneth MacGowan saw the actors as "the heart of the Moscow Art Theatre."[2] In a 1924 letter home, Stanislavsky wrote, "In America now, the Moscow Art Theatre is considered an American theatre."[3]

1
Bokhanskaia, Ol'ga Sergeevna. "Iz perepiski s Vl. I. Nemirovich-Danchenko (Evropa i Amerika 1922–1924)," *Ezhegodnik Moskovskogo khudozhestvennogo teatra*: 1943. Moscow: MKhaT, 1945: 539.

2
Ibid, 589.

3
Stanislavskii, K. S. *Sobranie Sochinenii*. Vol IX. Moscow: Iskusstvo, 1999: 154.

In 1965, the master acting teacher, Lee Strasberg echoed Stanislavsky's words, when he welcomed a new generation of Moscow Art Theatre actors to New York by saying, "Many people in America think, that Stanislavsky must be an American. Otherwise how could he have possibly influenced the American theatre to the extent that he has?"[4] Strasberg does not overstate the case. Stanislavsky had indeed become American in the minds of those in the US who adopted him as their mentor.

His impact on American acting has been enormous and long lasting, but not unalloyed. Young American actors and aspiring directors had watched him and his company perform, sensing that the Russian actors were doing something unique that could be learned. In short, the Moscow Art Theatre tours created an avalanche of interest in Stanislavsky's approach to actor training. Beginning in 1923, Americans began to adopt and adapt his Russian System to their own needs and sensibilities; they accentuated his interest in the psychology of emotion and downplayed other interests like his application of Yoga to creative work. Thus, his Russian System became the American Method.[5]
By mid-century, the Americanization of Stanislavsky's ideas was known world-wide through the work of US citizens: star actors (like Stella Adler, Marlon Brando, Dustin Hoffman, and Robert de Niro); innovative stage and film directors (like Harold Clurman, Robert Lewis, Joshua Logan and Elia Kazan); and a brand new kind of master acting teacher (gurus of great authority like Lee Strasberg, Stella Adler, and Sanford Mesiner). Even today, in the twenty-first century, actor training in the US rarely proceeds without reference to Stanislavsky and his American progeny. There is now no easy way to avoid this "American" artist if one wishes to become an actor.

Stanislavsky's return to Moscow, however, did not mean that he had returned home. Russia was a place transformed by revolution. In a 1936 letter to his US translator, Stanislavsky acknowledges how distant he felt from Soviet values. The young people around him, he explains, grew up in difficult circumstances that inculcated in them radically different attitudes from his own. They are, the old man marvels, "actually new people."[6]

These "new people" remade Stanislavsky's ideas in their own image, much as had his American progeny. Marxism demanded emphasis be placed on the actor's material body, not spirit, and that the System be treated as an absolute science, not art, of acting. By mid-century, the Sovietization of the System had turned Stanislavsky into a "canonized and mummified" icon of Socialist Realism. By century's end, young Russian actors and directors emigrated to the US "to escape from the ghost of Stanislavsky," unaware of precisely how important he had become there. Ironically "they could only feed themselves by teaching […] the Stanislavsky System."[7]

During 1923 and 1924, Stanislavsky's letters from the US suggest that he was indeed considering emigration: "He, who has been to America and felt this boundless

[4]
Strasberg, Lee (1956–1969) "The Actors Studio," Sound Recording No. 339A, 1956–1969, Wisconsin Center for Film and Theatre Research, An Archive of the University of Wisconsin, Madison, and the State Historical Society of Wisconsin, Madison. 16 February, 1965.

[5]
Carnicke, Sharon Marie. *Stanislavsky in Focus*. New York: Harwood/Routledge, 1998. Second Edition, October 2008.

[6]
Stanislavskii, K. S. (1999): 656.

[7]
Butova, T. V. *Amerikanskii teatr: proshloe i nastoiashchee*. Moscow: Gosudarstvennii institut isskusstvoznaniia, 1997: 6–7.

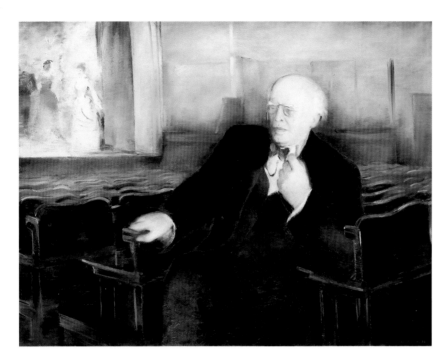

**Peter Williams.** Portrait of Konstantin Stanislavsky. 1933
Oil on canvas. $51^{1}/_{4}$ x 69 in. (130.2 x 175.5 cm)
Received in 1934 via Vsekokhudozhnik
State Russian Museum

expanse, he, who has seen the endless lines of people every day at the box office and these lines do not end he, who has heard the voices and the invitation from the provinces, from hundreds of cities with populations of millions, and many of these are Russian — he will understand that we can do business only in America."[8]

Many Moscow Art Theatre actors certainly felt that they could establish themselves in emigration, and several remained in New York after the tours, among them Maria Ouspenskaya, Vera Solovieva, Lev Bulgakov and his wife Varvara. Why did Stanislavsky not remain with them? Russian theatre scholar Anatoly Mironovich Smeliansky suggests a political reason: the Soviet government may have used his partner Nemirovich-Danchenko and the non-touring members of the company as hostages for Stanislavsky's return.[9] If this likely scenario is true, Stanislavsky's later decision to send his System into emigration is all the more poignant. In 1930, he signed a sweeping agreement with translator and US citizen, Elizabeth Reynolds Hapgood, giving her full legal rights to all his books so that she could publish them in the US.[10] The first volume of his acting manual thus appeared in English as *An Actor Prepares* before its publication in his native language. Without doubt, Stanislavsky's decision to publish abroad represented more than a financial strategy to recover international royalties on his writing; he also sought to protect his System from its appropriation by communist ideologues. Beyond politics, however, Stanislavsky's letters also suggest artistic reasons for his return. He seems to have taken a long, hard look at his protégé Richard Boleslavsky, who had emigrated in 1919 and temporarily rejoined the Moscow Art Theatre during its tours. Boleslavsky had floundered in his émigré career until Stanislavsky gave him permission to speak publicly about the System. In 1923, only eight days after the Moscow Art Theatre opened in New York, Boleslavsky became Stan-

8
Stanislavskii. K. S. (1999): 80.

9
Stanislavskii, K. S. (1999): 50.

10
Theatre Arts Books Archives. Accessed at the offices of Routledge Publishers, New York, in 1989–90.

islavsky's first official English-language spokesperson when he delivered ten public lectures about his mentor's training methods. While the Russian company still performed in the US, Boleslavsky also published the first English-language article on the System in *Theatre Arts Magazine*.

Stanislavsky saw that Boleslavsky was struggling to make ends meet financially, and that his connection with the prestigious Moscow Art Theatre helped him find work in New York. Perhaps giving Boleslavsky permission to speak about the System was Stanislavsky's way of assisting his former student. In a letter home from 1924, Stanislavsky writes that Boleslavsky's temporary return to the Moscow Art Theatre during the tours proved how difficult it was for Russian actors to establish themselves in the West. He called Boleslavsky's US career a cautionary tale for young artists who might consider emigrating.[11] In returning to Moscow, Stanislavsky may have needed the caution himself.

## Three Russian Born Actors Who Remained in America

Compare the experience of three extraordinarily influential actors from the Moscow Art Theatre who honed their art in Russia with Stanislavsky, moved to New York (America's theatre capital), and died in Hollywood where acting is a commodity in the aptly called "film industry."

**Richard Boleslavsky** (1889–1937) was born Boleslaw Ryszard Srzednicki in what had once been Poland. He entered the Moscow Art Theatre School in 1906, one of only three students accepted through audition. Despite his obvious talent, Stanislavsky admitted Boleslavsky for a single probationary year, his future dependent upon his ability to lose his accent and adopt Muscovite Russian. He succeeded so admirably that even his wife did not know that he spoke another language until they were fleeing across the border to Poland with Soviet bullets in literal pursuit of them. Boleslavsky then cried out to the border guards for protection in Polish.[12]

He joined the full Moscow Art Theatre company in 1909, when Stanislavsky was beginning to formulate a System for actors to harness moments of creative inspiration. Boleslavsky's talent and openness to his mentor's new ideas "made him Stanislavsky's pet," according to fellow company members.[13] From 1909 to 1915, Boleslavsky played significant roles in major productions at the Moscow Art Theatre, the two most notable being Laertes in *Hamlet* (guest directed by the formidable British director Gordon Craig) and the tutor Beliaev in Turgenev's *A Month in the Country* (directed by Stanislavsky as a test for his developing System). Boleslavsky was tall, handsome, with a boyish and adventuresome face. Moscow audiences admired his energy and spirit.

[11] Stanislavskii, K. S. (1999): 137.

[12] Roberts, J. W. *Richard Boleslavsky: His Life and Work in the Theatre*. Ann Arbor: UMI Research Press, 1981: 80–1.

[13] Birman, Serafima. *Put' aktrisy*. Moscow: VTO, 1959: 87.

When Stanislavsky decided in 1911 to create an experimental workshop for the further development of his System, he invited his most talented, open-minded actors to join. Boleslavsky immediately became central to this First Studio. He played a range of characters from a German intellectual in Hauptmann's *The Festival of Peace* to the silly Sir Toby in Shakespeare's *Twelfth Night*. He also began directing; his 1913 production of *The Wreck of "The Good Hope"* (by Dutchman Herman Heijermans), became a signature production for the Studio. Just before emigrating from Soviet Russia in 1919, he tapped his Polish roots as well by staging Stowacki's *Balladyna*. Unable to support the Bolshevik revolution, he and his wife fled from Russia using false papers. He worked in Poland for a time. Then, in Prague, he acted and directed for a group of Moscow Art Theatre actors who had been cut off from Russia while on tour by the post-revolutionary civil war. Finally he came to the United States. He arrived in New York with a cabaret evening of songs and skits, *La Revue Russe*, which he had directed and for which he served as "master of ceremonies." Another Russian/American artist featured in this exhibit, Sergei Sudeikin, designed the scenery. The revue had visited Berlin, Madrid, Nice and Paris before arriving in New York in October 1922, where it did not capture an American audience.

**Richard Boleslavsky.** 1921
Photograph. Reproduced from: *Artists Abroad. Golden Book of Emigration. The First Third of the 20th Century.* Encyclopedic dictionary. Moscow, 1997

Boleslavsky waited in New York for the Moscow Art Theatre to arrive, because he had Stanislavsky's invitation to join his former company as assistant and actor for the duration of the tours. Thus, in 1923 and 1924, Boleslavsky rehearsed extras for crowd scenes, adjusted familiar stagings to new theatres, filled in for actors beset by illness, played some of his former roles, and alternated with Stanislavsky as Satin in Maksim Gorky's *The Lower Depths*.[14] When the company left, Boleslavsky never again performed as an actor; he pursued instead directing and teaching.

Following his first public lectures on Stanislavsky's System, Boleslavsky signed a formal agreement with a group of American trustees to establish a New York Theatre and school to promote Russian methods for American actors.[15] History would soon prove that this decision was his most important. At the American Laboratory Theatre (1923–1930), Boleslavsky taught a group of students — directors Lee Strasberg and Harold Clurman, actor Stella Adler, and theatre scholar Francis Fergusson among them — who would remake both Stanislavsky's System and the American Theatre in the coming decades.

Among Boleslavsky's lofty goals was the creation of a theatre that would emulate the ensemble organization of the First Studio. As he wrote in the School's catalogue: "The lot of actors is to be bound by numerous threads of interdependence, ranging from a theatric bond with the humble usher to the highly trained rapport with fellow players. This constitutes the essence of the collective method of education in the art of the Theatre, or what I prefer to call *team work*. In order to get the most harmonious results, a group should be trained collectively."

[14] Roberts (1981): 107.

[15] *Ibid*, 108.

But the commercial environment of New York did little to nourish Russian artistic ideals. For all seven years of its existence, the American Laboratory Theatre struggled against financial ruin. Actors were asked to pay weekly sums to maintain solvency. One backer, Miriam Kimball Stockton, mortgaged her house to save the enterprise. Boleslavsky could survive financially only by splitting his time between the Lab and commercial work on Broadway. He often "ghost directed" plays that were in trouble, becoming especially adept at staging crowd scenes for productions directed by others. His most substantial directing assignments were for two light musicals, *The Vagabond King* (1925) and *Ballyhoo!* (1927).

By 1929, pragmatism had trumped his idealism. The Lab had no production in sight, *The Queen of Sheba*, which he had directed, closed before reaching Broadway, and his two shows on Broadway, a comedy (*Mr. Money Penny*) and a drama (*Judas*), failed to interest audiences. "I got work on Broadway," he sarcastically wrote, "because I like to try myself out in the merciless and boiling conditions of the theatrical game. I like to see if I can fight with my art as well as enjoy it."[16] In a more meditative mood, he said, "Here in America I have learned to live, fight for money, fight for a place in life… But when I think about art, about the present state of art, I inevitably think only of Russia."[17] In search of more lucrative projects, he moved to Hollywood in 1930. He worked first as a screen writer (an ironic job given his poor command of English). After two years, he found an opportunity to direct, when the director of MGM's *Rasputin and the Empress* (1932, starring Ethyl, John and Lionel Barrymore) resigned. While the screenplay romanticizes story of the Russian revolution, Boleslavsky's direction is innovative. He splices in documentary footage to give the acting greater historical context; he displays his ability to craft interesting crowd scenes; and he deftly uses shadows to create strong atmospheres. The film, however, became infamous when Count Usupov, one of Rasputin's actual assassins, sued MGM for libel, objecting particularly to the sexualized portrayal of his wife.[18]

Boleslavsky's subsequent forays in film proved more successful. His direction of Frederic March and Charles Laughton earned *Les Misérables* an Academy Award nomination for best picture in 1935 and one year later Boleslavsky's leading lady in *Theodora Goes Wild*, Irene Dunne, was nominated for best actress. But his now budding career as a film director was cut short by a heart attack. He died just short of his forty-ninth birthday.

**Maria Ouspenskaya** (1887–1949) was born in Tula, Russia. She began her study of acting at the Adashev School, which was founded by a member of the Moscow Art Theatre in 1906 and where many of Stanislavsky's top protégés taught, including Boleslavsky. She joined Stanislavsky's full company in 1909 and like Boleslavsky became a founding member of the First Studio. With a tiny frame and prune-like face,

**Maria Ouspenskaya**
Photograph

[16]
*Ibid*, 210.

[17]
*Ibid*, 220.

[18]
Napley, David. *Rasputin in Hollywood*. London: George Weidenfeld and Nicolson Ltd., 1990.

she distinguished herself as a character actress. She could play small boys and old women equally well. Among her most notable roles in Russia were the allegorical character "The Flu" in Maurice Maeterlinck's *The Bluebird*; the wise, old nurse Marina and the quirky circus performer, Charlotta, in Anton Chekhov's *Uncle Vanya* and *The Cherry Orchard*. As a member of the First Studio, she worked closely in productions with Boleslavsky, including *Balladyna*.

She was one of the Moscow actors, who brought tears to the eyes of American audiences in 1923 and 1924. Unlike Stanislavsky, she did not see Boleslavsky's emigration as cautionary; rather, she joined him. Ouspenskaya began to teach at the American Laboratory Theatre in 1924, while still performing with the touring Moscow Art Theatre. When Stanislavsky and the company left, she remained in New York. With Boleslavsky often busy with other more commercial projects, she became essential to the Lab. Boleslavsky may have set the school's tone and artistic goals through his lectures, but she taught the practical techniques of acting day after day. Without her, the Lab would never have lasted for seven years.

While on-line biographical sketches speak of her work on Broadway, her only documented role was in a 1924 vaudeville by Stark Young (best known today for his translations of Anton Chekhov's plays). She learned, as had Boleslavsky, that surviving as a theatre artist without commercial work was difficult at best. Given that teaching was her primary occupation, she struggled financially even more than he. She thus moved in with Boleslavsky and his wife for years at a time, an uncomfortable living situation made worse by her dangerous propensity to smoke in bed.[19]

Her teaching marked her impact on American theatre. In 1929, she left the Lab to open her own School of Dramatic Art. In 1932, when her School, like the Lab, faltered economically, she moved to Hollywood where she combined teaching with film acting. She became known as a brilliant, but intensely demanding task-master, sometimes evoking tears in her students and sometimes sipping gin, masked as water, during class. No doubt, she, not Stanislavsky, was the model for a generation of American gurus, like her student Strasberg, who could inspire fear as readily as art in their students.

In Hollywood, she supplemented her income by playing supporting and character roles in dozens of films. She gave several notable performances in the last decade of her life, winning Academy Award nominations for her wily matriarch, the Baroness von Oberdorf, in *Dodsworth* (1936) and an aging, sentimental French mother in *Love Affair* (1939). Her strong accent, however, usually limited her to stereotypical foreign characters. For example, she played the Russian ballet mistress in *Dance Girl Dance* (1941, starring Lucille Ball) and the fortune-telling Gypsy Maleva in the *Wolfman* films (1941 and 1943). Her screen performances suggest her strengths as an actress, even when the film itself is

[19]
Roberts (1981): 120.

93

uneven. Her work is always simple, direct and unadorned, but carefully crafted through expressive details. Perhaps this is so because she stubbornly refused to forget what she had learned from Stanislavsky, that acting can be an art of great depth. As she once told a reporter, "Before I went to Hollywood, people told me there was a different technique out there. I didn't believe them, and now after having been out there, I still don't believe them. An actor is an artist, and he would use the same technique anywhere."[20] She died all too predictably after setting her bed on fire with a cigarette.

**Michael Chekhov** (1891–1955) — Mikhail in Russian — was born in St. Petersburg into an artistic family: his uncle, Anton, was the famous playwright and his aunt, Olga Knipper, a famous actress at the Moscow Art Theatre. The young Chekhov chose between cartoon art and acting, both of which benefited from his keen sense of the ridiculous. He decided on acting and in 1907 enrolled at St. Petersburg's Suvorin School, where, by negative example, he decided that actors should develop their own individualities as artists. In 1912, at the prompting of his aunt, he auditioned for Stanislavsky, who immediately saw in him a rare talent. Chekhov thus joined both the Moscow Art Theatre company (where he first appeared as an extra in Craig's *Hamlet*) and Stanislavsky's First Studio. In the younger troupe, he became an actor known for his deep creativity and an uncanny ability for self-transformation in a variety of radically different roles. Among his most notable performances were the mentally-handicapped fisherman, Kobe, in Boleslavsky's 1913 production of *The Wreck of "The Good Hope"* and the toymaker Caleb in a dramatic adaptation of Dickens' *Cricket on the Hearth*.

His personal past, however, came to haunt him. His father had been an intellectually brilliant man, but also an alcoholic, who left his son a legacy of mental instability and alcoholism. Starting in 1916, Michael Chekhov began to display self-destructive behavior that interfered with his performing career: he would upstage fellow actors with overly silly improvisations; he would return home inexplicably in the middle of performances; or fearing to leave home, he would not show up at the theatre at all. By 1918, he suffered a mental breakdown. One way he cured himself was through teaching at his home. When he returned to the stage in 1921, he suspended classes.[21] Another cure came through the spiritual teachings of Rudolf Steiner's Anthroposophy, which would be banned by the Soviet government in 1926. Chekhov tells us that Stanislavsky had been teaching Yoga at the First Studio as part of his System, and its study had prompted the curious young actor to read more widely in the occult. For Chekhov, Steiner brought Eastern spirituality into alignment with Christianity.[22]

When Chekhov returned to the stage, he created his two most brilliant and dynamic performances, Strindberg's melancholy *Eric XIV* (1921) and Gogol's arch con-artist Khlestakov in *The Inspector General* (also 1921). Through these performances, he

[20] Ouspenskaya, Maria. *Clippings*. The New York Public Library for the Performing Arts.

[21] Knebel', M. O. *Vsia zhizn'*. Moscow: VTO, 1967.

[22] Chekhov, M. A. *Literaturnoe nasledie*. Vol. I. Moscow: Iskusstvo, 1995: 152–157.

became widely known for his striking ability to improvise every night within the set limits of a fully rehearsed play. In 1922, he became the Artistic Director of the First Studio and oversaw its transformation into an independent theatre, the Second Moscow Art Theatre. During his last year in Russia, he directed and starred in Shakespeare's *Hamlet*. He staged Hamlet's ghost as a spiritually disembodied voice, a choice that disturbed Soviet authorities. This spiritualized production together with his Anthroposophy made Chekhov into an enemy of the Soviet people; he fled his native land in 1928 when he learned that an arrest warrant had been prepared for him.

**Michael Chekhov.** Circa 1928
Photograph. Reproduced from: Chekhov M.
*Literaturnoe nasledie.* Vol. 1. Moscow. 1986

Life in emigration brought Chekhov only short periods of calm. From 1928, he acted and directed in a number of different countries and in a number of different acquired languages. He worked in Germany with Max Reinhardt, in France, Latvia, and Lithuania. As he travelled, he also taught, leaving behind him students who blossomed into artists in their own right. In 1935, he visited New York with a group of Russian émigré actors whom he had organized into the Moscow Art Players. There his work inspired a wealthy American family, the Elmhirsts, to sponsor him at their arts colony, Dartington Hall, in England. For three years (1935–1938), he found an artistic home where he could develop his ideas as a theatre director and teacher of acting. His unique artistic voice stressed the development of imagination and the relationship between the physical and psychological in performance. War interrupted this home, however; the Elmhirsts moved him and his school to Ridgefield, Connecticut (near New York), where he continued to teach from 1938 to 1942. Thus, the United States became his last home.

Like his fellow expatriates, he first tried to establish himself in New York and then moved to Hollywood. In 1939, he had directed an adaptation of Dostoevsky's novel *The Possessed* on Broadway, but its Russian themes did not capture the American imagination. Resettling in Hollywood in 1943, he, like Ouspenskaya before him, combined teaching and film acting. In twelve years he played supporting roles in nine films. Like Ouspenskaya, however, his thick accent limited his opportunities to stereotypical roles. For example, in *Spectre of the Rose* (1946) he plays a silly, but idealistic Russian ballet impresario. In two performances we find sparks that suggest his former fire as an actor. He earned an Academy Award nomination for the role of Dr. Alex Brulov in Alfred Hitchcock's *Spellbound* (1945); his improvisatory skill is revealed through his controlled handing of a drugged glass of milk offered to a dangerous patient (Gregory Peck) as against the comic scattering of matches when Brulov is flustered by his young protégé (Ingrid Bergman). In *Rhapsody* (1954, starring Elizabeth Taylor), he appears in a single, but crucial scene as the intuitive Professor Shulman, who immediately understands that his student's love of music masks her deeper love for a musician. He died of a heart attack in 1955 leaving behind a generation of loving and grateful students, who have carried on with his teaching.

Chekhov bemoaned the substitution of entertainment for art in the US, even as he developed short cuts to acting that eased his students into the hurried work that film demanded of them. To his friend, the visual artist and set designer Mstislav Dobuzhinsky, Chekhov wrote: "My work here [in Hollywood], I admit, does not satisfy me artistically. [...] How *deeply* I hate what they call theatre and what they call actors here. [...] Oh, what an awful, non-artistic, cruel and talentless little town this is!"[23]

## Acting in Emigration

If Stanislavsky had looked to Boleslavsky's life in the West as a cautionary tale, what more can we learn about actors who emigrate by looking to the careers of Ouspenskaya and Chekhov as well? All three established themselves as major voices in American actor training, but all three also found it difficult to practice their art at the same level that they had in Russia. Their commonality of experience exposes two aspects of acting as a unique form of art.

First, acting is an art that is inextricably tied to the actor's body and voice. The actor's canvas is the self, making it sometimes difficult to tell where art and artist part company. Actors use all of themselves — from head to toe, body and soul — to make their art. In this regard, one special "detail of behavior," a person's native language, makes crossing borders tough on actors. While audiences made allowances for the Russian-speaking actors who toured in the 1920s, they were not as forgiving to the same actors who remained behind and now spoke English with Russian accents.

Second, theatre is made through close collaboration with others: acting partners, playwrights, directors, designers, computer graphics specialists, stage hands, dressers, theatre managers, etc. A role performed alone in one's living room leaves nothing behind for later discovery by art historians. Actors need others to make their art visible. Yet, different cultures create entirely different organizational structures for theatrical collaboration. In this regard, actors who cross borders often find social and economic structures of work that bear little resemblance to theatrical organizations in their native lands. For the Russians, the business of acting in the US resembled little the ensembles which had nurtured them. Stanislavsky was keenly aware of both these artistic hurdles when he toured the United States. No doubt, his decision to return to Moscow took account of them.

First, he understood that performing for American audiences, who generously listened, without understanding, to the language that served him and his actors as their natural medium was one thing; but mastering English and wielding it as powerfully as his native Russian would be quite another. Accent reduction becomes crucial whenever an actor moves from one culture to another. Stanislavsky had made Boleslavsky's future with the Moscow Art Theatre explicitly dependent upon his ability to lose an accent. At age 17, Boleslavsky could comply. At 30, however, when he

23
Byckling, Liisa. Pis'ma Mikhaila Chekhova Mstislavu Dobuzhinskomu (gody emigratsii, 1938–1951). Helsinki: Slavica Helsingiensia 10, 1992: 72, 75, 77.

moved to the US, losing his accent proved impossible. An American student remembered that, "His English was pretty terrible, but he would act out whatever he wanted to say […]. He would act out almost everything he talked about."[24] While Boleslavsky replaced his ambitions as an actor with directing, Ouspenskaya and Chekhov found their opportunities as actors limited by their speech patterns.

Second, Stanislavsky saw how the commercial structure of theatre in the US had put special strain on him and his actors during their tours. They were exhausted and often ill from the unusually heavy schedule of presenting the same play eight times each week (as against the Russian repertory system that presents different plays during a single week, affording actors a varied slate of performances). Union pay scales and US taxes drained all their profits. The Moscow Art Theatre left America, having earned only artistic praise and influence. A refrain of despair pervades Stanislavsky's letters from the US. "I am losing what remains of my health. My spirits are low. I'm depressed, I've almost lost heart, and at times, I think of giving it all up."[25]

Closer comparison of the ways in which the Russian and American theatrical systems differ sheds even more light on the experience of émigré actors. In Soviet Russia, young people vied for places in the prestigious theatrical institutes, where they learned to act in rigorous and disciplined training programs. Theatre directors would then choose new members for their repertory companies from among the graduates. Professional actors spent their lives in theatrical ensembles, collaborating with teams they came to know as deeply as their families. Such a system encouraged both actors and audiences to view acting as a legitimate art.

In the US, people can audition for comprehensive training programs, but they can also opt for whatever classes in private acting schools attract them. This culture of training made it relatively easy for Russian actors to open schools of their own. But, beyond training, the business of acting in the US is complex. Actors audition for specific projects, rarely for repertory companies. Thus, American actors constantly collaborate with new people, who may or may not share their artistic training and values; it is an extraordinary luxury to find oneself working with the same like-minded artists regularly. Moreover, getting an audition involves dealing with a layer of bureaucracy which includes agents (both commercial and theatrical), personal managers, casting directors, and union representatives from AEA (Actors' Equity Association for stage), SAG (The Screen Actors Guild for film), and AFTRA (The American Federation for Television and Radio Artists), who authorize agents and auditions for their members. The business of acting can puzzle Americans just as much as it mystifies émigré artists.

No wonder so many Russian actors — Boleslavsky, Ouspenkaya, and Chekhov among them — longed to re-create the repertory system they knew in their native land! Bo-

[24]
Roberts (1981): 149.

[25]
Benedetti, Jean. *Stanislavski: A Biography*. New York: Routledge, 1990: 278.

leslavsky's artistic ensemble at the American Laboratory Theatre inspired Americans, too, to seek a better way to make theatrical art. His students (Lee Strasberg, Harold Clurman, Stella Adler and others) eagerly founded the Group Theatre in the 1930s, only to face the same economic difficulties that their parent organization had encountered before them. Over and over again, idealistic actors (Russians and Americans) create short-lived repertory companies (like Theatre in Action founded during the 1980s in New York by two émigrés, Lev Shekhtman and Albert Makhtsier, for American actors).

In the late 1940s, when former members of the Group Theatre again sought to create a Russian-style theatrical home, they benefited from their earlier experience, now envisioning the Actors Studio as a special club where life-time members could hone their craft and discuss their careers, as they struggled to find agents and roles elsewhere. Unlike Stanislavsky's Moscow Art Theatre and First Studio, unlike Boleslavsky's American Laboratory Theatre and his students' Group Theatre, and unlike companies akin to Theatre in Action, the still successful Actors Studio abjures commercial production and depends instead upon fund-raising.

As I prepared this essay, I thought about the many émigré Russian actors whom I had met over the course of my own career. By looking hard at their work in emigration, I see them grappling with the same two hurdles described above.

Regarding language acquisition, some planned careers as directors even before they emigrated. Others, who had played a broad range of characters in Russia, were typecast in the US by virtue of their accents as cabbies, waiters, janitors, suspicious foreigners, and villains. Like Boleslavsky, Ouspenskaya and Chekhov before them, most find teaching more rewarding than such acting. Even so, as Albert Makhtsier reminded me, they generally teach in private classes that are far different from the comprehensive curricula from which they learned to act.[26]

Regarding the business of the art, many are frustrated by the circularity of union rules that allow only members to audition for high profile productions, while accepting for membership only those who have secured roles in such productions. Of course, émigré actors share this frustration with Americans, who also seek to become actors under the same puzzling conditions; but for the professionally trained actors who had once been well-known in their homeland and who are now barred from auditioning for roles well within their talents, the frustration can run especially deep. Edward Rozinsky, a specialist in stage movement who emigrated in the 1979, explained to me that "the main problem, in my opinion, is the artistic shock that many Russian actors experience once they are introduced to the routine in American theatre." He gave, as example, the unquestioned authority given to directors over all aspects of productions. "With all the authoritarianism of the Soviet society, the actors were allowed

[26] Makhtsier, Albert. Telephone conversation with author. Los Angeles, 6 Feb. 2008.

[27] Rozinsky, Edward. Email to author. 30 Jan. 2008.

to present their own point of view on the play, and on the way the play should be produced, and a polite discussion, even an argument, was the norm in the relationship between Russian director and actors." Echoing Boleslavsky's and Chekhov's words cited above, Rozinsky concludes that, "The initiative, the creativity, and finally the inspiration are soon gone."[27]

Of course, there are actors who cross boundaries successfully. They are perhaps the lucky few. The majority, however, teach us that acting is, at base, a most fragile, linguistically dependent, and collective art form that we, actors and audiences alike, must treasure.

Beth Holmgren,
Ph.D., Duke University

# settling for the real hollywood:

In December 1926 Vladimir Nemirovich-Danchenko, the co-founder with Konstantin Stanislavsky of the famed Moscow Art Theatre, pitched an expensive proposition to Joseph Schenck, then President of United Artists. Nemirovich-Danchenko (1858–1943) insisted that "a Russian studio be established" in Hollywood, one that at least initially would employ the "talented Russian artists" relocated in America and would teach the Americans how to go about their business.[1]

September of that year the Russian director and his secretary/translator Sergei Bertenson had been United Artists' honored and neglected guests, contracted by the Russian-born Schenck to create screenplays and films and "do whatever [they] wanted."[2] Unfortunately, what Nemirovich-Danchenko wanted — a studio filled with Russian talent, film projects ranging from an adaptation of a Russian fairy tale to a film version of Dostoevsky's *The Gambler* — was not at all what his American host studio had in mind. The eminent director, accustomed to cultural reverence and eager acolytes in his homeland, left Hollywood one year later, thoroughly frustrated, still confused about what he had been invited to accomplish, and with no credit to his name.

Nemirovich-Danchenko's avid courtship and then quick fall into disregard at United Artists illustrates a recurring cultural misunderstanding between studio-era Hollywood and the great Russian artists it attracted as the new world capital of film, the exciting frontier for film technology.[3] In the late 1920s and early 1930s, even as the studio system was hardening in place, a succession of Russian luminaries temporarily went Hollywood — including the filmmaker Sergei Eisenstein (1898–1948),

# russians in studio-era american film

the choreographer of Diaghilev's *Ballets Russes* Michel Fokine (1880–1942), and the writer Boris Pil'niak (1894–1937?).[4] All were disenchanted and defeated by Hollywood's seemingly omnipotent commercialism, its assembly-line mode and tempo of film production, and its reliance on market-driven conventions of genre, storyline, and character types. Nemirovich-Danchenko founded no studio, Eisenstein made no Hollywood picture, Pil'niak abandoned all attempts to write a screenplay, and Fokine languished without work.

Yet it would be a mistake to read their stories of Russian high art defeated by American business as the whole truth. The misunderstanding between Russians and Americans in Hollywood was complicated by very different cultural contexts and paved with good intentions on both sides. Moreover, the Russians who remained in Hollywood actively contributed to the system that commodified them and, in subtle ways, influenced that system in onscreen and offscreen supporting roles. These lesser-known

[1]
S. L. Bertenson, *V Gollivude s V. I. Nemirovichem-Danchenko (1926–1927)* ed. K. Arenskii (Monterey, CA: K. Arensburger, 1964): 68.

[2]
*Ibid.*, 3–4. Bertenson kept a copious record of his and Nemirovich-Danchenko's joint Hollywood experience. Ironically, giving his antipathy to the American film industry, Bertenson spent the rest of his life working there after the great director's departure.

[3]
As Harlow Robinson points out in his richly informative *Russians in Hollywood, Hollywood's Russians: The Biography of an Image* (Boston, Hanover, NH & London: Northeastern University Press and University Press of New England, 2007), Nemirovich-Danchenko was "the first of several prominent Soviet film and theatre people" to experience this treatment (37).

[4]
For more on Eisenstein and Pil'niak's visits, see Robinson (2007): 45–51. 51–58.

émigrés' experience reflects a fascinating double acculturation — on the one hand, how ethnicity was exported to and then processed in American popular culture and, on the other, how Hollywood indelibly conditioned and incorporated its own.

## The Hollywood Factory and High Culture Dreams

The Russians who settled and worked in studio-era Hollywood were not in the main high profile imports. Most arrived in the wake of the Bolshevik Revolution and civil war in the early-to-mid 1920s, although some went to California a few years before, and others made the journey incrementally, as "reémigrés" first from Europe and then from the theatres of New York.[5] This small stream of talent from Russia began with the arrival in 1917 of Alla Nazimova (1879–1945), a minor Moscow Art Theatre player who flourished as the first "foreign sexual sophisticate" on the American silent screen; broadened in the 1920s to include directors Richard Boleslavsky (1889–1937) and Rouben Mamoulian (1897–1987) and such players as Akim Tamiroff (1899–1972), Maria Ouspenskaya (1876–1949), Olga Baclanova (1896–1974), and Mischa Auer (1905–1967); and concluded before the Second World War with the arrival of actors Michael Chekhov (1891–1955) and Anna Sten (1908–1993) and director Anatole Litvak (1902–1974).[6]

Most of the émigrés living and working in Hollywood were neither dramatically dispossessed aristocrats nor former stars of the Moscow Art Theatre, whomever they expediently advertised themselves to be to impress their Hollywood employers.[7] Yet to a great extent, both the émigrés and their visiting compatriots shared certain national notions of what it was to be cultured and to create serious art. In his intriguing 1934 sociological study of 1500 Russian émigrés settled in Hollywood, George Martin Day insists that "[e]very Russian of the Hollywood colony who pretends to any culture whatever has been reared on the great operas of Russia, upon the drama presented in both the state theatres and particularly in the private Moscow Art Theatre; he is saturated with his own literature, knows the masterpieces of art and painting at the Tretyakov Gallery and Hermitage, and has reveled in the great ballet performances given in the theatres of the chief cities of Russia. All of this is the warp and woof of the cultural life of the Hollywood Russians."[8]

Interwar Hollywood was destined to disappoint them. Tracing the piecemeal "infiltration" of motion pictures into this one-time "paradise for retired Iowan farmers," film historian Kevin Brownlow characterizes Hollywood as a typical American provincial backwater, lacking art galleries, concert halls, "proper theatres and museums," and all "those links with the past that give stability to the present." "Europeans," he specifies, "could find no point of reference, and they were made uneasy by the all-pervading

[5]
In "Russkie v Amerike (kinoemigratsiia pervoi volny)," *Kinovedcheskie zapiski* 43 (1999), Natal'ia Nusinova outlines the small sequential waves of émigrés into Hollywood from the early 1900s until the beginning of the 1940s, when Russian Jewish actors were fleeing a war-torn Europe (174–75).

[6]
On the successful beginning of Nazimova's career, see Gavin Lambert, *Nazimova: A Biography* (New York: Alfred A. Knopf, 1997): 210. On the "stage-managed" arrival of Litvak to Hollywood in 1936, see John Russell Taylor, *Strangers in Paradise: The Hollywood Émigrés, 1933–1950* (New York: Holt, Rinehart, and Winston, 1983).

[7]
In "Russkie v Gollivude/Gollivud o Rossii," *Novoe literaturnoe obozrenie*, 54 (2002), Olga Matich notes the widespread phenomenon of the "pretender" in Hollywood — among the émigrés who dreamed up aristocratic or high military pedigrees to improve their professional lot and among other industry newcomers who transformed themselves into "exotic" Russians as proof of their artistic talent (408–410). One famed example of the latter: the transformation of Winifred Shaughnessy from Salt Lake City into Natacha Rambova, a set designer and one of the wives of Rudolf Valentino (see Lambert (1997): 233–44, 247.

[8]
George Martin Day, *The Russians in Hollywood: A Study in Culture Conflict* (Los Angeles: University of Southern California Press, 1934): 35. Day's own Russian experience included "eight years' sojourn in Russia prior to and during the war," where he spent two years as a student at the University of Saint Petersburg.

settling for the
real hollywood:
russians in studio-era
american film

atmosphere of impermanence. It was a cultural vacuum."[9] Moreover, in its early decades, the film industry in Hollywood was indiscriminate and voracious in developing material and recruiting personnel. Scripts were culled from every imaginable source — serious literature as well as pulp romances, dime novels, time-tested melodramas, and vaudeville revues.[10] Directors often trained on the job, and screen actors required neither high culture pedigree nor professional schooling, breaking into the movies from the legitimate stage, vaudeville, the music hall, and studio modeling.[11] Some theatrical stars such as the Barrymores risked the less prestigious venue of the screen, but most successful film actors had much more modest performing credentials and minimal education. Silent screen leading ladies Norma Talmadge and Gloria Swanson stepped directly from modeling into film when they were in their teens.[12] Even Mary Pickford, who together with Charlie Chaplin and her husband Douglas Fairbanks invented the phenomenon of a Hollywood aristocracy, had forfeited her education to support her family as a child actor and, once she had become a star, relied on her friend, screenwriter Frances Marion, to "read to her [in private] without fear of being condescended to or judged."[13]

In a sense, the high-profile Russian visitors demonstrated the first stage of most Russians' culture shock in America. They did not understand or appreciate Hollywood's dizzying emergence from American popular entertainment — its exuberant and makeshift experimentation, the cultural insecurity underlying its risk-taking, its obsession with pleasing rather than uplifting the masses. In this, they radically differed from the Jewish, Russian-born producers who had emigrated before the Revolution and became entrenched as the thoroughly Americanized moguls of studio-era Hollywood — men such as Louis B. Mayer, Samuel Goldwyn, and even Joseph Schenck, who "worked himself up from being a messenger boy to co-owner with his brother, Nick, of the Palisades Amusement Park and an investor in Loew's musical theatres."[14] The visiting Russians never had to cope with market supply and demand and mass consumer tastes. Their solipsism was encouraged, at least at the outset, by Hollywood's omnivorous appetite for talent (what director Fritz Lang dubbed "trophy hunting") and abetted by a few local artists and intermediaries with high culture ambition.[15] After the Revolution, Russian artists — particularly performing artists — were attracting admirers and students the world over. When the Moscow Art Theatre twice toured the United States in the mid-1920s and Pickford and Fairbanks experienced Russian theatre firsthand on their 1926 trip to Moscow, Hollywood became temporarily infatuated with Russian talent.[16] The fervent welcome the Moscow Art Theatre actors received on tour persuaded some to remain in the United States, where they followed the well-worn path from New York to California.

The delusions of Nemirovich-Danchenko and Eisenstein about a finer future Hollywood were reinforced by their contacts with similarly ambitious American "aristo-

**Anna Sten**. Photograph. Reproduced from: Vasil'ev A.
*Krasota v izgnanii: tvorchestvo russkih emigrantov.*
Moscow, 2005

9
Kevin Brownlow, *The Parade's Gone By...* (New York: Alfred A. Knopf, 1968): 38.

10
Thomas Schatz, *Hollywood Genres: Formulas, Filmmaking, and the Studio System* (Philadelphia: Temple University Press, 1981): 5.

11
Brownlow observes that "[s]ilent-film directors were mostly young men,... and came from every conceivable background" (1968): 67. In *An Evening's Entertainment: The Age of the Silent Feature Picture, 1915–1928* (New York, Toronto: Charles Scribner's Sons, 1990), Richard Koszarski describes the "chaotic state" of recruiting and training new personnel, and notes that "[r]elying on the theatre as a model had limited application" for acting onscreen (95).

12
Koszarski (1990): 263, 285, 295.

13
Cari Beauchamp, *Without Lying Down: Frances Marion and the Powerful Women of Early Hollywood* (New York: Scribner, 1997): 81; see also 33.

14
*Ibid.*, 135. For more on these thoroughly Americanized Russian Jewish producers, see Neal Gabler, *An Empire of Their Own: How the Jews Invented Hollywood* (New York: Crown, 1988).

15
Taylor attributes this term to Lang in *Strangers in Paradise* (1983): 56.

16
See Robinson (2007) on the Moscow Art Theatre's high-grossing 1923 tour. In the introduction to his edited anthology, *Wandering Stars: Russian Émigré Theatre, 1905–1940* (Iowa City: University of Iowa Press, 1992), Laurence Senelick remarks that "the Moscow Art Theatre's long-standing and well-advertised aesthetic program and artistic principles won respect for it wherever it performed" (xx)... See in the same volume Anatoly Smeliansky, "In Search of El Dorado: America in the Fate of the Moscow Art Theatre" (44–68).

crat stars." Eisenstein and his entourage, the future filmmaker Grigorii Aleksandrov and cameraman Eduard Tissé, were inspired by the example of Charlie Chaplin, who served as their volunteer guide and boon companion.[17] Chaplin was one of the very few stars who had achieved artistic independence through his consistent box office appeal. He had earned Hollywood's greatest luxury — time — to polish his art and produce a picture every two or three years, working, as Aleksandrov remembered, only when he was inspired and always respecting, rather than pandering to, his audience.[18]

According to Bertenson, Nemirovich-Danchenko felt buoyed up by the real talent and artistic respect he discovered in Mary Pickford, Lillian Gish, and John Barrymore, and he contemplated screenplays that would showcase their art. Yet he failed to grasp the specifics of Hollywood acting and production — the special onscreen qualities that distinguished a film star from an accomplished actor, or the prerequisite conventions of a surviving hero and a happy end in a Hollywood screenplay.[19] It was the mercurial Barrymore, the actor Nemirovich-Danchenko most admired and relied upon in vain to help him with his "reforms," who finally educated him about the contingent price of quality in Hollywood. As the American explained to the Russian, a star's creative control depended on whether or not his next picture was a hit.[20]

Despite the promise they sometimes glimpsed, these Russian visitors inevitably confronted and rejected the system that Russian settlers in Hollywood necessarily accepted and variously managed to exploit. The American film industry's mass production and market sensibility would not be revolutionized by the Russians' creative ideas and professional methods, their impetus to educate and civilize rather than to entertain.[21] Director-pedagogues and dictatorial artist-visionaries simply could not fit into Hollywood's studio system, where studio heads or designated producers decided on a massive output of product and ruled over a vast stable of talent, inclusive of directors, actors, designers, composers, cameramen, and other technicians.[22] Bertenson sums up the irrelevance of the would-be Russian reformers as he observes a dispirited Fokine in 1929: "And here it turns out that no one needs or is interested in him…he is living the same tragedy that all great artists suffer in Hollywood: there's nothing for them to do."[23]

### Romance and Revolution: Hollywood Russianness

While the grand plans of the reformers came to naught, the recent events of the Russian revolution, the influx of postrevolutionary Russian émigrés and their culture into Hollywood, and the worldwide circulation of Russian talent (be these Soviet exports or permanently touring expatriates) fed a vogue for Russian subjects in interwar European and American film.[24] In her comparative study of French, German, and Ameri-

[17]
G. V. Aleksandrov, *Epokha i kino* (Moscow: Izdatel'stvo politicheskoi literatury, 1976): 125, 130–33; S. M. Eisenstein & Richard Taylor, ed. *Beyond the Stars: The Memoirs of Sergei Eisenstein*, trans. William Powell (London: BFI Publishing, 1995): 33

[18]
Aleksandrov (1976): 134, 132.3.

[19]
Bertenson (1964): 26, 32.

[20]
*Ibid.*, 12, 15, 23, 54–55, 61, 87–88. On the rocky relationship between Barrymore and the Russian director, see also Robinson (2007): 35–39. Robinson argues that the 1928 *Tempest*, starring Barrymore as a poor Russian dragoon who saves a princess after the revolution, reflects, but of course does not acknowledge, Nemirovich-Danchenko's input.

[21]
Senelick (1992) notes the Russian theatre's "civilizing function" (xvi).

[22]
Schatz (1981): 4; Koszarski (1990): 109–110.

[23]
K. Arenskii, *Pis'ma v Gollivud. Po materialam arkhiva S. L. Bertensona* (Monterey, CA: K. Arensburger, 1968): 58.

[24]
Matich (2002): 404.

settling for the
real hollywood:
russians in studio-era
american film

can interpretations of this vogue, Oksana Bulgakowa shows how Hollywood productions "disconnected the Russian stereotype from [the] modernism, perversity, and morbid, decadent exoticism" accentuated in European film and "mainly adapted Russianness to their own genres and narrative paradigms."[25] The Russian vogue in Hollywood played out in romantic mésalliances between peasants and aristocrats, monarchists and revolutionaries, and on sets stocked with stereotypical Russian props and types (vodka, samovars, troikas, long Russian beards, wild folk dances, devilish gypsies, agile Cossacks), all of which were projected against the dramatic backdrop of the Revolution.[26] The tragic fate of the Romanoff family and the mesmerizing villainy of Rasputin also recurred as promising subjects for Hollywood films; Hollywood's early love affair with foreign royalty readily extended to Russia's fallen or dispossessed aristocrats.[27] In general, Hollywood screenplays mined the Revolution's class warfare (all those riches-to-rags and rags-to-Communist-power stories) for romance rather than tragedy or social critique, recasting the Revolution as a democratizing "battle of the sexes."[28]

In their avid quest for material, the studios also tried out assorted film adaptations of Lev Tolstoy's works, including three variants of *Anna Karenina*, with Greta Garbo starring as the suffering heroine in the silent 1927 and talking 1935 adaptations; two versions of *The Living Corpse* (1915, 1930); two versions of *Resurrection* (the second 1934 film was titled *We Live Again*); and a highly flawed, yet visually spectacular adaptation of *The Cossacks* (1928).[29] These adaptations perhaps best demonstrate how Hollywood processed Russianness to suit its own market-oriented terms. For example, the first Hollywood version of *Anna Karenina* (1927), produced by Metro-Goldwyn-Mayer and retitled *Love* to ensure its mass appeal, was scripted by Frances Marion, a highly experienced screenwriter who was pained by, but proficient in, making the ludicrous compromises the studio demanded for the film adaptation of a classic.[30] Marion had to bear in mind, as she had learned since her early days producing screenplays for Pickford, that her script was to function as an effective star vehicle, in this case for the popular real-life romantic pair of Garbo and John Gilbert. She accordingly stripped down Tolstoy's complex plot and character relations to a love story tailormade for the Garbo-Gilbert chemistry. Marion also complied when MGM ordered her to dream up a "happy ending" for a second variant of film that was to be distributed on the provincial moviehouse circuit.[31] For one set of American moviegoers, Anna Karenina never threw herself under that train, but was eventually reunited with her lover through her son.

Up until World War II, when the Soviet-American alliance required that a different sort of untruth be screened about our Russian ally, Hollywood continued to process this sort of Russianness for American moviegoers, albeit in romantic comedies and even musicals during the 1930s. In some instances, most notably Ernest Lubitsch's

25
Oksana Bulgakowa, "The 'Russian Vogue' in Europe and Hollywood," *Russian Review*, 64 (April 2005): 228, 213.

26
*Ibid.*, 406; Nusinova, 178–79.

27
Robinson (2007): 25. Brownlow (1968): 34.

28
Bulgakowa (2005): 233.

29
Bulgakowa (2005) notes Hollywood's strong preference for Tolstoy's work over Dostoevsky's (215).

30
Beauchamp (1997) describes this painful experience as well as the ignorance of Marion's supervisor at MGM, who misidentified Tolstoy as an inept writer "from our stable" (215).

31
*Ibid.*, 216. Bertenson (1964) provides a caustic paraphrase of *Love*'s bowdlerized script (162).

**A still from the movie *The Cossacks*.** 1928
Photograph
Collection of Mike Protzenko
The author thanks Mr. Protzenko for his
generous permission to reproduce this photo.

1939 comedy *Ninotchka*, the resulting film provided fine entertainment and elicited deft performances from its stars (Garbo again — Hollywood's favorite "Russian" leading lady — and Melvyn Douglas). Such movies as *Ninotchka*, Anatole Litvak's *Tovarich* (1937), Reinhold Schünzel's *Balalaika* (1939), and King Vidor's *Comrade X* (1940) usually featured a romantic mésalliance between beautiful antagonists (a revolutionary and a Cossack officer in *Balalaika*, or a western man and a Soviet woman in *Ninotchka* and *Comrade X*), celebrated the pleasures of the western world and charming aristocratic exiles (the royalty become servants in *Tovarich*), and trotted out the usual Russian props (vodka, Cossacks, wild or mournful Russian folk songs). Hollywood Russianness still pivoted on glamorous stars engaged in a battle of the sexes which "transcended" politics and capitalized on popular perceptions of Russian exoticism and extravagance. The final scenes of the musical *Balalaika* make plain the film's function as a kind of souvenir display, showing how American tourists enjoy typical "Russian" entertainment at a restaurant an exiled Cossack officer (played by Nelson Eddy) is reduced to running in post revolutionary Paris.[32]

The émigrés in Hollywood of course scorned such processed Russianness, what they privately deemed "*razvesistaia kliukva*" or "ridiculous nonsense." But their relationship to this nonsense was complicated. The film industry was a key source of income for professional Russian actors as well as émigrés who found work as extras during the silent film era.

The Russians in Hollywood could not afford to boycott Russia-themed pictures no matter how these distorted their identities and their past. Thus genuine Cossacks (a

[32] Robinson (2007) remarks that the restaurant "cater[s] to tourists hungry for some Tsarist nostalgia" (100–101).

settling for the
real hollywood:
russians in studio-era
american film

staple of American popular entertainment since Buffalo Bill's *Wild West* shows)
stood on call to ride as film *Cossacks*, and former White Army officers served as
local color or even story consultants for such movies as *The Cossacks* or Josef von
Sternberg's more authentic *Last Command* (1927), a film that highlights the tragic
fate of a former White Army general-turned-extra who confuses a Hollywood set
with his Russian past and dies in costume before the camera. Others were recruit-
ed as "dress extras," hired for their evening clothes and high society *savoir faire*.[33]
On the basis of her interviews with surviving émigrés, Olga Matich suggests that the
Russian non-professionals likely benefited psychologically from these stints of "illu-
sory repatriation" on the set, finding respite there from their diminished American
status as waiters, taxi drivers, and the like.[34] The professionals, be they actors,
designers, composers, or the occasional director (Richard Boleslavsky, Anatole Litvak,
Rouben Mamoulian, Lewis Milestone, Gregory Ratoff) generally accepted the work re-
gardless of its political orientation or ethnic "nonsense," and attempted to improve its
quality and authenticity insofar as they were able.

**Boris Chaliapin.** Portrait of Gregory Ratoff. 1941
Oil on canvas. $31^{1}/_{2}$ x $39^{2}/_{5}$ in. (80 x 100 cm)
Reproduced from: Chertok S. M. *Khudozhnik
Boris Shalyapin*. Leningrad. 1972. P. 30.

Yet the émigrés themselves inevitably contributed to the production and persistence of
Hollywood Russianness, although they initially had hoped to preserve and disseminate
"true" Russian history and culture in American film.[35] They managed to recreate Rus-
sia best in physical terms, through their function as authentic background and the
efforts of such designers as Alexander Toluboff (1882–1940), who masterminded the
extraordinary set of *The Cossacks* (1928). The screenplay for this film, another one of
Marion's formula-bound adaptations of Tolstoy's work, moved the plot back from the
nineteenth to the seventeenth century and jumbled Tolstoy's narrative with motifs from
Nikolai Gogol's Cossack novel *Taras Bul'ba*, the famous ballad about the Cossack
leader Sten'ka Razin, and a visual quote of Il'ia Repin's great historical painting, *The
Cossacks Write a Letter to the Sultan* (1891).[36] But Toluboff's masterful transformation
of the San Fernando Valley into a Cossack village, complete with a pretty Russian
church, partially redeemed the fiasco, at least for Bertenson. "After seeing how 'Rus-
sian pictures' usually suffer from careless hack work, the set of *The Cossacks* seems
meticulous," he writes approvingly after visiting Toluboff's village in November 1927.
"It generally helps that the film's artistic director is a Russian."[37]

Given the industry's penchant for "scenic and technical accuracy," MGM indulged
Toluboff in his expensive and painstaking recreation, although the set designer was
said to complain about "getting his ideas and ideals of what is true to Russian art
accepted by careless and indifferent actors and supervisors."[38] It bears noting, how-
ever, that Alexander Golitzen (1908–2005), Toluboff's younger Russian assistant on
another costume drama, was able to achieve remarkable power and renown as Super-
vising Art Director of Universal Studios, winning three Oscars for "art direction-set
decoration" of *Phantom of the Opera* (1943), *Spartacus* (1960), and *To Kill a Mock-*

[33]
Olga Matich, "The White Emigration Goes Hollywood," *Russian
Review*, 64 (April 2005): 195. For more information on these émi-
grés' "accidental careers," see 195–96, 199–203.

[34]
Matich (2002): 405.

[35]
Matich (2005): 203.
Bulgakova (2005): 228–29; Bertenson (1964): 134–35.

[37]
*Ibid.* 155.

[38]
On Hollywood's preference for realistic sets, see Koszarski (1990):
119–20. Identifying Toluboff as the assiduous "Mr. T.," Day reports
the artist's dissatisfaction (1934): 44.

[39]
Robinson (2007): 160–61.

*ingbird* (1962).[39] A second-generation Russian designer, as it were, Golitsen was no longer intent on preserving "true" Russianness, but more generally implementing the high standards he shared and learned with Toluboff.

For the most part Russian professionals and extras allowed Hollywood to commodify their ethnicity, contributing their looks, clothes, manners, cultural knowledge, and (after the birth of talkies) accented English to authenticate Russia-themed pictures.[40] Although they were scandalized when Tolstoy's son Il'ia endorsed the romantic hash made of his father's works, actually appearing as his father in framing episodes for the 1927 *Resurrection,* the émigrés also were complicit in packaging their culture for local sale or general export.[41]

By the late 1920s the cultural vacuum of Hollywood had been transformed into a company town where local businesses could exert a direct impact on the industry. Here movie stars bought gowns and posed for publicity pictures at the shop of the Russian Mme. M. and Princess G; frequented Russian restaurants such as *The Double Eagle* owned by General Fedor Lodyzhensky, a sometime actor and story consultant "discovered" by Gloria Swanson; and patronized the "Russian American Art Club" decorated with wall murals of Russian legends and featuring Russian talent performing traditional Russian fare (primarily gypsy and Russian folk songs).[42] A devotee of Russian high culture, Day nonetheless admits: "Practically every Russian affiliated with [the club] depends upon the movies for a living, and the club in return depends largely upon the patronage of the motion picture people. Hence the movie people are bound to influence to a large degree the type of performance presented on the club stage."[43]

What was happening in Hollywood was happening throughout the diaspora, as Russian performing artists experimented with Russian shows that would pack non-Russian houses. In a sense, the famous touring cabaret *La Chauve-Souris* (*The Bat*), with its charismatic master of ceremonies (Nikita Balieff), its showcasing of folk and popular prerevolutionary Russian materials in songs and sketches, and its combination of "the high artistic level of the legitimate theatre with the wit and informality of the traditional vaudeville show" suggested a winning commercial formula for "Russian American" art clubs everywhere.[44]

The Russians were making their art more accessible and predictable to ensure its survival. Hollywood Russianness still represented "ridiculous nonsense" to the émigrés, but their own performance of Russianness became cliched, fossilized, and hybridized the longer they remained in exile and before American audiences. Émigré actors onscreen often reinforced various Hollywood stereotypes of the Russian "as politically fanatical, steeped in high culture, wild-living and hard-drinking, emotionally childlike

**Nikita Balieff.** Photograph. Reproduced from: *Russian Artists Abroad. Golden Book of Emigration. The First Third of the 20th Century* Encyclopedic dictionary. Moscow, 1997

[40] Matich (2002): 404, 405; Matich (2005).

[41] Nusinova (1999): 179–80; Matich (2005): 203–4.

[42] Day (1934): 39–40. On Lodyzhensky, see Matich (2005): 195–96.

[43] Day (1934): 40–41.

[44] Alma Law, "Nikita Balieff and the Chauve-Souris," in Senelick (1992): 16–31

[45] Beth Holmgren, "Cossack Cowboys, Mad Russians: The Émigré Actor in Studio-Era Hollywood," *Russian Review* 64 (2005): 258.

[46] For more on this intriguing story, see Matich (2005): 190–92.

settling for the
real hollywood:
russians in studio-era
american film

and spontaneous, or genially 'mad'."[45] Indeed, for the Russians in Hollywood, "true" Russianness sometimes elided with its onscreen reconstruction, as was the case of the Holy Virgin Cathedral, a Russian Orthodox church built in Los Angeles in 1928 and clearly based on Toluboff's design for the Russian church in *The Cossacks*.[46]

## Coaches and Character Actors

Like the would-be reformers Nemirovich-Danchenko and Eisenstein, the Russian directors and actors who remained in Hollywood soon learned that theirs could never be the leading part offscreen or onscreen (after the advent of talking pictures). (See Harlow Robinson's essay in this volume for a description of how Russian composers worked in Hollywood.) Directors such as Anatole Litvak, Rouben Mamoulian, Lewis Milestone (1895–1980), and Gregory Ratoff (1897–1960) sometimes produced high quality films such as Milestone's Academy Award-winning *All Quiet on the Western Front* (1930), Mamoulian's *Dr. Jekyll and Mr. Hyde* (1931) and *Queen Christina* (1933), and Ratoff's *Intermezzo* (1939). During World War II, both Milestone and Litvak succeeded in facilitating very different Hollywood representations of Russia, producing and/or directing stark documentaries about the Soviet war effort that incorporated Soviet newsreel and propaganda footage (see Milestone's *Our Russian Front* [1942] and Litvak and Frank Capra's *The Battle of Russia* [1943]).[47] Their extensive quotation of Soviet materials surely demonstrated that Hollywood's formulaic Russia-themed pictures were unequipped to depict the Soviet war experience, an impression reinforced by such war-era fiction films as the unabashedly pro-Stalin *Mission to Moscow* (1943, dir. Michael Curtiz) and the socialist realist-styled *North Star* (1943, dir. Lewis Milestone), which also drew on newsreel or newsreel-like footage.[48] But Russian directors, like their non-Russian counterparts in the industry, generally had to play by studio rules or risk unemployment, as Mamoulian discovered "for taking too long and spending too much" on his productions.[49]

Entering the studio stables, Russian actors came up against a baffling hierarchy that overlooked their professional credentials and automatically demoted them. Stunned by the conditions of his first Hollywood set (for the 1943 film *Song of Russia*), the great actor Michael Chekhov, a nephew of the famous playwright, fulminated against this "terrible, unartistic, cruel, and talentless little world": "They treat the character actors so badly that they should be shot... And the actors here have become total, conscious slaves. Lord knows what kind of actors they are, it's true, but they still shouldn't be made slaves. The stars here are truly the beings with power. They're a separate caste. As in Rome."[50] A relative latecomer to the Hollywood scene, Chekhov articulated the dismay of other talented Moscow Art Theatre alumni, for whom acting remained a high calling and required rigorous training. In the words of one of their fellow exiles, these displaced

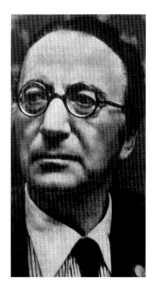

**Rouben Mamoulian,**
a movie director. (1897–1987)
Photograph

**Michael Chekhov. 1929**
Photograph. Reproduced from: Chekhov M.
*Literaturnoe nasledie.* Vol. 1. Moscow. 1986

[47]
Robinson (2007): 116

[48]
Beth Holmgren, unpublished ms. "From Screwball to Shockworker: Hollywood Takes on Russia, 1937–1945".

[49]
Robinson (2007): 173–74.

[50]
16 July 1943 to M. V. Dobuzhinsky in Michael Chekhov, *Vospominaniia, pis'ma* (Moscow: Lokid-Press, 2001): 462–63.

[51]
Day is quoting from a 24 April 1930 lecture delivered by the young art critic Mme. Y. at Occidental College (1934): 37.

performing artists believed that the theatre "had a very high educational purpose and was far more than entertainment — it was a temple where people would go to see themselves, to see their faults and their merits. They would go to laugh and cry there, to understand better the high ideals and philosophy of life, to absorb the beauty of life."[51]

A number of Moscow Art Theatre veterans strived to maintain this mission and propagate their version of the Stanislavsky system in New York, their first station of American exile. Here Richard Boleslavsky and Maria Ouspenskaya founded the American Laboratory Theatre, an enterprise that would spawn the Group Theatre and influence a later generation of film actors long after both collectives had dissolved.[52]

**Olga Baclanova**. Photograph. Reproduced from: Vasil'ev A. *Krasota v izgnanii: tvorchestvo russkih emigrantov.* Moscow, 2005

Michael Chekhov, who had already moved beyond Stanislavsky in developing his own principles of acting, was able to maintain a studio and company in Ridgefield, Connecticut, for a few years after he had emigrated from London.[53] When these and other former Moscow Art Theatre actors went Hollywood for better professional prospects or mere survival, they persisted in their off-screen roles as educators, in part to satisfy their abiding artistic ambitions and perhaps in larger part to cash in on their Stanislavskian connections, what Natal'ia Nusinova dubs their "Hollywood calling card."[54] Thus the formidable Ouspenskaya, who reportedly taught wearing a monocle and equipped with a pitcher of gin, moved her Maria Ouspenskaya School of Dramatic Arts from New York to Hollywood and, according to a posthumous tribute, counted among her students Anne Baxter, Joan Crawford, Frances Farmer, John Garfield, Katherine Hepburn, and Franchot Tone.[55]

Through his earnings as a screen actor and the support of other Hollywood Russians, Chekhov fashioned for himself an intellectual and spiritual retreat in Hollywood by writing on acting and serving as inspiring "professor" to such stars as Ingrid Bergman, Yul Brynner, Gary Cooper, James Dean, Rex Harrison, Gene Kelly, Marilyn Monroe, Patricia Neal, Paul Newman, Gregory Peck, Tyrone Power, Anthony Quinn, and Robert Taylor.[56] Chekhov's biographer Liisa Byckling remarks that his primary shift to teaching in the early 1950s fortuitously coincided with the greater influence and prestige of the Stanislavsky system in Hollywood.[57]

While some Russian actors achieved a cult status off-screen as drama coaches, albeit on a much more modest scale than they would have been guaranteed in their homeland, émigré actors were almost never admitted into the high "caste" of the stars. Those very few exceptions succeeded as "exotics" rather than Russians. Only Alla Nazimova achieved stardom in the silent era as the Arab girl, gypsy, and apache dancer, among other roles, and the half-Russian Yul Brynner (1915–1985) became "Hollywood's first Russian émigré leading man" after conquering Broadway as the peremptory Siamese monarch in *The King and I*.[58] The lovely and talented Olga Baclanova,

52
Sharon M. Carnicke, "Boleslavsky in America," in Senelick (1992): 116–28.

53
Robinson (2007): 137; Liisa Byckling, *Mikhail Chekhov v zapadnom teatre i kino* (St. Petersburg: Akademicheskii proekt, 2000): 377, 383–88. For a description of Chekhov's studio teaching and his company's productions, see Deidre Hurst Du Prey, "Michael Chekhov in England and America," in Senelick (1992): 158–70.

54
Nusinova (1999): 177. Also Byckling (2000): 382 and Senelick (1992): xiv.

55
Lambert (1997): 263; Robinson (2007): 84–85; 4 December 1949, *New York Herald Tribune.*

56
Robinson (2007) supplies this list of stars and comments on Chekhov's "invaluable" influence on Monroe (138,141)

57
Liisa Byckling, "Mikhail Chekhov v amerikanskom kino," *Kinovedcheskie zapiski* 33 (1997): 133.

58
Lambert (1997): 190, 203, 210, 227: Robinson (2007), 152–53

59
Aleksandr Vasil'ev, "Krasavitsa Baklanova," Kinovedcheskie zapiski 29 (1996): 158075.

settling for the
real hollywood:
russians in studio-era
american film

another Moscow Art Theatre actress, seemed destined for leading parts after her success in Josef von Sternberg's *Docks of New York* (1929), but her star faded after she played the heartless beauty in Todd Browning's daring film *Freaks* (1931); at the film's close the title characters, a close-knit circus troupe, mutilate her horribly for murdering one of their own, her rich dwarf husband.[59] Samuel Goldwyn himself attempted to launch the beautiful Anna Sten, an actress with Moscow Art Theatre and German film experience, as a Russian variant on such successful imports as Garbo and Marlene Dietrich, but her films' consistently poor box office nipped her stardom in the bud.[60] Since the studios depended on established stars as one of the main sources of a picture's value, they typically cast market-proven screen actors in leading roles and tacitly prescribed a star's "regular" (that is, unexotic) beauty and unaccented-to-barely-accented English.[61] This meant that the markedly ethnic actor or actress was sidelined to character roles. Character actors, in contrast, thrived on irregular looks and traits, for they "shoulder[ed] the burdens of eccentricity" in facilitating the stars' appeal and action, serving, for example, as catalyst, foil, comic sidekick, or (as the Russian extras well knew) colorful background.[62]

**Julie Brown.** Portrait of Alla Nazimova
Reproduced from: Litavrin M. *Americanskiye sady Ally Nazimovoy.* Moscow, 1995.

The studios only intermittently matched real with depicted ethnicity, and often cast foreign actors across ethnic and even racial lines. For example, while Ouspenskaya played a stern Russian ballet mistress in *Waterloo Bridge* (1940) and *Dance Girl Dance* (1940), she also appeared as Grandmére Marie in *Kings' Row* (1941), a gypsy in two Wolf Man pictures with Lon Chaney (1940, 1943), and a maharani in *The Rains Came* (1939).[63]

The highly successful character actor Akim Tamiroff, another Moscow Art Theatre veteran, changed his onscreen nationality regularly, incarnating an Indian emir in *Lives of a Bengal Lancer* (1934), a Chinese arch-villain in *The General Died at Dawn* (1936), the treacherous Spanish partisan Pablo in *For Whom the Bell Tolls* (1943), and an Arab in *Five Graves to Cairo* (1943).[64] Ethnic identity in Hollywood proved generic and all-purpose, a character actor's eminently fungible value. No Russian actor better illustrated his worth as an ethnic chameleon than Vladimir Sokoloff (1889–1962), who had performed in the Moscow Art Theatre as well as Max Reinhardt's troupe and whose Hollywood parts included Paul Cézanne in *Zola* (1937), a Moroccan astrologer in *Road to Morocco* (1942), the good Spanish partisan Anselmo in *For Whom The Bell Tolls*, and the old man in *The Magnificent Seven* (1960). In 1944 *Motion Picture Magazine* praised his capacity to disappear: "Paying audiences sit enthralled when they see him and they don't know what to call him. They hardly even know his name. He looks different in every picture. He acts different. He is different."[65]

Successful Russian character actors learned to network, compromise, and "belong" according to Hollywood's implicit system. Tamiroff owed his big break into film to

[60] Robinson (2007): 65

[61] Tino Balio, *Grand Design: Hollywood as a Modern Business Enterprise, 1930–1939* (New York: Scribner, 1993): 144, 155; Mark Winokur, *American Laughter: Immigrants, Ethnicity, and 1930s Hollywood* (New York: Macmillan, 1996): 4, 125.

[62] Winokur (1996): 190–91, 232–33.

[63] Robinson (2007): 84-85, 88; Lambert (1997): 264.

[64] Robinson (2007): 72–77.

[65] *Motion Picture Magazine* (October 1944): 130.

[66] Robinson (2007): 75.

[67] *Ibid.* 137–38; Byckling (2000): 377, 383–88; Yuri Tsivian, "Leonid Kinskey, the Hollywood Foreigner," *Film History* 11 (1999): 175, 178.

the intervention of Gary Cooper, a major star in the Hollywood pantheon.[66] Other actors were eased into productions through émigré solidarity; so director Gregory Ratoff and the famed composer pianist Sergei Rachmaninoff rescued Chekhov after his studio's collapse and brought him to Hollywood to play in *Song of Russia*.[67] Those actors who earned the most screen time — Tamiroff, Sokoloff, Mischa Auer, Leonid Kinskey (1903–1998) — tolerated and adroitly worked the system. The Moscow Art Theatre credentials of Tamiroff and Sokoloff won them automatic respect, but they applied themselves to screen acting without condescension or fuss, whatever its artistic flaws or physical demands. Sokoloff may have resembled Ouspenskaya and Chekhov as "director, play doctor, producer and, most of all, guide and mentor to youthful talents" in his own little company of players, but he ultimately declared himself "Stanislavsky-free." In an April 1960 interview he insisted: "To h — with ALL the acting theories, including the Stanislavsky method. Before he died in 1938, Stanislavsky himself told me: 'Adapt and adjust, Vladimir. No longer accept my method, letter for letter. The world's changing. Acting is changing and it will change even more.'"[68] Auer and Kinskey readily adapted and adjusted because they had been theory-free popular entertainers all along. Kinskey had performed as a mime in Russian theatres and was touring with Al Jolson's company (along with Tamiroff) when he opted to go Hollywood.[69] Auer, born in 1905, launched his acting career in the United States and left the Bertha Kalisch company for the movie business when his troupe stopped over in Los Angeles in 1928.[70] Both became staple character actors in 1930s and 1940s pictures, the "big little people" retained in studio stables to provide highly qualified, recognizable, and versatile support for the stars.[71]

While stardom was a foregone impossibility, the émigrés discovered surprising benefits in character acting, for these parts allowed them, within limits, room for experimentation, innovation, and eccentric performance. Even Chekhov, who complained bitterly about Hollywood's shortcomings (its star system, lack of sensitive direction, insistence on speedy production), was satisfied with certain roles and a director or two. He made his reputation and won an Academy Award nomination as the bemused Freudian analyst (Ingrid Bergman's mentor) in Alfred Hitchcock's *Spellbound* (1945), and he seemed to enjoy his roles as the mad actor in John Berry's *Cross My Heart* (1946) and the effeminate ballet impresario in Ben Hecht's *Spectre of the Rose* (1946), perhaps in part because he liked both directors. As he later taught his students, he trained himself in Hollywood to play "episodic" roles effectively for the camera.[72]

Hollywood itself formally valued the émigrés' onscreen abilities as Ouspenskaya, Tamiroff, and Auer, in addition to Chekhov, were nominated for Oscars in the Best Supporting Actor category. David Selznick, a second-generation Hollywood producer of large artistic ambition, so admired the talents of Chekhov and Nazimova that he intervened to expand their roles in, respectively, *Spellbound* and the wartime melodrama

**Boris Chaliapin.** Portrait of Vladimir Sokoloff. 1939
Oil on canvas. 32 x 25$^{1}/_{5}$ in. (81 x 64 cm)
Reproduced from: *Kartiny Borisa Shalyapina v dome otsa*
Moscow, 1995. P. 39.

68
Erskine Johnson, "Stanislavski Pupil Raps 'Methods,'" 1 April 1960, *Los Angeles Mirror*

69
It bears mentioning here that Al Jolson himself was a Russian-born Jewish entertainer (1886–1950) who had emigrated to the United States as a child.

70
Holmgren (2005): 239–40.

71
Arthur McClure and Alfred Twomey single out Kinskey and Auer as Americans' favorite Russian character actors in "Big Little People: The Historical Importance of the Character Actor in the American Motion Picture," in *Beyond the Stars: Stock Characters in Popular Film*, ed. Paul Loukides & Linda K. Fuller (Bowling Green: Bowling Green University Press, 1990): 216–17. For more on how Kinskey and Auer figured as best-case examples of Russian émigré actors in studio-era Hollywood, see Holmgren (2005).

72
Byckling (1997): 123-28, 133.

73
*Ibid.*, 125. Lambert (1997) 368, 380-81. Selznick also played good fairy in the career of Gregory Ratoff, importing him to Hollywood from New York in the early 1930s (Robinson, 2007: 90).

74
Robinson (2007): 74, 76.

settling for the
real hollywood:
russians in studio-era
american film

*Since You Went Away* (1944). In the latter film Selznick himself wrote the role of the immigrant shipyard worker for Nazimova, whom he considered "one of the greatest actresses in the world."[73] Tamiroff, in turn, won the admiration and friendship of another ambitious filmmaker, Orson Welles, who cast him in three films — *Mr. Arkadin* (1955), *A Touch of Evil* (1958), and *The Trial* (1962).[74]

Moreover, these successful Hollywood Russians, viewed regularly by American moviegoers, developed recognizable screen personae which, in some instances, translated into offscreen celebrity through studio publicity and coverage by the industry and local press. Character actors became such familiar presences onscreen "that audiences had a subconscious impression of them not as movie actors, but as members of the community — fixtures in their own lives."[75]

The Russians' screen personae were determined not by ethnicity, but by the character types assigned them in Hollywood's genre films, what the Association of Motion Picture Producers vaguely designated by ranking ("lead," "minor"), types (usually listed by profession), and "characterizations" ("straight," "comic," "sympathetic," "unsympathetic," "indifferent").[76] So Tamiroff, with his sinister face, growling voice, and heavy Russian accent, was often cast as the "heavy" or "stylishly florid villain."[77] After his success in *Spellbound*, Chekhov reprised several times the kindly, eccentric, Central European intellectual. Ouspenskaya alternated between the imperious, but ultimately sympathetic, dowager and the spooky gypsy seer. Both Kinskey and Auer often played comic sidekicks to the stars, Kinskey most famously as Sascha who bartended for Humphrey Bogart's Rick in *Casablanca* (1942).

Auer sometimes exceeded the bounds of his type and indelibly personalized his performances. His Oscar-nominated rendering of Carlo in *My Man Godfrey* (1936) fused together a screwball artist with a Park Avenue parasite and an impromptu beast (Auer's excellent impersonation of a gorilla won him special notice among critics and audiences). Auer's performance as the haughty, venal, histrionic deputy Boris Stavrogin to James Stewart's understated sheriff in *Destry Rides Again* (1939) proved so popular that it secured him similar "featured player" parts in a series of Universal pictures (*Seven Sinners* [1940], *Trail of the Vigilantes* [1940], *The Flame of New Orleans* [1941]).[78]

Ultimately, the most successful Russian character actors graduated from type to individualized commodity, to the familiar talent that producers and directors sought out as audience-pleasing support. They figured no longer as Hollywood's Russians, but as Hollywood's own.

Where were Russian artists in studio-era Hollywood film? Most were not where they had expected and trained to be. The Hollywood factory in the studio-era resisted

**Akim Tamiroff, actor**
Photograph

[75]
McClure & Twombley (1990): 220.

[76]
Holmgren (2005): 243.

[77]
Wheeler Winston Dixon, "Archetypes of the Heavy in the Classical Hollywood Cinema," in Loukides & Fuller (1990): 201.

[78]
Holmgren (2005): 252–54, 255–57.

serious collaboration with major Russian artists on the latter's terms as impractical. Hollywood's Russian-born movie moguls were for all intents and purposes American businessmen invested in selling popular entertainment rather than creating art. They were loath to tinker with the proven formulae — the stars, genres, and storylines — that their mass audience readily consumed.

The studios courted talent without reckoning on that talent's independent agenda, and Russian visitors and émigrés sometimes found common cause with other studio artists and director/producers who were struggling for greater creative control and were awed by the Russians' culture, training, and abilities. Indeed, although the Russians first balked at Hollywood's cultural vacuum and obsession with the bottom line, those who settled there increasingly discovered that Hollywood's cultural insecurity could work to their benefit, as producers recruited them to be story consultants and set designers, and aspiring actors and established stars turned to Russian acting gurus for professional training and confidence building.

Yet both Americans and émigrés tolerated the stereotyping and jumbling of Russian life and culture in Hollywood film. Americans experienced in the industry accepted this as business as usual. The Russians, however, keenly suffered the plunge from high culture into "ridiculous nonsense," deploring Hollywood's distortion of their classics and their past. Nevertheless, they desperately needed industry jobs and the industry's good will for their local businesses. In the meantime their own attempts to preserve Russia's "true" history and culture inevitably grew more cliched and redundant the longer they remained cut off from their homeland and the more accustomed they became to the exigencies of American popular entertainment. As Day already predicted in 1934, the second generation of Hollywood's Russian colony, denied the possibility of repatriating or reconnecting with Russia, would "more or less succumb to the Americanization process."[79]

The Hollywood Russians intervened and corrected their ethnic representation wherever and whenever they could — as appropriately dressed and mannered extras in the background of a Russia-themed silent film, bonafide Cossacks performing the daredevil stunts no American cowboys could pull off, set designers who so convincingly reconstructed Russian landscapes that their design was reincarnated in Hollywood's real Russian community, Russian directors who assembled Russian talent for their film to ensure its overall quality, or the character actors who incarnated more nuanced portraits of their compatriots and also demonstrated how distinctively Russian training and commitment to their craft yielded admirable, award-worthy, and generically ethnic performances. They wielded their modest influence on an individual basis, most often on the sidelines of the industry or onscreen in the supporting cast.

[79] Day (1934): 81.

[80] For a fine survey of Russian characters and Russian players in post-World War II Hollywood films, see Robinson (2007).

settling for the
real hollywood:
russians in studio-era
american film

Paradoxically, but predictably, those Russian artists who succeeded in studio-era Hollywood eventually outstripped their ethnic identity. This processing continued even after the studio system's decline and throughout the waging and waning of the cold war.

The contents of Hollywood Russianness certainly altered and sometimes grew more sophisticated in response to international politics, more independent film production, and the defection of such ready-made Russian celebrities as Mikhail Baryshnikov.[80] But the industry consistently banked on proven commodities. Successful émigré artists evolved into Hollywood players and Hollywood names, whose Russianness distinguished and enriched, but could not wholly define, their onscreen cachet.

# RUSSIA. 1910s—1920s

War, starvation, pogroms, unemployment, destruction and finally the 1917 Revolution were the reasons for immigration from the Russian Empire and the Soviet Russia in the early 20th century.

1. Unemployed at the Labour Exchange. Petrograd. 1918
2. July Demonstration Shot down by the Provisional Government
3. First Days of the February Revolution. Petrograd. March 1917
4. Peasant Family. 1910s
5. Soldiers' Detachment at the Winter Palace. Petrograd. 9 January 1905
6. Barricades in Liteiny Prospekt. 1917
7. February Revolution. Document Check-Point at the Tauride Palace. Petrograd. February 1917
8. Participants in the workers' food battalions, who were killed by wealthy peasants. Petrograd. 1920

7

10

8

11

9

12

9. The accused of stealing church treasures. Petrograd. June 1922

10. Soldiers of the 7th Army Converting a Church into a Social Club. Borovichi, Novgorod Province. 1918

11. Carrying the Dead for Burial. The Field of Mars. Petrograd. 8 June 1919

12. One of the American Labor Communes Organized by the Society of Technical Support and Society of Friends of Soviet Russia. Vsevolozhsk Stanitsa, Petrograd Province. 1921–1922

# AMERICA. 1900s—1920s

Arrival of Immigrants in the U.S. in the early 20th century. Beginning of a New Life. Hope for economic stability, security, civil rights and liberties.

13

16

14

17

15

18

13. Arrival of Immigrants. Early 1930s
14. Ellis Island, NY. Between 1909 –1932
15. A View of New York City. 1920s

16. A View of the Brooklyn Bridge. Ca. 1904
17. Brooklyn Bridge. Ca. 1900
18. Immigrants Arriving, Ellis Island. 1910s

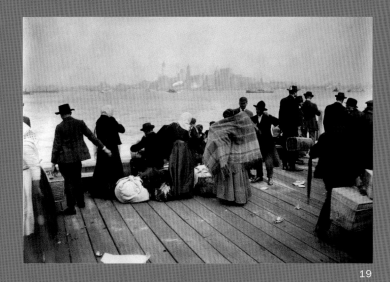

19

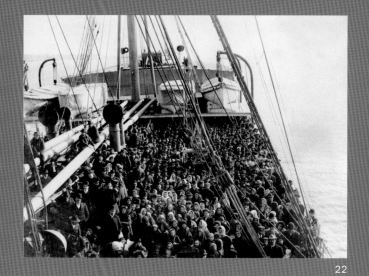

22

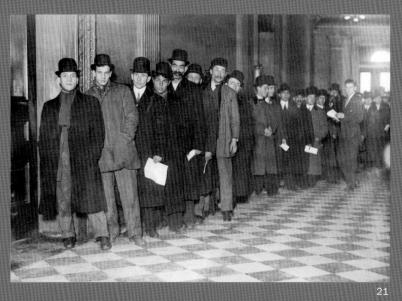

20

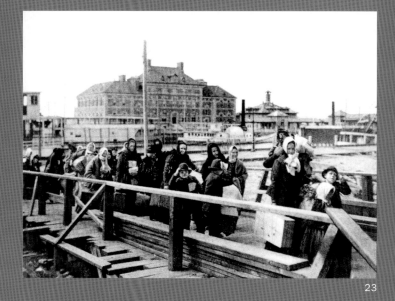

23

21                                                24

19. In Anticipation of Arrival. Early 1900s

20. Immigrants Arriving, Ellis Island, NY. Ca. 1915

21. Waiting Turn at Naturalization. 1916

22. Immigrants Arriving on the *Atlantic Liner*. December 10, 1906

23. Immigrants Coming to the "Land of Promise." 1920s

24. Peddler Selling Socks on the Street Corner, New York. Ca. 1915

25. Suffragettes. Early 1900s

26. Million Dollar Corner (34th Street & Broadway), New York City, NY, December 21, 1911

27. Crowd to Hear Suffragettes. October 28, 1908

28. Lower East Side, Hebrew District, New York. Ca. 1907

29. America's First Suffragette Parade. February 1905

30. Lithuanian Americans. Late 1920s

31. Free Coffee at Bowery Mission for the Unemployed. January 2, 1908

32. Migrant Workers. 1920s

33. Russian Labor Association in Labor Parade. May 1909

34. Public Baths, Milbank Memorial. Ca. 1908–1916

35. Parade of the Unemployed. May 31, 1909

36. Crowd Outside of a Municipal Lodging Building, NYC. January 18, 1914

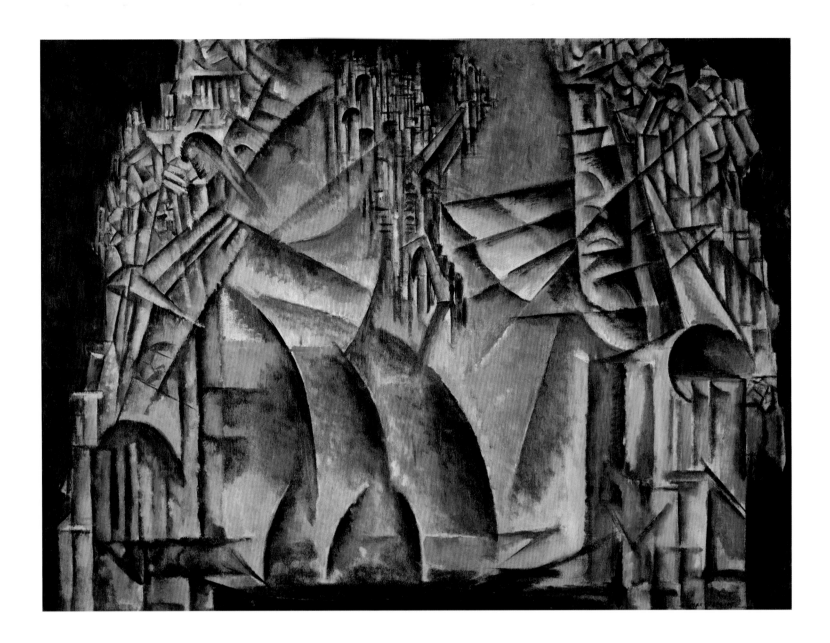

1

**Max Weber**

Interior of the Fourth Dimension. 1913 \*

Oil on canvas. $29^{13}/_{16}$ x $39^{1}/_{2}$ in. (75.7 x 100.3 cm)

National Gallery of Art, Washington, DC

Gift of Natalie Davis Spingarn in memory of Linda R. Miller and in Honor of the 50th Anniversary of the National Gallery of Art

Like many artists at the beginning of the 1910s, Weber was interested in exploring how to make the images appear to go beyond the limits of the painting itself. *Interior of the Fourth Dimension* is one of these experiments in a Cubo-futurist spirit.

124

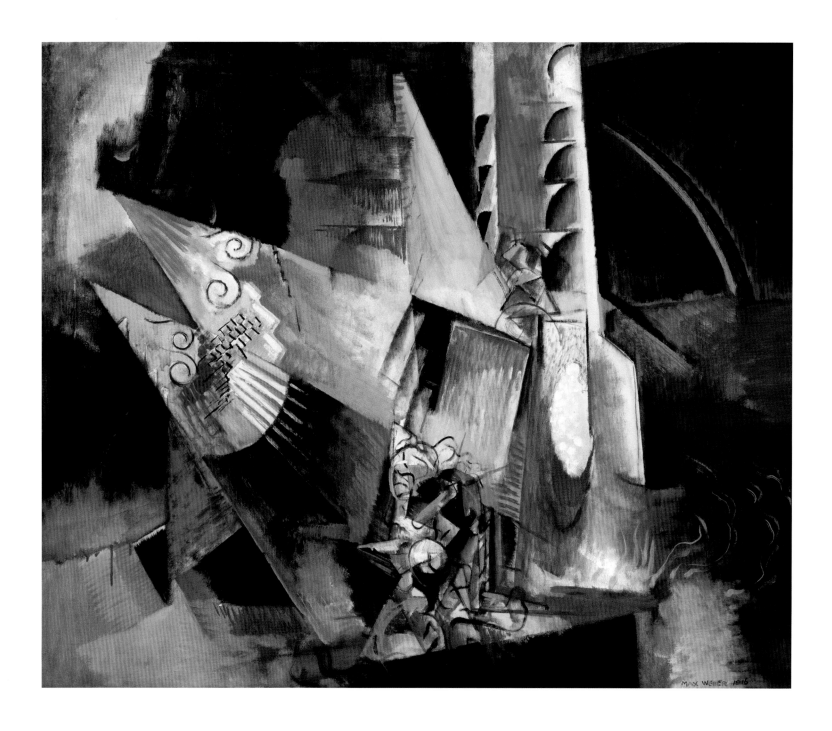

During 1906 in Paris, the first tour of Sergei Diaghilev's Ballets Russes was organized using the title *Russian Seasons*. From the middle of the first decade of the 20th century to the beginning of the second decade, Russian ballet received worldwide praise while performing in many cities, including New York. Weber's portrayal of the scene presents an impression of the very colorful activity in Ballets Russes. In the middle of the 1910s, design of the ballets was accomplished with the participation of such artists as Alexandra Exter and Natalia Goncharova, who were working in the Cubo-futuristic style.

2

**Max Weber**

Ballets Russes. 1916

Oil on canvas. 30 x 36 in. (76.2 x 91.4 cm)

Brooklyn Museum of Art

New York, NY

Bequest of Edith and Milton Lowenthal

3
**Louis Lozowick**
Pittsburgh. 1922–1923 *
Oil on canvas. 30 x 17 in. (76.2 x 43.2 cm)
Whitney Museum of American Art,
New York, NY
Gift of Louise and Joseph Wissert

*Pittsburgh* is one of the most famous of Lozowick's works where the artist clearly and aesthetically expresses the particular nature of the urban landscape in Cubist forms characteristic of him.

4

**David Burliuk**

Hudson. 1924

Oil on canvas. $37^4/_5$ x $37^4/_5$ in. (96 x 96 cm)

ABA Gallery, New York, NY

One of Burliuk's Cubo-futurist works, which was painted upon his arrival in America.

128

Having immigrated to America, David Burliuk paradoxically considered himself to be an agent of Soviet Russia — a revolutionary artist representing the interests of the Proletariat. He did not miss a chance to call the United States "the country of gruesome capitalism," and the USSR — "The great country of workers and peasants." This was possible since his freedom of speech in America was constitutionally protected. He was eager to exhibit his works in his Motherland and he always strived to send his paintings abroad, publish his manuscripts, and by word and deed to educate the victorious class and instill aesthetic tastes in them. He considered his paintings, created in the U.S. and dedicated to the life of the working class and the history of the labor movements, to be his achievements for the USSR and hoped that some day they would find their place in the best museums in Russia and Ukraine. However, this part of the Burliuk's legacy is not represented in Russia.

5

**David Burliuk**

Workers. 1924

Oil on canvas. 41⁴/₅ x 36 in. (106.2 x 91.7 cm)

ABA Gallery, New York, NY

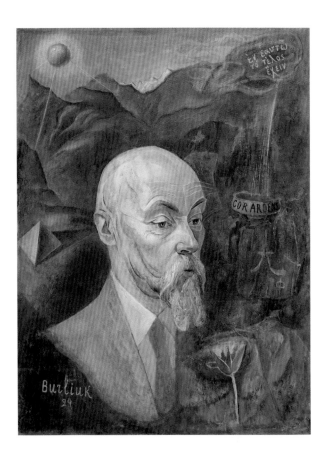

6

**David Burliuk**

Portrait of Professor Nicholas K. Roerich,

First President of the World of Art Group. 1929 *

Oil on canvas. $24^{1}/_{8}$ x 18 in. (61.3 x 45.7 cm)

Philadelphia Museum of Art, PA

Gift of Christian Brinton, 1941

The portrait was done in America where both artists,
who knew each other well in Russia, found them-
selves.

Nicholas Roerich (1874–1947) — a Russian artist, ar-
chaeologist, expert on Eastern philosophy and ethnog-
raphy. After 1920 he lived in the U.S. and India. His
monumental, symbolic, and philosophical works were
dedicated to all humanity. His social work was devot-
ed to the ideas of unification of all peoples and preser-
vation of world cultural monuments.

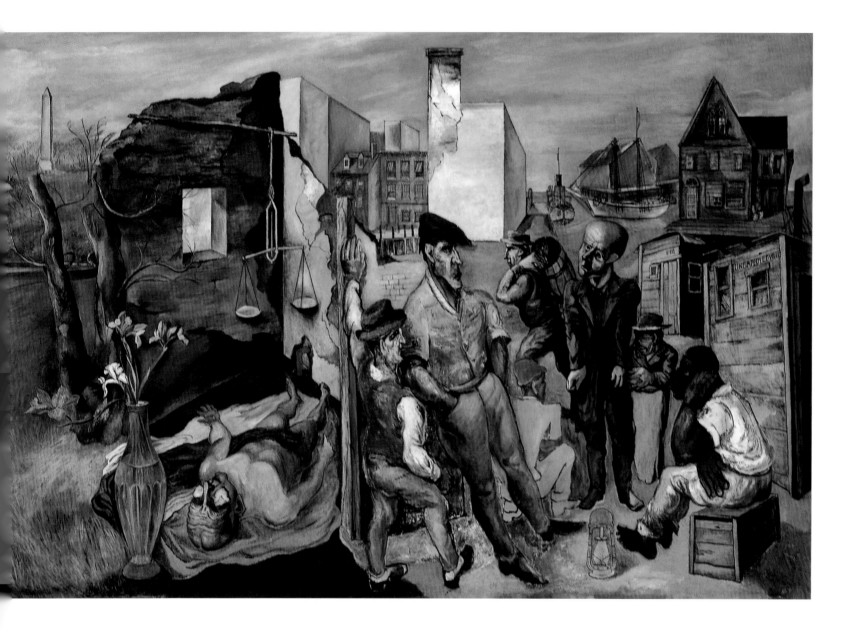

The painting represents the social charge and demonstrative scandalous nature of futurist Burliuk very well. The idea portrayed in the canvas mirrors the artist's statement about the social effects of the Great Depression on the working class. At the right is a Hooverville with a group of men, each representing a distinct character: "Fear, Cynicism, Babbitry, Embrio (sic) of Protest, Love for good-time under every condition." At the center, the philosopher Diogenes lies dead with two small stones placed on his eyes. His lantern appears at the right in front of the unemployed. At the far left is the modern city, constructed by workers now neglected and forgotten like those who built *Cleopatra's Needle*, the Egyptian obelisk in New York City's Central Park, which is visible in the background. It was accompanied by a written manifesto that introduced the viewer to the painting's program. Burliuk concludes his manifesto: "An immense city with tens of thousands and piles of food wasting away provokes me to give my picture a title — SHAME TO ALL BUT TO THE DEAD." This painting has not been seen in public since it was exhibited in 1933 at the Grand Central Palace in New York. Futurist Burliuk's devoted much of his attention to acute social problems and this work was close to a social realism genre, which was rather popular in America of 1930s. Also see *American Artists from the Russian Empire and the Soviet Union*.

7

**David Burliuk**

Shame to all but to the Dead
(Or, Unemployedville). 1933 *

Oil on canvas. 66 x 144 in. (167.6 x 365.7 cm)

Collection of the Nasher Museum of Art

at Duke University, NC

Museum purchase

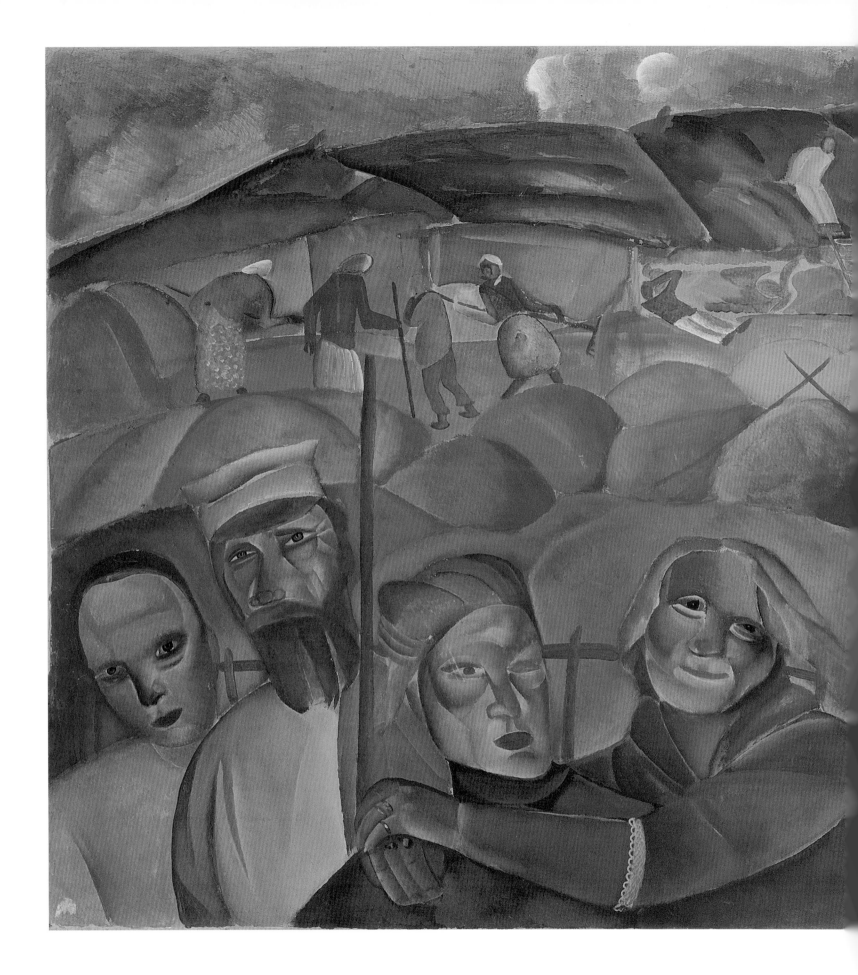

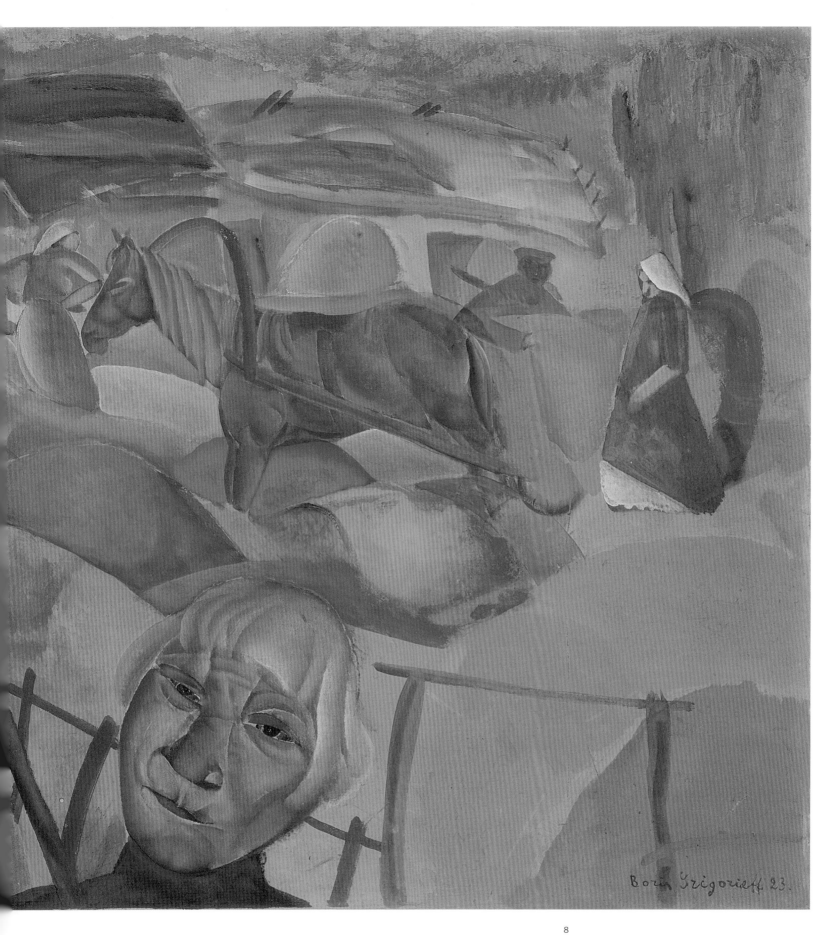

Boris Grigorieff 23.

The series of paintings and drawings dedicated to peasant Russia was first shown in 1918 under the title *Russie.* Later Grigoriev continued to work on the same theme, having changed the title to *Images of Russia*. *The End of Harvest* belongs to these compositions created in the beginning of the 1920s and presented in other countries (France and Germany), as well as in America.

8

**Boris Grigoriev**
End of the Harvest (Faces of Russia). 1923 *
Tempera and oil on canvas mounted
on cardboard. 28⅝ x 36 in. (72.7 x 91.4 cm)
Philadelphia Museum of Art, PA

133

Boris Grigoriev's principal creative method was painting from nature. Therefore, in his still lifes the objects are expressively molded into pliant artistic mass resembling a powerful organ chord. In the old photographs of Boris Grigoriev's studio one can see a simple table, which was usually used for the artist's still lifes, as well as a set of objects from his everyday life. Through the broadness and freedom of the artist's brush-work one can see the dynamic texture revealing the influence of the old masters of Northern Europe. The artist had great interest in it during his summer journeys.

9

**Boris Grigoriev**
Still Life with Bread. Late 1920s
Oil on canvas. 19 x 24$^4/_5$ in. (48 x 63 cm)
Private collection, New York, NY

134

At the end of the 1920s, Grigoriev practically stopped painting Russian-themed paintings. He traveled extensively during that time (Chile, Argentina, Uruguay, Brazil) and changed his thematic arsenal and expressive language. *Still Life with a Cat*, like his gouaches with everyday scenes, is very characteristic of the end of the 1920s. The sharpness of the reality he presented, the change of the color gamma to the darker one and on the reverse to the lighter one represent a different Grigoriev, who was searching for new paths for his art.

10

**Boris Grigoriev**

Still Life with a Cat. Circa 1928–1929 *

Oil on canvas. 21 x 29$^{1}$/$_{2}$ in. (53 x 75 cm)

ABA Gallery, New York, NY

11

**Sergei Sudeikin**

Pre-Lenten Festival. Second half of the 1920s *

Oil on canvas. $32^3/_4$ x $44^3/_4$ in. (83 x 113.5 cm)

ABA Gallery, New York, NY

This work is very typical of Sudeikin's art of the 1910s–1920s. It has realistic observations of Russian winter holidays with carousels, sledding in the snow, church productions; however, at the same time the activities are removed from reality theatrically. The artist does not paint his scenes from real life, nor does he make it look real. He creates an image of Russian Mardi Gras, sharpening all that is taking place with his own imagination.

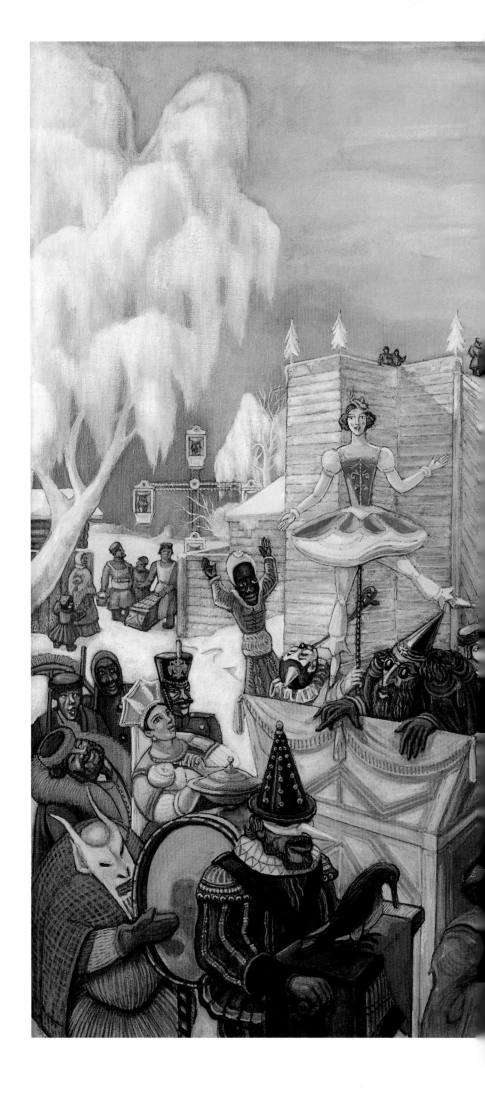

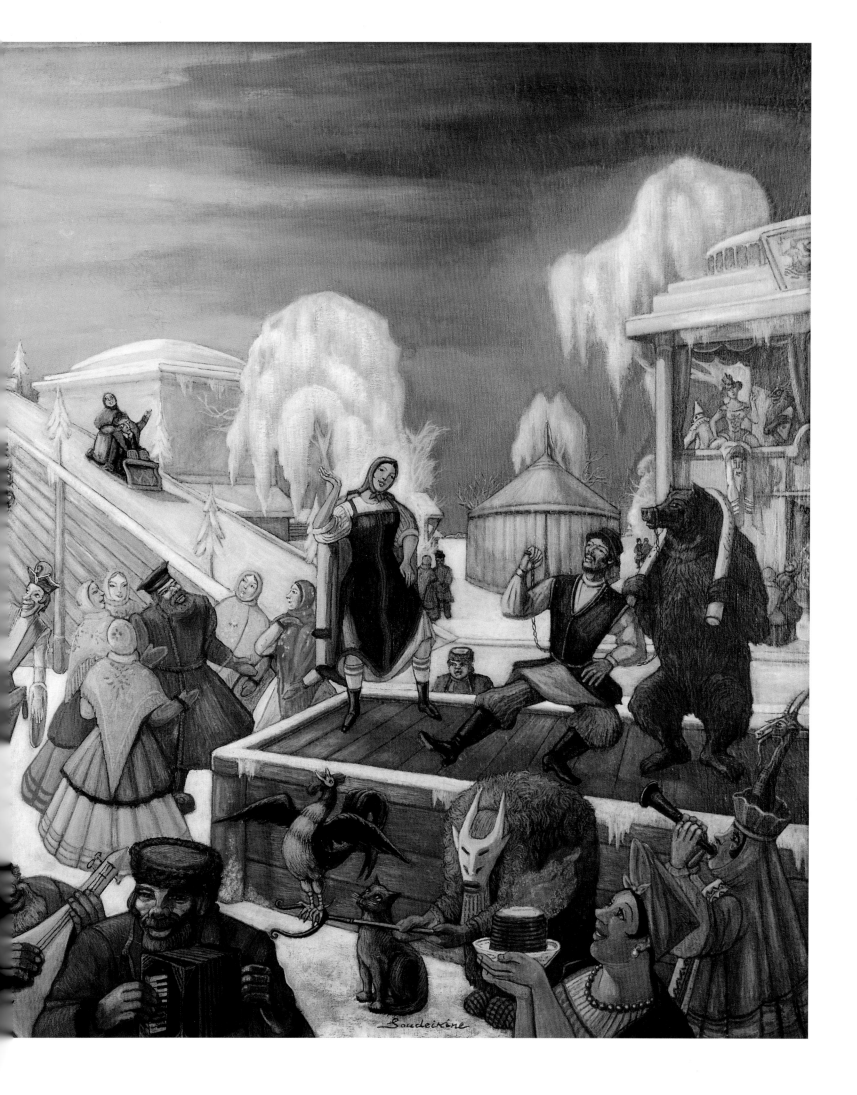

Sudeikin left many portraits. All of them, including the *Portrait of Nina Schick* are unique in their character of an image. Nina Schick is not only presented as a beautiful young woman but also as an artist. She is depicted by Sudeikin leaning on the frame of a painting, which is turned backwards to the viewer.

12

**Sergei Sudeikin**

Portrait of Nina Schick. Circa 1937 *

Oil on canvas. 35$^1/_2$ x 29$^1/_2$ in. (90.2 x 74.9 cm)

Private collection of Anthony and Judy Evnin

138

The artist turned to images of Harlequin and Pierrot, classical figures of the Italian comedy who personify playfulness and theatricality, in different periods of his life. At the end of the 1920s, working a lot on set designs for the Metropolitan Opera, Sudeikin was in search of pictorial and plastic solutions, consonant with tendencies in contemporary art. The images created by the artist clearly contain the idea of theatricalisation of life and inclination for transformation of everyday life. The ambivalent nature of Sudeikin's oeuvre, expressed in the play between the conditional and the concrete, reality and mystification, was further developed in the works of the 1920s. The decorativeness of the artistic solution reveals an emotional implication, pointing out the secret essence of these popular theatrical characters.

13

**Sergei Sudeikin**

Harlequin and Pierrot,
Double Self-Portrait. Circa 1927

Gouache on cardboard. $10^4/5$ x $13^4/5$ in. (27.5 x 35 cm)

Boris Stavrovski collection, New York, NY

139

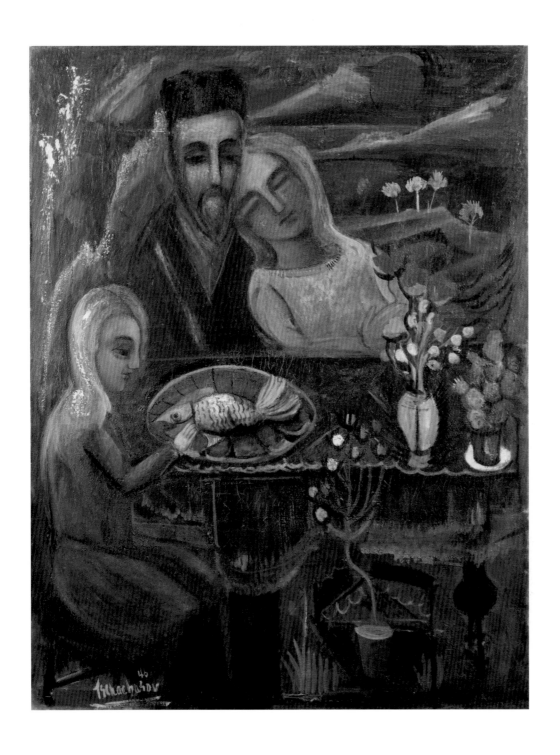

In *Friday Night*, a traditional Jewish family is seated at the Sabbath table. The background suggests the rocky landscapes ubiquitous in Old Master depictions of the Holy Family. The still life objects, blooming plants and red moon, typify the symbolic forms emblematic of Jungian psychoanalysis, which also influenced the artist.

14

**Nahum Tchacbasov**

Friday Night. 1946

Oil on canvas. 47 x 36 in. (121.9 x 91.4 cm)

The Jewish Museum, New York, NY

Gift of Samuel B. Cohn

140

Vasilieff portrayed interior family scenes in a neo-primitive genre characteristic of him. Furniture items and portrayed characters are often repeated in similar paintings, creating a slow and calm rhythm of life.

15

**Nicholas Vasilieff**

Couple at the Table. Circa 1923–1924 *

Oil on canvas. 42 x 50 in. (106.6 x 127 cm)

ABA Gallery, New York, NY

16

**Nicholas Vasilieff**

Still Life with Tea Cup and Vegetables *

Oil on canvas. 30 x 36¹/₄ in. (76.2 x 92.1 cm)

ABA Gallery, New York, NY

142

Tables with fruit, flowers and dishes are one of Vasilieff's favorite themes. Painted in neo-primitive genre like his portraits and interior scenes, they are wonderful in their simplicity and, delicate color and plasticity.

17

**Nicholas Vasilieff**
Still Life with Bouquet. 1920s–1930s [5*]
Oil on canvas.  22 x 29 in. (55.9 x 73.7 cm)
Private collection, Germany

143

18
**Leon Gaspard**
Russian Village, Mother
with Children. Late 1920s *
Oil on fiberboard. 15 x 19 in. (38.1 x 48.3 cm)
Fred Jones Jr. Museum of Art
The University of Oklahoma, Norman
Gift of William H. Thams in memory
of Roxanne P. Thams, 2003

19

**Leon Gaspard**

Les Artistes Inconnu. 1928 *

Oil on silk mounted on board. 12²/₅ x 20 in. (31.4 x 50.5 cm)

Fred Jones Jr. Museum of Art,

The University of Oklahoma, Norman

Gift of William H. Thams in memory

of Roxanne P. Thams, 2003

In this, as in other works on Russian themes, the artist returns to memories of his Motherland. The depicted images of peasant women and men are always drawn as if from nature, and although small in size, these scenes combine light irony with lyrical nostalgia.

Gaspard had a great ability to recreate the atmosphere of countries and places in his canvases. The artist led a life of adventure, traveling extensively through Asia and North America. Like most of Gaspard's work, *Pearl River at Canton* is painterly, displaying brilliant color and broad brushstrokes. Local colors of crowded life on the water in small and large boats are realistic and poetic in this landscape genre of the artist. The composition is Chinese-inspired, with a high horizon line, the figures and boats pushed to the outer edges, and the negative space of the river occupying the painting's center.

20

**Leon Gaspard**

Pearl River at Canton. 1926 *

Oil on fiberboard. 20 x 22¹⁄₄ in. (50.8 x 56.6 cm)

Fred Jones Jr. Museum of Art

The University of Oklahoma, Norman

Gift of William H. Thams in memory

of Roxanne P. Thams, 2003

146

The painting of Leon Gaspard's hometown, Vitebsk, was the first of eleven works by the Russian-born artist purchased by the Thams family. Old Vitebsk, with its churches and houses, towers in front of the viewers and they look at it together with people who are traveling alongside the Dvina banks in their carriages. Vitebsk, which is located on the Dvina, is not only Gaspard's hometown, but it is also the hometown of Marc Chagall. After reading about Gaspard, the Thams had developed an interest in his work. The acquisition was the only time the couple set out with the intention of buying a painting by a certain artist. So, in 1974, when they heard of a showing in Taos at the Byzantine adobe home built by Gaspard, they went determined to acquire one of his paintings. William Thams well remembers the experience saying, "We walked in the house and the walls were filled with these brightly colored Gaspard paintings, with antique Oriental carpets all over the floors, and this wonderful early American furniture... It was really quiet a *tour de force*".

21

**Leon Gaspard**

Vitebsk on the Dvina. Second half of the 1920s *

Oil on board. 18 x 26 in. (45.7 x 66.1 cm)

Fred Jones Jr. Museum of Art

The University of Oklahoma, Norman

Gift of William H. Thams in memory

of Roxanne P. Thams, 2003

147

22
**Leon Gaspard**
To Market. Second half of the 1920s *
Oil on canvas. 14$^{1}/_{2}$ x 9 in. (36.8 x 22.9 cm)
Fred Jones Jr. Museum of Art
The University of Oklahoma, Norman

23
**Leon Gaspard**
King Solomon. 1940 *
Oil, gouache and gold leaf
on paper. 30 x 24 in. (76.2 x 61 cm)
Fred Jones Jr. Museum of Art
The University of Oklahoma, Norman
Purchase, Richard H. and Adeline J.
Fleischaker collection, 1996

*King Solomon* is typical of Gaspard's flamboyant color and decorative surfaces. The artist, as if illustrating a scene from the book of *Kings*, describes this scene as follows: "… the king made a great throne at its rear, and arms on each side of the seat, and two lions standing beside the arms." The wealth that surrounded a wise, legendary king created numerous possibilities for the artist to decorate the surface of his canvas. The colors were applied loosely, showing the artist's study of Impressionism.

24

**Nikolai Fechin**

Manuelita with Kachina. 1927–1933 (?) [6*]

Oil on canvas. $20^{1}/_{4}$ x $16^{1}/_{8}$ in. (51.5 x 41.96 cm)

San Diego Museum of Art, CA

Bequest of Mrs. Henry A. Everett

25

**Nikolai Fechin**

Standing Nude. Late 1920s *

Oil on canvas. 24 x 20 in. (61 x 50.8 cm)

Fred Jones Jr. Museum of Art

The University of Oklahoma, Norman

Gift of William H. Thams in memory

of Roxanne P. Thams, 2003

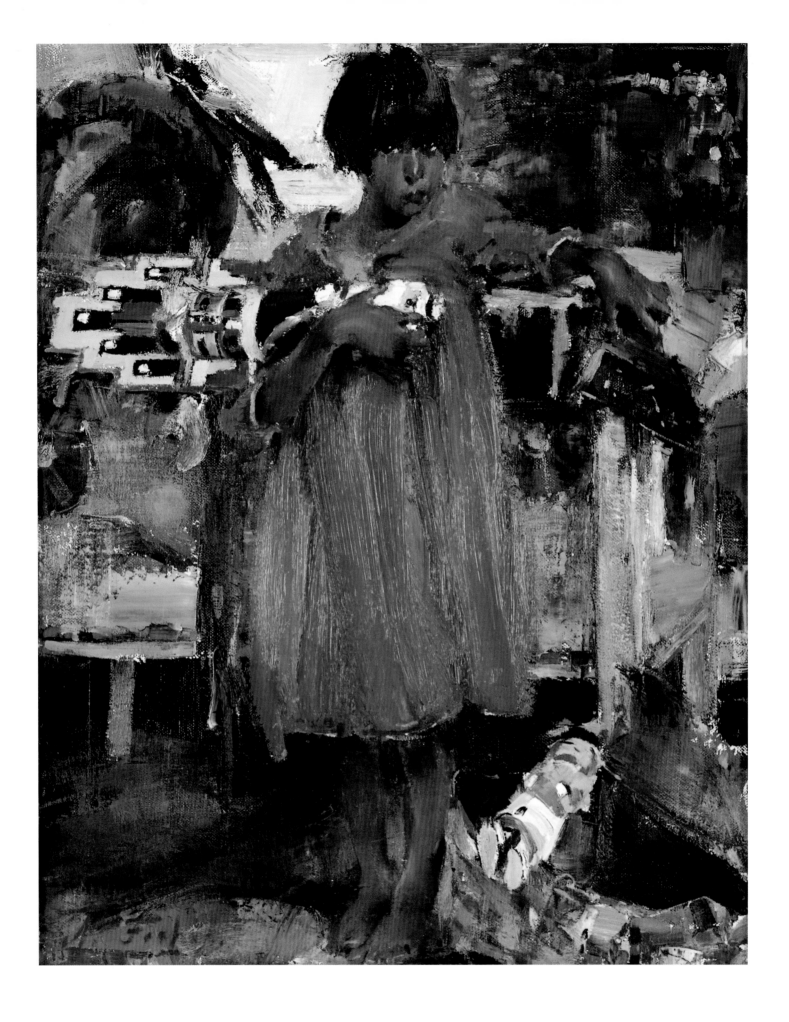

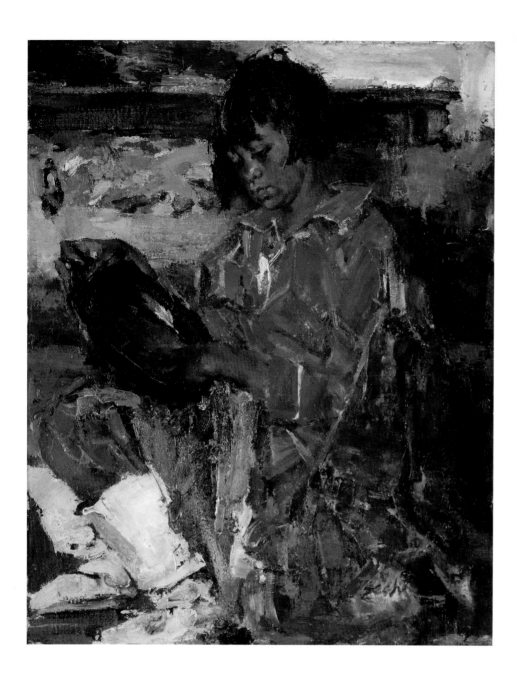

26

**Nikolai Fechin**
Girl in Purple Dress
Late 1920s — early 1930s *
Oil on canvas. 20 x 16 in. (50.8 x 40.7 cm)
Fred Jones Jr. Museum of Art
The University of Oklahoma, Norman
Gift of William H. Thams in memory
of Roxanne P. Thams, 2003

The artist's interest in woodcarving may account for his inclusion of *kachinas* in many of his Native American portraits, such as *Girl in a Purple Dress*.

27

**Nicolai Fechin**
Indian Girl with Pottery
Late 1920s — early 1930s *
Oil on canvas. 20 x 16 in. (50.8 x 40.7 cm)
Fred Jones Jr. Museum of Art
The University of Oklahoma, Norman
Gift of William H. Thams in memory
of Roxanne P. Thams, 2003

The pottery held by the girl in the painting is similar to ones made by Marina Martinez, the famous potter of San Ildefonso. Fechin's friend, Alice Marriott, introduced the artist who was interested in Native American pottery making, to Maria. According to Marriott, Maria explained her techniques in great detail to Fechin and even gave him two of her family's prized polishing stones.

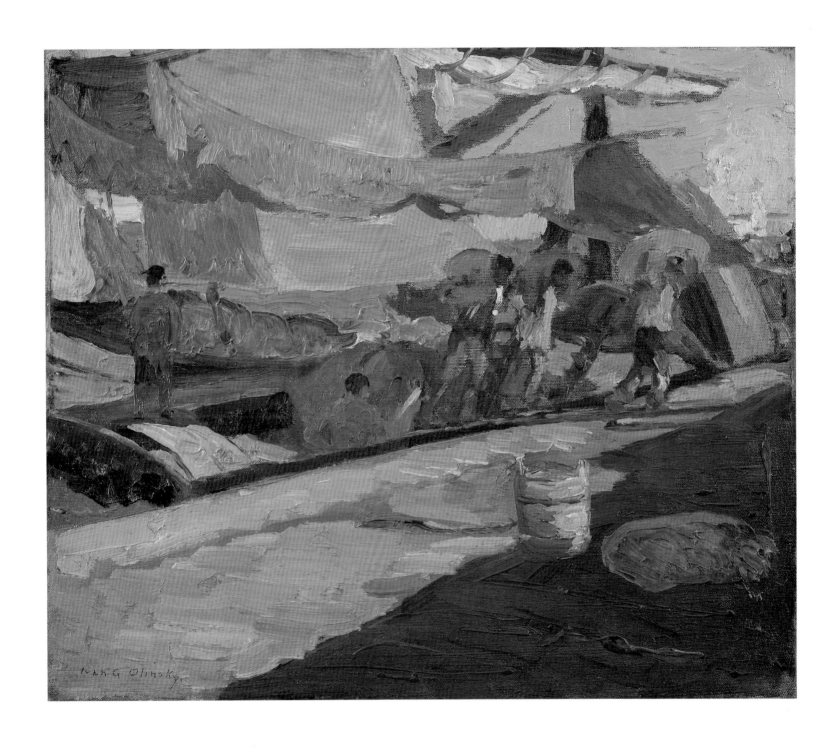

28

**Ivan Olinsky**

*Venice Waterfront — Boat and Water. 1930s* *

Oil on canvas mounted on board. 15 x 18 in. (38 x 45.7 cm)

Spanierman Gallery, New York, NY

In the 1920s, Olinsky experimented with new approaches to figure painting, for
example against a background of transparent curtains or in front of a mirror.
His style gradually became simpler in the late 1920s. In the 1930s, he remained
true to minimalism. Over the course of decades, he drew portraits of women
from whom the energy of a contemporary city blew. In addition to portraits,
which earned him a living, he did figure compositions.

29

**Ivan Olinsky**
Portrait of a Woman (Redheaded). 1915 *
Oil on canvas. 40 x 30 in. (101.6 x 76.2 cm)
Spanierman Gallery, New York, NY

Filled with lyrical mood, the *Woman on Beach*, delicate in color and plastic decisions, is done in the style of easel painting, which was characteristic the artist at the end of the 1910s.

30

**Boris Anisfeld**

Woman on a Beach. 1920s *

Oil on canvas. 50 x 40 (126.9 x 101.6 cm)

ABA Gallery, New York, NY

The painting is from the series of works dedicated to Jesus Christ. Clearly portraying the scene of *Descent from the Cross,* the artist associates this work, as well as other works from the series, with his own destiny.

31

**Boris Anisfeld**

Destiny. 1956 *

Oil on canvas. 71 x 51 in. (180.3 x 129.6 cm)

Boris Stavrovski collection, New York, NY

32

**Boris Anisfeld**

Self-Portrait. 1955

Oil on canvas. 32 x 26 in. (81.3 x 66 cm)

Boris Stavrovski collection, New York, NY

33

**Nikolai Cikovsky**

Self-Portrait. 1930s–1940s [5*]

Oil on board. $14^4/_5$ x $10^1/_5$ in. (36.5 x 26 cm)

Private collection, Germany

34

**Abram Manevich**

Still Life with Bottle. 1930s

Oil on canvas. $35^2/_5$ x $38^1/_5$ in. (90 x 97 cm)

ABA Gallery, New York, NY

35

**Abram Manevich**

Autumn. Second half of the 1930s *

Oil on canvas. 32$^{1}/_{4}$ x 27$^{1}/_{2}$ in. (81.2 x 69.9 cm)

From the collection of Irene and Alex Valger

36

**Ben Benn**

Flowers (Still life). 1938 *

Oil on canvas. 29$^{1}/_{2}$ x 23$^{3}/_{4}$ in. (75 x 60.3 cm)

Collection of Irene and Alex Valger

37

**Ben Benn**

On the Beach. First half of the 1930s

Oil on canvas. 32 x 22$^{4}/_{5}$ in. (81 x 58 cm)

Collection of Irene and Alex Valger

Benn was an artist who worked in various styles and genres. In this multi-figured composition, possibly on the beach, the artist is close to European impressionism. In *Still Life with Flowers*, he demonstrates an acute and sharp manner of drawing, a delicate understanding of the beauty of artistic nuances. One critic noted that Ben Benn "loves flowers with all his soul… and uses common rich and dense colors, which express the enviable energy of the artist and his enjoyment of his work." (William Murreel, Ben Benn, February 13th to March 4th, Gallery 144 West 13th Street.

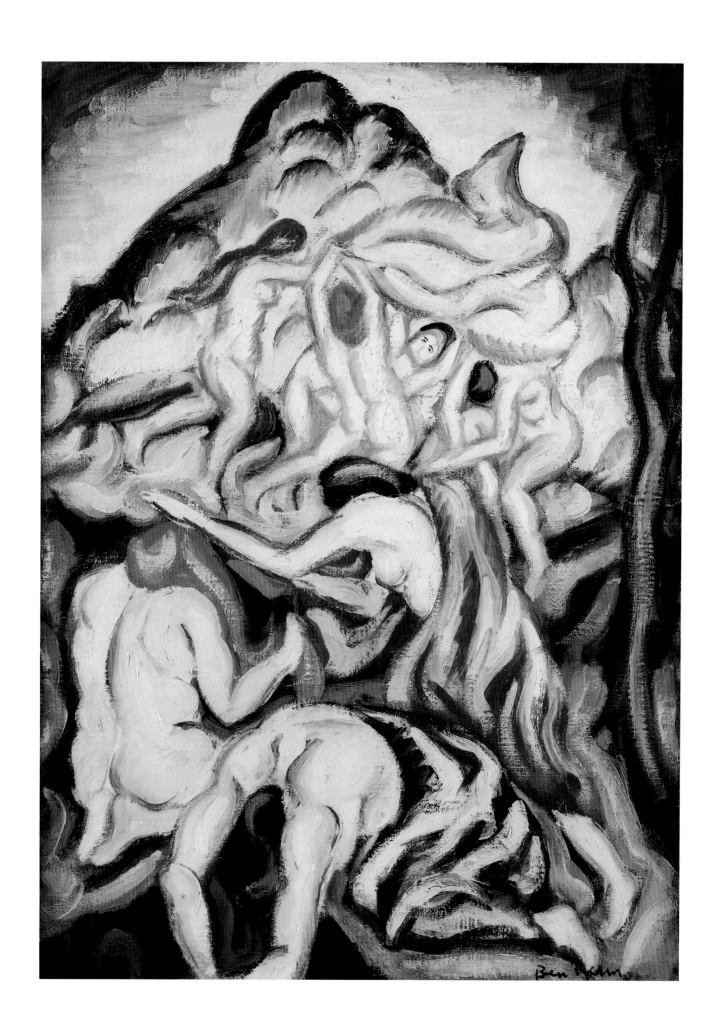

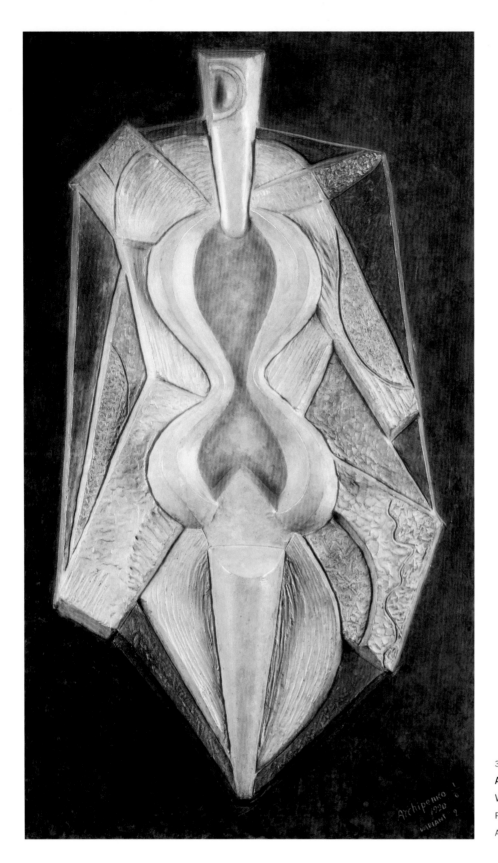

38

**Alexander Archipenko**

Woman. Abstraction. 1920 *

Polychromed bronze relief. 28 x 16$^{1}$/$_{4}$ in. (71 x 41 cm)

ABA Gallery, New York, NY

Colorful non-objective relief is one of the bright particularities of Archipenko's art of the mid-1910s. Turning to the same type of images in the 1920s, he did not use wood, which was the main material used for his reliefs in the mid-1910s — but bronze. He incorporates a conditional but visible image of the woman's figure into the form of the abstract background. Archipenko's 1950s works can also be characterized as figurative. Although in those works the artist also remains first and foremost a sculptor creating pliant images by plasticity of his artistic decisions.

39

**Alexander Archipenko**

Figures. 1950s *

Oil and mixed media on board. 24 x 18 in. (62 x 47 cm)

ABA Gallery, New York, NY

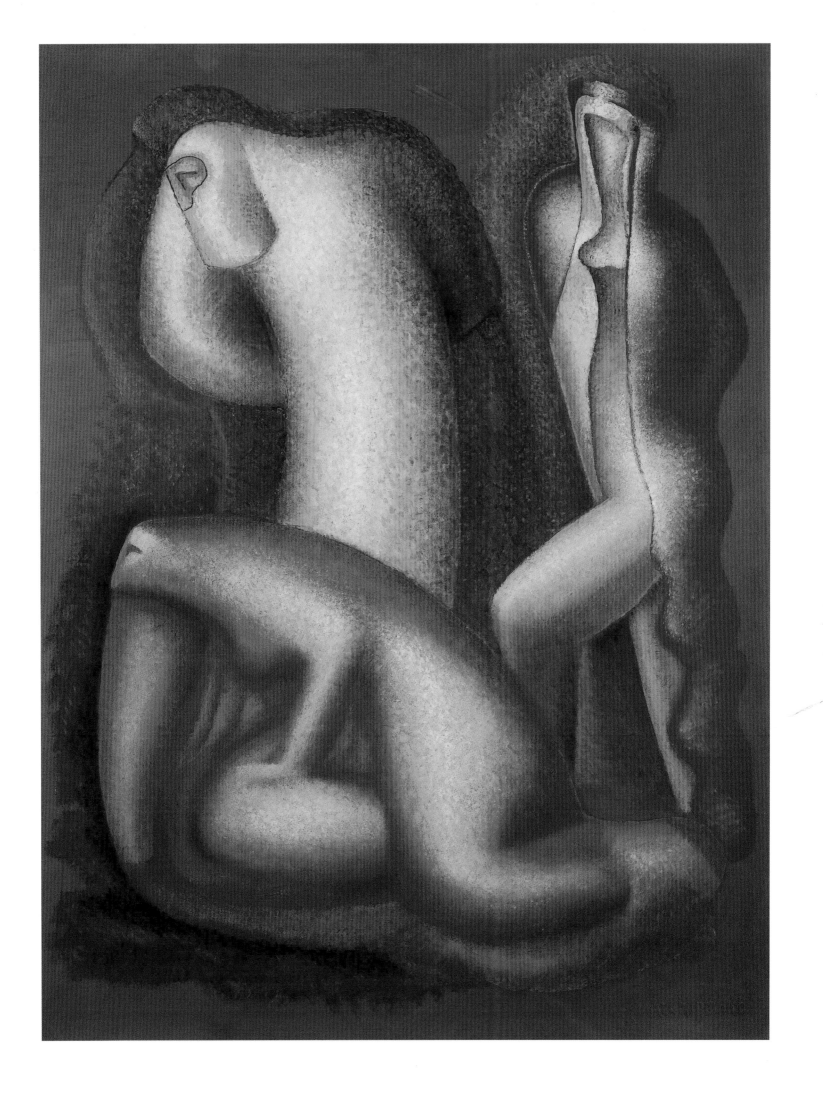

40

**Peter Blume**

Pig's Feet and Vinegar. 1927 *

Oil on canvas. $20^3/_{16}$ x $24^1/_2$ in. (51.3 x 62.2 cm)

The Jewish Museum, New York, NY

Purchase: gift of David Kluger, by exchange; Miriam and Milton Handler Fund; Charlotte Levite Fund in memory of Julius Nassau; Hanni and Peter Kaufmann, Gladys and Selig Burrows, Hyman L. and Joan C. Sall, and John Steinhardt and Susan Margules Steinhardt gifts

The image created by Blume is simultaneously serious and ironic. The small figure of a woman, painted into the winter landscape, is contrasted with the enlarged still life with pig's feet and the forbidden fruit, which is not available to a Jewish girl.

167

41

**Max Weber**

Gaillardias. 1933 *

Oil on canvas. 38¹/₄ x 17 in. (97.2 x 43.2 cm)

Whitney Museum of American Art

New York, NY

Museum purchase

The imagery of flowers by Weber was unusual for the genre of still life on a monochromatic scale, with a shimmering violet-grey-brown background, close in terms of the choice of colors to his multi-figured compositions.

42

**Max Weber**

The Talmudists. 1934 ⁵*

Oil on canvas. 50 x 34¹/₈ in. (127 x 86.7 cm)

The Jewish Museum, New York, NY

Gift of Mrs. Nathan Miller

Max Weber, one of the vanguard American modernists, was one of the few artists to adapt the language of modern painting to representations of Jewish themes. *The Talmudists*, with a nervous silhouette and Mannerist composition, that shows Weber's admiration of El Greco. He appropriates the gestures of El Greco's ecstatic Christian figures and saints for the excited gesticulation of the mystical Hasidic sect.

Max Weber was a pioneering figure in the introduction of European Modernism to the United States. His painting *Two Vases* depicts thin vases with long-stemmed flowers. Parallel vertical lines, offset by curving lines, frame and echo the forms of the vases. Planes of rich blue establish the dominant hue, while accents of yellow, green, and red enliven the painting, which is not a rare quality for the work of Jewish artists. In *Two Vases*, Weber uses both saturated, atmospheric color and cubistic, fragmented forms.

43

**Max Weber**

Two Vases. 1945 *

Oil on masonite or fiberboard

$39^{1}/_{4}$ x $31^{3}/_{4}$ in. (99.6 x 80.6 cm)

Fred Jones Jr. Museum of Art

The University of Oklahoma, Norman

Purchase, U.S. State Department collection, 1948

Max Weber's Jewish-themed works of the 1940s were painted with an awareness of the morbid conditions facing European Jews during the Holocaust. The heavily outlined figures, depicted with an emotional energy, although in cool, monochromatic tonalities that add to the contemplative, yet grave mood of the picture, inhabit an ascetic and timeless interior.

44

**Max Weber**

Sabbath. 1941

Oil on canvas. 21 x 28 in. (53.7 x 71.1 cm)

The Jewish Museum, New York, NY

Gift of Bella and Sol Fishko

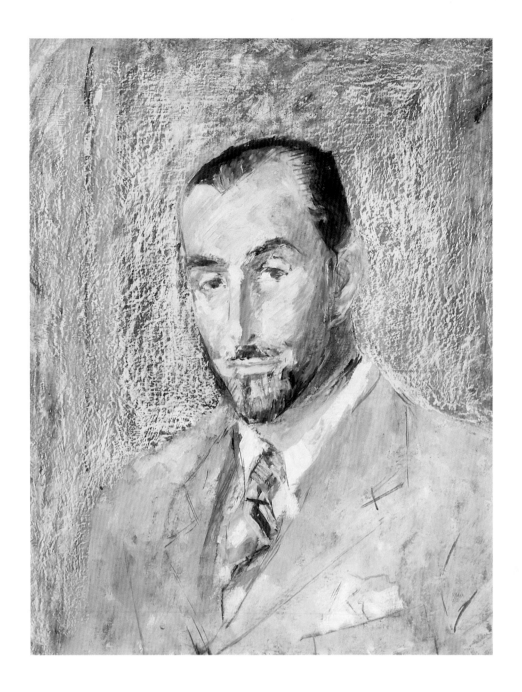

45

**Alexis Arapoff**

Study for Portrait of Yakovlev. 1936 *

Oil on canvas. 30$^1/_2$ x 25$^1/_2$ in. (77.4 x 64.7 cm)

Private collection of Mary Arapoff

In 1936, the Grace Horne Gallery in Boston hosted Arapoff's personal exhibition. It is evident that the *Study for the Portrait of Yakovlev*, who was already gravely ill and died later the same year, was painted then. This work was shown in a posthumous exhibition of Arapoff's works organized at the Museum of Fine Arts, Boston, in 1952 (catalogue, No. 331). Alexander Ye. Yakovlev (1887–1938) — a painter, representative of Neoclassicism in art of the early 20th century. His works are in numerous museum and private collections of the U.S. and Russia.

46

**Alexis Arapoff**

Artist's Wife in Red Jacket. 1933 *

Oil on canvas. 45$^1/_2$ x 29$^1/_2$ in. (115.6 x 75 cm)

Private collection of Mary Arapoff

Arapoff often painted his wife. *Artist's Wife in a Red Jacket*, painted in 1933, was exhibited at the artist's posthumous exhibition (Boston, 1952, No. 20).

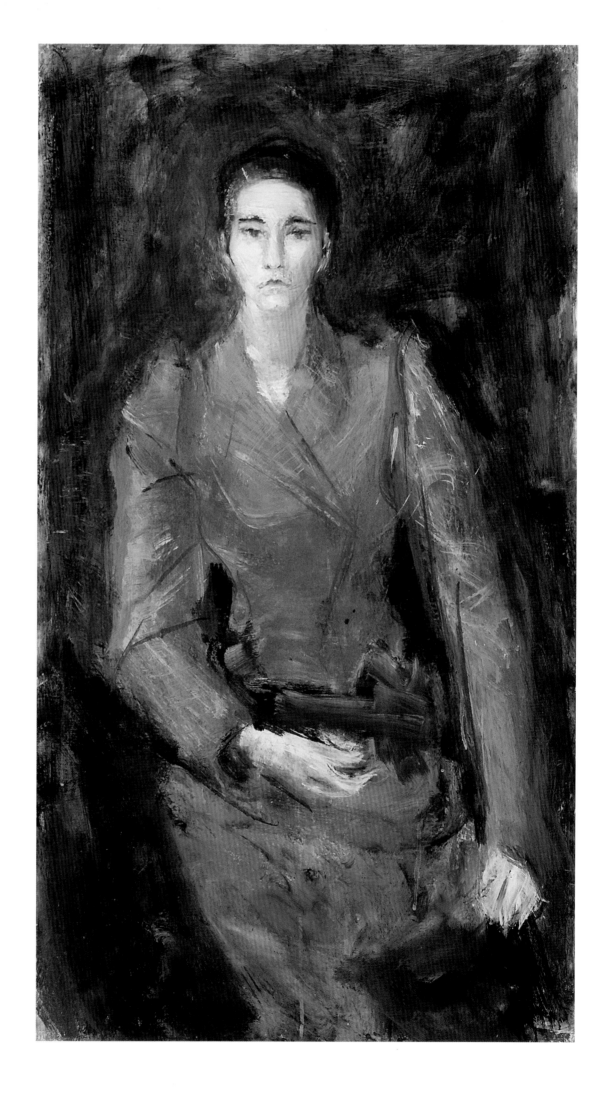

47

**Nicolai Cikovsky**
Still Life. 1930s–1940s [5*]
Oil on canvas. 25$^{4}$/$_{5}$ x 35$^{3}$/$_{5}$ in. (65.4 x 90.5 cm)
Private collection, Germany

Nicolai Cikovsky painted still lifes all of his life. The
artist often depicted the atmosphere of his own house.
The loneliness of a person occupying these spaces is
especially sharply represented in these works.

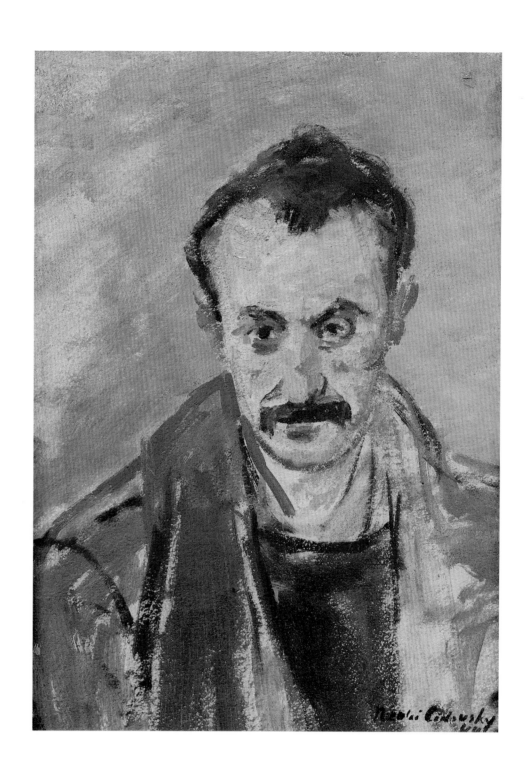

48

**Nicolai Cikovsky**

Portrait of Arshile Gorky. 1944 [5*]

Oil on board. $14^{1}/_{2}$ x $10^{1}/_{4}$ in. (36,5 x 26 cm)

Private collection, Germany

Arshile Gorky (1904–1948) was one of Nicolai Cikovsky's friends. The artist portrays Gorky submerged in his own deep thoughts, a state very characteristic to him.

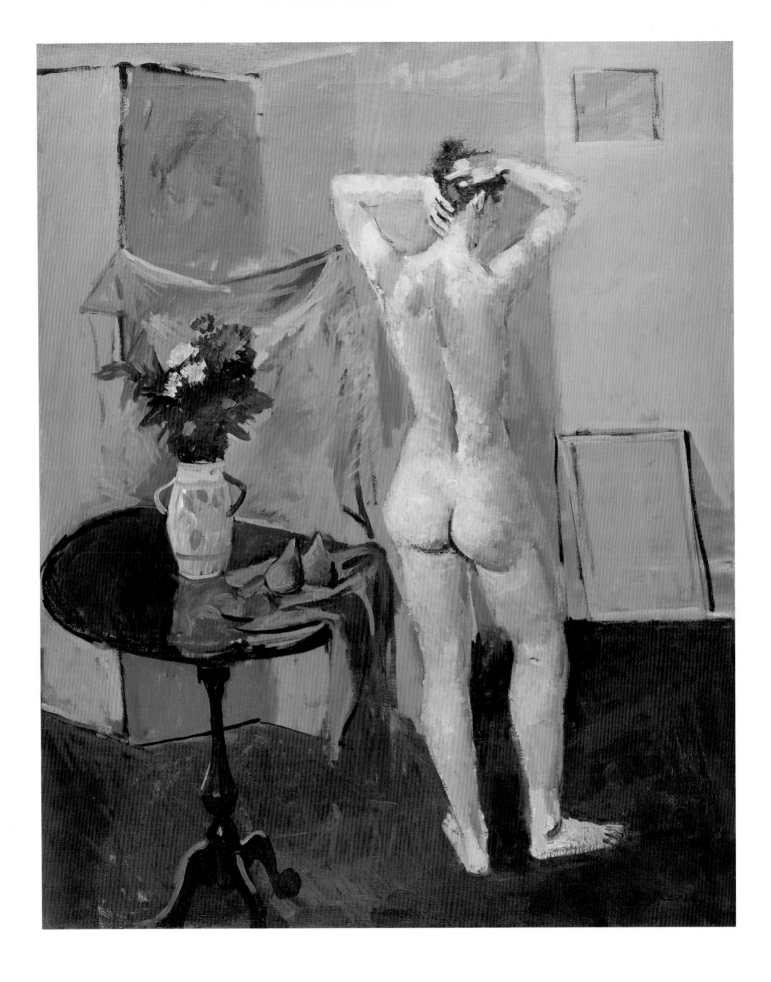

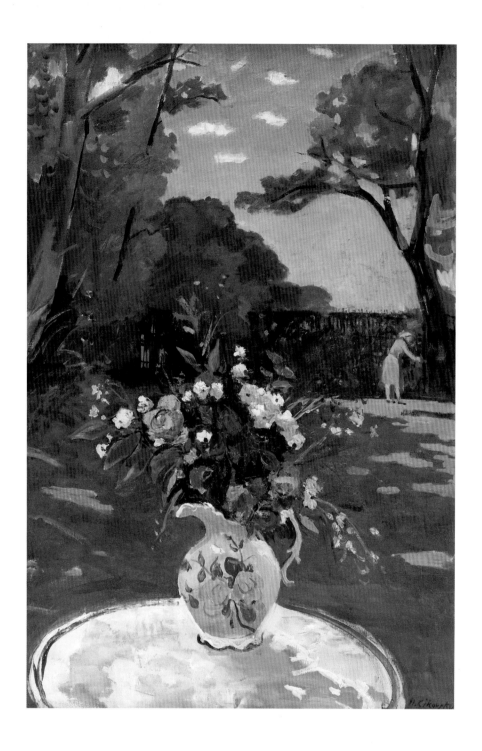

49
**Nicolai Cikovsky**
In the Studio. 1930s–40s
Oil on canvas. 30 x 24 in. (76.2 x 61 cm)
Spanierman Gallery, New York, NY

50
**Nicolai Cikovsky**
Still Life in a Garden,
Long Island. 1930s–1940s
Oil on canvas. 35 x 23 in. (88.9 x 58.4 cm)
Spanierman Gallery, New York, NY

Nicolai Cikovsky worked in different genres, demonstrating his skills as a painter and as a colorist, having received a good education and at the same time, an ability to use colors and shapes freely.

177

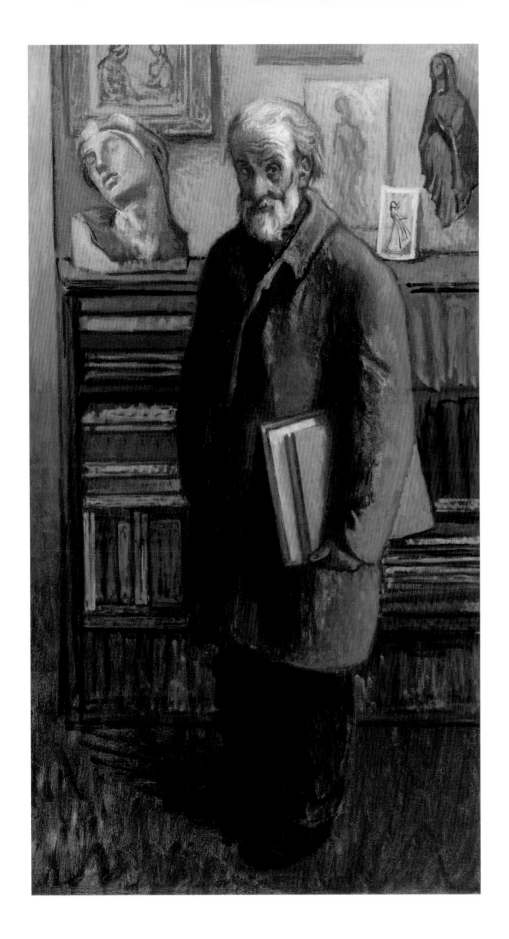

51

**Moses Soyer**

The Lover of Books. 1934 *

Oil on canvas. 42 x 23$^{1}$/$_{2}$ in. (106.7 x 59.7 cm)

The Jewish Museum, New York, NY

Gift of Ida Soyer

In this painting, the artist's father poses in front of shelves of books atop which are small sculptures, paintings and drawings. Though he is modestly dressed, he is associated with these signs of learning and high culture. Soyer's father had been a *maskil*, a purveyor of Jewish and general culture in Hebrew in Russia before immigrating to the United States.

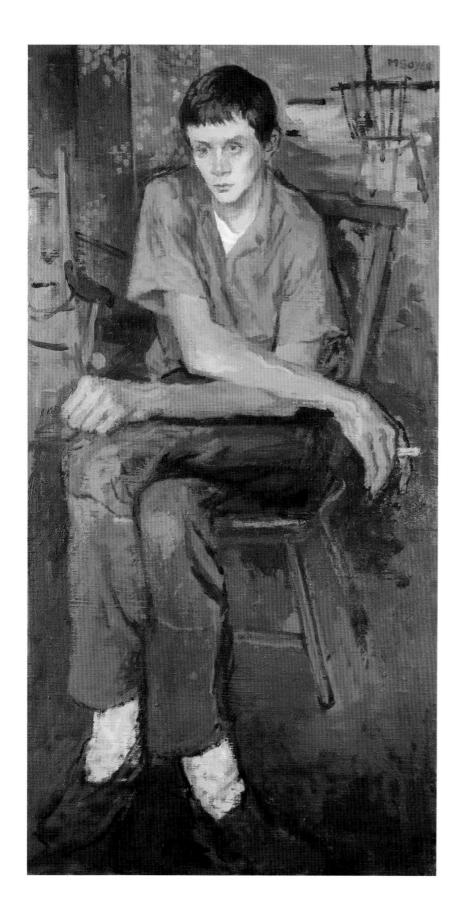

52
**Moses Soyer**
Felix. 1930s
Oil on canvas. 40 x 20 in. (101.6 x 50.8 cm)
National Academy Museum, New York, NY

Felix is probably one of Moses Soyer's friends or ac-
quaintances for he painted him rather frequently.

53

**Raphael Soyer**

Blond Figure. 1940s *

Oil on canvas. 32 x 21$^{1}/_{16}$ in. (81.4 x 53.3 cm)

National Gallery of Art, Washington, DC

Gift of James N. Rosenberg

Rafael Soyer often sketched and painted nudes. But in these works he did not train his hand as much as he searched for characteristic details in poses, clothing, and the surroundings, which he needed for his future works.

54

**Raphael Soyer**

Roommates. Circa 1934

Oil on canvas. 32 x 22 in. (81.2 x 55.9 cm)

Courtesy of Michael Rosenfeld Gallery, LLC

New York, NY

"I consider myself a modern artist, who paints modern life," Rafael Soyer often said about himself. "I only paint people in the natural context, people of my time," emphasized the artist. These statements were true to his art — depictions of real lives of typical Americans of the mid-20th century.

55

**Raphael Soyer**

Self-Portrait. 1950

Oil on canvas. $24^1/_2$ x $20^1/_8$ in. (62.2 x 51 cm)

National Academy Museum, New York, NY

Rafael Soyer often painted self-portraits following the classics — Rembrandt, Corot, Daumier. Looking into his own face, the artist mirrored the time, his moods and those of the epoch in which he lived.

56

**Moses Soyer**

Nude in Front of a Mirror. 1930s

Oil on canvas. 15 x 24 in. (38 x 61 cm)

Collection of Irene and Alex Valger

Just like his brother Rafael, Moses Soyer often painted nudes, sometimes so that he could later use his natural studies for his genre compositions.

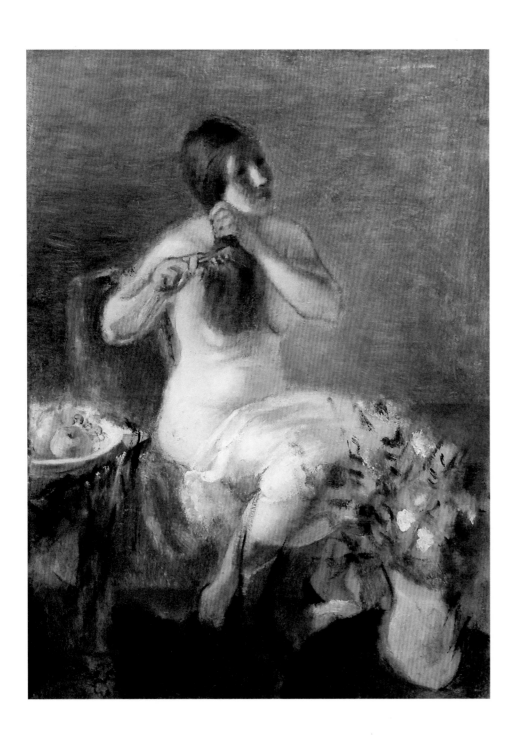

57

**Simka Simkovich**

Model Combing Her Hair

Second half of the 1920s — early 1930s *

Oil on canvas.  24 x 18 in. (60.9 x 45.7 cm)

Abby M. Taylor Fine Art, Greenwich, CT

184

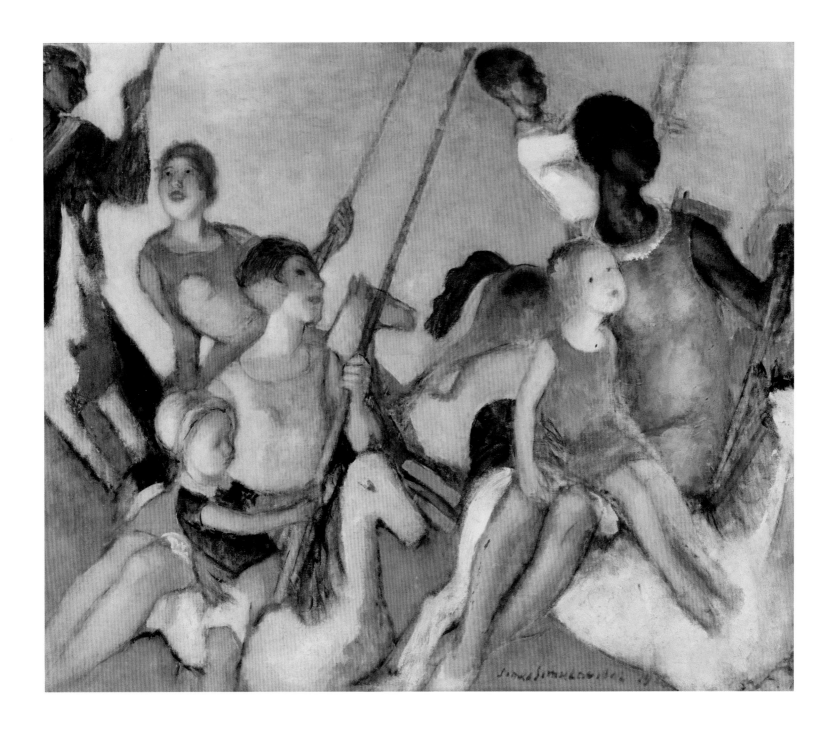

Simka Simkovich first presented his works in America in 1927. Then and later the critics noted his masterful skills and ingenuity, and the unique nature of his multi-figure compositions in the circus, on carousels, and during other public gatherings in gardens and parks. Having arrived in America, the artist devoted much of his time to murals. It is not by accident that his works often carried the effects of *grisaille* and pastels.

58

**Simka Simkovich**
Merry-Go-Round. 1930 *
Oil on canvas. 25 x 30 in. (63.5 x 76.2 cm)
Whitney Museum of American Art, New York, NY
Museum purchase

185

The city and its inhabitants are the main themes of Nina Schick's works of 1930–1940s. In her interest in everyday life, the artist was true to social realism, which was one of the most important genres of American art of that time.

59

**Nina Schick**

Manhattan Fish Market. 1938 *

Oil on fiberboard. 27 x 21 in. (68.6 x 53.3 cm)

Private collection of Anthony and Judy Evnin

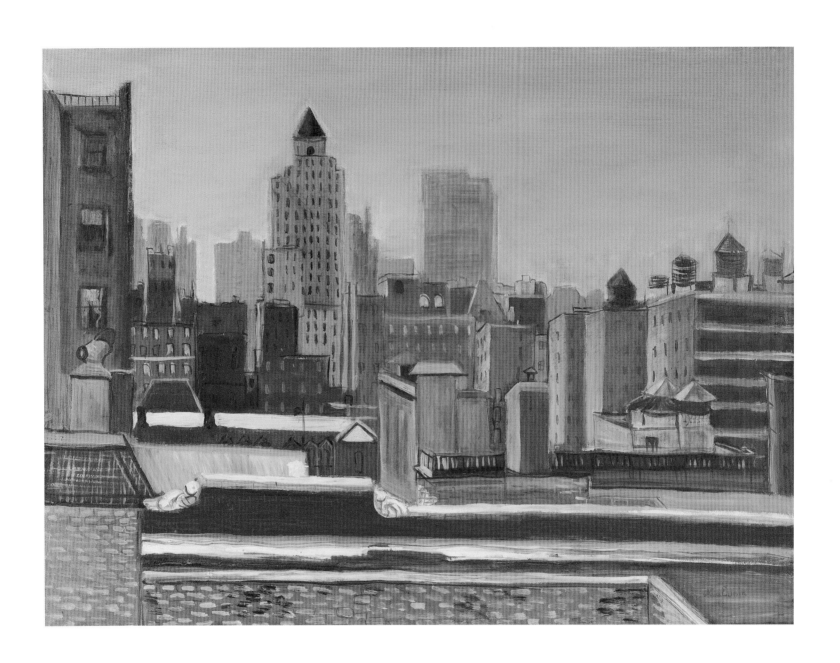

60

**Nina Schick**
Manhattan Cityscape. 1940s *
Oil on fiberboard. $24^{1}/_{2}$ x $18^{1}/_{2}$ in. (62.2 x 47 cm)
Private collection of Anthony and Judy Evnin

187

61

**Leonid Berman**

Faraduro, Portugal. 1952 *

Oil on canvas. 40 x 32 in. (101.6 x 81.3 cm)

National Gallery of Art, Washington, DC

Gift of the Avalon Foundation

Eugene Berman is rightfully called one of the brightest neo-romantics of the first half of the 20th century. Interested in old architecture, the artist often painted ancient cities in romantic light (*Roman Evening*). He frequently paints fountains, ruins, destroyed towers, empty windows, open gates, and limitless arcades. These details not only transport the viewer into the past epochs, but also become the metaphors for fame and grandeur, alternating with the forgotten and the desolate — metaphors for loneliness of an individual in the world that surrounds him.

62

**Eugene Berman**

La Fontana. Undated *

Oil on canvas mounted on paper

11³/₄ x 8¹/₂ in.  (29.8 x 21.6 cm)

Boris Stavrovski collection, New York

63

**Eugene Berman**

Roman Evening. 1954 *

Oil and gouache on wooden board

10 x 14 in. (25.4 x 35.6 cm)

Boris Stavrovski collection, New York

191

64

**John Graham**

Untitled (Pink Acrobat). 1927 *

Oil on canvas. 22 x 14 in. (55.9 x 35.6 cm)

Courtesy of Michael Rosenfeld Gallery, LLC

New York, NY

Like many artists of the 20th century, Graham liked the circus and often used scenes from the lives of circus people. His acrobat, reminiscent of Picasso figures, does not fit into the allotted space which is limited by the surrounding walls. Just like *Circus Horse*, the acrobat represents an allegory of freedom constricted by circumstances.

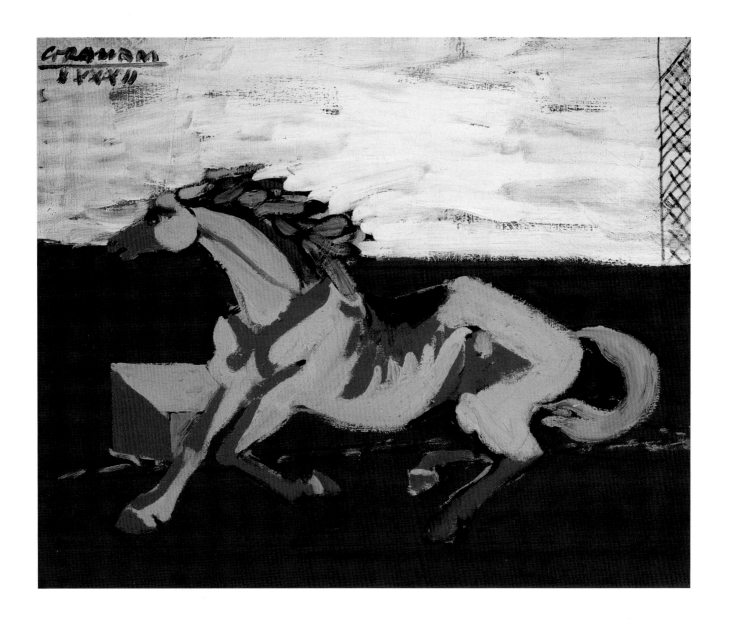

The theme of the circus runs through twentieth-century art. Among several prominent examples, the subject emerges in the work of Joan Miró and Alexander Calder — both of whom completed circus series in the late 1920s — and it recurs throughout Picasso's career. The allure of the circus for twentieth-century artists derives from its thrilling spectacle as well as its location at the crossroads of high and low culture; the circus offers entertainment for the masses even as it exists outside the mainstream of society. Like modern art, the circus mounts an exuberant revolt against accepted conventions of beauty and behavior. Yet, as anarchic as the circus appears to be, it operates according to rules and traditions of its own. In this way, Graham's horse suggests that in the world of the circus, and perhaps modern art, too, true freedom is a myth bolstered by a forceful illusion of wildness.

65

**John Graham**
Circus Horse. 1942 **
Oil on canvas. 20 x 24 in. (50.8 x 60.8 cm)
Hollis Taggart Galleries, New York, NY

66

**John Graham**

Reclining Soldier. 1942 *

Oil on canvas. 20 x 24$^1$/$_8$ in. (50.8 x 61.2 cm)

Smithsonian American Art Museum, Washington, DC

Museum purchase

67

**John Graham**

Poniatowsky. Circa 1942 *

Oil on canvas. 30 x 24 in. (76.2 x 60.8 cm)

Courtesy of Michael Rosenfeld Gallery, LLC

New York, NY

Both works belong to the series of works produced by Graham during World War II as his memories of his own military service in Russia and are, of course, connected to the war that Soviet soldiers were fighting.

195

68

**Ben Shahn**

Renascence. 1946 *

Gouache on Whatman hotpressed board

21⁷/₈ x 30 in. (55.5 x 76.2 cm)

Fred Jones Jr. Museum of Art

The University of Oklahoma, Norman

Purchase, U.S. State Department collection, 1948

Painted immediately after World War II by a leading Socialist Realist, *Renascence*, whose title means "rebirth," represents the hope for regeneration after the ravages of war. Emblems of fertility and renewal include the thicket of spring grain (a product of nature) and the phallic column (a product of civilization). A heap of tangled metal in the background represents the urban landscape's recent devastation and recalls images of Hiroshima's ruins, which newspapers reproduced widely at the time.

197

69

**Ben Shahn**

New York. 1947 5*

Tempera on paper mounted on panel

36 x 48 in. (91.4 x 121.9 cm)

The Jewish Museum, New York, NY

Purchase with funds provided by the Oscar and Regina Gruss

Charitable and Educational Foundation Fund

The image of an old Jew with a New York window display in the background is a unique symbol of the Post-War city where many representatives of this nationality remained alive. At the same time, a modern American window display as a background for the main character can also be associated with the traditional vendor kiosks in Jewish settlements in Russia, which the author of the canvas, without a doubt, remembered well.

This nostalgic and dreamlike composition presents a collage of images from the artist's past. It was inspired by two photographs Ben Shahn took in the 1930s, one of a fish market on New York's Lower East Side, and another of a young boy wearing swim trunks. Shahn links these motifs to evoke the hardship of his immigrant experience and sombre recollections of his younger brother, who had died in a swimming accident two decades earlier.

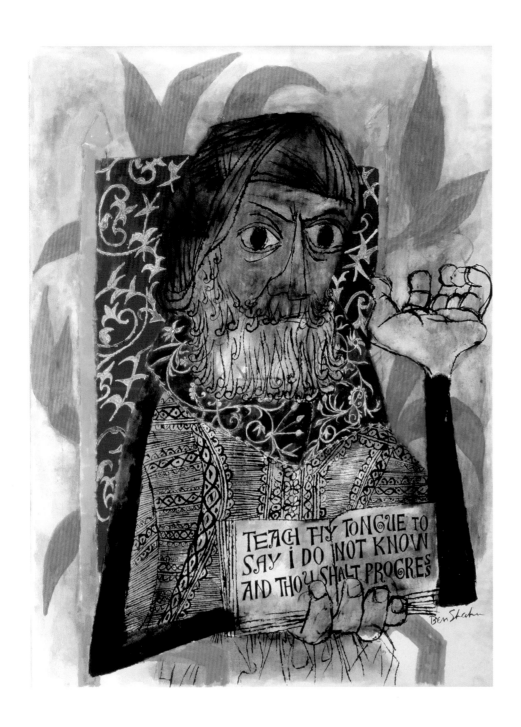

70

**Ben Shahn**

Maimonides. 1954 [5*]

Tempera on paper mounted on panel

35$^{1}$/$_{2}$ x 26$^{1}$/$_{2}$ in. (90.2 x 67.3 cm)

The Jewish Museum, New York, NY

Bequest of Jacob and Bronka Weintraub

*Maimonides* is related to a large scale work of the same subject originally commissioned for the business offices of the eminent research psychiatrist, medical advertising and publishing entrepreneur, and art collector, Dr. Arthur M. Sackler (1913–1987). The image reappeared in Shahn's mural *Apotheosis*, in which the figure of the 12th century rabbi, physician, and philosopher served as a symbol of the necessity for moral and spiritual values to counteract civilization's path toward self-destruction.

71

**Emmanuel Mane-Katz**

The Musician *

Bronze. $10^{1/2}$ x 12 x 8 in.

(26.6 x 30.5 x 20.3 cm)

ABA Gallery, New York, NY

Many of Mane-Katz's works address historical and re-
ligious Jewish themes, which was influenced by his
move to Israel after World War II. *The Musician* is one
example from a series he made of Jewish musicians.
He was extremely popular during his lifetime and his
works are housed in museums throughout the world.

72

**Pavel Tchelitchew**

Portrait of Flo Tanner

Second half of the 1930s—early 1940s

Oil on canvas. 39$^{1}/_{2}$ x 31 in. (100.2 x 78.7 cm)

From a private collection

73

**Pavel Tchelitchew**

Maude Stettiner. 1931 [4*]

Oil on canvas. 51$^{1}/_{8}$ x 35$^{1}/_{8}$ in. 129.6 x 89.2 cm

Hirshhorn Museum and Sculpture Garden

Smithsonian Institution, Washington, DC

Gift of the Joseph H. Hirshhorn Foundation, 1966

Flo Tanner is the mother of Allen Tanner, who was a very close friend of Tchelitchew in the second half of the 1920s — beginning of the 1930s.

This portrait, like an image of Maude Stettiner, is executed in an unusual style for this genre. The portraits carry the artist's interest towards details in the appearance of his models. Their characteristics are built on colors — at times it is somewhat muted and almost monochrome (*Portrait of Flo Tanner*) and at times it is a bright spot on a dark background (*Maude Stettiner*).

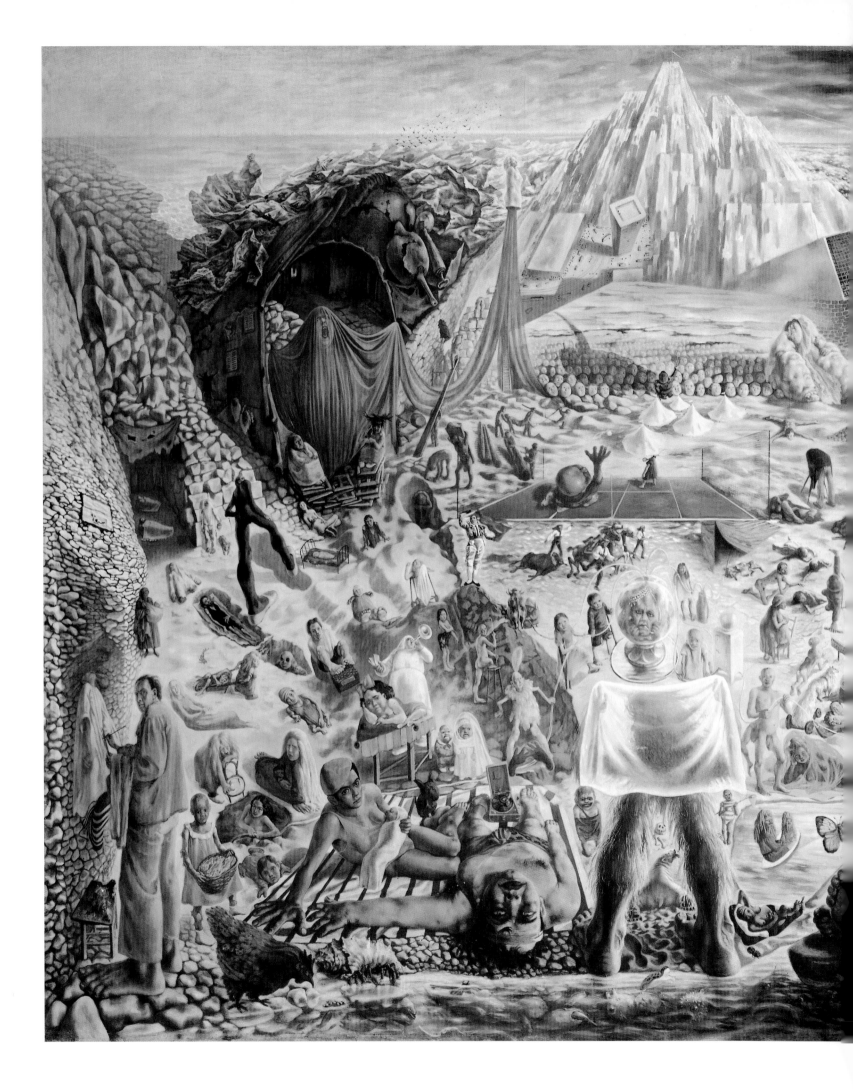

74

**Pavel Tchelitchew**

Phenomenon. 1936–1938 [5]*

Oil on canvas. $79^{1}/_{2}$ x $106^{3}/_{5}$ in.

(202 x 271 cm)

State Tretyakov Gallery

Bequeathed in 1962 by the artist

*Phenomenon* is Pavel Tchelitchew's main work. It depicts Hell, to which humans have condemned themselves. The painting is full of symbolic meaning, grotesque images, and irony.

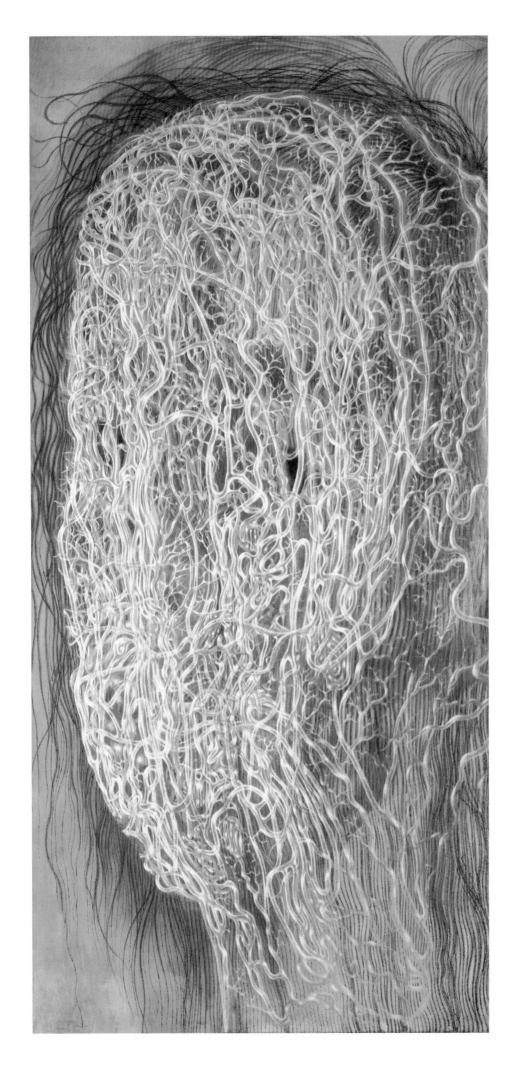

75

**Pavel Tchelitchew**

Interior Landscape. Circa 1947 *

46 x 22 in. (117.2 x 55.9 cm)

Courtesy of Michael Rosenfeld Gallery, LLC

New York, NY

76

**Pavel Tchelitchew**

Head of Gold. 1947 *

25$^{1}/_{5}$ x 18 in. (64.1 x 46 cm)

Collection of Halley K. Harrisburg and Michael Rosenfeld

New York, NY

The head for Tchelitchew is a model of a stellar globe to which all humanity is connected by some unseen ties, imagined the artist. Portraying humans without skin and revealing their essence was helpful in understanding these invisible ties, Tchelitchew believed.

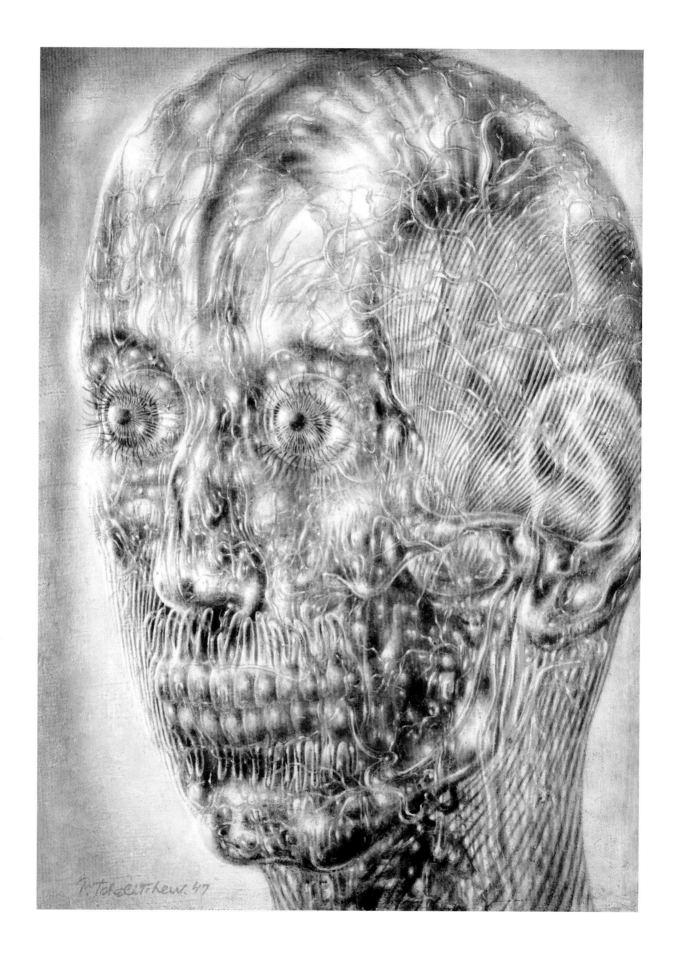

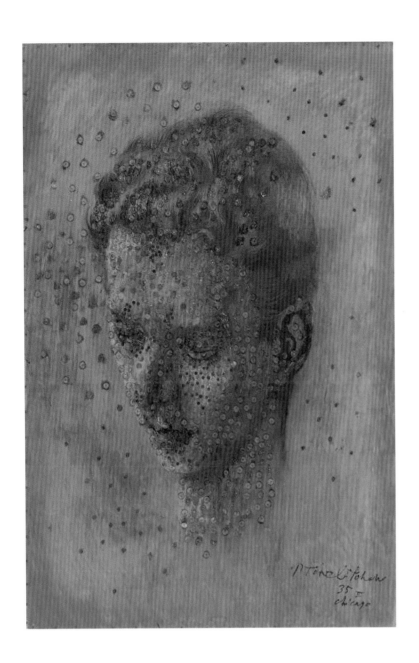

77

**Pavel Tchelitchew**

Spangled Head (Portrait of Charles
Henry Ford under Snow). 1935
Watercolor, gouache and sequins
on illustration board. $29^{1}/_{2}$ x $19^{3}/_{5}$ in. (75 x 50 cm)
Boris Stavrovski collection, New York, NY

Portraits did not interest Tchelitchew in the traditional
meaning of this genre. He always searched for new
expressive ways of portrait creation. Charles Henry Ford,
a close friend of the artist, is featured with snow spark-
les covering his face.

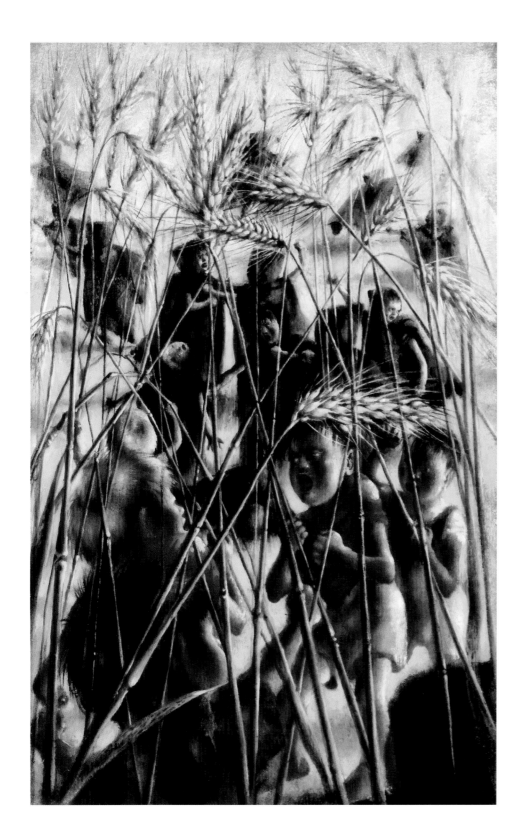

78

**Pavel Tchelitchew**

Boys Fighting in Wheat

1939–1941 *

Oil on canvas. 28³/₄ x 18¹/₄ in. (73 x 46.3 cm)

Courtesy of Michael Rosenfeld Gallery, LLC

New York, NY

*Boys Fighting in Wheat*, as many other Tchelitchew's works, is an allegory. In this case the painting symbolizes cruelty, characteristic of humans from birth. Children's heads, still in the wombs of their mothers who are walking across the field, strengthen this symbolism.

79
**Pavel Tchelitchew**
Anatomical Painting. 1946 *
Oil on canvas. 56 x 46 in. (142.2 x 116.8 cm)
Whitney Museum of American Art, New York, NY
Gift of Lincoln Kirstein

Tchelitchew called similar works anatomical land-
scapes for a reason. The artist in fact presented hu-
man structure as part of nature, changing in color and
form throughout the growth process.

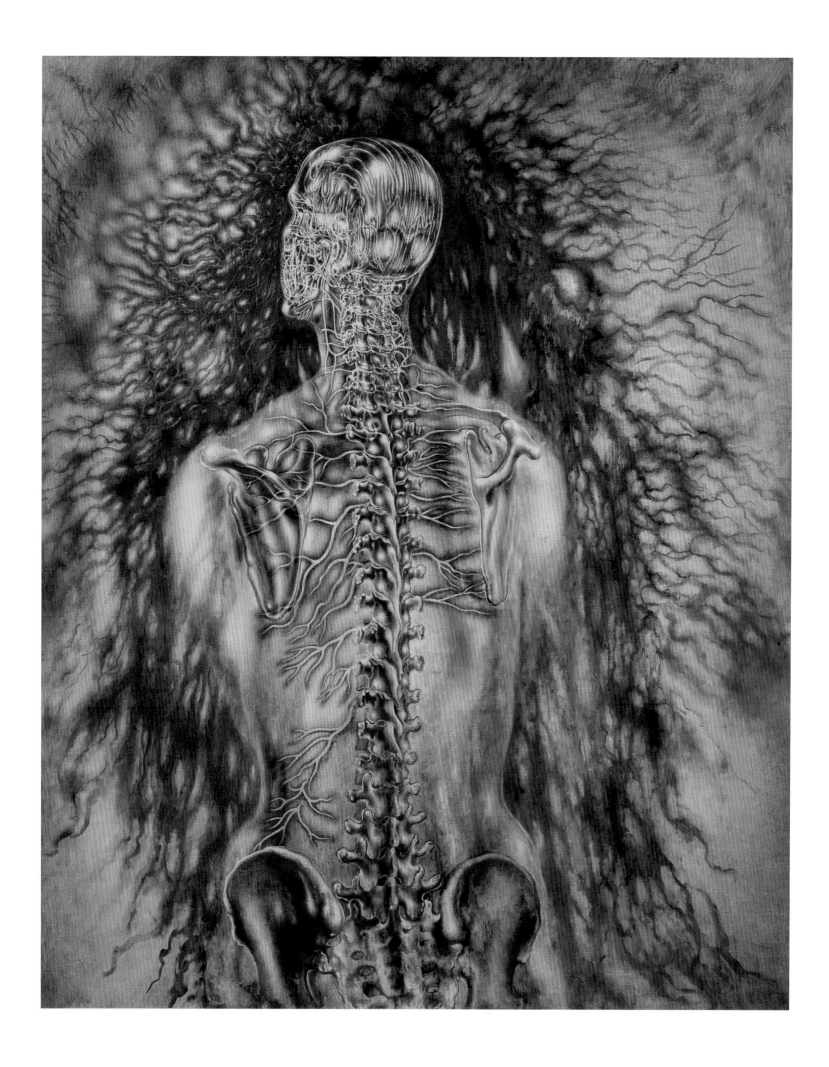

80

**Arshile (Archil) Gorky**

Abstract Composition. 1930 *

Oil on canvas. 14 x 18 in. (35.5 x 45.5 cm)

ABA Gallery, New York, NY

81

**Arshile (Archil) Gorky**

Abstract Composition. 1930s *

Oil on canvas. $19^{3}/_{4}$ x $15^{3}/_{4}$ in. (50 x 40 cm)

ABA Gallery, New York, NY

Both compositions are from Gorky's early Abstractionist period. Stylistically they are very close to the painting *Figure* (circa 1930, Courtesy of Ostin), and also to the mural done by the artist for the Newark Airport.

212

82

**Ben-Zion**

The Forest. Circa 1935–1939

Oil on canvas. 36$\frac{1}{4}$ x 30 in. (92.1 x 76.5 cm)

Smithsonian American Art Museum, Washington, DC

This is a characteristic technique of simple and expressive language, which Ben-Zion used to create works in different genres.

214

*Jacob Wrestling with the Angel* has been a theme in art from Rembrandt in the seventeenth century to Gauguin in the nineteenth. Here human and divine elements merge in a struggle that blurs the boundaries between abstraction and figuration. The avian motifs suggest indigenous American art as static symmetry gives way to a non-Western, dynamic circular design, while the large hands evoke the physical and spiritual powers linking the poet, artist, and prophet.

83

**Ben-Zion**

Jacob Wrestling with the Angel. 1935

Oil on canvas. 38³/₈ x 47³/₁₆ in. (97.5 x 119.9 cm)

The Jewish Museum, New York, NY

Bequest of Jula Isenburger; gifts of Mrs. Ethel L. Elkind and Mr. and Mrs. Jacob Shulman, by exchange

215

84
**Boris Lovet-Lorski**
Winged Sphinx. 1930–1932 *
Egyptian granite. $22^1/_8$ x $40^1/_2$ x $14^1/_2$ in.
(56.1 x 102.7 x 36.8 cm)
Hirshhorn Museum and Sculpture Garden
Smithsonian Institution, Washington, DC
Bequest of the artist, 1978

Lovet-Lorksi is a sculptor who always surprised his contemporaries with the variety of materials he chose with precision for the creation of his images. In the 1930s he worked in a monumental manner that corresponded to the latest modernist style which was also used in American architecture as well as in sculpture.

85

**Jacques Lipchitz**

Man with Mandolin. 1925

Bronze. $17^{3}/_{4}$ x 8 x $7^{5}/_{8}$ in. (45.1 x 20.3 x 19.4 cm)

Hirshhorn Museum and Sculpture Garden

Smithsonian Institution, Washington, DC

Bequest of Joseph H. Hirshhorn, 1981

86

**Jacques Lipchitz**

Reclining Woman with Guitar. 1928 *

Bronze. $16^{1}/_{8}$ x $29^{5}/_{8}$ x $12^{3}/_{4}$ in. (41.1 x 75.3 x 32.3 cm)

Hirshhorn Museum and Sculpture Garden

Smithsonian Institution, Washington, DC

Gift of Joseph H. Hirshhorn, 1966

219

87

**Jacques Lipchitz**
Miracle II. 1948
Bronze. 30¹/₂ x 14 in. (76.8 x 34.6 x 33.5 cm)
The Jewish Museum, New York, NY
Gift of Karl Nathan

Jacques Lipchitz fled France and worked in New York during World War II. Created in the aftermath of the Holocaust, *Miracle II* evokes two miracles: Hanukkah, which commemorates the rededication of the Second Temple in the Second Century B.C.E., and the birth of the State of Israel in 1948. These events are recalled through the motif of a fertility sculpture suggested by the figure in a prayer shawl merging with a flaming menorah and Decalogue.

88

**Jacques Lipchitz**
Joy of Orpheus. 1945/cast by 1957 [4*]
Bronze. 18³/₈ x 10 x 7¹/₄ in. (46.5 x 25.4 x 18.5 cm)
Hirshhorn Museum and Sculpture Garden
Smithsonian Institution, Washington, DC
Gift of Joseph H. Hirshhorn, 1966

This is a typical Lipchitz work in its plasticity and is characteristic of the artist in its knot-like forms.

89

**Peter Krasnow**

Demountable (4 Segments). 1938

Walnut. 58 x 13 x 10 in. (147.3 x 33 x 25.4 cm)

Tobey C. Moss Gallery, Los Angeles, CA

Peter Krasnow was very interested in wood while cre-
ating sculpture, giving preference to local stumps, logs,
and remnants from saw-mills. He created a sculpture
form that consisted of many joints and separate details.
Alternating protrusions and cavities, he created images
reminscent of ancient totems.

90
**Ossip Zadkine**
Study for the Prisoner. 1943 *
Bronze. 17³/₄ x 7³/₄ x 6⁵/₈ in. (45.1 x 19.7 x 16.8 cm)
The Jewish Museum, New York, NY
Gift of Iris Cantor (Mrs. B. Gerald Cantor), New York

Created after Zadkine's departure for the U.S. from occupied France, *The Prisoner* is dedicated to those who were imprisoned in the Nazi camps. The work is done in Zadkine's characteristic manner, based on the elements of Cubism and in accordance with a stylistic archaic style

Esphyr Slobodkina '50

Esphyr Slobodkina, wife of Ilya Bolotowsky in the 1950s, was part of the abstract artists group. *Abstract Composition* is characteristic not only of Slobodkina's work of that period, but also of American Abstractionism.

91

**Esphyr Slobodkina**

Abstract Composition. 1950 *

Oil on masonite (or fiberboard)

$10^7/_8$ x $19^3/_4$ in. 27.5 x 50 cm

ABA Gallery, New York, NY

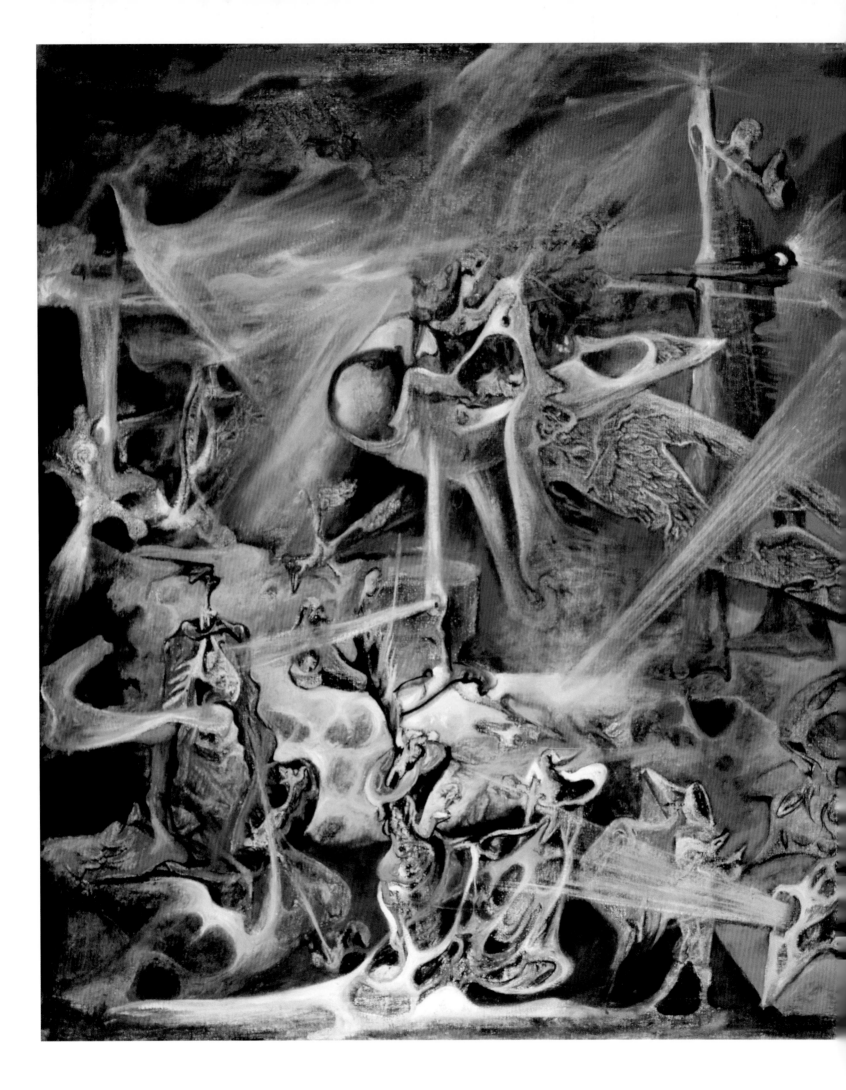

92
**Boris Margo**
Matrix of the Unborn World. 1939 *
Oil on canvas. 30 x 36 in. (76.2 x 91.4 cm)
Courtesy of Michael Rosenfeld Gallery, LLC
New York, NY

Abstract paintings by Boris Margo, as a rule, often deal with unknown natural causes. He depicts underground explosions and explosions in the sky invisible to the eye, and human life in its environment.

227

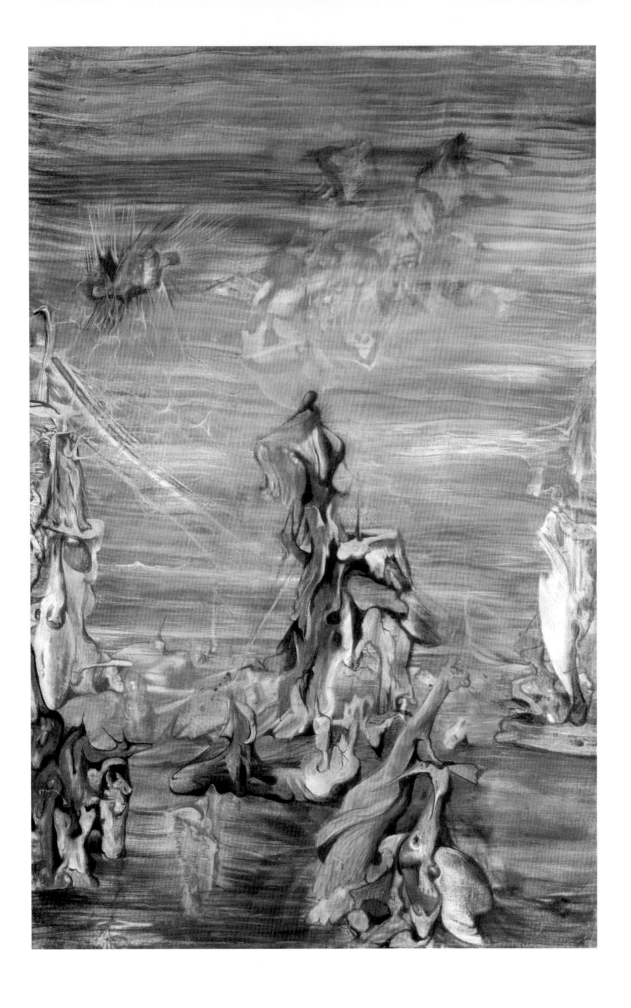

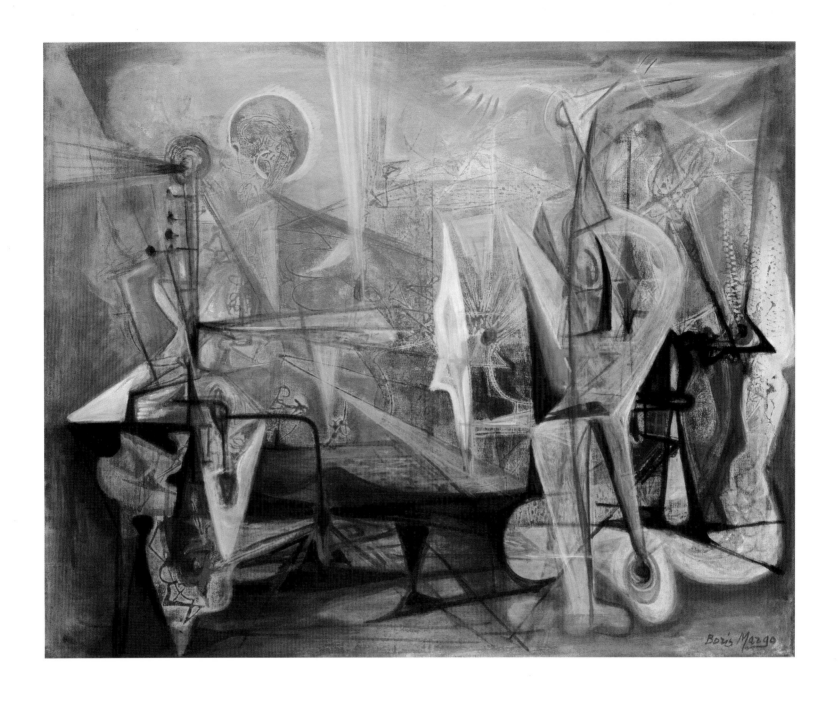

93
**Boris Margo**
Untitled. 1942
Oil on silk mounted on paper
23 x 15 in. (58.4 x 38 cm)
Courtesy of Michael Rosenfeld Gallery, LLC
New York, NY

94
**Boris Margo**
Thermal Forces. 1947 *
Oil on canvas. $30^{1}/_{4}$ x 38 in. (76.8 x 96.4 cm)
Courtesy of Michael Rosenfeld Gallery, LLC
New York, NY

95

**Mark Rothko**

Figure Composition. 1936–1937 *

Oil on canvas. $16^1/_{16}$ x $20^1/_{16}$ in. (40.7 x 50.9 cm)

National Gallery of Art, Washington, DC

Gift of the Mark Rothko Foundation, Inc.

The painting is one of Rothko's early compositions when the artist painted on the streets and on the subway. During this period Rothko and his American contemporaries expressed an interest in primitive and archaic art.

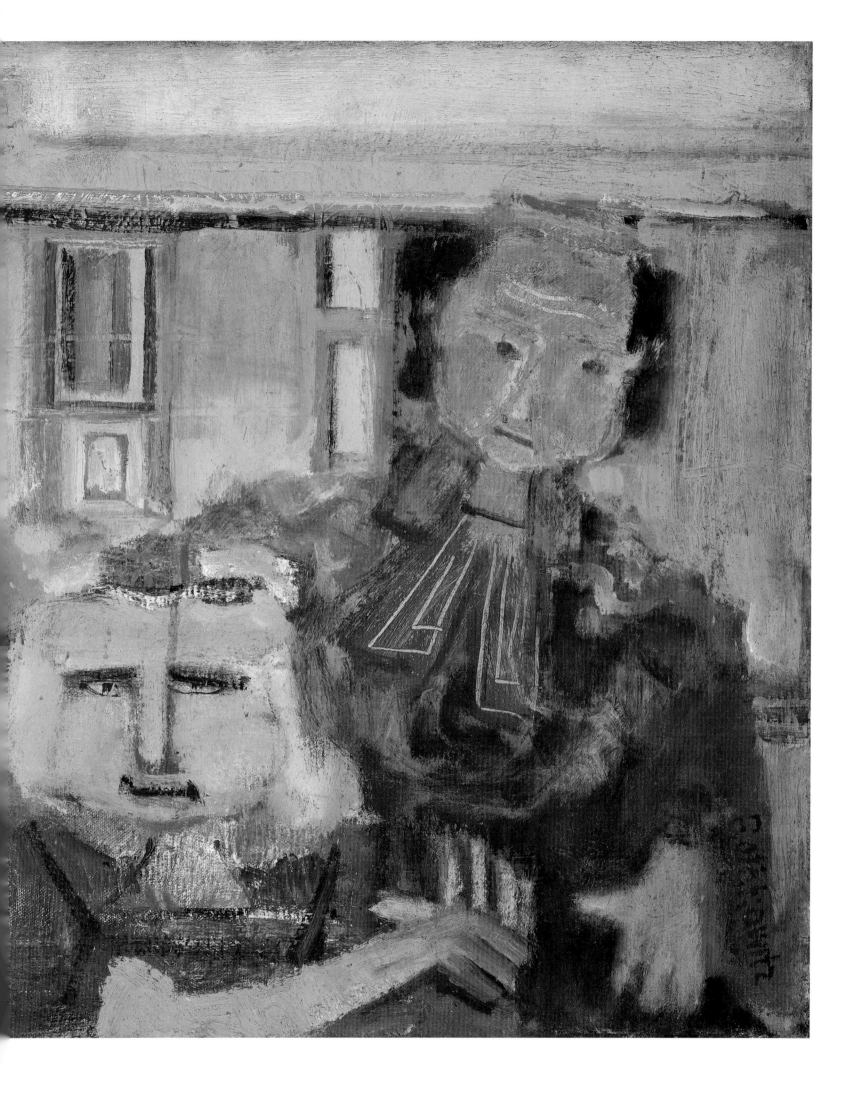

96

**Mark Rothko**

Olympian Play. 1943–1944 *

Oil on canvas. $19^5/_8$ x $27^9/_{16}$ in. (49.9 x 70.1 cm)

National Gallery of Art

Gift of the Mark Rothko Foundation, Inc.

This work belongs to a series on mythological themes which interested Rothko in the beginning of the 1940s.

97

**Mark Rothko**

Composition. 1941–1942 *

Oil on canvas. 28$^{1}/_{2}$ x 24$^{1}/_{2}$ in. (72.4 x 62.2 cm)

Courtesy of Michael Rosenfeld Gallery, LLC

New York, NY

The artist also painted compositions with birds in the beginning of the 1940s. They, just as the works with mythological themes, combined the elements of Surrealism and Abstractionism.

98
**Mark Rothko**
Untitled. 1947 *
Oil on canvas. 44 x 27$^{15}$/$_{16}$ in. (111.8 x 71 cm)
Brooklyn Museum of Art,
New York, NY
Gift of the Mark Rothko Foundation, Inc.

One of the earlier abstract works by Rothko, where the artist is already showing his interest in the red color.

234

99

**Mark Rothko**

Untitled (White and Orange). 1955 *

Oil on canvas. $59^{7}/_{16}$ x $49^{3}/_{4}$ in. (151 x 126.4 cm)

National Gallery of Art, Washington, DC

Collection of Mrs. Paul Mellon in Honor of

the 50th Anniversary of the National Gallery of Art

100

**Mark Rothko**

No. 7 [?] (Orange and Chocolate). 1957 *

Oil on canvas. 69$^{5}$/$_{8}$ x 43$^{1}$/$_{2}$ in. (176.9 x 110.5 cm)

Collection of Kate Rothko Prizel and Ilya Prizel

A typical abstract composition by Rothko where feelings and senses of a human being are represented by colors.

237

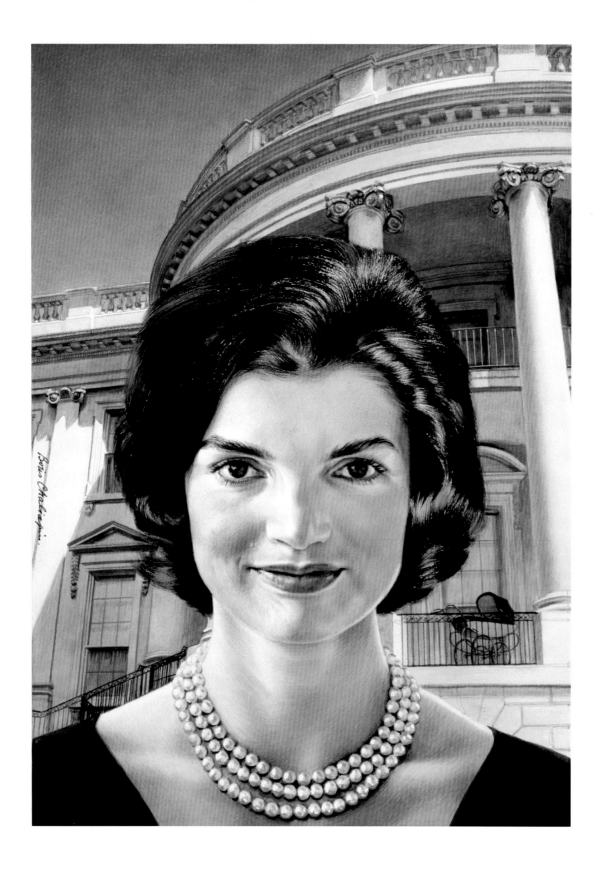

101

**Boris Chaliapin**

Jacqueline Kennedy Onassis. 1960–1961 \*\*\*

Gouache, watercolor and pencil on board

30 x 24 in. (76.2 x 61 cm)

National Portrait Gallery

Smithsonian Institution, Washington, DC

Gift of Time Magazine

Jacqueline Kennedy (July 28, 1929 — May 19, 1994) was the First Lady of the United States, married to President John F. Kennedy. Later she married a multi-millionaire Aristotle Onassis. This beautiful and self-assured woman was always at the center of public attention worldwide.

John Fitzgerald Kennedy was the 35th President of the United States between 1961 and 1963. He was born on May 29, 1917 in Brookline, MA and was assassinated in Dallas, TX on November 22, 1963. Kennedy was the first U.S. President of the Catholic faith, first President born in the 20th century, and the youngest elected president in the history of the country. Kennedy's two-year Presidential term that ended abruptly by the assassination was marked by the Cuban crisis, serious steps towards civil rights and the beginning of the U.S. Space Program.

102

**Boris Chaliapin**

John F. Kennedy. 1960

Graphite and watercolor on illustration board

29 x 23 in. (73.7 x 58.4 cm)

National Portrait Gallery

Smithsonian Institution, Washington, DC

Gift of Time Magazine

Chaliapin, the author of landscapes and compositions, was a very good portrait artist. He did about 400 covers of famous people for the "Time Magazine" between 1939 and 1970.

Muhammad Ali (born Cassius Marcellus Clay Jr. on January 17, 1942) is a world famous American boxer. He was an Olympic Light-Heavyweight Gold Medallist in 1960 and three-time World Heavyweight Champion between 1964 and 1974. He is one of the founders of modern boxing. "Float like a butterfly, sting like a bee" is a tactical scheme created by Ali and adopted as a fighting style by many boxers throughout the world. In 1999 Ali was crowned "Sportsman of the Century" by *Sports Illustrated* and the BBC.

103

**Boris Chaliapin**

Muhammad Ali. 1963 [5]*

Watercolor and graphite pencil on illustration board

$22^{3}/_{4}$ x $16^{3}/_{4}$ in. (57.8 x 42.5 cm)

National Portrait Gallery

Smithsonian Institution, Washington, DC

Gift of Time Magazine

Marilyn Monroe (born Norma Jeane Baker) was born on June 1, 1926 in Los Angeles, CA and died in Brentwood, CA on August 5, 1962. She studied in the Actors Studio in New York. Marilyn Monroe was a legend during her life and after her death. She lived a colorful but short and hard life. America's sex-symbol, an object of many men's dreams, a beautiful woman envied by millions of women, an actress whose sudden ascend to stardom seemed to be a miracle, was also a woman whose personal life did not play out as well and whose tragic death gave rise to many speculations and rumors that are still heard today.

104

**Boris Chaliapin**

Marilyn Monroe. 1956 \*\*\*

Gouache, watercolor and graphite pencil

on illustration board. $24^1/_2$ x $18^1/_2$ in. (62.2 x 47 cm)

National Portrait Gallery

Smithsonian Institution, Washington, DC

Gift of Time Magazine

105

**Vladimir Izdebsky**

Dancers. Mid-1920s [5]*

Cast 2001

Bronze. $18^{1}/_{8}$ x 12 x $10^{1}/_{4}$ in. (47.5 x 26 x 20 cm)

State Russian Museum

Received in 2004, Gift of Galina Isdebsky-Pritchard, New York

This is a repetition of an earlier sculpture made in the
1920s in the Cubo-Futurist manner.

106

**Vladimir Izdebsky**

Composition. 1950–1965 [5*]

Tinted plaster. 24 x 22$^{1}/_{8}$ x 8$^{3}/_{4}$ in. (61 x 56 x 22 cm)

State Russian Museum

Received in 2004, Gift of Galina Isdebsky-Pritchard, New York

After arriving in America, Izdebsky worked with sculpture, using figurative and abstract forms.

243

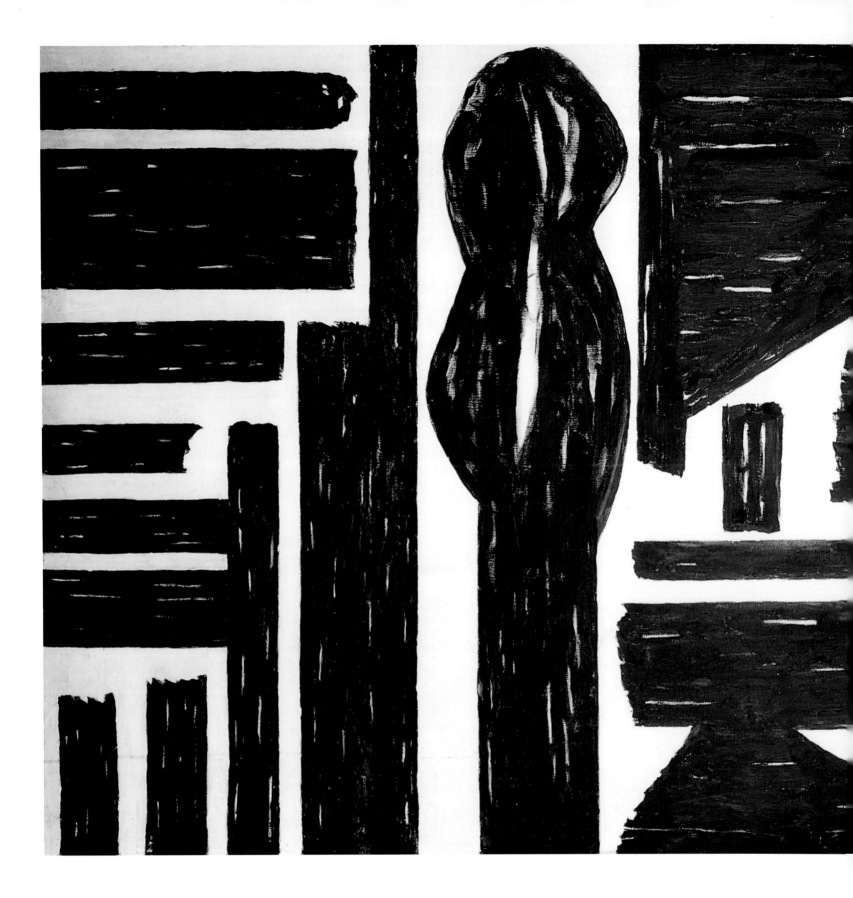

107

**Vladimir Izdebsky**

Untitled. First half of the 1960s [5*]

Oil on canvas. $50^{1}/_{2}$ x 100 in. (128.5 x 254 cm)

State Russian Museum

Received in 2004, Gift of Galina Isdebsky-Pritchard, New York

This is one of Izdebsky's most characteristic compositions of the first half of the 1960s.

108

**Vladimir Izdebsky**

Untitled. First half of the 1960s [5]*

Mixed media on canvas mounted on cardboard

$17^1/_2$ x $23^1/_2$ in. (44.5 x 60 cm) (In light)

State Russian Museum

Received in 2004, Gift of Galina Isdebsky-Pritchard, New York

The artist uses techniques characteristic of the Russian avant-garde of 1910–1920s in this work, where captions, numbers, and letters scattered across the canvas, substituted for other themes.

109

**Alexander Liberman**

Omega IV. 1961

Oil on canvas. 60 x 37 in. (152.5 x 94 cm)

National Gallery of Art, Washington, DC

Gift of Mr. and Mrs. Burton

110

**Alexander Liberman**

The Little Mysteries II. 1963 *

Acrylic on canvas. $42^{1}/_{4}$ x $33^{1}/_{4}$ in. (107.3 x 84.5 cm)

Smithsonian American Art Museum, Washington, DC

Gift of the Woodward Foundation

Both compositions are done in the Abstract genre using a circle as the symbol of the Universe.

111

**Alexander Liberman**

Maquette for On High. 1978 *

Welded and painted steel on steel base

$23^5/_8$ x 16 x 16 in. (60 x 40.6 x 40.6 cm)

Smithsonian American Art Museum, Washington, DC

Transfer from the General Services

Beginning in the 1940s, Louise Nevelson's sculpture developed from tabletop pieces to human-scale columns to room-size walls, monumental installations and public art. She assembled her sculptures from street detritus that she collected and transformed with white, black or gold spray paint. While composed of discarded materials from every-day life, her themes evoked marriage, royalty, displacement, loss, and mortality as expressed through cubist and surrealist inspired fantasy.

112
**Louise Nevelson**
Classic Column. 1967 *
Painted wood. 42 x 30 x 9 in. (106.7 x 76.2 x 22.9 cm)
The Jewish Museum, New York, NY
Gift of Diana Truelove MacKown, 1994

In the Abstract compositions of the 1970s, Bolotowsky moves further away from Mondrian, who influenced him greatly at the beginning of his artistic career. The use of red and black that appears more and more frequently in Bolotowsky's works is reminiscent of works by Russian avant-garde artists, especially of Malevich's paintings which Bolotowsky was acquainted with by that time.

113

**Ilya Bolotowsky**

Red, Blue, White Ellipse. 1973 *

Acrylic on gessoed linen

$67^{7}/_{8}$ x $39^{15}/_{16}$ in. (172.4 x 101.5 cm) (oval)

Brooklyn Museum of Art

New York, NY

Healy Purchase Fund B

Late in his career, Bolotowsky abandoned all references to the tangible, material world in his paintings and started creating pruly non-objective works. He adopted Mondrian's use of simplified forms, strongly defined horizontal and vertical lines, and a limited palette. Also like Mondrian, Bolotowsky was interested in making a painting in its own right; he did not wish to make a painting representation of something else. Bolotowsky was a staunch promoter of abstract art in America, especially during the 1930s, 1940s, and 1950s, and was a highly regarded teacher. He was cofounder, a charter member, and past president of American Abstract Artists, an organization formed in 1937 that promoted abstract art in America through exhibitions of its members' works and whose stated purpose was "to unite abstract artists residing in the United States, to bring before the public their individual works, and in every possible was foster public appreciation for this direction in painting and sculpture.

114

**Ilya Bolotowsky**

Tondo. 1973

Oil on canvas. Diameter: $39^{1}/_{2}$ in. (100.3 cm)

Collection of the Flint Institute of Arts

Flint, Michigan

115
**Ilya Bolotowsky**
First Rhomboid Column. 1976 *
Acrylic on wood. $95^{1}/_{2}$ x 16 x 10 in.
(242.5 x 40.6 x 25.4 cm)
Courtesy of Michael Rosenfeld Gallery, LLC
New York, NY

In clean and simple forms of Bolotowsky's columns, one can trace a familiarity with Kazimir Malevich's Architectones.

116
**Jules Olitsky**
Green Spread. 1968 *
Synthetic polymer on canvas
$90^{5}/_{8}$ x 44 in. (230.1 x 110.8 cm)
Hirshhorn Museum and Sculpture Garden,
Smithsonian Institution, Washington, DC

117
**Jules Olitsky**
Bad Bugaloo. 1968 *
Acrylic on canvas. $117^{1}/_{4}$ x $43^{1}/_{4}$ in. (297.8 x 109.9 cm)
Hirshhorn Museum and Sculpture Garden
Smithsonian Institution, Washington, DC

259

"Paint is important to art," said Olitsky. "Paint can be color. Paint can become art, when color fills the surface." The artist's works are completely true to his statements, especially his work *Salome's Rock*.

118
**Jules Olitsky**
Salome Rock. 1990
Acrylic on canvas. 48 x 24 in. (121.8 x 60.9 cm)
National Academy Museum, New York, NY

# biographies of artists

These biographical notes were written based on the main theme of the exhibition — to introduce the works of artists who came from Tsarist or Soviet Russia to the U. S. and made major contributions to American and world cultures. To provide a better understanding of the artists included in the exhibit, the biographical notes contain information about their heritage and reasons for their emigration/immigration.

Each biographical note contains brief information about the life of the artist, beginning from the Russian period and through the period of immigration, with an emphasis on the artists' work in Russia and the U. S. We are including the main artistic activities, names of educational establishments attended, years of attendance and teaching experience; as well as names of the artists' teachers, when possible. We have also listed personal and group exhibitions and specified major locations of their collections.

Countries other than Russia or the U. S. where the artists were born are also mentioned.

**ANISFELD, Boris (Ber)**
1879, Bieltsy, Bessarabia Guberniya (now Moldova) —
1973, New Canaan, CT
Emigrated to U.S. in 1917 from Russia

**ARAPOFF, Alexis**
1904, St. Petersburg — 1948, South Ashburnham, MA
Emigrated to U.S. in 1930 with American wife from France
U.S. citizenship in 1937

Theatrical designer, painter, graphic artist, and teacher. Son of a merchant. Studied at the Odessa School of Drawing (1895–1900) under K. Kostandi and G. Ladyzhynsky, at HAI and IAA (1900–09) and under Ilya Repin and D. Kardovsky. Exhibited since 1903, including international exhibits: Paris (1906), Berlin (1906, 1907), Venice (1907), and Vienna (1908). Member of Salon d'Automne in Paris (1906). Contributed to exhibitions of the Union of Russian Artists (1906–10), the *World of Art* (1911–17, 1921), and the Jewish Society for Appreciation of Artists (1915–17). Taught in the Zvantseva Art School, St. Petersburg (1906). Provided drawings for *Joupel* and *Mail from Hell* magazines (1905–1906) and *Satirikon* journal (1908). Designed for Vera Komissarzhevskaya Theater (1907), Mariinsky Theater (1912), Sergei Diaghilev's *Saisons Russes* (1908–11), Anna Pavlova's company (1912–14), Mikhail Fokin's *Seasons* in Berlin and Stockholm (1913–14), Metropolitan Opera (1919–20, 1922–24), The Chicago Civic Opera (1921), and worked with Vazlav Nizhinsky (1914), and Mikhail Mordkin (1926). Left Russia in 1917 and arrived in the U.S. by way of the Far East, Japan and Canada. Settled in New York (1918) and same year organized an exhibit of 200 works at the Brooklyn Museum of Art, which was later exhibited in many other cities and brought fame to the artist. Took part in numerous art shows: exhibitions of Russian Art in Paris (1921), New York (1923), Pittsburgh (1925), and Philadelphia (1926, gold medal), and London (1935). From 1928 lived in Chicago and taught advanced painting at Art Institute of Chicago (1928–57). From 1934 regularly traveled to Central City, CO with his students. His later works were lyrical landscapes and had religious themes. One-man shows: Pittsburgh (1946–49), New York (1956), Chicago (1958), and Washington, DC (1971). His collections can be found in museum and private collections in Russia, the U.S. and many other countries.

Painter, sculptor, stage-designer, and iconographer. Son of a Major General who was an Army doctor and the first female eye surgeon, niece of Leo Tolstoy. Spent his childhood and youth in Saratov. After graduating from the gymnasium (1918), received his first art lessons from Hans van Burgler, who was later a professor at the Vienna Art Academy. Studied at the Saratov State HAI (1921–23) under V. Ustkitsky. From 1923, lived in Moscow. Designed sets and costumes for avant-garde theater of Foregger in Moscow (1923), painted portraits of government officials, etc. Traveled to Warsaw with theater troupe *Faux Miroir* (1924). Settled in Paris and started with scarf designs at first, and then painted landscapes, portraits, and still life. Held three one-man shows in Paris (1927, 1928, 1930) and participated in numerous group exhibitions: Salon d'Automne, Paris (1926), Salon des Independants (1928), in Paris galleries (1929–31), and also in the Russian Department of the exhibit *Contemporary French Art* (Moscow, 1928). Married an American from a Catholic family in 1929 and moved to Boston in 1930, Interest turned to religious painting after conversion to Roman Catholicism (1934), created a series of paintings entitled *Stations of the Cross* (1935), painted icons and other paintings and sculpture. Had numerous one-man shows in Boston (1935, 1938). Died in a car accident. Retrospective exhibit in Boston Museum of Fine Arts (1952) included oils, gouaches, watercolors, drawings, and icons.

**ARCHIPENKO, Alexander**
1887, Kyiv (now Ukraine) — 1964, New York, NY
Emigrated to U.S. in 1923 from Germany, U.S. citizenship
in 1929

**BEN-ZION (Ben-Zion Weinman)**
1897, Stary Constantin, Volyn Guberniya (now Ukraine) —
1987, New York, NY
Emigrated to U.S. in 1920 from Poland

Sculptor, graphic artist, and teacher. Son of Professor of Mechanical Physics in Kyiv University of St. Vladimir. Studied at Kyiv Art School (1902–05), expelled for criticizing the school system. Exhibited in Moscow group shows (1906). Moved to Paris (1908), and lived in artists' colony *La Ruche.* Briefly studied at Ecole des Beaux-Arts under Amadeo Modigliani, and then studied independently and at Musée du Louvre. Established his own Art College (1912), worked on the concept of Cubism and later incorporated various techniques in his works. Exhibited at Salon d'Automne (1911–13, 1919) and Salon des Independants (1910–14, 1920), and first German Salon in Berlin (1913). Had first solo show in Berlin gallery Der Strurm (1913). Lived in Nice (1914–20), where he worked on "sculptural painting," based on three-dimensional sculpture with color and frame. Exhibited in Berlin (1921–23), and settled there (1921), where he also started his own college. Participated in *First Russian Art Exhibition* in Berlin (1922) and *Russian Paintings and Sculpture* in Venice (1920), Berlin (1922), Amsterdam (1923), New York (1923). Brussels (1928), Wilmington (1932). Moved to the U. S. (1923) and developed and patented "Archipenktura" — mechanism for creating an illusion of painted objects with determined speed and rhythm (1924–27), exhibited in New York and Tokyo. Produced a series of "color modulations" — a series of half see-through plexiglass sculptures illuminated from within. Established art schools in New York, Woodstock (1923), Los Angeles (1935) and New Bauhaus School in Chicago (1937). Taught at the universities in Seattle (1935–36), Kansas City (1950), British Columbia (1956), the Art Institute of Chicago (1946–47), and Carmel Art University (1951). Received recognition as one of the founders of avant-garde painting. Received various honors in the U. S. and in Europe, member of the International Institute of Arts and Written Word (1953), and American National Institute of Art and Written Word (1962). Had more than 150 one-man shows during his 40 years in the U. S. Exhibits honoring the 100th anniversary of the artist's birth were held at the National Gallery of Art, Washington, DC and in Tel-Aviv Art Museum (1986–87). Works represented in major museums throughout the world.

Painter, sculptor, poet, and teacher. Son of a Jewish cantor and composer, who wanted him to become a rabbi. Educated in a yeshiva and self-taught as artist. Lived with his family in Poland. Studied briefly at art school in Vienna, no formal training. In the U. S. changed his name to Ben-Zion. Founding member of *The Ten* (1935–39) that included Mark Rothko, Joseph Solman, Allan Gottlieb, Ilya Bolotowsky and others. Portraits of Jews and religious themes dominated his art. Participated in group shows in New York and Paris. First solo exhibition at Artist's Gallery in Greenwich Village. His solo exhibit was featured during opening of Jewish Museum in New York (1948). Subject of recent exhibitions at St. John's College (2005) and Museum of Biblical Art (2007). Taught in summer camps and Cooper Union (1943–50), Ball State University (1956), and University of Iowa (1959). In pre-war years wrote poetry and prose in Yiddish, but was shaken up by Holocaust and could not write any longer. His works can be found at the Metropolitan Museum of Art, Whitney Museum of American Art, Museum of Modern Art, Chicago Art Institute and others.

**BENN, Ben (Benjamin Rosenberg)**
1884, Kamenets-Podolsky (now Ukraine) —
1983, Bethel, CT
Emigrated to U. S. in 1894 from Russia

**BERMAN, Eugene**
1899, St. Petersburg — 1972, Rome, Italy
Emigrated to U.S. in 1935 from France, U. S. citizenship in
1944, left for Italy in 1955

Painter. From 1894 lived in New York. Studied in New York at the Art Students League and National Academy of Design (1904–08). First major exhibition at Forum Exhibition of Modern American Painters in Andersen Gallery (1916), followed by solo exhibitions at Neumann Gallery (1925) and Babcock Gallery (1963–70). Painted portraits, still life, landscapes, leaning towards figurative and abstract images. Was influenced by Henri Matisse, Pablo Picasso, and Wassily Kandinsky. Participated in group exhibitions at Columbia University (1927), Whitney Museum of American Art (1927–50), Corcoran Gallery of Art (1932, 1957), Pennsylvania Academy of Fine Art (1942, 1952). Works in permanent collections of the Museum of Modern Art, Whitney, Newark Museum, Baltimore Museum of Art, Albany Institute of Art, Butler Art Institute, Knoxville Art Center, and University of Minnesota. Member of American Society of Painters and Sculptors, American Artists Congress, and the Woodstock Artist Association.

Painter, graphic artist, stage designer, and collector. Son of bank employee, brother of Leonid Berman. Having lost his father at an early age, was brought up by his stepfather — banker and collector E. Shaikevich. Lived in St. Petersburg until 1908, then in Germany, France and Switzerland with his family (1908–14), and then again in St. Petersburg (1914–18), where he studied in private studios of artists P. Naumov and architect and graphic artist S. Groosenburg. Arrested in 1918, spent two months in jail. Emigrated to Finland and then England and France upon completing jail sentence. Studied in Paris at Académie Ranson (1919–20) under Maurice Denis, Edouard Vuillard, Pierre Bonnard, and others. Visited Italy with brother Leonid and Christian Berard. Painted landscapes in Impressionist style. Exhibited in Salon d'Automne and Salon des Independants (1923–25), and other Russian exhibitions including *Modern French Art* in Moscow (1928). Along with brother Leonid, Pavel Tchelitchew, and Christian ("Bebe") Berard took part in an exhibit in Drut Gallery that started neo-humanitarian (or "neo-romantic") style of art (1926). Painted mystic landscapes and paintings with futuristic architectural themes under the influence of Giorgio de Chirico. Lived and worked in Southern France in the 1930s, visited Italy multiple times and was influenced by Salvador Dali. Solo exhibitions with Galerie l'Etoile in Paris (1928), with Julian Levy in New York (1932), and Art Institute of Chicago (1944). Stage designer for Hartford Music Festival (1936–39). Painted for magazine covers (1935–43) and did set-designs for ballet, including *Ballet Russe de Monte Carlo* (1938), choreographers S. Lifarev (1938), F. Ashton (1939) and George Balanchine (1941), among others. Worked with Metropolitan Opera (1950s). Last work was for the set-design of the Balanchine Ballet *Pulcinella* (New York, 1972). Moved to Italy (1955) after suicide of his wife and settled in the Palace of Princes Doria Pamphili, where he founded a library and a collection of Greek and pre-Columbian art. Member of the American Academy of Art (1964). His works can be found in private collections in New York, London, and Paris.

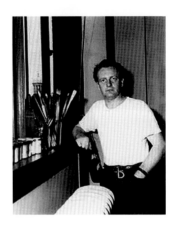

**BERMAN, Leonid**
1896, St. Petersburg — 1976, New York, NY
Emigrated to U.S. in 1946 from France

**BLUME, Peter**
1906, Smorgon (now Belarus) — 1992, New Milford, CT
Emigrated to U.S. with parents in 1911

Painter. Son of bank employee, brother of Eugene Berman. Brought up by his stepfather — banker and collector E. Shai-kevich. Left for Finland (1918) and studied with Nicholas Roerich, who gave him a recommendation for further study with Morris Denis. Settled in Paris (1919) and studied painting at Académie Ranson with Denis, Vouillard, Bonnard, and others. Visited Italy with brother Eugene and Christian Berard. Exhibited in Salon d'Automne and Salon des Independants. Visited Southern France often (1925–29), painted landscapes, port scenes and life of fishermen. Along with brother Eugene, Pavel Tchelitchew, and Christian ("Bebe") Berard took part in an exhibit in Drut Gallery that started neo-humanitarian (or "neo-romantic") style of art. One-man shows in Paris (1926–28, 1935–36). During economic crisis suffered greatly and received assistance from Christian Dior who rented a house for him in Normandy and helped organize a personal exhibition *Julian Levy: in New York* (1935). Mobilized into the French Army (1939). After the fall of Paris, he assumed someone else's identity in Southern France, for which he had to work at hard labor for three years. After the War moved to New York, traveled widely in North and South America and Indochina. Continued his sea-themed landscapes that he painted from bell towers and hills. Had about twenty solo exhibitions in New York and other U.S. cities (1950–70s). Works in permanent collections at National Gallery of Art and Museum of Modern Art, and in other collections in the U.S. and in Europe.

Painter. Studied at Educational Alliance (1921), and Art Students League and Beaux-Arts Academy (1919–24) in New York. Painted post office murals. Participated in art exhibits at Daniel Gallery (1926–31) and became recognized for anti-Fascist works (1930s). Received first prize for *South of Scranton*, which was included in 32nd Carnegie International Exhibition in Pittsburgh (1934). Became known as artist of Magic Realism Movement (1943–50s). Works in permanent collections at Art Institute of Chicago, Whitney Museum of American Art, Museum of Modern Art, Metropolitan Museum of Art, and Smithsonian American Art Museum.

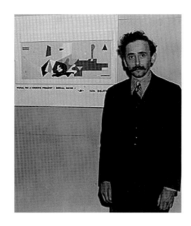

**BOLOTOWSKY, Ilya**

1907, St. Petersburg — 1981, Sag Harbor, NY
Emigrated to U.S. in 1923 from Turkey,
U.S. citizenship in 1929

**BURLIUK, David**

1882, Semirotovchina, Kharkov Guberniya
(now Ukraine) — 1967, Southhampton, Long Island, NY
Emigrated to U.S. in 1922 from Japan,
U.S. citizenship in 1930

Painter, teacher, writer. Son of a lawyer. Lived in Baku, Azerbaijan, and moved to Kutaisi and Batumi, Georgia, after the Turkish occupation, and then to Istanbul where he was educated at Collège St. Joseph (1921–23). Continued his education at National Academy of Design in New York (1924–30) under Ivan Olinsky. Received recognition from the National Academy of the Arts (1925, 1926), the Hollgarten Foundation (1929, 1930), and L. K. Tiffany (1929, 1930). Traveled in Italy, Germany, Denmark, England, and France (1932). Painted his first abstract paintings under Piet Mondrian and Joan Miro (1930s). Was one of the founding members of the *American Abstract Artists* (and became its president) (1936), and *The Ten* (1938). Earliest works were for Federal Government's Public Works of Art Project (1933–34), followed by murals for Works Project Administration (1934–36) at Williamsburg Housing Project and Hall of Medical Science in the Health Building at the New York World's Fair (1939–41). Served in Army Air Corps in Alaska during World War II as interpreter. After the war, mostly painted abstract works in oil and acrylic. Created three-sided columns, each of which represented a finished painting, and two of which, if observed at an angle, represented a finished composition. Participated in group exhibitions at Museum of Modern Art (1936), and shows of *The Ten* (1936–37). Developed solo exhibitions after return from War (1946–1970s), including retrospective at Solomon R. Guggenheim Museum (1974). Pursued teaching career at Black Mountain College in North Carolina (1945–47), University of Wyoming and Brooklyn College (1948–57), State Teacher's College in New Paltz, NY (1957–65), and University of Wisconsin-Whitewater. Also pursued creation of experimental films while in Wyoming. Created about forty short documentary films about art and artists and wrote novels, and various scripts in Russian and English; author of the *Russian-English Dictionary of Art and Sculpture* (1962). Works in permanent collection of numerous museums, including Art Institute of Chicago, Metropolitan Museum of Art, The Phillips Collection, Brooklyn Museum of Art, Hirshhorn Museum and Sculpture Garden, and Smithsonian American Art Museum.

Painter, poet, book illustrator, author of manifests and critical articles. Son of a property manager, who was also an author on agronomy and an amateur artist. Educated at Art School in Kazan (1898–99) under K. Mufke and G. Medvedev, in the Art Institute of Odessa (1899–1900, 1910–11) under K. Kostandi, G. Ladyzhsky, and A. Popov; then at Royal Academy in Munich (1902–1904), followed by study in Paris at the workshop of F. Cormone (1905), and MIPSA (1911–14) under Leonid Pasternak and A. Arkhipov, but expelled for futurism propaganda. Participated in group exhibitions with *Zveno* (*The Link*) in Kyiv (1908), *Blaue Reiter* in Munich (1911), and *Jack of Diamonds* in Moscow (1917). Founder of *Hylaea*, a publishing venture of futuristic writer's group (1910). Considered star of Russian avant-garde and father of "Russian Futurism." Traveled in Siberia and the Far East (1918) with propaganda for "leftist" art. Left for Japan with his family where he created more than 500 works (1920–22). Settled in New York (1922), painted and delivered lectures in labor unions. Member of the *Hammer and Sickle* Association and John Reed Club. Began painting portraits, including those of Nicholas Roerich, Vladimir Lenin, and Vladimir Mayakovsky. Participated in numerous group exhibitions, including in New York (1923), and Wilmington (1932). Almost annually had one-man shows in New York, Washington, DC, Chicago, San Francisco and other places. Together with wife, founded *Publishing House of M. N. Burliuk* and published novels, poems, and memoirs. U.S. Publisher of *Color and Rhyme* (1930–67). Built a house in Long Island and opened a gallery. Visited U.S.S.R. (1956, 1965). Traveled around the world (1962) and had solo shows at the SRM (1955, 2000). Works in permanent collection of numerous museums including Museum of Fine Arts, Boston, Smithsonian American Art Museum, Baltimore Museum of Art, Brooklyn Museum of Art, and the Phillips collection.

**CHALIAPIN, Boris**
1904, Moscow — 1979, New York, NY
Emigrated to U.S. in 1935 from France

**CIKOVSKY, Nicolai**
1894, Pinsk (later Poland, now Belarus) —
1987, Washington, DC
Emigrated to U.S. in 1923 from Russia

Painter, illustrator, graphic artist, sculptor, set-designer. Son of Feodor Chaliapin, renowned Russian opera singer and famous Italian ballerina, Iola Tornagi. Interested in painting since childhood. Studied at St. Petersburg SLAWS (1919) under V. Shukahev, Moscow SLAS I and II (1920–23) under D. Kardovsky, A. Archipov, F. Zakharov, Moscow VKhUTEMAS (Workshop for the Art of the Future) under S. Konenkov (1923–25). Spent about three months in Paris (1923) and left for good (1925). Father bought him a workshop on Montmartre. Continued education at workshops of Ch. Gerene, K. Korovin, and D. Stepanov's. First solo exhibition of ten works at London Covent Garden Theater during his father's tour (1927). Painted portraits of people surrounding him, created gallery of paintings, works on paper, and sculpture of his father during his performances. Designed sets for operas and films (*Demon*, *Don Quixote*) and participated in exhibits of Russia art at D'Alighan and La Renaissance galleries (1930s). Received a major award for *Nude* sculpture from Salon d'Automne (1935). Along with his father, came to New York (1935), painted portraits of leading art figures, landscapes of the American West and Italian cities, still life, and religious-themed paintings; later worked on wood sculpture. Well known for more than 400 illustrations for *Time Magazine* (1938–70). Created first series of portraits of artists of *Ballet Russes de Monte-Carlo* (1940–41). In 1946, donated *Portrait of S. V. Rachmaninoff at a Piano* to M. Glinka Moscow Museum of Music and Culture (1940). Visited Israel and painted portraits of political leaders (1962–66). Visited U.S.S.R. multiple times (1960s) and had a personal exhibition at the Moscow Friendship House (1968). Other personal exhibitions include New York (1935, 1937, 1938, 1958, 1959), Philadelphia (1937), Los Angeles (1941), Palos Verdes and Palm Springs, CA (1942), San Francisco (1944), Westport, CT (1957), El Paso, TX (1971), Palm Beach, FL (1975), London (1959), Switzerland (1973). Member of Society of Illustrators and Society of Independent Artists. Works in permanent collections of National Portrait Gallery and Smithsonian American Art Museum, and many other museums.

Painter, muralist, lithographer. Son of a fisherman, who encouraged him to paint and draw at an early age. Educated at Vilna Art School (1910–14) and Penza Royal Art School (1914–18). Attended Moscow Technical Institute of Art (1921–23), studying under Favorsky and Mashkow. Was an instructor at Ekaterinburg Higher Technical Art Institute (1919–21). Emigrated to U.S. in 1923. Painted murals at U.S. Department of Interior and post offices in Towson and Silver Spring, Maryland. Became a close friend of Raphael Soyer, whom he met during his first solo exhibit at Daniel Galleries. Joined John Reed Club (1930s), and established The American Artists School in New York City, associated with socialism and the American Radical Movement. School emphasized art that was not only technically excellent, but also alive and stressed socially relevant issues. School closed in 1941, but role it initiated of integrating art and society continued. Taught at St. Paul School of Art (1934–35), Cincinnati Art Academy (1935–36), Corcoran School of Art (1940s) as well as Art Students League of New York, College of Notre Dame (MD), and the School of the Art Institute of Chicago. Recipient of numerous awards, including Harris Bronze Medal (1931), Logan Purchase Prize (1932) from the Art Institute of Chicago, three bronze medals from the Washington Society of Artists and others from the Worcester Art Museum and the National Academy of Design. His works can be found in collections at the Museum of Fine Arts Boston, the Brooklyn Museum, Art Institute of Chicago, Metropolitan Museum of Art, Whitney Museum of American Art, and the Phillips collection, among others.

**DERUJINSKY, Gleb**

1888, Otradnaya Estate, Smolensk Guberniya —
1975, New York, NY
Emigrated to the U.S. in 1918 from Russia

Sculptor. Originally educated as lawyer to satisfy his father, a professor at the St. Petersburg and Moscow Universities and a Senator. After graduating from St. Petersburg gymnasium, studied at ISAA (1904) under sculptor U. Adreoletti. Received his legal degree from St. Petersburg University (1912) and having received Nicholas Roerich's support — he was the director of ISAA at the time — dedicated himself to art. Visited Paris where he spent time at the Julien and Colarossi Academies (1911, 1912); met Auguste Rodin. Upon return studied at HAI and IAA (1913–18) under G. Zaleman and V. Beklemishev. Participated in exhibitions after 1915. Worked with plaster, marble, terracotta, and bronze and also created small impressionist compositions and portraits of his contemporaries. Went to Crimea on the invitation of Felix Yussupov who was his classmate and left for Novorossiysk from there because of the Bolshevik invasion. Was hired as sailor and left for New York. Received his first order from the wife of a millionaire, G. Hammond, and in 1919 created a bust of Theodore Roosevelt. Participated in various exhibits at the National Academy of Art (1922), Salon d'Automne, Paris (1923), and exhibitions of Russian art in New York (1923) and Brussels (1928). One-man shows at New York galleries (1928, 1933, 1942). Taught at Sarah Lawrence College and in his own workshop. Known as author of Biblical themes and also for the original plaster sculptures done from life including Rachmaninoff, Prokofiev, Roosevelt, Adlai Stevenson and John F. Kennedy. Received a gold medal for participation in the International Exhibition in Philadelphia (1928) and World Exhibition in Paris (1937). Received various awards from the National Academy of Arts (1938), American Professional League (1957, 1958), and National Art Club in New York (1961, 1964). Active in WPA projects, including carved wood medallions of eight U.S. Postmaster Generals in the former Department of the Post Office building. His collections can be found in major museums in Russia and the U. S.

**FECHIN, Nicolai**

1881, Kazan — 1955, Santa Monica, CA
Emigrated to U.S. in 1923 from U.S.S.R.,
U.S. citizenship in 1931

Painter, sculptor, woodcarver, teacher. Son of iconostasis workshop owner. Studied at Art School of Kazan (1895–1901) and graduated from IAA in St. Petersburg and HAI (1901–09) under Ilya Repin. Awarded a scholarship for competitive painting to travel to Austria, Germany, Italy and France (1910). Taught at Kazan Art Academy (1908–22, with intervals). Participated in exhibits in Kazan, St. Petersburg, Moscow (1909–23), Munich (1909, 1910, 1913), Pittsburgh (1910–14), New York (1911), Rome (1911), Amsterdam (1912), Venice (1914), and San Francisco (1915). Received Academician of Art status (1916). Was very active in art life of Kazan. Awarded and painted murals for working class theaters, created decorations for Carmen at the Kazan State Opera Theater, took part in re-organization of Kazan Art School and was elected Chairman of Kazan SLAS (1920). With assistance from artists George Hunter and William Stemmel received U.S. visa (1923) and came with family to New York. Taught at New York Academy of Art and exhibited works at National Academy of Design (1924–25) where he won Thomas Proctor Prize for portraiture. Moved to Taos, NM (1927) for treatment of tuberculosis. Built a house with studio, decorated with wooden carving. Painted landscapes, portraits of native Americans, friends, and Russian immigrants: David Burliuk, Vera Fokina, Ariadna Mikeshina. Divorced (1933), lost house in Taos and moved to New York with his daughter. Eventually settled in Santa Monica (1948) and studied ceramics. His ashes were taken to Kazan in accordance with his will (1976). Works in permanent collections of numerous museums, including the Fred Jones Jr. Museum of Art, San Diego Museum of Art, Stark Museum of Art, Phoenix Art Museum, SRM, Taos Art Museum, and Art Institute of Chicago.

**GABO, Naum (Neemia Berkovitch Pevsner or Naum Abramovich)**
1890, Briansk — 1977, Waterbury, CT
Visited U.S. in 1938 from England
Emigrated in 1946, U.S. citizenship in 1952

**GASPARD, Leon**
1882, Vitebsk (now Belarus) — 1964, Taos, NM
Emigrated to U.S. in 1916 from France.

biographies of artists

Sculptor, architect, painter, designer, teacher. Son of engineer, younger brother of the artist, Antoine Pevsner. Upon graduation from Kursk gymnasium (1910), studied medicine, engineering and physics at University of Munich (1910–13). Having visited his brother in Paris (1913) became acquainted with cubists and decided to dedicate himself to art. During first years of World War I, in Scandinavia, created his first constructivist sculptures and signed them with a pseudonym "Gabo." Returned to Russia after 1917 Revolution and was active in the art life of Moscow. Issued *Realist Manifesto* in Moscow (1920) outlining principles of Constructivism. Went to Berlin on Anatoly Lunacharsky's order to organize first Russian exhibition (1922). Member of the avant-garde group *Novembergruppe* (Board President in 1925); member of *Style* movement and founding member of *G* magazine (1930). Contributed to agit-prop open air exhibitions in Moscow. Taught at Bauhaus and exhibited with *Novembergruppe* in Berlin (1922–32). With brother, had joint exhibition at the Galerie Percier, Paris (1924), and designed set and costumes for Diaghilev's ballet, *La Chatte* (1926). Exhibited with *Abstraction-Création* group in Paris (1932–36). Editor of journal *Circle* in London (1937) and participated in group exhibitions. Worked on design for *Jowett* automobiles. Taught at Graduate School of Architecture of Harvard University (1953–54). Created large-scale sculptures in public areas of America and Europe (1948–75). Received American Art Institute's Logan Medal (1954), Brandeis Award (1960), and a Guggenheim Fellowship. Visited Moscow and St. Petersburg (1962). Received Honorary Knighthood (KBE) from Queen Elizabeth II (1972). Works in permanent collections of numerous museums, including the Phillips collection, Museum of Modern Art, and Nasher Sculpture Center.

Painter. Son of a merchant and pianist, who was Anton Rubinstein's student. Studied in Vitebsk under Pen, in the Odessa Art Institute under K. Kostandi (1890s) and at Academie Julian in Paris (1901), followed by studies at Toudouze and Bugro (until 1908). Married an American dancer (1908) and traveled to Siberia for two years. Painted portraits and landscape, as well as genre paintings with a Russian theme. Exhibited at the Paris salons, and other European venues. Injured during service with French Air Corps at beginning of World War I, and exhibited wartime drawings in U.S. (1916). Settled in Taos, NM on recommendation of doctors and became part the established artist's colony (1918), which later included Nikolai Fechin. First solo show at the Art Institute of Chicago (1919–20). Traveled extensively through Asia (Japan, China, Gobi Desert, Mongolia, Tian-Shan, Chinese Turkestan, and Altai Steppes) (1921–24) and created many studies during that time. Created one-man show at the Art Institute of Chicago (1924) based on the journey's results, as well as several exhibits in Taos which brought him fame. Went to Paris (1932) and on the request of the French Government traveled to Morocco, Algeria, and Tunis. Returned to Taos (1933) and continued painting Russian, Asian, and Indian motifs. Widowed in 1956, became depressed and stopped painting. Two years later remarried an artist and traveled with her to Europe and U.S.S.R. Solo show in Taos as a result of this trip (1961). Works can be found in private collections and at the Fred Jones Jr. Museum of Art in Oklahoma and other museums.

 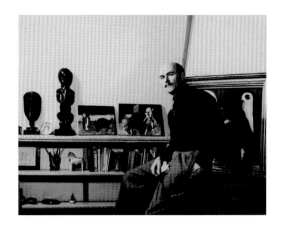

**GORKY, Arshile (Vosdanig Anouk Adoian)**
1904, Khorkom Vari Haiyotz Dzore, Armenia
(now Turkey) — 1948, Sherman, CT
Emigrated to U.S. in 1920 from Armenia
(annexed Turkish province of Van)

**GRAHAM, John (Ivan Gratianovich Dombrovski)**
1886, Kyiv (now Ukraine) —
1961, London, England
Emigrated to U.S. in 1920 from Germany

Painter. Son of landowner, who emigrated to the U.S. in 1908. Having lost his mother (1919), decided to relocate to the U.S. where he adapted his new name based on the ancient Greek hero Achilles and the pseudonym of the proletariat writer Gorky (in addition, the Russian word *gorky* means "bitter" and reflected his hard childhood and youth). Worked hard on creating his own image, which emphasized Russian-Jewish heritage. Self-educated artist, eventually enrolled and taught part-time in New School of Design in Boston (1922). Worked on abstract composition that united elements from different cultures, but first of all Armenian and Russian cultures. Taught at the Art Students League where he studied under Rothko. Having gone through various artistic interests and having experienced the influence by expressionist abstract art by Kandinsky, found his own style and created his own technique (drawing by scratching a thick layer of dried paint over canvas), which received the name of "art of action." Characteristically painted in bright Southern colors and had delicate poetic metaphors for his paintings (for example, *An Embroidered Apron of My Mother Through My Fate*, 1944). Returned often to painting portraits of his mother. Received stipend from Public Works of Art Project (1933–41). Participated in large group show at Whitney Museum (1935), followed by annual shows (1936–48). Received grant from The New-Land Foundation (1946). Solo shows presented by Julien Levy (1945–48). During a fire in his workshop, injured his right hand, and family drama led to his suicide at a young age. Honored posthumously by retrospective show at Whitney (1951). Works in permanent collections of numerous museums, including the Art Institute of Chicago, Guggenheim Museum, Metropolitan Museum of Art, Museum of Fine Arts, Houston, Museum of Fine Arts, Boston, Museum of Modern Art, National Gallery of Art, and San Francisco Museum of Modern Art.

Painter, writer, collector, linguist. Educated at Imperial University of St. Vladimir in Kyiv, as a lawyer (1908–12), and the Nikolaev Cavalry School (1915–19). Served in the Tsar's Army in the World War I and received St. George's Honor. Arrested and given death sentence (1918). Repatriated, after which he escaped to Poland and fought with the White Army. Emigrated to Germany, after which he moved to New York (1920) where he began working on his art. Studied at the Art Students League (early 1920s) under D. Sloan. Became one of the founding members of the Abstract American Artists and was a member of John Reed Club and *The Ten*. Participated in many international exhibitions and initial solo shows took place in Modernist Galleries in Baltimore (1926), Phillips Memorial Gallery in Washington, DC and in Dudensing Gallery in New York (1929). Traveled to Paris frequently and exhibited his work at the Zborowski Gallery which enhanced his career and helped gain notoriety in the U.S. Authored the Socratic dialogue *System and Dialectics in Art* (1937). Became close to Jackson Pollock (whom he introduced to Lee Krasner), Stuart Davis, Arshile Gorky, David Smith, and Willem de Kooning, among others. Assembled a noteworthy group show at the McMillen Gallery that placed work by Jackson Pollock, William de Kooning, and Krasner alongside work by Picasso and Matisse (1942). Works in major collections, including Whitney Museum of American Art, Smithsonian American Art Museum, and the Phillips collection.

**GRIGORIEV, Boris**
1886, Moscow — 1939, Cagnes-sur-Mer, France
Emigrated to U.S. in 1923 from France,
lived in New York, 1934–1936

**IZDEBSKY, Vladimir**
1882, Kyiv (now Ukraine) — 1965, New York, NY
Emigrated to U.S. in 1941 from France

Painter, graphic artist, teacher. His father was an accountant and his mother was the daughter of a sea captain who served in Alaska. Family moved to Rybinsk in Yaroslavl Guberniya (1894). Studied at Stroganov School of Art and Industry (1903–07) under D. Shcherbinovsky and the IAA (1907–12) under A. Kiselev and D. Kardovsky, expelled due to absence of a work for the school competition. Lived in Paris (1911–14) and attended Académie de la Grande-Chaumière (1911–13) sporadically. Participated in exhibits from 1909, member of *Triangle* (1909), Societie des Independents (1912–13), and *World of Art* movement (from 1913). Worked as caricaturist for Russian journals *Satiricon* and *Novy Satiricon*. Published a novel under the name of Boris Gris, *Young Rays*. Alongside Alexander Yakovlev and Sergei Sudeikin, decorated an artist café and created set-design for *Black and White* (1916). Lived in Moscow (first half of 1919) and taught at SLAS. Left for Finland with wife on a boat (1919) and later moved to Germany. First one-man exhibit in Berlin (February 1920). Moved to Paris (1920), became part of the reborn committee World of Art (1921) and took part in its exhibitions (until 1930). On the invitation of the Director of the Brooklyn Museum took part in the exhibition of Russian Art in New York (1922). Solo exhibits in Worcester and New York (1923). Other solo exhibits in Germany (1920), back to France (1922), then the U.S. (1923) and finally settled in France (1926). Bought land in Southern France in Cagnes-sur-Mer and built *Borisella* villa. Taught at educational establishments in Chile (1928–29), had exhibitions in Argentina, Chile, and Uruguay. Returned to Paris and taught at the Sukhotina-Tolstoy Russian School of Art (1930) and his own school of Art and Drawing (after 1931). Took part in various exhibits in the U.S. (after 1934) and became the Head of Art Faculty at the New York Academy of United Arts (1935). Second South American tour (1936). Last personal exhibit in New York (1938). Returned to Cagnes-sur-Mer because of illness (March 1938). His works can be found in the collections of U.S., Russian and other museums in the world.

Sculptor, impresario, journalist, publisher, teacher. Son of a nobleman, manager of the train station. From 1890s lived in Odessa. Studied at the Art School in Odessa (1897–1904). Participated in student exhibitions (after 1897). Arrested and deported from Odessa (1905–06). Departed for Europe and studied at the Bavarian Royal Academy, Munich, after moving to Germany (1909). Founding member of the *Neue Kunstlervereiningung Munchen* (1909) along with Kandinsky. Became famous for salons held in Odessa, Kherson, Kyiv, St. Petersburg and Riga (1909–11). Co-founder of *The Green Parrot* — a cabaret-theater of satirical miniature (1910) and a drama theater at Harmony Hall (1913) in Odessa. Moved to Paris with his family (1913–17), then left again for St. Petersburg and later fled to Finland and back to Paris (1919). Was active in Parisian art life and alongside his countrymen Jacque Lipchitz, Oleg Meshchaninov, and Ossip Zadkine was against the *World of Art* movement as it did not reflect "Russian traditions of new art." Forced to flee Nazis in Paris, moved to the U.S. (1941). First solo exhibition held at SRM, St. Petersburg (2005). His works can be found in the collections of the U.S., Russian, and Ukrainian museums.

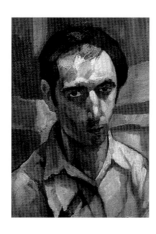

**KRASNOW, Peter**
1887, Village of Zawill (now Ukraine) —
1979, Los Angeles, CA
Emigrated to U.S. in 1907

**LIBERMAN, Alexander**
1912, Kyiv (now Ukraine) — 1999, Miami Beach, FL
Emigrated to the U.S. in 1941 from France,
U.S. citizenship in 1946

Painter, wood sculptor, graphic artist. Son of a provincial artist-decorator and his apprentice. Spent his youth in a Jewish settlement in Southwestern Russia. Moved to the U.S. (1900s) with family because of Jewish pogroms. Studied at the School of the Art Institute of Chicago (1908). Moved to New York where he painted scenes from New York suburbs and places of his youth in Russia in expressionist style (1919–22). Moved to Los Angeles with his wife (1922). Became a member of Macdonald Wright's Group of Independent Artists. Received a Guggenheim grant (1930) and lived in France (1931–34) where he worked on country and circus themes. Returned to California (1935) and developed abstract wood sculptures in his backyard. Reintroduced painting to his activities (1940), and later recalled his Jewish heritage in calligraphy and other subjects (1950–70). Had numerous solo and group exhibits including Whitney Studio Club, Pasadena Art Institute (1954), Stendahl Art Galleries, and Los Angeles County Museum of Art (1931, 1943, 1946, 1965).

Painter, sculptor, publisher, and photographer. Son of a forest specialist and Henrietta Pascal who was the director of the First State Theater for the Children in Moscow. Spent childhood in St. Petersburg. After Russian Revolution (1917) moved to London with mother and then France, where he was educated and was looked after by the Russian Ambassador Leonid Krasin. Also studied at Ecole des Roches in France (1926). Began publishing career with *Vu* and participated in the creation of the first color films, dedicated to art. Received a gold medal for the magazine graphics at the World Exhibition in Paris (1937). Worked for *Vogue* and then *Conde Nast* after emigrating to New York (1941), where he held the position of Editorial Director (1962–94). Took up painting (1950s) and later, metal sculpture, utilizing industrial objects and bright colors. Often allowed his assistants to finish his works due to a lack of time. Published *An Artist in His Workshop* (1960) and exhibited his photographs of 39 artists of the "Paris" school as a photo-essay. First solo exhibition at the Betty Parsons Gallery (1960). Later exhibited a series of photo-essays, one in collaboration with Ilya Brodsky in Rome. Works in the collections of Metropolitan Museum of Art, Storm King Art Center, Hirshhorn Museum and Sculpture Garden, Tate Gallery, the Smithsonian Museum of American Art, and the Guggenheim Museum.

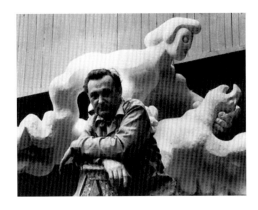

**LIPCHITZ, Jacques (Chaim Jacob Abrahamovich)**
1891, Druskieniki (now Lithuania) — 1973, Capri, Italy
Emigrated to U.S. in 1941 from France,
U.S. citizenship in 1958

**LOVET-LORSKI, Boris**
1894, Khovenskaya Guberniya (now Lithuania) —
1973, New York, NY
Emigrated to U.S. in 1920, U.S. citizenship in 1925

Sculptor. Oldest in the family of a construction worker. Studied at *yeshiva* (from 1899), in the Commerce Institute of Bialystok (1902–06), and at Gymnasium and Drawing School in Vilnius (from 1906) in preparation for becoming an architect. Moved to Paris (1909) without father's knowledge and studied at Ecole des Beaux-Arts and Académie Julien. Went to Russia to serve in the military but due to poor health, was exempt from service (1912). Returned to Paris, rented studio in La Ruche artist's residence and worked closely with Pablo Picasso, Amedeo Modigliani, and Juan Gris, and was converted to Cubism (1915). First exhibits in Salon d'Automne and the National Society of Fine Arts (1913). First solo exhibition (1920). Gained French Citizenship (1924), moved to Boulogne-sur-Se, where he had his workshop in the house. Stereo-metrical volumes grouped into monolith compositions began to change into dynamic and decisive compositions (mid-1920s). During his U.S. years, began to incorporate biblical and mythological references into his work (1930s). Gained international fame after a retrospective exhibit in Paris (1930). Participated in numerous exhibits, had many solo shows, and received numerous awards in the years to follow. Visited U.S.S.R. (1935) and had sympathetic feelings towards the Soviet Government. Settled in New York (1941). Had solo exhibits at Museum of Modern Art, Walker Art Center, Cleveland Museum of Art (1955), New Gallery, NY (1955) and participated in several group exhibits, including the Guggenheim Museum (1963) and Whitney Museum of American Art (1958). Spent summers in his villa in Italy (from 1961), visited Israel (1963, 1967). Published his memoirs *My Life in Sculpture* (1972). Returned to Europe not long before death and spent his last years in Capri. His grave is in Jerusalem. Received the Medal of the Legion of Honor (1946), gold medals from the Academy of Fine Arts (1952, 1968), and other honors from various universities.

Sculptor, graphic artist. Studied at Imperial Academy of Art in St. Petersburg and HAI (1913–17) under G. Zaleman, where he worked briefly as an architect. During World War I, served as an officer. Upon arrival in the U.S., taught at Layton School of Art in Milwaukee and had his first solo exhibit at the Milwaukee Art Institute (1921). Created one-dimensional decorative animal figures from stone, utilizing a primitive style. Later moved towards a more academic manner and created symbolic figures of groups, heads of women and children from marble, wood, ivory, etc. Created portraits of Feodor Chalapin and members of the Italian Court (1930s). Moved to France (1926) and exhibited at the Salon d'Automne. Severe arthritis forced him to concentrate on bronze castings (1950s). Associate member of National Academy of Design, member of National Sculpture Society and Salons of Paris. Solo shows in New York galleries including J. Seligmann (1927), Grand Central Palace (1928), Wildenstein (1931, 1934, 1938, 1940, 1945, 1954), and World House (1963). Received award for a Monument to the American Soldiers at Fort McKinley, Philippines (1955). Works in numerous permanent collections including the Petit Palais of Paris, British Museum, Metropolitan Museum of Art, San Diego Fine Arts Society, and Columbia University.

**LOZOWICK, Louis**
1892, Village of Ludvinovka, Kyiv Guberniya
(now Ukraine) — 1973, South Orange, NJ
Emigrated to the U.S. in 1906 from Russia

**MANE-KATZ, Emmanuel**
**(Emmanuel Leizerovich Katz)**
1894, Kremenchug, Poltava Guberniya (now Ukraine) —
1962, Tel Aviv, Israel
Lived in New York, 1940–1945, arriving from France

Painter, lithographer, illustrator. Grew up in wealthy Jewish family. Attended Kyiv School of Fine Arts (1904–06). Upon immigration studied at National Academy of Design (1912–15) under L. Kroll, E. Carlsen, and Ivan Olinsky, received a degree from the Ohio State University (1915–18) and joined the Army (1918). Lived in Paris (1919) and attended Sorbonne. Moved to Berlin (1920) and attended lectures at the University of Friederich Wilhelm. Created first paintings and lithographs for the series *Cities* and explored other technical elements in his work. While in Berlin (1920–24), became friends with avant-garde Russian artists affiliated with the *Novembergruppe*. Moved to Russia (1923) and explored Constructivism. Upon return to New York (1924) joined executive board of *New Masses* and began exhibiting machine drawings. Worked with *Nation, New Masses, Revue, Arts, Theater Arts Monthly* magazines. Delivered lectures on Soviet art at Société Anonime and published articles about Soviet artists in the American press. Published *Contemporary Russian Art*. Visited Moscow (1927) and delivered a lecture on *New Art in America* as well as had a personal show (1928). As a member of American Artists Congress, he treated socially relevant themes continuously (1930s). Joined Graphic Arts Division of WPA Federal Arts Project (1938–40). From 1944 lived in South Orange. Took part in group exhibitions in the U.S. and in Europe. Works in the collections of Smithsonian American Art Museum, Terra Foundation, Fine Arts Museums of San Francisco, the State Pushkin Museum of Fine Arts, Moscow, and others.

Painter, sculptor, teacher, collector. Father served in synagogue. Studied at *yeshiva*, Kyiv School of Fine Arts (1911–13), visited Paris and attended Ecole des Beaux-Arts (1913–15), and at the New Art Workshop, St. Petersburg, under Mikhail Dobuzhinsky (1916–17). Returned to Russia (1915) and studied collections of the Jewish museum. Took part in exhibitions of Jewish Society and *World of Art* (1916). Appointed professor at Academy in Kharkiv (1918–19), had first solo exhibition there. Left for Berlin (1921), settled in Paris (1922), became French citizen (1927). Painted Jewish themes, landscapes of Paris and the French Riviera, portraits, flowers, and other genre scenes. Had solo exhibition at Galerie Percier, Paris (1923). Also exhibited at Salon d'Automne and Salon des Independants (1930s). Visited Palestine (1928, 1935, 1937), traveled through Europe (1930s), and Mexico (1938). Fled to New York during German occupation of World War II, where he began to make sculptures as well as paintings. Visited Israel annually (after 1948) and continued to travel throughout the world. Died in Tel-Aviv. Most works were bequeathed to the town of Haifa (1958), where there is a museum devoted to his work. His collections can be found in major museums in the world, including the Metropolitan Museum, New York, National Museum of Modern Art, Paris, Tate Modern Gallery, London, and others.

**MANEVICH, Abram (Abraham)**
1881, Mstislavl, Mogilev Guberniya (now Belarus) —
1942, New York, NY
Emigrated to the U.S. in 1921 from Poland

**MARGO, Boris (Boris Margolis)**
1902, Volochisk, Volyn Guberniya — 1995, Hyannis, MA
Emigrated to the U.S. in 1930 from Canada,
U.S. citizenship in 1943

Painter, teacher. Grew up in patriarchal Jewish family and showed tendencies towards drawing at early age. Studied at Kyiv School of Fine Arts (1902–04) under I. Seleznev and received a stipend for study abroad at Munich Academy of Art (1905–06). Participated in exhibits from 1904. Painted landscapes, portraits, still life, and life of Jewish settlements. First solo exhibition in Munich (1907), second, at the Kyiv Art Museum (1909). Lived in Switzerland, Italy, England, and France (1910–15). Visited Maxim Gorky on Capri (1910) and painted his portrait. Exhibited at Paris salons (from 1911). Personal exhibit in Paris (1913) and was highly recognized by Emile Verharen. Returned to Russia (1915). Became a professor of landscape studios at the Kyiv Art Academy (1917). Organized many exhibits in Kyiv and Moscow with Jewish artists. Moved to the U.S. (1920) at first painting the Jewish *shtetl* and hometown themes and later returning to landscapes and city skylines. Participated in numerous exhibitions of Russian art in the Brooklyn Museum (1923) and modern art in the Pittsburgh Museum of Art (1925). Personal exhibitions in New York (seven exhibitions, beginning from 1922), Philadelphia (1923), Chicago (1926), Baltimore (1928), Montreal (1930), Boston (1934), Toronto (1938). Works in the collections of Hermitage, Kyiv and Odessa Art Museums, SRM, Lyons Art Museum, Vilna Gaon Jewish Museum in Lithuania, and others.

Painter, graphic artist, teacher. Enrolled in Polytechnic Institute of Art in Odessa (1919–24) and received a grant to study at the "VKhUTEMAS" (Workshop for the Art of the Future) in Moscow (1924–25). Studied Old Masters in the Hermitage and attended Pavel Filonov's Analytical School of Art (1927). Emigrated to Montreal, where his mother, sister and younger brother (future artist David Margolis) settled. Worked as a muralist (1928). Moved to New York City (1930) where he studied and taught at Roerich Museum (1930–32). Painted surrealist paintings. Developed a technique of printed graphic, covered with cello-cut (1932). Created reliefs decorated with calligraphy. Had yearly solo exhibitions in New York (1939–60). Founded *Creative Art Seminar* in Orlando, FL (1943), followed by one in Provincetown, MA. Taught at Art Institute of Chicago, Syracuse University, Universities of Illinois, Michigan and Minnesota. First solo exhibit was at Artists Gallery in New York City and other important shows held at Brooklyn Museum, Tweed Gallery at University of Minnesota, Duluth and Michael Rosenfeld Gallery (1993).

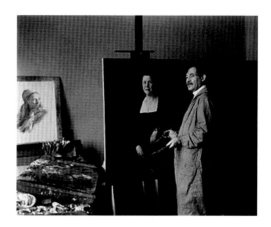

**NEVELSON, Louise**
1899, Kyiv (now Ukraine) — 1988, New York, NY
Emigrated to the U.S. in 1904 from Russia

**OLINSKY, Ivan**
1878, Elizavetgrad (now Ukraine) — 1962, New York, NY
Emigrated to the U.S. in 1890 from Russia

Sculptor, printmaker, teacher. Attended Art Students League (1929–30), then traveled to Munich to study with Hans Hoffman. Worked as assistant to Diego Rivera who introduced her to pre-Columbian art (1932–33). First solo exhibit featured terracotta and wood sculptures based on Mayan and other primitive imagery in Nierendorf Gallery, New York (1941). Focus shifted towards sculptures about myth and mystery (1950s), added plastics and formica to repertoire (1960s) and created monumental works in aluminum and steel (1970s). *Louise Nevelson Plaza* dedicated to the artist in lower Manhattan (1979). Works in the collections of Guggenheim Museum, Whitney Museum of American Art, Smithsonian Museum of American Art, National Gallery of Art, San Diego Art Museum, and many others.

Painter, teacher. Son of a merchant. First lessons in drawing received in Elizavetgrad. Started studies at a university (1888) when most of his classmates were twice his age. In New York, enrolled in National Academy of Design (1894–98) and worked as an assistant to John La Farge (1898–1906) on mural commissions and stained glass windows. Moved to Europe with his family and spent time studying and painting street scenes (1906–10). Upon return to New York (1910) set up a studio on Washington Square and painted portraits, mainly of women. Created church decoration for Lutheran Church of St. Thomas in the Bronx (1920–22), portraits and decorative panels at Loomis Institute in Windsor, CT (1925). Exhibited at New York galleries — Macbeth (from 1910s), Grand Central Palace (from 1923) and others. Taught at National Academy of Design for half a century (from 1912), as well as the Art Students League (1928–34, 1944–62). Became an Academician (1919). Had contract with Portraits Incorporated (1947–52). First memorial exhibition held at Art Students League (1962). Works in the collections of Art Institute of Chicago, Brooklyn Museum, Art Students League, Museum of Fine Arts, Boson, Detroit Institute of Art, Smithsonian American Art Museum, and others.

biographies of artists

**OLITSKY, Jules (Jevel Demikovski)**
1922, Snovsk, Chernigov Guberniya (now Ukraine) —
2007, New York, NY
Emigrated to the U.S. 1923 from Russia

**ROTHKO, Mark (Marcus Rothkovich)**
1903, Dvinsk (now Daugavpils, Latvia) —
1970, New York, NY
Emigrated to the U.S. in 1913, U.S. citizenship in 1942

Painter, sculptor. Attended public schools in New York, won a scholarship to Pratt Institute and admitted to National Academy of Design (1939–42). Joined U.S. Army during World War II and went to Europe on G. I. Bill. While in Europe attended Ossip Zadkine School (1949) and Academie de la Grande Chaumiere, Paris (1949–50). Upon return to New York earned B.A. and M.A. from New York University (1952–54) and painted in monochromatic colors, in opposition to color and imagery of his Paris works. Joined faculty of C.W. Post College (1956) and had his first solo show at Iolas Gallery, New York (1958). In addition to 150 solo shows during his life time, his works are in the collections of Museum of Fine Arts, Boston, Metropolitan Museum of Art, Museum of Fine Arts, Houston, Whitney Museum of American Art, National Gallery of Canada and others.

Painter, monumental artist, leading representative of Abstract Expressionism, one of the founders of the color field school, and teacher. Grew up in educated Jewish family with Yiddish, Hebrew and Russian languages spoken at home. Moved to the U.S. when he was ten. Studied at Yale University (1921–23) but dropped out returning 46 years later to receive his honorary degree. Attended Art Students League under Max Weber (1925), and the National Academy of Design under Arshile Gorky, which represented his only formal artistic training. Early works were of expressionist and surrealist nature. First group exhibition at Opportunities Galleries in New York (1928), at the same time meeting Milton Avery and Adolph Gottlieb who influenced his work. First solo exhibition at Contemporary Arts Gallery, New York (1933). Founding member of *The Ten*. Executed easel paintings for WPA Federal Art Project (1936–37). Peggy Guggenheim honored Rothko with a solo show at *Art of This Century in New York* (1945). Formed individual style (1947) which was influenced by Henri Matisse and Wassily Kandinsky. Taught at California School of Fine Arts, San Francisco (1947–49), also at Brooklyn College, University of Colorado, and Tulane University. Commissioned for three major projects: canvases for Four Seasons Restaurant and Seagram Building, New York; murals for Holyoke Center, Harvard University (1958–61); and canvases for an interdenominational chapel in Houston which is known worldwide as *The Rothko Chapel* (1962–64). Rothko committed suicide in 1970. Works in collections worldwide.

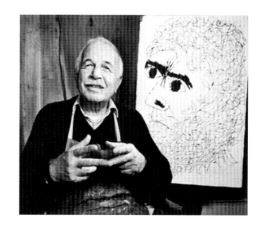

**SCHICK, Nina (Nina Fradkin)**
1909, Moscow — 1999, East Hampton, New York
Emigrated to the U.S. in 1935 from England

**SHAHN, Ben (Benjamin)**
1898, Kaunas (now Lithuania) — 1969, New York, NY
Emigrated to the U.S. in 1906 from Russia

Painter. Left Russia as a child with her parents, sister and brother (1917). Lived with her family in several countries, including Germany, Israel, and France (1917–26). Married Oscar Evnin (1926) in Paris and lived in England (until 1935). Moved to New York City where she raised a family. Lived and painted in New York City and East Hampton, Long Island (1935– 80). Studied with Sergei Sudeikin in New York City (1930–40s). Divorced (late 1940s) and married Alexander Schick (1950). Created and managed a successful floral design business in New York City (1949–80). After 1980, lived and painted in East Hampton and Paris, France until her death.

Painter, lithographer, social activist, teacher. Apprentice to a lithographer after elementary school (1913–17). Studied biology at New York University (1919–22) and briefly attended National Academy of Design (1920s). Traveled through Europe and Northern Africa and painted during his journey (1924–25, 1927–29). First solo show in New York (1930). Assisted Diego Rivera with the famous Rockefeller Center Mural (1935–38). Designed posters for the Office of War Information (1942) and other government departments (1944–46). Shahn was a teacher and a lecturer at many institutions and was named one of the ten best American painters by *Look* magazine (1948). Had many solo exhibitions in major art museums in New York, London, Amsterdam, Brussels, Rome, and Vienna. Member of National Institute of Art and Literature (1956), member of American Academy of Art and Sciences (1959). Last ten years of his life devoted to mosaic work and mural work for various buildings and churches. Works in the collections of National Gallery of Art, Fine Arts Museum of San Francisco, the Jewish Museum, New York, Harvard University Art Museum, and others.

biographies of artists

**SIMKOVICH, Simka**
1893, Novozybkov, Bryansk Region, Orlov Guberniya —
1949, Greenwich, CT
Emigrated to the U.S. in 1924 from U.S.S.R.

**SLOBODKINA, Esphyr**
1908, Chelyabinsk — 2002, New York, NY
Emigrated to the U.S. in 1929 from China,
U.S. citizenship in 1933

Painter, graphic artist, teacher. Son of a merchant. Attended an art school in Odessa (1905–11) and was recommended to attend the IAA in St. Petersburg, but did not make the quota allowed for Jews. Served in the Army before graduating (1911–12). Upon completion of this service, was finally able to attend IAA and HAI (1913–20). Participated in several Jewish exhibits in Odessa (1909), Moscow (1918), and in international exhibit in Florence (1924). Sent to the United States to do illustrations for Soviet textbooks (1924), applied and gained U.S. citizenship. Started working with Midtown Galleries and Marie Stern on a regular basis. Painted still life, landscapes, portraits, genre scenes, and Russian themes (*Carousel*, *Russian Dance*, etc.). Employed by WPA Federal Art Project and one of the largest commissioned murals was for the Mississippi Court House. Participated in exhibitions at Carnegie International (1933–45), National Academy of Design (1926, 1942, 1946, 1948), Art Institute of Chicago (1932–45), Metropolitan Museum of Art (1940, 1942), and many others. Works in the collections of Whitney Museum of American Art, as well as in museums in Poland and Russia.

Painter, sculptor, illustrator, writer. Daughter of a manager of an oil refinery. Lived in Ufa with family (from 1915), then Vladivostok (1919) and immigrated to China (1920). Studied art and architecture in China under P. Gunsdt, worked on designs for embroidery for mother's tailor shop. Enrolled in National Academy of Design (1929–33) upon arrival in the U.S. where she met her husband, another artist represented in the exhibit, Ilya Bolotowsky (1933). They parted ways five years later. Worked with fabric in Clifton and Patterson, NJ (from 1934). Painted in style of abstract surrealism and created sculpture (1930s). Founding member of American Abstract Artists group (1936) and Federation of Modern Painters and Sculptors (1941), and a member of the politically oriented Artist's Union. Was an outstanding sculptor but preferred exhibiting paintings. Illustrated many children's books, including her own, *The Clock* (1965), *The Long Island Ducklings* (1961), and *The Circus Caps for Sale* (2002). Established The Slobodkina Foundation (2002). Works in the collections of Metropolitan Museum of Art, Hillwood Museum, Corcoran Gallery, and many others.

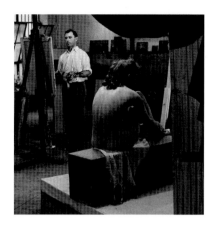

**SOLMAN, Joseph**
1909, Vitebsk (now Belarus) — 2008, New York, NY
Emigrated to the U.S. in 1912 from Russia

**SOYER, Moses**
1899, Borisoglebsk, Tambov Guberniya —
1974, New York, NY
Emigrated to the U.S. in 1912 from Russia

Painter. Studied at National Academy of Design, although attributed most of his learning process to sketching sleeping people on the subway while riding to and from school (late 1920s). Saw inaugural show at MOMA of George Seurat, Paul Gauguin, Vincent Van Gogh and Paul Cézanne which was the biggest event influencing his life and art. Founding member of *The Ten* (1935). Active in easel painting division of WPA Federal Art Project (1936–41). Honored with a retrospective exhibit at Phillips Memorial Gallery (1949). Received an award for painting from National Institute of Arts and Letters (1961). Elected editor of *Art Front Magazine*, as champion of modernism.

Painter, teacher. Son of teacher and amateur artist, twin brother of Raphael Soyer, represented in the exhibit. Took first lessons from his father, who taught him to love art through reproductions of Russian artists' paintings and took his children to Moscow to specifically see the Tretyakov Gallery. Studied painting in New York at Cooper Union (1914–17) and National Academy of Design (1918–22). One of the founding members of John Reed Club (1929). Taught at Contemporary Art School and New School of Social Research (1927–34). Prominent at Fourteenth Street School (1920s). During the Depression, with Raphael participated in WPA Federal Art Project and painted two murals at Kinglessing Post Office in Philadelphia, PA. Painted portraits and still life, and also worked on lithographs and graphic works. Influenced by classical American School of George Bellows and Robert Henri. Known as realist painter, whose models were family members and artists associated with his wife, a professional dancer. Solo exhibitions in New York galleries (1920–50s). Kept in touch with other Russian artists, including David Burliuk who wrote a poem entitled *The Brothers Soyer*. Works in the collections of Museum of Modern Art, Phillips Collection, National Academy Museum, Smithsonian American Art Museum, Brooklyn Museum, and many others.

**SOYER, Raphael**
1899, Borisoglebsk, Tambov Guberniya —
1984, New York, NY
Emigrated to the U.S. in 1912 from Russia

**SUDEIKIN, Sergei (Serge Sudeikine)**
1882, St. Petersburg — 1946, New York, NY
Emigrated to the U.S. in 1922 from France

Painter, teacher. Twin brother of Moses Soyer, represented in the exhibit. Studied painting in New York after the family moved there at Cooper Union (1914–17), National Academy of Design (1918–22, with intervals), and Educational Alliance Art School (1914–23). One of the founding members of John Reed Club (1929). Known as realist painter. Painted city life and working neighborhoods in New York (1920–1930s). Taught at Art Students League (1933–42). Prominent at Fourteenth Street School (1920s). First solo exhibit at Daniel Gallery, New York (1929). Left social themes and started painting portraits, interiors, and psychological scenes (1940s). Created a gallery of portraits of his artist friends, including Arshile Gorky, Ossip Zadkine, and others. With Moses participated in WPA Federal Art Project and painted two murals at Kinglessing Post Office in Philadelphia, PA. Traveled through Europe (summer of 1961) and produced a book of impressions illustrated with his own paintings. In 1958 he was elected to the National Institute of Art and Literature. Published *Diary of an Artist* — his thoughts about art. Works in the collections of Museum of Modern Art, the Phillips collection, Terra Foundation, National Academy Museum, Smithsonian American Art Museum, Brooklyn Museum, and many others.

Painter, graphic artist, set-designer. Came from a nobleman's family in Smolensk Guberniya, son of Assistant Police Chief of St. Petersburg who was killed by riots (1883). Studied under Konstantin Korovin at MIPSA (1897–1909), and under Dmitry Kardovsky at the IAA (1909–10). Contributed to exhibitions (since 1900), including those of Moscow Fellowship of Artists (1905), Union of Russian Artists (1905, 1907–09), *Scarlet Rose* (1904), *Blue Rose* (1907), *World of Art* (1911–17, 1921; member after 1911) and the Exhibitions of Russian Art in Europe (1906–10), New York (1924) and Pittsburgh (1924). Created stylized paintings, festivals, rich still life with flowers and statuettes, and other "gallant" scenes. Designed for many Russian theaters, most notably for Sergei Diaghiliev's *Saisons Russes*. Went to Crimea (1917) and worked on inventory at the Vorontsov Palace, participated in exhibitions. Moved to Tiflis (now Tbilisi), worked on monumental and decorative art and took part in *Small Circle* exhibit (1919). Through Batumi went to Marseilles, and Paris, working as stage decorator for the Baliev Theater group, as well as creating stage designs for the Anna Pavlova Ballet. Painted portraits of theater artists and took part in exhibitions of Russian artists (1921). Upon arriving in the U.S. with the Baliev Theater (1922), worked on stage-designs for the Metropolitan Opera and created designs for the Ballet Troupes of Mikhail Fokin and George Balanchine. Also created decorations for *Sunday*, a movie based on the Lev Tolstoy novel and filmed in Hollywood (1935). Participated in exhibitions of Russian art in New York (1923–24), Chicago (1923), Brussels (1928), and Wilmington (1932). Works in collections of museums in the U.S., France, Russia, including the SRM.

biographies of artists

**TCHACBASOV, Nahum**
1899, Baku (now Azerbaijan) —
1984, New York, NY
Emigrated to the U.S. in 1907 with parents

**TCHELITCHEW, Pavel**
1898, Dubrovka, Kaluga Guberniya —
1957, Frascati (near Rome), Italy
Lived in the U.S. 1934 —1949, U.S. citizenship in 1942

Painter, graphic artist, poet. Name was created as an anagram of different family names. Father emigrated from Russia (1905), settled in Chicago (1907), where he was later joined by wife and children. Artist left school at fourteen to help family and enlisted in the Navy (1918). Was inspired by the light of North Sea and drawn to painting. Earned a business degree upon return and worked as accountant (1919–29) and later, as business became successful, turned to painting (1930). Studied with Leopold Gottlieb, Marcel Gromaire, Fernand Léger in Paris (1932–34). Back in New York worked on WPA Federal Art Project, member of *The Ten* (1935–37), member of National Executive Committee of the American Artists Congress. First solo exhibition at Gallerie Session (1935), followed by many one-man and group shows. Works in the collections of Smithsonian American Art Museum, the Jewish Museum, and others.

Painter, sculptor, set designer. Heir of famous noble family, whose father was a wealthy merchant. Educated largely by private tutors, and later attended Moscow Art School (1907), took classes at Moscow State University (1916–18), and from costume artist of the Bolshoi Theater K. Korasne (1917). Family moved to Kyiv and he was encouraged to take classes at Kyiv Academy from Alexandra Exter and A. Millman (1918), as well as at the Monastery School of Iconography. Was influenced by Cubism and Constructivism. Took part in creating stage design in Kyiv (1919). Served in the White Army and was evacuated from Novorossiysk to Constantinople (now Istanbul) (1920). Settled in Berlin and had considerable success as stage designer (1921–23). Moved to Paris and became known, along with other artists, as Neo-Romantics (1923–34) and exhibited in solo and group shows, as well as designed sets and theater costumes for Diaghiliev. Solo exhibits in Paris (1929, 1931, 1939), London (1928, 1933, 1935, 1938), New York (1933, 1934, 1937), and Chicago (1935, 1938). Took part in exhibitions of Russian artists in Paris (1925, 1932) and in thematic exhibitions of *New Generation* (1932), *Clowns* (1932), *Russian Ballet of Diaghiliev* (1939). Upon arrival in the U.S. (1934), continued working on ballet and stage designs, which included work for Balanchine. During U.S. years painted his most famous *Hide and Seek* (1940–42). Despite gaining U.S. citizenship spent his last years in Italy. Works in the collections of Museum of Modern Art, Metropolitan Museum of Art, Hirshhorn Museum and Sculpture Garden, Tate Museum, Michael Rosenfeld Gallery, NY, and others.

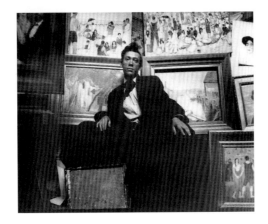 

**WALKOWITZ, Abraham**
1878, Tyumen — 1965, New York, NY
Emigrated to the U. S. in 1889 from Russia

**VASILIEFF, Nicholas**
1892, Moscow, Russia — 1970, Massachusetts, U. S.
Emigrated to the U. S. in 1923 from France

Painter. From wealthy Jewish family. After father's death, along with mother and two younger sisters moved from Siberia to New York (1899). Received first professional training at Cooper Union, Art Students League and National Academy of Design. Lived in Paris (1906–07) and attended Academie Julien (1906). Met Max Weber, who introduced him to modern art of Rodin, Matisse, and Picasso, as well as to Gertrude Stein and her circle. Met Isadora Duncan at Rodin's workshop, and her image became an inspiration to many of his works — her dance movements were captured in more than five thousand works on paper and in watercolors. Gained fame after returning from New York from France. Close to group of modernist artists gathering in 291 Gallery of photographer Alfred Stieglitz on Fifth Avenue. As American art moved from modernist experimentation to regionalism, lost his popularity. Lost vision (1940s). Spent remaining years in his Brooklyn apartment in a company of his niece. Works in major U. S. museums.

Painter. Studied at Konstantin Juon and Ivan Dubin's studio in Moscow (early 1900s), later studied at Moscow School of Painting, Sculpture and Architecture under Leonid Pasternak (1906–09). Taught at Moscow Free Art Studios and VKhUTEMAS (Workshop for the Art of the Future) in Moscow (1909–19). Took part in *Impressionism to Avant-Garde* exhibit (1919). Left for Istanbul (1919) and later for Germany and France (1922). Participated in such important shows as *First Russian Art Exhibition in Berlin* (1922). Upon arriving in the U.S. took part in *Contemporary Russian Art* exhibition in Philadelphia (1932). Participated in more than ten personal exhibits in New York (1938–63). His collections can be found in major museums including Whitney Museum of American Art, Brooklyn Museum, Philadelphia Museum of Fine Arts, the Yale University Collection, and others.

**WEBER, Max**
1881, Bialystok (now Poland) —
1961, Great Neck, NY
Emigrated to the U.S. in 1891 from Poland

**ZADKINE, Ossip**
1890, Smolensk — 1967, Paris, France
Lived in the U.S., 1941–1945

<div style="margin-left: 5rem;">biographies of artists</div>

Painter, sculptor, poet. Enrolled at Pratt Institute (1898) and studied under Arthur Wesley Dow. Moved to Paris, attended Académie de la Grande Chaumiere, Académie Julian and Académie Colarossi (1905–08) and organized a small class guided by Henri Matisse (1908). Befriended Henri Rousseau, frequented studios of Matisse and Picasso (1908), and exhibited his work at Salon des Independants and Salon d'Automne. Returned to America and taught at Clarence H. White School of Photography (1914) and Art Students League (1920). Selected as Director of Society of Independent Artists (1921), national chairman and honorary chairman of American Artists' Congress (1937–40). Museum of Modern Art selected his work for a one-person exhibition during inaugural year (1930), extensive survey of his work at Associated American Artists Galleries (1941) followed by many solo and group exhibitions. Works in the collections of the Jewish Museum, the Phillips collection, Smithsonian American Art Museum, Museum of Fine Arts, Boston, Terra Foundation for American Art, and many others.

Painter, sculptor, teacher. Son of a classical languages teacher at Smolensk Seminary. Spent his childhood and youth in Vitebsk, classmate of Mark Chagall and friend of Lazar Lissitsky. Received first lessons in painting from Yu. Pan. Attended the Regent Street Polytechnic School and Central School of Arts and Crafts in London (1905–09). Created first monumental sculpture from pink granite (1907). Moved to Paris and studied at Ecole National Des Beaux-Arts, but disillusioned in style of teaching, rented workshop on La Ruche (1910). Frequented La Rotonde and M. Vasilieva Academy; became part of the Paris artists circle. Exhibited for the first time at Salon d'Automne and Salon des Independants (1911). Was interested in Roman sculpture, African plastics, and archaic cultures. Worked as stretcher-bearer during World War I in the French Army and due to illness was demobilized. Produced many watercolors with war-themes and exhibited alongside Modigliani and Kisling in Paris (1918). Exhibited in Paris, Brussels, Antwerp, Chicago, and New York (1933–37). Fled to the U.S. during World War II and opened a workshop in New York, where he continued his active involvement in art. Taught in Art Students League in Arizona and North Carolina (1944–45). Returned to France (1945) and as professor, continued working with Académie de Grande Chaumiere. Participated in over one hundred exhibitions, including traveling exhibits to the U.S. and Canada and Japan (1955–60). Received many awards, including the Legion of Honor (1967). His workshop in Paris became Zadkine Museum in Paris, France. Works represented in collections in museums worldwide.

List of Abbreviations

| | |
|---|---|
| **HAI** | Higher Art Institute |
| **IAA** | Imperial Art Academy |
| **ISAA** | Imperial Society of Art Appreciation |
| **MIPAS** | Moscow Institute of Painting, Art and Sculpture |
| **SAA** | Society of Art Appreciation |
| **SLAS** | State Liberal Art Studios |
| **SLAWS** | State Liberal Art and Workshop Studios |
| **SRM** | State Russian Museum |

## index of artists

ANISFELD, Boris   *ill. on p. 26, 27; ill. 30–32*
ARAPOFF, Alexis   *ill. 45, 46*
ARCHIPENKO, Alexander   *ill. on p. 63;*
   *ill. 38, 39*

BENN, Ben   *ill. 36, 37*
BEN-ZION (Ben-Zion Weinman)   *ill. 82, 83*
BERMAN, Eugene   *ill. 45, 46*
BERMAN, Leonid   *ill. 61*
BLUME, Peter   *ill. 40*
BOLOTOWSKY, Ilya   *ill. on p. 42; ill. 113–115*
BURLIUK, David   *ill. on p. 32, 33, 61;*
   *ill. 4–7*

CHALIAPIN, Boris   *ill. 101–104*
CIKOVSKY, Nikolai   *ill. 33, 47–50*

DERUJINSKY, Gleb   *ill. on p. 35*

FECHIN, Nicolai   *ill. 24–27*

GASPARD, Leon   *ill. 18–23*
GORKY, Arshile   *ill. on p. 42, 55; ill. 80, 81*
GRIGORIEV, Boris   *ill. on p. 28, 29; ill. 8–10*
GRAHAM, John   *ill. on p. 38, 39; ill. 64–67*

IZDEBSKY, Vladimir   *ill. 105–108*

KRASNOW, Peter   *ill. 89*

LIBERMAN, Alexander   *ill. 109–111*
LIPCHITZ, Jacques   *ill. 85–88*
LOVET-LORSKI, Boris   *ill. 84*
LOZOWICK, Louis   *ill. on p. 54; ill. 3*

MANE-KATZ, Emmanuel   *ill. 71*
MANEVICH, Abram   *ill. 34, 35*
MARGO, Boris   *ill. 92–94*

NEVELSON, Louise   *ill. on p. 66; ill. 112*

OLINSKY, Ivan   *ill. 28, 29*
OLITSKY, Jules   *ill. 116–118*

ROTHKO, Mark   *ill. on p. 43, 52, 53;*
   *ill. 95–100*

SCHICK, Nina   *ill. 59, 60*
SHAHN, Ben   *ill. on p. 41; ill. 68–70*
SIMKOVICH, Simka   *ill. 57, 58*
SLOBODKINA, Esphyr   *ill. 91*
SOLMAN, Joseph   *ill. on p. 64*
SOYER, Moses   *ill. on p. 51; ill. 51, 52, 56*
SOYER, Raphael   *ill. on p. 40, 45; ill. 53–55*
SUDEIKIN, Sergei   *ill. on p. 30, 31;*
   *ill. 11–13*

TCHACBASOV, Nahum   *ill. 14*
TCHELITCHEW, Pavel   *ill. on p. 36, 37, 56;*
   *ill. 72–79*

VASILIEFF, Nikolai   *ill. 15–17*

WALKOWITZ, Abraham   *ill. on p. 50*
WEBER, Max   *ill. 1, 2, 41–44*

ZADKINE, Ossip   *ill. 90*

A View of the Brooklyn Bridge. Circa 1904
Photo Courtesy of the Library of Congress